THE COMPLETE
DIGITAL PHOTO
MANUAL

YOUR #1 GUIDE FOR BETTER PHOTOGRAPHY

THIS IS A SEVENOAKS BOOK

Published in 2013 by SevenOaks
An imprint of the Carlton Publishing Group
20 Mortimer Street
London W1T 3JW

10 9 8 7 6 5 4 3 2

Text © Carlton Books Limited and Bauer Media Limited 2011
Pictures © Bauer Media Limited 2011 (except pp.48–49)
Design © Carlton Books Limited 2011

A CIP catalogue record for this book is available
from the British Library.

ISBN 978 1 86200 791 8

Publishing Manager: Penny Craig
Project Editor and Additional Text by Liz Walker
Editorial Assistant: Alice Payne
Managing Art Editor: Lucy Coley
Design by Anna Pow
Production by Janette Burgin

Printed in Dubai

THE COMPLETE
DIGITAL PHOTO
MANUAL

YOUR #1 GUIDE FOR BETTER PHOTOGRAPHY

IN ASSOCIATION WITH
DIGITAL
PHOTO
MAGAZINE

SEVENOAKS

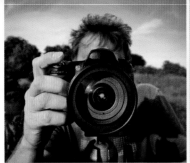

Introduction 6

1

CAMERA TYPES

Digital compacts10

Progressing to a DSLR12

Which type of DSLR?14

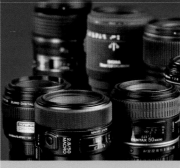

2

LENSES AND FOCAL LENGTHS

Lenses explained 20

Choosing and
using lenses 24

Buying lenses 26

3

ESSENTIAL ACCESSORIES

Tripods 32

Filters 34

Camera bags
and backpacks 38

Flashguns 40

Image storage
and monitors 42

Printing at home 44

Getting the colours right 46

Optional extras 48

4

CORE CAMERA SKILLS

Master the basics................... 52

Use the mode dial 54

Aperture, shutter
speed and ISO 56

Metering and
making exposures 60

Using depth of field 64

Maximizing sharpness 66

Freezing movement 68

Blurring movement 70

Panning 72

White balance74

Composition76

Using flash 78

5

PHOTOSHOP AND ELEMENTS TUTORIALS

Getting started 84

Transferring images and
file formats ... 86

Basic adjustments 88

The crop tool .. 90

Levels and curves 92

Hue/Saturation94

Clone Stamp and Healing Brush96

The Brush tool 98

Sharpening the image100

Making selections102

Transform selections 112

Understanding Layers 114

Working with new Layers 116

Adjustment Layers 118

Layer Masks ..120

Blending Layers122

Understand channels124

Convert to mono126

Popping colour into black
and white ...130

Changing colours132

Creative hand-colouring134

Stylish toning effects136

Get the "Toytown" look138

Add borders and text140

6

INSPIRATIONAL PHOTOGRAPHY

Make silhouettes from scratch 144

Panoramas 146

Create an upright panorama 148

Capture natural portraits150

Set up a multiple self-portrait152

Add selective blur to backgrounds 154

Take portraits of children ...156

Shoot fun and funky teenagers 158

Add texture effects160

Lift your summer landscapes162

Replace a boring sky 164

Shoot frosty winter landscapes166

Add seasonal sunrays168

Add atmospheric mist170

Blur waves with a long exposure172

Get creative with your pop-up flash 174

Paint with flash176

Use studio flash178

Turn a landscape black and white182

Control and boost contrast 184

Dodge and burn with Layers 186

Generate the lith film look .. 188

Apply a solarization effect190

Create liquid emulsion borders192

Shoot infrared in colour and black and white194

Try diffusion effects in black and white196

Traffic trails198

Shoot fireworks 200

Paint with light 202

Take natural close-up shots 204

Shoot a still life by torchlight 206

Capture backlit leaves 208

Shoot flower portraits 210

Shoot smoke patterns212

Add drama to static shots214

Present an image as a joiner216

Make a triptych 220

7

RAW IMAGING ADVICE

What is RAW?224

Using Adobe Camera RAW ...226

Basic RAW conversion 228

Convert to mono with RAW ...230

Split RAW conversions –
the basics 232

Split conversions – three Layers 234

Split RAW conversions –
black and white236

Control colour with RAW 238

Fix camera and lens problems 240

The RAW workflow244

Glossary250

Useful contacts252

Manufacturers
and distributors253

Index255

Introduction

PHOTOGRAPHY IS A WONDERFUL HOBBY. It's a blend of art and science, creativity and technology. It encourages us to see the world afresh, explore new places, pursue new ideas. It allows us to communicate and to express our artistic side. It takes patience and practice, and yet even a novice can catch a lucky grab shot on occasion.

Literally translated, photography means "drawing with light". It is the act of recording permanent images by projecting light onto a light-sensitive material. This is still as true today as it was back in the Victorian era when photography began, only now the technology has changed beyond recognition. Instead of painting glass panels with light-sensitive chemicals, nowadays our cameras come equipped with a tiny image-processing chip that records the light reflected by a scene in megapixels. And in place of arcane and elaborate "wet" darkroom manipulations, the modern DSLR photographer can open his files on the computer to add his own creative flourishes both quickly and easily.

Pioneering photographer William Henry Fox Talbot considered photography to be the "pencil of nature" – a tool to help us study the world around us. In the digital age we're no longer restricted to photographing what's actually there. We can alter reality at the click of a cursor, and make supernatural "fantasy" images entirely from scratch. At last we can use photography as a truly artistic medium, bringing our own personal interpretations to every image we produce. No other medium is as accessible or liberating.

In this book, we want to show you how to harness photography to express yourself and discover your own creative "signature style". Whether you want to improve your portraits and landscapes, start shooting natural details and macro subjects, or simply want to come home with better holiday snaps, you'll find there's plenty of inspiration and guidance right here.

In the first chapter we'll show you how to choose the right camera for you. Whether a compact camera or DSLR kit is more your style, finding the right one is key to building up your confidence as a photographer. Annotations reveal what to look for when shopping for a new camera, as we take you through the different types – from compacts right up to those top-of-the range professional-spec cameras.

Next, in Chapter 2, we look at accessories which will help you build up your camera system. We discuss which lenses to buy should you become frustrated by the shortcomings of your standard or 'kit' zoom. We look at how different focal lengths affect angle of view and how different creative perspective effects can be achieved. We cover how to care for your lenses and what to consider when upgrading, and the differences in image quality, handling and performance when comparing fast and slow lenses, primes and zooms.

In Chapter 3 we look at the many other useful accessories you'll need to help build up your system. From investing in a tripod and camera bag to choosing filters that help boost colour and contrast in your images, to flashguns, computer monitors and printers. We'll help you make sensible buying decisions, explaining why, with certain important items, it's often worth saving up before buying an accessory which you'd otherwise soon find inadequate or limiting.

That's why you don't need to have a "full" camera kit before getting to grips with the core camera skills in Chapter 4. Here we take beginners and improvers right through the process of taking their first successful photographs, from how to hold the camera steady to the vital roles of aperture, shutter speed and ISO in making a correct exposure. We'll gently wean you off using the full auto exposure modes and into using the semi-automatic ones – such as aperture-priority and shutter-priority – in order to learn about controlling depth of field and subject movement through your choice of exposure settings.

Next comes a whole section on Adobe Photoshop and its streamlined sister software, Elements, the two image manipulation software programs that we'll be using throughout the next chapters to help you improve your digital image files. First we'll explain what the software is – how the "interface" works, where to find the main tools and what each of them does. Next we look at making Selections and using Layers: two of the main features that make image alterations so much easier and more effective in Photoshop. We'll also look at the basics of taking colour images and making them black and white, how to tone them and add text.

This leads to Chapter 6, a step-by-step project-led extravaganza. If you want to merge perfect panoramic images, shoot dramatic silhouettes in daytime or retouch digital portraits, it's all here. There are still life scenes using "painting with light" techniques; fireworks and traffic trails; advice on working with studio flash and a whole range of clever ways to lift your landscapes in colour and black & white.

Finally, in Chapter 7, we look at the many reasons why you should take the plunge and start shooting RAW image files. We explain what RAW files are, and how to convert them using Photoshop's own Adobe Camera RAW plug-in. We also look at the real advantages of shooting RAW: how to make split conversions for land and sky, as well as how to make lens corrections. To round off the chapter, we reveal some expert tips on how to manage your RAW workflow, right from shooting and downloading images to editing, rating and labelling them using keywords.

Throughout each chapter, this manual will explain all you need to know to progress your photography to a more advanced and rewarding level, using step-by-step projects and expert advice panels to make everything crystal clear. We hope you enjoy it and find the projects inspire your own creative ideas.

LIZ WALKER

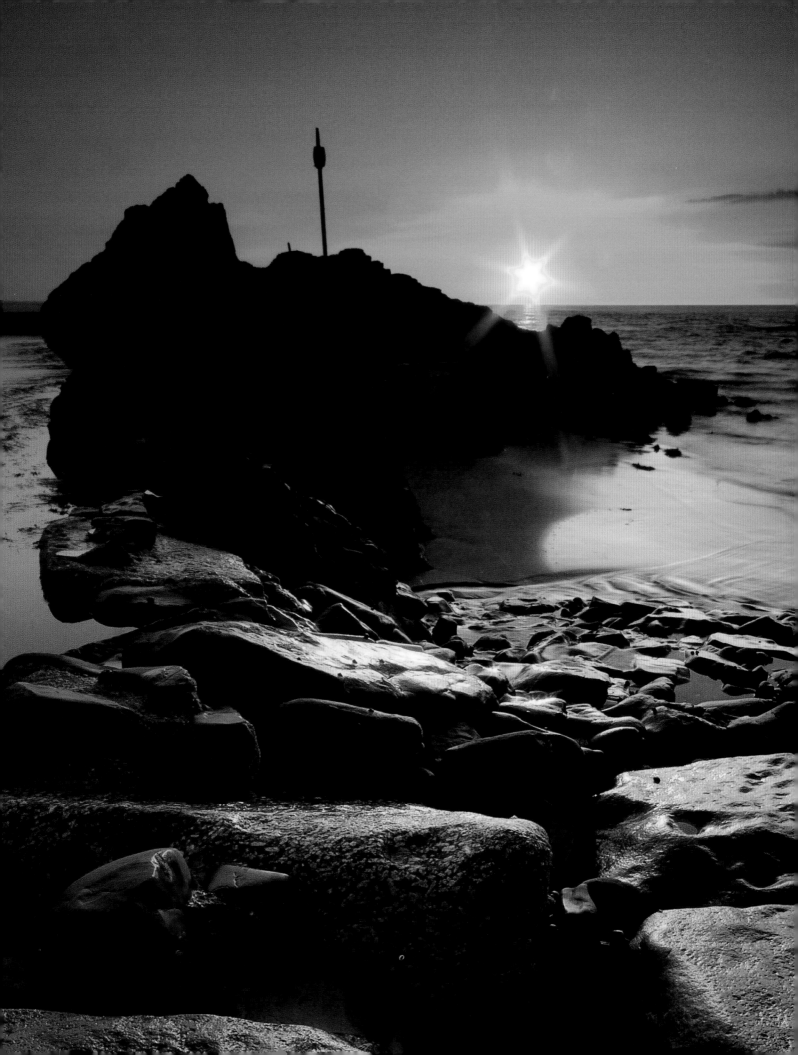

1 CAMERA TYPES

EVERYONE REMEMBERS the excitement of buying their first "proper" camera – the thrill of getting it out of the box, working out what all the cables and disks are for, and how to fit the lens on the front. It's all very exciting, not least when you realize how much creative potential now lies in your hands.

Whether you're buying your first DSLR (Digital Single Lens Reflex) or looking to upgrade to a camera with a more sophisticated spec, it pays to do a little research first to work out what you're really looking for. Start by making a list of design and feature priorities – intuitive layout, robust build, creative options, lens compatibility – and divide them into "essentials" and "nice to haves". Next, take a look at what's on the market and see what sort of camera best meets those needs.

Most digital cameras are sold on key points in their specification, chiefly: the number of megapixels offered by the sensor; the performance of the lens that comes with the camera body; the speed and accuracy of focusing; size, weight and build quality. On top of that, DSLRs have a bewildering range of special features to work your way around – everything from exposure optimization to automatic focus tracking, potential to trigger an array of wireless flash units, camera shake and red-eye reduction, burst rates and buffer speeds... so don't rush to buy without handling the camera first.

Usually, buying a new digital camera involves striking a realistic compromise between your budget and the features you can afford. In this chapter we've outlined some of the key things to look for when choosing a new camera.

Digital compacts

Choose a robust yet versatile compact offering manual overrides and RAW capability

For years dismissed as the poor cousin of the DSLR, digital compacts are nowadays incredibly sophisticated image-making tools, and very sleek-looking with it. Photographers seeking a slimline family camera that matches point-and-shoot simplicity with a high-megapixel sensor and good quality zoom lens could do worse than invest in a top-end compact. For simplicity, we've divided the best ones into three groups: prestige compacts, extreme compacts and superzoom compacts.

"Prestige" compacts offer much of the creative functionality of a DSLR: high resolution, a host of DSLR-style creative features, full manual control of aperture and shutter values, exposure compensation and bracketing (a means of controlling exposure), the facility to focus manually, and they'll even shoot RAW files. But, with a top-end spec comes a top-end price tag, reflected in the camera's build quality, optical quality, sophistication and functionality.

WHAT TO LOOK FOR... PRESTIGE COMPACTS

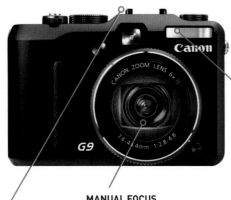

LCD SCREEN
A large monitor is great for composition and really useful for reviewing exposure and sharpness.

CREATIVE MODES
Control shutter and aperture values independently in Manual, aperture- and shutter-priority modes.

HANDGRIP
A sculpted handgrip and rear thumb rest ensure sturdy shooting when holding in one hand.

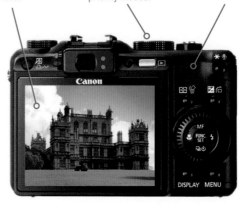

BUILT-IN FLASH
The built-in unit is convenient for shooting in low-light and should offer slow sync modes for creative use.

HOTSHOE
Use external flash units or studio flash for a more balanced and flattering light source.

MANUAL FOCUS
For precision focusing and pin-sharp shots every time, look for a compact that offers a manual focus mode.

WHAT TO LOOK FOR... EXTREME COMPACTS

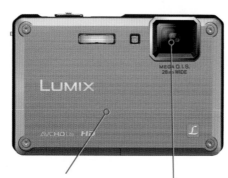

MONITOR
A good, clear monitor is essential to help compose and review images accurately.

MENU BUTTONS
Should be simple to operate, easily accessed and not too small.

MODE DIAL
Should offer a range of shooting modes to cover all kinds of situations and conditions.

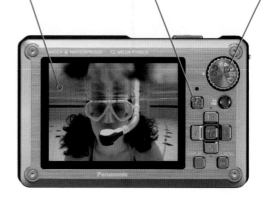

DURABLE, SEALED BODY
Extreme compacts can withstand wet weather, underwater use and hard knocks without failing.

LENS
A 3x optical zoom is pretty standard, but a 28mm wideangle setting is an advantage.

Surprisingly, many of the newer prestige compacts come not with a zoom lens, but a prime 28mm wideangle lens. This fixed focal length might seem rather restrictive compared to the versatility of a zoom, but it does have the added advantage of offering superior optical quality. It's also perfect for scenic shots and even close range portraits if you don't mind a little distortion.

"Extreme" compacts present a tough, hard-working and waterproof alternative to a DSLR. They're not just resistant to the odd splash – some can be submerged under water up to a depth of 10m and still carry on shooting. On top of that, most extreme compacts are shockproof too, withstanding drops from about 2m high. If you're unlucky enough to have someone run over your camera, some are even crushproof, withstanding loads of up to 100kg!

Using an extreme compact is not just about avoiding costly accidents. They're ideal for rough-and-tumble family holidays as they allow you to take more dynamic action pictures from in and under the water, rather than having to stand by the poolside all the time. It's the same if you're into active sports such as sailing, kayaking, climbing, skiing and mountain biking – using an extreme compact you can get right into the thick of the action, without worrying about your camera taking a serious knock.

"Superzoom" compacts get their name from their large zoom lenses, covering a wide range of focal lengths, but they're also referred to as 'bridge' compacts as they bridge the gap between the pocket-sized compact and the bulkier DSLR. Instead of having interchangeable lenses like a DSLR, their single superzoom is built in – often capable of up to 24x zoom magnification (eg 26mm at the wide end and a whopping 600mm at the long end).

Superzooms share many design similarities with DSLRs: a solid handgrip, a viewfinder located above their LCD screen (although these are electronic, unlike a DSLR's reflex viewfinder system), exposure controls operated via the camera's mode dial, with Program, shutter-priority, aperture-priority and Manual modes all available.

Unlike larger DSLR sensors, superzooms have much smaller 6.13x4.6mm (1–2.3in) sensors inside, positioned much closer to the lens, and this results in a camera that offers greater depth of field throughout its range, making it hard to throw a cluttered backdrop out of focus.

Another slight drawback is the issue of holding the camera steady: when using a longer focal length to magnify a subject, camera shake is magnified too. That's why most superzoom compacts feature some form of image stabilization.

WHAT TO LOOK FOR... SUPERZOOM COMPACTS

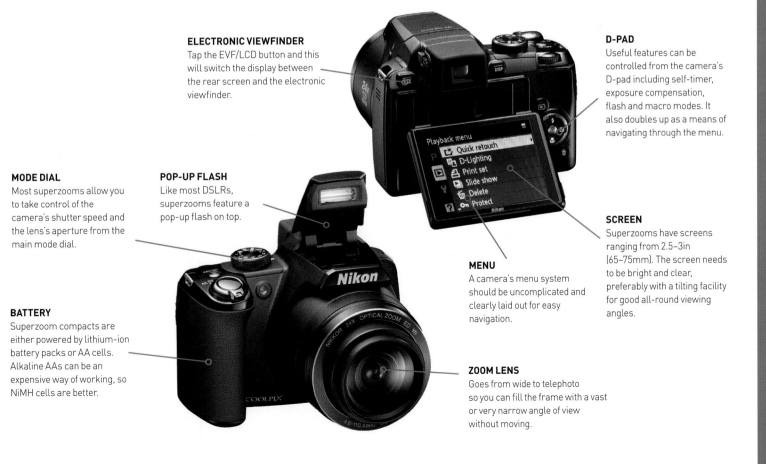

ELECTRONIC VIEWFINDER
Tap the EVF/LCD button and this will switch the display between the rear screen and the electronic viewfinder.

D-PAD
Useful features can be controlled from the camera's D-pad including self-timer, exposure compensation, flash and macro modes. It also doubles up as a means of navigating through the menu.

MODE DIAL
Most superzooms allow you to take control of the camera's shutter speed and the lens's aperture from the main mode dial.

POP-UP FLASH
Like most DSLRs, superzooms feature a pop-up flash on top.

MENU
A camera's menu system should be uncomplicated and clearly laid out for easy navigation.

SCREEN
Superzooms have screens ranging from 2.5–3in (65–75mm). The screen needs to be bright and clear, preferably with a tilting facility for good all-round viewing angles.

BATTERY
Superzoom compacts are either powered by lithium-ion battery packs or AA cells. Alkaline AAs can be an expensive way of working, so NiMH cells are better.

ZOOM LENS
Goes from wide to telephoto so you can fill the frame with a vast or very narrow angle of view without moving.

Progressing to a DSLR

Compact cameras are ideal in certain scenarios: occasions when you don't want to carry around a bulky DSLR, perhaps when you're on holiday with the family, taking part in sport activities, or shooting in locations where security is an issue. However, for any other photography, a DSLR really comes into its own.

Not only does a DSLR system give you a wide range of interchageable lenses and other accessories to choose from, the cameras are specifically designed to give you control over key creative aspects such as exposure, focus and composition. Although it might seem a big step at first – with lots of attendant jargon to learn – here we've highlighted some of the main DSLR features you'll need to recognize.

Alongside the sensor itself, the image processor is probably the most important part of your DSLR. Once the light has been converted into a digital signal by the sensor, the image processor then applies all of the adjustments needed to make it into an image file such as JPEG or RAW.

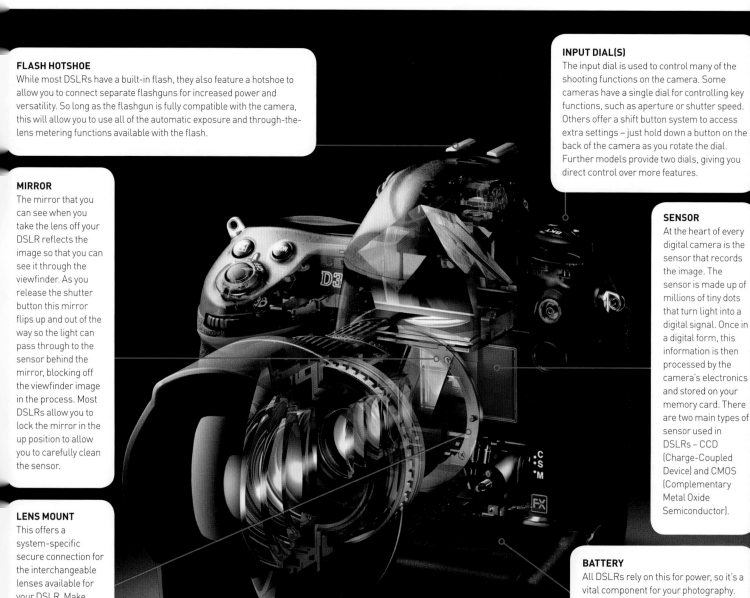

FLASH HOTSHOE
While most DSLRs have a built-in flash, they also feature a hotshoe to allow you to connect separate flashguns for increased power and versatility. So long as the flashgun is fully compatible with the camera, this will allow you to use all of the automatic exposure and through-the-lens metering functions available with the flash.

INPUT DIAL(S)
The input dial is used to control many of the shooting functions on the camera. Some cameras have a single dial for controlling key functions, such as aperture or shutter speed. Others offer a shift button system to access extra settings – just hold down a button on the back of the camera as you rotate the dial. Further models provide two dials, giving you direct control over more features.

MIRROR
The mirror that you can see when you take the lens off your DSLR reflects the image so that you can see it through the viewfinder. As you release the shutter button this mirror flips up and out of the way so the light can pass through to the sensor behind the mirror, blocking off the viewfinder image in the process. Most DSLRs allow you to lock the mirror in the up position to allow you to carefully clean the sensor.

SENSOR
At the heart of every digital camera is the sensor that records the image. The sensor is made up of millions of tiny dots that turn light into a digital signal. Once in a digital form, this information is then processed by the camera's electronics and stored on your memory card. There are two main types of sensor used in DSLRs – CCD (Charge-Coupled Device) and CMOS (Complementary Metal Oxide Semiconductor).

LENS MOUNT
This offers a system-specific secure connection for the interchangeable lenses available for your DSLR. Make sure that any extra lenses you buy are fully compatible with all of the features on your camera.

BATTERY
All DSLRs rely on this for power, so it's a vital component for your photography. Most models have a custom-designed battery, as DSLRs require lots of power. Keep the battery charged up. It's worth buying a spare battery pack to make sure you don't run out of power during a shoot.

TOP-PLATE LCD

While many smaller DSLRs use the rear LCD screen to display the shooting information when you're taking pictures, many models also offer an LCD on the top of the camera to show you specific data such as the shutter speed, aperture and any exposure compensation. Much of this information is shown in the viewfinder too. This separate LCD (often with its own illuminator light) is handy when using the camera on a tripod, and when it's tricky to see the rear viewing screen.

AUTOFOCUS/AUTO EXPOSURE BUTTONS

While the autofocus and auto exposure are activated by pressing the shutter release, most DSLRs also offer extra buttons on the back of the camera to lock these settings, or activate them, independently from the shutter release.

reen gives you access to the huge range of s available on your camera. The clarity and vary between models, but on most current : 2.5in (65mm). Some cameras also allow to view the image you're framing up viewfinder, a feature known as Live View.

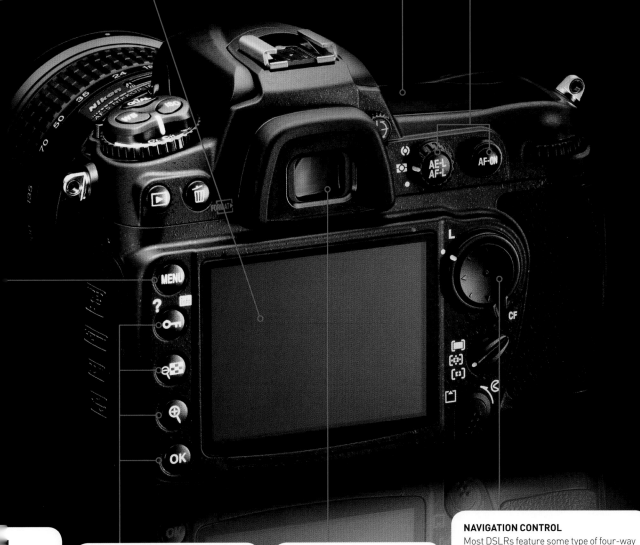

LCD SCREEN PLAYBACK

These controls allow you to review your images on the rear LCD screen. As well as displaying your images you can also zoom in to assess sharpness, display shooting information such as shutter speed or aperture, and access the histogram for assessing the exposure.

VIEWFINDER

This is the optical system that can be used to compose your images, sometimes offering a dioptre-adjustment toggle for spectacle wearers. Looking in here on a DSLR shows you the same view that your lens will record.

NAVIGATION CONTROL

Most DSLRs feature some type of four-way controller on the back of the camera to allow you to navigate through the on-screen menus, scroll through your images and, often, to control functions such as the autofocus point when you're taking pictures. In addition to the four-way selector, many DSLRs also use the centre of the control as an Enter, Select or OK button.

ge of
e
ctions of
enus are
several
u may need
controls to

Which type of DSLR?

Choose the right DSLR to suit your experience level, creative needs and budget

WHAT YOU'LL LEARN
BUDGET, BEGINNER
AND ENTHUSIAST DSLRS
VERSUS FULL FRAME;
IMAGE SENSORS;
CROP-FACTORS

THE SLR, OR SINGLE LENS REFLEX CAMERA, has been the mainstay of serious amateur photographers and many professionals for decades and there's good reason for that. Offering a huge array of advanced features and functions in a relatively compact shell that's convenient to handle and transport, the SLR offers the best blend of great performance, comfortable handling and – most importantly – top-notch image quality.

In the digital age the DSLR is simply the next generation of SLR camera and uses a digital sensor to record the pictures instead of film. This has great cost-saving benefits of no film or processing to pay for, so you can literally snap away, uninhibited by cost.

Then there are the more practical benefits of digital; by being able to review your shots on the LCD screen as soon as you've recorded them, the photographic learning curve is much gentler as it allows you to evaluate any mistakes straightaway. You can then assess and correct the problem there and then while the scene is still right in front of you, as opposed to days later when your film is processed.

If you're thinking of buying your first DSLR, don't be daunted by the advanced technical features. All entry-level DSLRs feature simple point-and-shoot modes alongside the more creative ones, so you'll still be able to get great shots from day one. You'll then have time to familiarize yourself with your new camera's creative controls and, with a little experimentation and instruction from this book, progress to more complex techniques.

With a wide range of accessories available, such as additional lenses and flashguns that are often brand-specific, when you buy your first DSLR you're not only investing in a camera body, but you're also committing yourself to using one particular camera system. Often the lenses are more expensive than the body itself, so, once you've bought one or two extra lenses, you'll have made a significant investment in a particular system and are likely to stick with that brand for a while. For that reason, it's prudent to find out as much as possible about the different cameras that are available and the systems that support them, making sure you choose the model that best suits your needs.

DSLR JARGON BUSTER

APERTURE
The 'window' in a lens through which light passes. The window can be enlarged or reduced in size to allow more or less light to pass through to the imaging sensor. Large apertures have low f/numbers (e.g. f/2.8) and small apertures have high numbers (e.g. f/22).

DEPTH OF FIELD
The zone of sharp focus around the point within a scene you've focused on. This depth is controlled by the aperture value, via a dial on the camera body, with large apertures giving shallow depth of field, and small apertures giving a greater zone of sharpness.

D-PAD/NAVIGATION CONTROLLER
Four-way selector button on the back of a DSLR that's used to scroll through menus and picture playback on the LCD screen. Can also be used to select autofocus points in the viewfinder.

ISO
Governs the light sensitivity of the sensor, with low values giving the least sensitivity and high values giving the most. The best quality and least "noise" is offered by the lowest value.

JPEG
This stands for Joint Photographic Experts Group – an industry-standard file format that takes all the data from a picture and compresses it into a relatively small file so it takes up less space on a memory card.

LCD
Stands for Liquid Crystal Display and refers to the screen on the back of a camera that displays pictures, Live View and exposure data such as histograms and exposure settings in use.

NOISE
A visible grain-like structure in an image that's created by the camera. This gets progressively more pronounced as you increase the image-processing chip's sensitivity, using higher ISO values such as 1600 and 3200.

RAW
A file format where the data comes directly from the camera's sensor. No image-processing is performed in-camera, so you can adjust colour, contrast, sharpening, white balance and other important image criteria on your PC, using special conversion software.

SENSOR
The silicon chip inside a digital camera that's sensitive to light. It lies on the focal plane and the analogue information (light) it records is converted into digital data which ultimately becomes an electronic image made up of millions of pixels.

SHUTTER SPEED
Measured in seconds, the shutter speed controls the amount of time light is allowed to pass through the lens and reach the sensor to make an exposure. Normally varies between B (Bulb) and 1/4000sec.

WHITE BALANCE
Different light sources have different colour temperatures, and the white balance control interprets this information to give natural-looking colour. It also allows you to select pre-determined daylight, indoor and fluorescent settings to get accurate colours in these conditions.

■ SEE GLOSSARY FOR MORE TERMS

IMAGE SENSORS IN DIGITAL SLRs

The DSLR image sensor is a chip containing millions of photosites which are sensitive to light. It occupies the place where the film used to go in a traditional 35mm film SLR. The information recorded by these photosites is turned into pixels (picture elements) – a matrix of tiny squares that makes up a digital image – by the image-processing chip.

Sensors come in various sizes, but in budget DSLRs the sensor is smaller than a frame of 35mm film (see right). This means that, when you use a lens designed for a conventional 35mm film (or "full frame") SLR camera, the effective focal length of that lens will be altered. This is because the smaller sensor captures less of the image, cropping off the edges and recording only what's in the centre. The angle of view that a lens gives will always crop in by a fixed percentage or "crop-factor".

On many budget models this crop-factor or "focal length conversion" is 1.5x – so, a 50mm lens behaves like a slightly longer 75mm lens. On other models it's 1.6x, turning a 50mm lens into an 80mm optic, and on others still, the conversion factor is 2x, so a 50mm becomes a 100mm.

Because of the popularity of the smaller format sensors (often referred to as APS-C sensors), specific lenses have been developed for them. These "digital only" lenses give a smaller image circle, so can't be used with film SLRs or full-frame DSLRs as the lens won't cover the whole image frame.

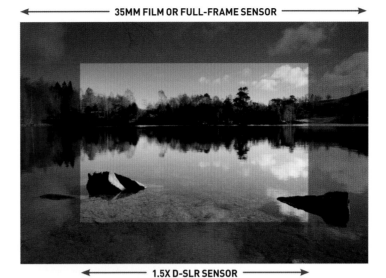

35MM FILM OR FULL-FRAME SENSOR

1.5X D-SLR SENSOR

SENSOR SIZE (NOT TO SCALE)
Most DSLRs are based on 35mm film cameras, but the sensors are smaller in budget models, so you get a cropped view of the central portion of the image when using a lens of the same focal length.

WHAT TO LOOK FOR... BUDGET DSLRs

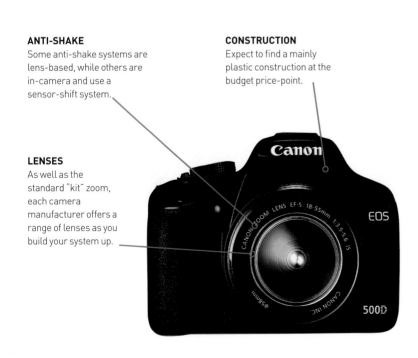

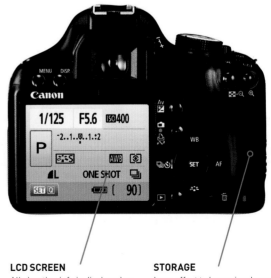

ANTI-SHAKE
Some anti-shake systems are lens-based, while others are in-camera and use a sensor-shift system.

CONSTRUCTION
Expect to find a mainly plastic construction at the budget price-point.

LENSES
As well as the standard "kit" zoom, each camera manufacturer offers a range of lenses as you build your system up.

LCD SCREEN
All shooting info is displayed on the rear screen on these DSLRs, as well as Live View and video, where available.

STORAGE
In an effort to keep size down and an easy transition from a compact, most budget DSLRs accept SD/SDHC cards.

BUDGET AND ENTHUSIAST DSLRs

If you're making the jump from a compact or are getting into photography for the first time, the most obvious choice is a budget, entry-level DSLR to get you started. These offer a blend of solid specification, compact size and straight-forward handling. To keep costs low, features and spec are limited, which you may find restricts your creativity within a relatively short time, as your photography improves.

If you've honed your skills on a budget DSLR, growing in experience and confidence, you may have got to the point where you're now thinking about upgrading to a model with even more sophisticated features and build. That's where the enthusiast DSLR comes in.

The main differences between beginner DSLRs and the slightly more advanced enthusiast DSLRs is that the latter are generally bigger, offering more features, faster performance, better resolution and wider ISO range than the entry-level budget models. Often set at a mid-price point, the enthusiast DSLR is squarely aimed at those looking for more advanced controls and handling. Build quality takes a step-up, with a more rugged construction – often a metal chassis compared to shock-proof plastic – that'll withstand more heavy-duty use.

Some models even feature professional levels of weather-sealing to protect the camera from the elements.

You'll also notice an increase in image quality. Instead of the more standard 10Mp resolution seen on budget DSLRs, enthusiast models start at 12Mp, rising to just over 15Mp – offering you even greater scope to enlarge your images or crop into them. In some cases, the ISO range is more extensive too, offering you even greater flexibility in dimmer-than-usual lighting conditions.

Other advantages can be found in overall performance. You can expect a more advanced autofocus system on an enthusiast DSLR – often with more AF points, more precise focus acquisition and intelligent focus-tracking. Then there's the continuous shooting. While 3fps (frames per second) on a budget or beginner DSLR is respectable, enthusiast DSLRs can shoot much more quickly – often up to 6fps and 8fps.

Most enthusiast DSLRs are available body-only, allowing you to build up your own system according to your needs, or use existing lenses from your present gear if you're sticking with the same camera brand after upgrading. Remember that you're not necessarily tied to the same manufacturer's system if you haven't invested much in your existing kit.

WHAT TO LOOK FOR... ENTHUSIAST DSLRs

BUILD
You'll find the build quality and finish take a step-up compared to budget models.

THE SYSTEM
Each manufacturer offers a range of lenses, flashguns and accessories.

ANTI-SHAKE
Some DSLRs have systems built into their bodies, while others rely on specific lenses.

SCREEN
This should be clear and bright, allowing you to assess the sharpness of a shot easily.

LIVE VIEW
Handy if you want added versatility when shooting at awkward angles.

STORAGE
The type of storage will vary between models, either being SD/SDHC or CompactFlash.

FULL-FRAME DSLRs

Here we step into the preserve of the semi-pro and professional DSLR photographer. Full-frame DSLRs have a "full-frame" sensor inside them that's exactly the same size as the old 35mm film frame (36x24mm) compared to the smaller, cropped APS-C format sensors you typically find in budget and enthusiast DSLRs (which can measure from 20.7×13.8mm to 28.7×19.1mm).

Not only is the sensor larger, full-frame DSLRs are generally bigger and bulkier all round. They have a rugged build quality and weather-sealing that can withstand everyday professional use, plus a host of advanced features, improved handling and performance. Expect to see features such as sophisticated autofocus tracking, an extended range of ISO settings for use in low-light, and all manner of custom functions that make the full-frame DSLR a mighty tool for jobbing sports and press photographers, and landscape photographers looking for the ultimate in resolution.

Full-frame DSLRs are generally well supported by a comprehensive range of lenses and other accessories too – everything from specialist tilt and shift and macro lenses to flash trigger systems and underwater housings.

It's easy to see the appeal of a full-frame DSLR. First, you don't have a sensor crop-factor to take into account. This means that all the premium quality 35mm-format lenses will provide exactly the same focal length as they did on a 35mm film SLR. Another benefit is the larger viewfinder – because there's no crop-factor to worry about, the viewfinder is generally larger and brighter.

The main appeal of having a full-frame sensor is superior image quality. Because the image sensor is physically bigger, the pixels are larger, so they can render detail and colour more accurately. Noise is also handled better, because the pixels aren't as bunched up as they would be on a smaller sensor with the same pixel-count.

Sadly there are some downsides too: full-frame sensors aren't cheap to manufacture, and command a high price tag. Also, if you've already invested in digital-only lenses (which produce a smaller image circle to match the APS-C sized sensor), their use is going to be limited. Canon's EF-S lenses won't even physically fit on a full-frame Canon DSLR, and while Nikon DX and Sony DT lenses will fit, they'll give reduced resolution and the viewfinder will be cropped to compensate for the smaller field of view. To get the best image performance from a full-frame DSLR you really need to invest in a set of optimum quality lenses to avoid edge softness and vignetting, and building up your system with a new set of optics could be quite a costly exercise.

WHAT TO LOOK FOR... FULL-FRAME DSLRs

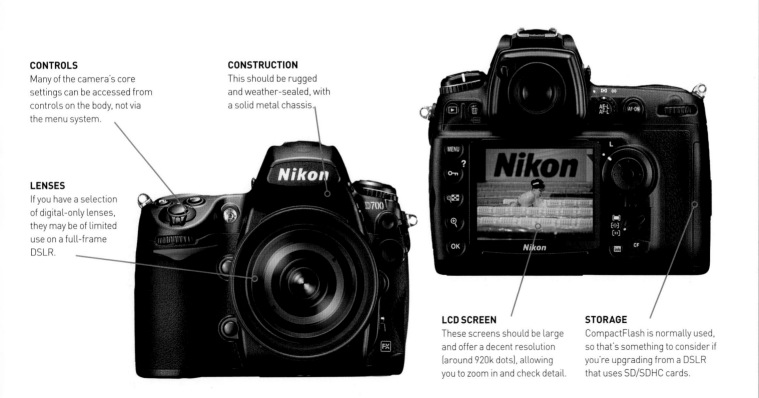

CONTROLS
Many of the camera's core settings can be accessed from controls on the body, not via the menu system.

CONSTRUCTION
This should be rugged and weather-sealed, with a solid metal chassis.

LENSES
If you have a selection of digital-only lenses, they may be of limited use on a full-frame DSLR.

LCD SCREEN
These screens should be large and offer a decent resolution (around 920k dots), allowing you to zoom in and check detail.

STORAGE
CompactFlash is normally used, so that's something to consider if you're upgrading from a DSLR that uses SD/SDHC cards.

2 LENSES AND FOCAL LENGTHS

THE CAMERA LENS is a sophisticated tool. Comprising a series of specially coated glass elements and electro-mechanical motors, it's just as vital to your image-making as the the camera itself. Thanks to the time-honoured design of the Single Lens Reflex (SLR) camera – wherein the image you see in the viewfinder is the same image "seen" by the lens – the photographer's lens really does become their window on the world.

Although lenses are principally designed for fast, smooth and pin-sharp focusing, high resolution and faithful colour rendition, they can do far more than just capture a straight record of the scene in front of you. Lenses are a key part of your creative arsenal, allowing you to crop in or zoom out, frame and reframe a composition to your heart's content.

Lenses can help draw attention to a subject by blurring its backdrop, or keep every tiny detail sharp, as far as the distant horizon. They can magnify distant subjects so they fill the frame or make them look quite small instead – like a scene from Toytown. They can squeeze a tall building into frame even when you're standing right next to it. They can transform a misty landscape into a bold planes of graphic colour, or focus on the natural details that are hidden within it. With the right lens on your camera, the whole world is your photographic plaything.

Lenses explained

Increase your creativity by investing in new lenses for your DSLR system

WHAT YOU'LL LEARN
FOCAL LENGTHS;
VIBRATION
REDUCTION; PRIMES
VERSUS ZOOMS; FAST
AND SLOW LENSES

Many DSLRs sold today come with a kit lens in the box – most usually a standard zoom. These versatile lenses are fine for every day picture taking, and many photographers never even consider buying more lenses to build up their DSLR system. However, the standard zoom does have its limitations (covered in more detail on page 26), and if you want more creative versatility – perhaps shooting macro subjects or wildlife, portraits or landscapes – it's worth considering what other, more specialist optics are available for your camera.

With such a staggering variety of lenses on the market, it can be hard to know where to start. First though, it's important to realize that not every type of lens will fit your DSLR. Each camera manufacturer has its own specific lens mount, designed for its own range of cameras. For instance, if you have a Nikon DSLR, you'll only be able to use Nikon's "Nikkor" lenses, or designated "Nikon-fit" lenses made by independent manufacturers such as Sigma, Tamron and Tokina. This is true of all DSLR manufacturers, with one slight exception: Olympus and Panasonic DSLRs use an open standard FourThirds lens mount, so any FourThirds lens will fit on any Olympus or Panasonic DSLR.

FOCAL LENGTHS

Next consideration is the focal length of your lens. All lenses are described in terms of their focal length, measured in millimetres, which in turn determines the lens's angle of view – or, how much of the scene you can get into frame. The shorter the focal length, the wider the angle of coverage. These are known as wide angle lenses and typically cover an angle of 110–75° (measured diagonally). Conversely, the longer the focal length, the narrower the angle of view. These are known as long or "telephoto" lenses, and usually offer an angle of view between 30° and 32°.

In traditional 35mm film photography, the 50mm focal length was considered the "standard" lens as its angle of view (roughly 35–40°) most closely resembles the angle of view of the human eye, looking forward.

Of course, the camera's sensor size also has a vital role to play here, potentially affecting your lens's angle of view and thus altering its effective focal length. If you own a DSLR with an APS-C sensor you may at times need to apply a crop factor to calculate effective focal length when using conventional 35mm SLR focal lengths. (Note that digital-only lenses are already labelled with the correct focal length.) On Nikon, Sony, Pentax and Fujifilm DSLRs, apply a crop-factor of 1.5x to get the effective focal length; on Canon models, 1.6x; on Canon EOS-1D range, 1.3x; and on FourThirds DSLRs, 1.5x. Generally speaking, your cropped APS-C sensor will make each lens seem slightly longer than you might expect.

Aside from the physical aspects of a lens, there are lots of very clever but unseen design points worth noting. First, many modern autofocus lenses have an especially smooth, quiet operation driven by "hypersonic" or "ultrasonic" motors. Also, certain DSLR systems (eg Nikon and Canon) have the facility to counteract camera shake built direct into their lenses. These systems work using using gyroscopic sensors to detect horizontal and vertical movement during an exposure, which is then counteracted by floating glass elements that change the path of the light, producing a sharper image. These systems stabilize the image projected on the sensor before the processor converts it into digital information.

EXPERT ADVICE

PRIME OR ZOOM?

THERE ARE TWO MAIN TYPES OF LENS – primes and zooms. A prime lens has a single, fixed focal length such as 28mm, 50mm, 85mm, etc. A zoom lens, meanwhile, offers a range of focal lengths between two limits. The lens supplied with most entry-level DSLRs is a standard zoom, normally with a range of 18–55mm, allowing you to shoot at any focal length between an 18mm wide angle and a 55mm short telephoto.

Primes are generally "faster" (see right) than zoom lenses and, as such, have better light-gathering capabilities. And because prime lenses are designed for optimum performance at one specific focal length, the results are marginally better as there's less of a compromise, optically. This has always been the case in the past, especially in pre-digital days but, with dramatic improvements in zoom lens design, it's now much harder to tell the difference between prime and zoom results.

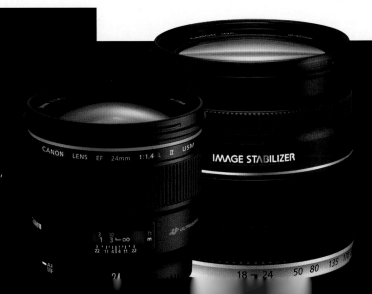

UNDERSTANDING FOCAL LENGTHS

These shots, taken using a DSLR with a 1.5x cropped sensor, show how different focal lengths affect field of view and subject magnification.

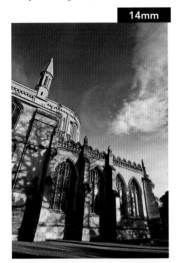
14mm

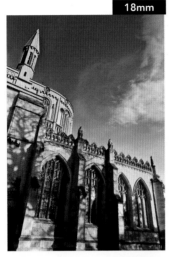
18mm

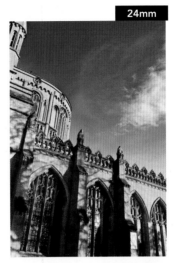
24mm

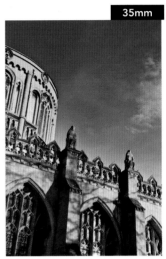
35mm

WIDE FOCAL LENGTH

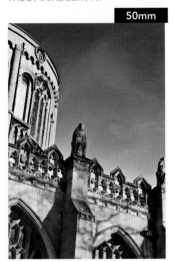
50mm

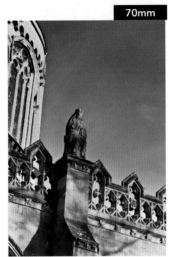
70mm

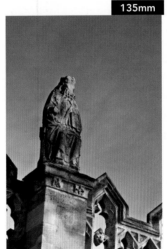
135mm

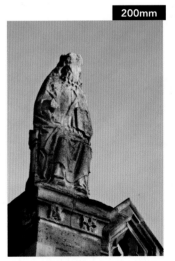
200mm

TELEPHOTO FOCAL LENGTH

EXPERT ADVICE

FAST OR SLOW?

LENSES ARE DESCRIBED AS "FAST" when they have a wide maximum aperture such as f/2.8 or f/1.8. This is because the wider aperture allows more light to reach the camera's sensor which in turn allows photographers to use faster shutter speeds to freeze action, even in low-light conditions.

A slow lens on the other hand may only have a maximum aperture of f/5.6. In low-light conditions the photogrpaher with a slow lens will be forced to resort to a slower shutter speed, tripod, higher ISO, or even flash to achieve a correct, sharp exposure.

An example of a slow lens is an 18–55mm zoom, which has a variable maximum aperture of f/3.5 at the 18mm end of the zoom, dropping to f/5.6 at its 55mm end. Although slow zooms make working in low-light tricky, they are generally more affordable, lighter and more compact.

A fast lens with a similar zoom range would be larger and heavier and would have a maximum aperture of f/2.8 straight through the zoom range. You'd have greater control over depth of field, allowing for greater creativity with differential focus. If you can justify the extra cost, fast lenses are a very worthwhile investment – offering large apertures, top-notch optics and the flexibility to shoot at faster shutter speeds in low-light.

W YOUR LENS

N LENSES CAN INCLUDE almost as much
ogy as the camera itself, so here's your guide to
ures and controls you'll find on many zooms.

FOCUS RING

Although all DSLRs offer autofocus, you can also opt to focus manually. The focus ring on many budget lenses is very small, making it difficult to accurately control the focus, while more expensive lenses offer larger controls with a smoother action, giving you much better control.

OM RING

e zoom control of your
s is adjusted using this
g. It's usually the largest
ntrol on the lens, as it's
e one most commonly
ed. Many lenses also
ve intermediate focal
gths displayed on the
om ring, helping you
rk out at which focal
gth you're shooting.

FILTER THREAD

Almost all lenses have a screw thread on the front to allow you to attach filters and accessories. These vary in size according to the diameter of the lens so, before you buy any accessories, make sure they're the right size for the lens you want to use.

FOCUS SWITCH

Switching between automatic and manual focusing modes is often controlled by a small switch on the side of the lens barrel. If there's no switch, then focus will either be controlled via a switch on the camera

FOCUS SCALE

This displays the distance from the camera to the position where the lens is focused. It's handy as a reference, especially when using some advanced focusing techniques such as pre-focusing and hyperfocal distance. For most techniques you can ignore it – many lenses don't even have the feature.

LENS MOUNT

As well as simply allowing you to attach the lens to the camera, this also incorporates loads of connections to transfer information between the two. This is where you need to take care when choosing extra lenses, to ensure that the new lens is compatible with all of these features and connections.

VIBRATION REDUCTION

This refers to the system of optical image stabilization offered by state-of-the-art lenses. Many manufacturers claim their systems offer up to three f/stops of extra stability, allowing users to shoot with the camera handheld in low-light conditions, without the risk of camera shake.

WHAT DO THE NUMBERS AND LETTERS MEAN?

MOST LENSES CARRY a series of letters and numbers on their barrels. These tell you the features and functions the lens offers. Here's a guide to some of the terminology you'll see.

EF (Electronic Focus) – Used to denote Canon's range of autofocus lenses.

EF-S (Electronic Focus, Short) – Digital-only lenses that have a short back focus for non-full frame DSLRs.

IS (Image Stabilizer) – An in-lens system that detects camera shake and corrects it in the lens itself.

USM (Ultra Sonic Motor) – A focus motor offering fast and quiet focusing.

DO (Diffractive Optical element) – A combination of lens elements used to combat chromatic aberration (colour fringing) and reduce lens size.

AF-D (Distance) – The lens supplies distance information to the camera to assist focusing.

AF-I (Internal) – An internal autofocus motor used to speed up focusing.

AF-G (Genesis) – Similar to AF-I but features a newer internal drive motor and lacks a manual aperture ring altogether. The G classification is to be found on most new models.

AF-S (Silent) – These lenses feature a silent wave motor (SWM), which enables faster and quieter autofocus.

IF (Internal Focus) – A system used so that the lens doesn't change length during focusing. This gives a more compact design, a non-rotating front element and a closer focusing distance.

ED (Extra-low Dispersion) – A type of glass used to help reduce chromatic aberration (colour fringing) on lenses.

VR (Vibration Reduction) – A system of sensors and tiny gyros inside the lens to help minimize problems with camera shake.

Micro – Nikon's term for macro. These lenses have a very short close focus distance, allowing you to get very close to your subject.

DX (Digital Only) – These lenses are for all Nikon's digital cropped-sensor DSLRs.

FX (Full-frame) – The latest DSLR sensor format from Nikon, with a sensor measuring around 36x24mm.

Choosing and using lenses

Focal length affects angle of view, but perspective is controlled by where you stand

WE'VE ALREADY SEEN how focal length affects the angle of view in a scene, but there's another part of this creativity equation to consider: camera-to-subject distance, which in turn affects perspective.

Telephoto lenses are also said to compress perspective – visually "flattening" a scene to make it look more two-dimensional. This is not strictly true: in reality it's the act of moving further away from your subject to create a telephoto composition which achieves this flattening effect (see Expert Advice, below).

Wide angle lenses also have an apparent effect on perspective. If you get very close to a portrait sitter with a wide angle lens, you can distort the face for quite dynamic results (some might say "unflattering" results, as the forehead, nose and chin often look quite bulbous in centre frame). In reality, it's the fact you have to get very close to fill the frame using a wide angle lens that affects perspective.

So wide angles are good for wide scenes and shooting large subjects from close range; they can make foreground subjects loom large in frame; and, because they have good depth of field characteristics, they'll keep your subject sharp from close range all the way to the horizon. (We'll be covering Depth of field at length in Chapter 4.)

In contrast, telephotos are good for magnifying distant subjects, making them seem nearer; they can create bold, graphic images where perspective seems flat; and, thanks to optical physics, they offer shallow depth of field so you can use techniques such as differential focus to help make a subject stand out from a blurred backdrop.

LENS CLEANING

Keeping your lens's front (and rear) element clean is a delicate job, but essential to avoid smudges, smears and other marks spoiling your pictures. It's quite straightforward so long as you follow some simple rules: only use cleaning products specifically designed for the job. Don't use them for anything other than cleaning your lenses.

Hurricane blower

Lens cleaning fluid

Lens cloth

LENS PROTECTION

A good way of protecting your lens from dirt and scratches is to fix either a screw-in skylight or UV filter over the front element for safety. Technically a skylight filter will have a slight warming effect, and the UV filter will cut out a little haze in your images, but with DSLRs these filters have little or no effect on the image.

PERSPECTIVE EFFECTS OF LENSES

The longer the focal length, the more the shot appears to be compressed – an effect created not by the lens itself but by the act of moving further away from the subject. Here we've kept the car the same size in each shot, but, owing to the greater camera-to-subject distance and wider angle of view at shorter focal lengths, more has been squeezed into the frame.

WIDE FOCAL LENGTH

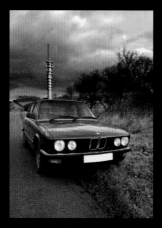

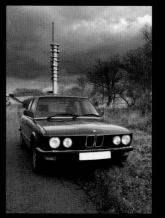

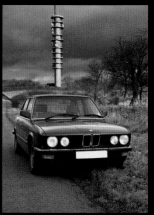

18mm 24mm 35mm

STANDARD ZOOM

WIDE ANGLE

STANDARD ZOOM

Most DSLRs come supplied with a standard zoom, commonly offering a zoom range of around 18–55mm, giving you a range of focal lengths from a basic wide angle at the 18mm end to a short telephoto at 55mm. The lens is fine for most everyday subjects such as landscape views, holidays and family outings.

WIDE ANGLE LENSES

Although your standard zoom gives you a basic wide angle option, lenses shorter than 18mm will allow you to include even more of the scene in your shots. You'll find that many wide angle zooms will overlap with the shorter end of your standard zoom but they usually go down to 10mm or 12mm at the shortest end for a greater angle of view.

TELEPHOTO

MACRO

TELEPHOTO LENSES

Although any lens longer than 35mm can be classed as a telephoto (in the APS-C format), you'll find that the focal lengths for most telephoto zooms start between 55mm or 70mm. This means they're the perfect complement to your standard zoom, with hardly any overlap. At the longer end they usually go to either 200mm or 300mm, allowing you to pick out distant subjects and magnify them in your image.

MACRO LENSES

These specialist lenses usually have a focal length of between 50mm and 105mm, although longer focal length versions are available. The difference between macro and normal telephoto lenses is that macro lenses allow you to focus really close to the subject, allowing you to record small subjects such as flowers and insects at life-size magnifications.

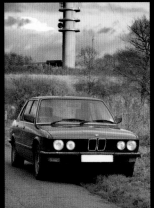
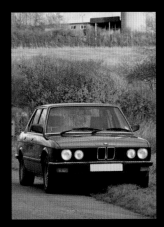
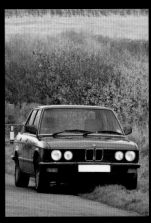

TELEPHOTO FOCAL LENGTH

| 50mm | 70mm | 135mm | 200mm |

Buying lenses

Build up your DSLR system with lenses

WHAT YOU'LL LEARN
DIFFERENT TYPES
OF ZOOM LENSES;
PORTRAIT AND
MACRO LENSES

Most DSLR owners shoot using the standard zoom "kit" lens that came with their camera, and these can be great for general photography. However, as standard zooms tend to see the most action of all our lenses, it makes sense to have a good quality one that delivers premium results, such as the so-called "ultra" standard zoom lens, which represents a step-up in both quality and performance.

Ultra standard zooms sit at the mid-price point between cheaper kit lenses and the more expensive fast standard zooms, which have a build quality designed for professional use and benefit from a "fast" maximum aperture of f/2.8, fixed through the range (see page 21). However, the benefits of upgrading your kit lens to an ultra standard zoom may not be immediately obvious when checking the specification details. Ultra standard zooms don't have a long telephoto focal length and they don't offer the fixed, fast maximum aperture of their pro spec cousins. So, why bother upgrading?

Well, for starters, ultra standard zooms have a superior range of focal lengths on offer in comparison with kit lenses. Typically covering 16–85mm compared to your average 18–55mm, which taking into account, say, a 1.5x crop-factor

on an APS-C sensor DSLR, is equivalent to a 24–127mm zoom in 35mm terms.

While that may only seem a modest improvement over the typical 18–55mm range of your kit lens, that extra bit of reach at both ends actually makes an ultra standard zoom a lot more versatile, and that means you can shoot a wider range of subjects and swap lenses less often.

WHAT TO LOOK FOR... STANDARD ZOOMS

MANUAL FOCUS RING
If you want to focus manually you'll need a focusing ring with a smooth and sturdy action that enables you to accurately fine-tune what's sharp and what isn't.

FOCAL LENGTH
An ultra standard zoom offers a versatile range of focal lengths. However, check the crop-factor of your DSLR – the difference between 17mm on a Canon 1.6x crop and 16mm on a Nikon 1.5x crop is quite significant.

MAXIMUM APERTURE
Wider, "faster", maximum apertures let more light reach your camera's sensor – very useful for low-light shooting; it also makes autofocus more effective.

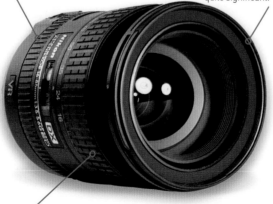

ZOOM RING
Size and grip are crucial on a zoom ring as it'll be called into action regularly. It should also have a smooth action and hold itself in place at any given point, never creeping out of position.

IMAGE STABILIZATION
Unless image stabilization is built into your camera body you'll need it in your lens. More advanced image stabilization systems have a couple of modes to choose from, depending on the circumstances you're shooting in.

METAL LENS MOUNT
When paying good money for a lens you should expect a durable build with hard-wearing components. A metal lens mount is less likely to break than a cheaper plastic alternative.

WIDE ANGLE ZOOMS

Picture the scene. There's a brilliant landscape in front of you and you want to get the whole vista into your shot. Trouble is, you pull your lens back to its widest setting, but you still can't fit everything into the frame. It's probably happened to every single one of us. It'll then normally involve a couple of steps backwards to try to squeeze everything in – frustrating, and sometimes impossible.

A dedicated wide angle zoom is the answer, allowing you to capture everything in frame thanks to its wide range of short focal lengths. Though it probably doesn't sound like you're gaining much, a 12–24mm wide angle zoom offers a far greater angle of view than a standard 18–55mm zoom lens, after you've factored in the 1.5/1.6x focal length magnification on most DSLRs.

If that's still not wide enough, some wide angle zoom lenses go as wide as 10mm. It's at this point you'll start to wonder what those things are at the bottom of the frame, and then you'll realize it's your feet! Because of this massive field of view, you can also expect to get some extreme barrel distortion at the shortest setting, too – horizontal and vertical lines curving inwards – a phenomenon that can be exploited to produce striking results.

There are a couple of things you need to bear in mind, however. Lens flare can be a problem every now and again as it's tricky to keep a very wide lens properly shaded. Lens hoods can help but watch you don't catch them in the picture.

Similarly, if you use a stack of screw-on filters, this can also cause problems – don't be surprised if you experience vignetting (darkening at the image corners) caused by the extra filter mounts shading the front of the lens.

WHAT TO LOOK FOR... WIDE ANGLE ZOOMS

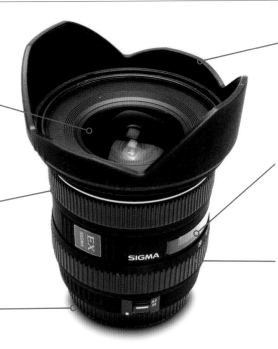

FRONT ELEMENT
Expect to find a fairly bulbous front element, which sometimes means they protrude quite a bit. This can be an issue if you like using filters, as there won't be anywhere to mount them unless the lens has a slot for gel filters at the rear.

MANUAL FOCUS RING
You could find yourself using manual focus a lot with a wide zoom, so make sure the manual focusing ring is nicely weighted for precise control.

LENS MOUNT
Should be a durable metal construction to withstand repeated mounting. There should be a positive, secure fit onto the camera body with no play.

LENS HOOD
Though fairly short and stumpy on wide angle zooms, this helps to shade the front lens element from direct sun, keeping down lens flare.

MAXIMUM APERTURE
Most wide angle zooms have a variable maximum aperture, so when you see f/3.5–4.5, that means the maximum available aperture changes through the zoom range. The lower number will always be at the shortest (widest) setting, and the higher number will be at the longer end.

ZOOM RING
Look out for a nice, fluid action when you zoom in-between the long and the short ends of the focal lengths. The zoom should also hold itself in place between the extremes, so it doesn't move if you're shooting directly up or down.

SUPERZOOM LENSES

There's a common misconception that when you buy into a DSLR system you'll necessarily end up with a heavy bag full of lenses for every conceivable shooting situation. This is where the superzoom lens really scores: it cuts down on the number of different lenses you need to carry around, covering in just one lens a massive range of focal lengths, from wide angle to telephoto. Most cover 18–200mm, while some extend even further still.

However, to tackle the wide range of focal lengths required, superzooms are generally stacked with optical elements, running greater risk of vignetting, distortion and chromatic abberration. When buying, look for a lens with a fast range of maximum apertures, some form of image stabilization, and be aware that the lens barrel will probably double its length when focusing at the telephoto end.

TELEPHOTO ZOOM LENSES

The focal length of a standard 18–55mm zoom lens is great for general photography, providing both a wide angle and short telezoom shooting option. However, on many occasions you'll find the 55mm zoom end just isn't long enough for frame-filling compositions of, say, garden birds. That's where the longer 55–200mm focal length of a telephoto zoom lens comes in handy. It's a versatile and attractive lens to have as it provides photographers with plenty of options for either shooting portraits at around 70mm or zooming in much tighter for those sports or wildlife shots.

What's more, shooting at the long end of the range conjures up the attractive visual effect of apparently compressing perspective – something that's just not possible using a standard zoom. With these advantages, a 55–200mm makes a great second lens for your system, and is entirely compatible with your 18–55mm standard zoom.

Most manufacturers offer the perfect telephoto zoom to partner their standard zoom, but it's worth shopping around to look for a product with bonus features too, such as a faster range of maximum apertures and a close-focusing macro facility offering at least 1:2 (half life-size) reproduction.

It's at this point you might decide that it makes more sense in the long term to invest in a good quality prime telephoto that's longer still (say 300mm), with a faster maximum aperture (say f/4), making sports and wildlife photography more feasible. Although this may represent a more costly option in the short term, many telephoto zooms are hampered by a slow maximum aperture which makes freezing action impossible in anything but the brightest sunshine conditions. Consider what you need the lens for before buying.

WHAT TO LOOK FOR... TELEPHOTO ZOOM LENSES

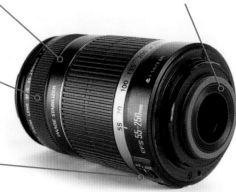

IMAGE STABILIZATION
Combats camera shake when you are zoomed in and using slower shutter speeds.

FOCUS RING
A well-sized and nicely weighted focus ring helps you achieve more precise control when you want to focus manually.

AUTO/MANUAL SWITCH
Many lenses can change between AF/MF modes via a switch on the lens as opposed to on the camera.

LENS MOUNT
If you're constantly changing lenses, a metal mount is more durable.

INTERNAL FOCUS
If the front element rotates during focusing this will cause problems with screw-on filters.

ZOOM RING
A well-built lens will provide a smooth zoom action throughout its range of focal lengths.

MACRO LENSES

Your standard kit lens is great for general photographic duties, but as soon as you try to focus very close on a subject you'll realize its limitations. A standard zoom will get to a certain point – a focusing distance of roughly 30cm (12 in) from the subject – and then, frustratingly, it won't be able to focus any closer. This is disappointing if you want to get into the world of close-up photography, for which the best solution is a specialist macro lens.

Certain telephoto zoom lenses offer a "macro" setting, but this will only normally offer a reproduction ratio of around 1:2 – this means the maximum your subject can be recorded at is half life-size. There's no question that this can be a useful feature, especially when it's a bonus "extra" on a lens, but it's not genuine macro. Real macro requires a life-size or 1:1 reproduction ratio, available only macro lenses.

A dedicated prime macro lens means you can get really close to your subject and take shots that reveal the object you're shooting as it would be if you placed it directly on the sensor. Most DSLR users will find a macro lens with a focal length between 50–90mm spot-on for their needs, as the crop-factor on most DSLRs will allow for an excellent working distance between lens and subject. Combine this short telephoto focal length with a maximum aperture of f/2.8 that most macro lenses have, and you've got yourself a perfect portrait lens for no extra cost...

Close-up photography is very precise and requires you to get your focus spot-on, which means that you often have to switch to manual focus, even if you've got a brilliant AF system at your disposal. A macro lens should have a nice, large manual focus ring, finely balanced for precise control.

PORTRAIT LENSES

A good portrait can be one of the most satisfying pictures you'll ever take and the best way to achieve one is by using a dedicated portrait lens.

The first thing to notice is that these specialist optics are all prime lenses – they don't zoom, but are fixed at a single focal length. Historically, the quality of zoom lenses was not considered high enough for portraiture, and though many modern zoom lenses have put this complaint to rest, you'll still find the construction of a prime lens produces superior sharpness and less distortion because it's dedicated to get results at only one focal length.

Another thing to notice is that portrait lenses usually have a telephoto focal length – perfect for head and shoulders portraits taken at a slight distance from the sitter. For those photographers with an APS-C-sensor DSLR, a 50mm f/2.8 lens is ideal; the crop-factor gives the focal length a slight telephoto effect, while the fast maximum aperture allows for attractive differential focus effects.

WHAT TO LOOK FOR... PORTRAIT LENSES

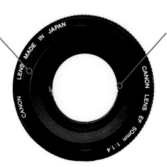

FRONT ELEMENT
This may extend on focusing and if it goes too far can block the flash from your camera. Also, it shouldn't rotate as this can affect your filters.

MAXIMUM APERTURE
The larger the maximum aperture of the lens, the more the out-of-focus areas will blur and the faster the shutter will fire in low-light.

WHAT TO LOOK FOR... MACRO LENSES

MANUAL FOCUS RING
This should be a decent size, and also well-balanced for precise control.

FOCUS DISTANCE INDICATOR
As well as offering accurate focusing, some lenses also feature reproduction ratio markings.

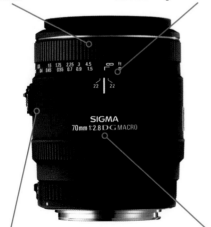

FULL/LIMIT SWITCH
For normal shooting, switch to Limit for quicker AF (focusing range is reduced), but for macro work select the Full option.

MAXIMUM APERTURE
As macro lenses are prime lenses, expect a maximum aperture of f/2.8.

FOCUS RING
For manual focusing, this needs to provide a good grip and have a smooth action. An AF/MF switch on the body is also handy.

DISTANCE WINDOW
This displays the distance of your focus point in feet and metres, and therefore allows you to use hyperfocal distancing in your shots.

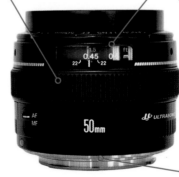

LENS MOUNT
A metal lens mount will stand up to a lot more abuse than a plastic one, so look for this if your lens is likely to get a lot of use.

3 ESSENTIAL ACCESSORIES

IF THERE'S ONE ESSENTIAL TRUISM that all photographers should learn early on, it's the fact that you don't need lots of expensive kit to take great photographs. In the right hands, even the most basic DSLR and lens combination can be used to take a thoughtful, emotive, high-impact image. Look at examples of great photography in art galleries the world over and you'll realize that it's the idea behind the picture, and its successful execution, that really count.

However, there is a slight proviso to all this. While your DSLR can be considered the main workhorse in putting your ideas into practice, there are certain accessories that will help. Think of them as photographic allies, making it easier to communicate your great ideas.

Some accessories, such as tripods and filters, will help you refine your picture taking technique to get better results. Others, such as camera bags, memory cards and sensor-cleaning kit, help you care for your DSLR and maintain it. Others still, such as computers, monitors, software and printers, help you create a "digital darkroom" at home centring on your personal computer, where you can edit your images and present them for others to enjoy.

The main thing to remember is that you don't need all these accessories straightaway. Most of the items featured in this chapter should be acquired over time, as and when your budget allows. It's better to avoid making false economies buying the cheapest "beginner-designated" accessories; invest in those which will stand the test of time, and accommodate your growth as a photographer.

Tripods

Keep the camera steady with a tripod for pin-sharp results

WHAT YOU'LL LEARN
WHEN TO USE A
TRIPOD; DIFFERENT
TYPES OF TRIPOD

IF THERE'S ONE ITEM OF PHOTOGRAPHIC GEAR that always seems to get neglected, it's the tripod. You can have the best gear in the world – the latest DSLR and a bag full of pro lenses – but it's all going to be a big waste of time and money if your shots keeping coming out slightly blurred. The main culprit is camera shake, which we'll deal with in greater depth in the next chapter. Suffice it to say here that the best and most reliable way to counter camera shake is to use a tripod to help steady the camera.

Although most DSLRs these days offer some form of image stabilization technology, this can only do so much to stop camera shake. What's more, as you become more ambitious and creative with your photography, you will find a tripod is often indispensible – especially for long exposures, night-time shooting and for many remote flash set ups. Best of all, a tripod slows you down and makes you consider the image before you take it. If a shot's worth taking, it's worth getting the tripod out.

Though it's true that "the best tripod is the one you've got with you", there's actually a huge difference between tripods costing £30 and those costing £200. The shortcomings of budget tripods really aren't worth enduring if you love your photography and intend to stick at it.

A budget tripod will get you started in longer exposures, more considered composition and creative effects that demand a locked-off camera, and it'll be nice and light to carry. But it'll also have leg-locks that will eventually fail, components that will flex under pressure, critical parts that will snap off when you clonk them against rocks, and delicate threads that will eventually strip when you over-tighten them. The end result is you'll be splashing out on another tripod sooner than you think.

Buy a pro tripod and though it'll be bigger and heavier, it'll also be designed to avoid all those problems and compromises mentioned above. It'll offer more adaptability too – you're not always going to be shooting at eye-level, and a pro spec model can be positioned at various angles, both vertically and horizontally.

Though most tripods are made of aluminium, the best pro spec tripods are made of lightweight but super-strong carbon fibre, offering a high strength-to-weight ratio. Another lightweight material used for tripods is basalt rock: crushed and then melted at high temperatures, basalt fibres offer a 20% lighter alternative to aluminium. The luxury of owning a lightweight tripod like this comes at a premium; if you're serious about switching from alloy to carbon you'll need to spend an extra £100 or so for the privilege.

It may seem that a pro tripod is a pricey option, but look after it and it'll last a lifetime, unlike cheaper models that'll need to be replaced time and time again.

CHOOSING A TRIPOD HEAD

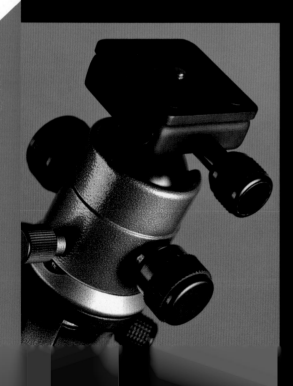

ONCE YOU'VE PICKED OUT YOUR TRIPOD, next you've got to start thinking about which type of head you want to go with it, as the camera doesn't sit directly on the tripod legs.

Although it might seem expensive to buy a pro tripod with a separate head, it's actually a bonus, as it means you can choose the right head to suit your photography. There are several types of head to choose from:

■ **Ball and socket.** Landscape photographers swear by these as they allow complete manoeuvrability in all directions and normally feature a single locking mechanism. This makes a ball head very quick to use out in the field. They're also quite compact – ideal if you're going to carry the tripod around all day. The downside is that they're not suited to panning and precise adjustments.

■ **Pan and tilt/three-way.** As the name suggests, these have three adjustments for vertical, horizontal and side-to-side control.

These are slower to use than a ball and socket heads, but the three individual controls offer plenty of precision, as each one can be locked off independently, making it ideal for subjects such as macro and still life and also for panning shots. Whereas a ball head is compact, a three-way, with its handles, is more cumbersome.

■ **Panoramic.** Specialist professional tripod head designed for shooting smooth panoramic sequences. These tripod heads allow you to position the lens's "nodal point" above the axis of rotation, helping the sequence of images to align correctly.

■ **Quick-release plate.** If you're taking your camera on and off the tripod a fair bit, a quick-release plate is very handy. Rather than having to screw the camera back onto the tripod every time you want to use it, simply screw the quick-release plate to the camera's bottom and it'll snap on and off the tripod as and when you need it.

WHAT TO LOOK FOR... TRIPODS

CONSTRUCTION
Most tripods are aluminium construction, though carbon fibre and basalt models are available.

STANDARD OR WIDE SPREAD
As well as having a standard leg angle of around 30°, there should also be options for wider spreads for ultra low-angle shooting.

CENTRE COLUMN
For added shooting flexibility, the centre column should be able to be shortened, reversed and positioned horizontally, too.

³/₈IN STUD
³/₈in is the standard thread for a pro tripod head. If the tripod has a ¹/₄in stud (as on the base of a camera), it's an amateur tripod and will be limited in scope.

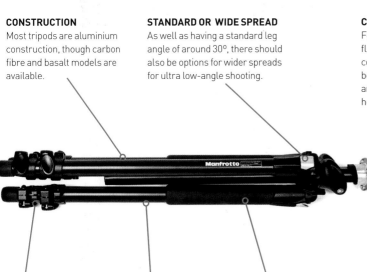

LEG LOCKS
Most tripods extend by three or four telescopic sections. The leg locks should be quick and easy to operate and, once locked, should not slip under load.

CLOSED LENGTH
A compact closed length is always an advantage, whether it's for storage, comfortable carrying or stowing away in the boot of your car.

LEG WARMERS
These pad your shoulder to add comfort when carrying the tripod, and if it's really chilly, also protect your hands from the cold aluminium.

SEALED LOWER LEGS
You'll often need to stand the lower leg sections in water, so look for sealed lower legs that won't hold water then leak it all over your car boot later.

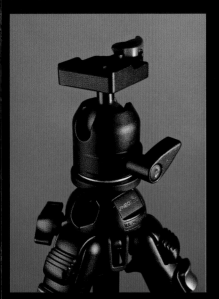

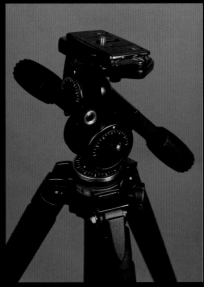

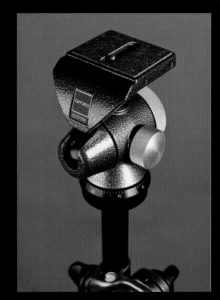

BALL AND SOCKET HEAD
Ideal for landscape photographers as it's compact and offers complete freedom in all directions with generally just one lock.

THREE-WAY PAN AND TILT HEAD
A bit more cumbersome than a ball head, but it's more precise to adjust and is also great for panning shots.

OFF-CENTRE BALL HEAD
A variation on the ball head, this one also offers the ability to pan and tilt for extra flexibility – though it's a bit larger.

Filters

Use filters to control exposure

The Neutral Density grad or ND grad is a useful tool for balancing landscape exposures where the sky is much paler or brighter than the land below. The filters come in a range of strengths, commonly reducing the light from the sky by one, two or three stops, to suit different lighting conditions. The most useful is the 2-stop grad, especially at sunrise or sunset.

When choosing between ND grads, you can opt for either hard or soft-edged filters. This refers to the type of graduation between the dark and clear areas (see comparison, right). ND grads come in different strengths, but different manufacturers use different numbering systems. The chart (shown right) compares the Cokin and Lee filters systems.

SOFT EDGE

HARD EDGE

Light reduction	Cokin	Lee
1-stop	ND2	0.3
2-stop	ND4	0.6
3-stop	ND8	0.9

A 1-stop ND grad is good for reducing the contrast between sky and land, when brightness is only just beyond the capability of the camera. The 2-stop ND grad is more versatile as an all-rounder.

EXPERT ADVICE

GET THE GRAD EFFECT, DIGITALLY

EVEN IF YOU DON'T HAVE ANY ND GRAD FILTERS, it's possible to get a similar effect in one exposure by shooting RAW images. Because these files contain more highlight and shadow detail than JPEGs, you can adjust the exposure when you process them, creating two images (one at 1 stop under, the other at 1 stop over, see below) then combining them again to create a final image with more detail in the sky.

As you only shoot one image, you don't risk encountering any subject movement between exposures.

Combining two images from the same RAW file has the advantage of allowing you to mask specific areas. This means you can deal with complicated and intricate detail separately. The downside is that all this image manipulation takes more time than simply slipping a filter over the lens.

1 STOP UNDER

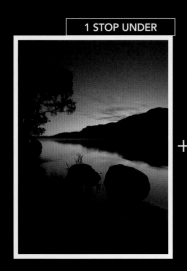

+

1 STOP OVER

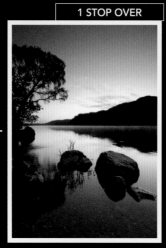

=

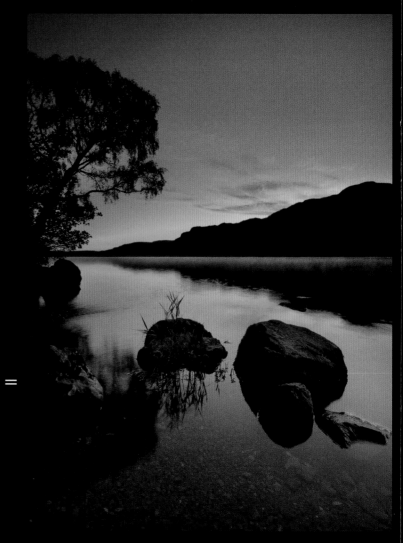

RETAIN SKY WITH AN ND GRAD

ND graduated filters are half grey and half clear – the darker half cuts down the amount of light reaching the sensor, while the clear half allows all the light through. Simply by positioning the dark half of the filter over the brightest part of the scene (usually the sky), you can retain extra detail in your landscapes.

The effect of a soft-edged grad is less obvious than a hard-edged one, making it better for scenes where objects such as trees, mountains or buildings cross the horizon. A hard-edged grad is better suited to subjects where the horizon is clearly defined, such as seascapes.

WITHOUT ND GRAD

WITH ND GRAD

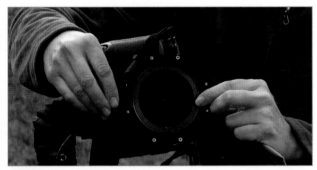

1 ATTACH THE HOLDER Almost all ND grads are square and can be slotted into a special holder (shown above). This fits over the front of the lens via an adapter, rather than screwing directly into the lens. Most filter holders have two or more slots, allowing you to use several filters at the same time, but you should always use the slot nearest the lens for your ND grad. Getting the filter as close to the lens as possible ensures that the filter effect remains out of focus, so makes it less likely that you'll be able to see the transition between the dark and clear areas of the filter.

2 ASSESS EXPOSURE Do this before you fit the ND grad into the holder. The most reliable and accurate way of getting the exposure right is to set the camera to manual exposure mode, and then point the camera down so that the foreground fills the frame. Set the desired aperture, then take your meter reading and select the shutter speed according to the conditions.

Once you have set the exposure you can then re-frame the image and place the camera on a tripod, but keep the same shutter speed and aperture settings.

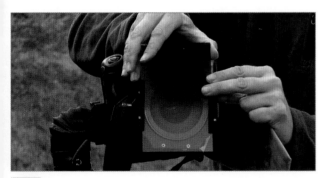

3 ALIGN THE FILTER This is where it becomes clear why most ND grad filters are the square, slot-in design. Unlike a round screw-in filter, using a filter holder allows you to gently slide the filter up and down so that the transition between the dark and clear areas of the filter are correctly aligned with your subject. For many landscapes this transition will need to be positioned along the horizon. It can be tricky to see the position of the transition, so take a little time and slowly move the filter down so that the dark area just covers the sky, but doesn't mask any of the land or water below the horizon.

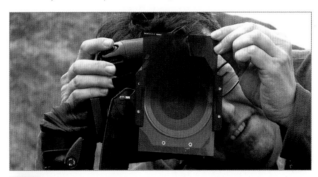

4 TILT THE FILTER Although the transition is usually positioned horizontally along the horizon of your image, sometimes the change between the light and darker areas is at a different angle. The most common example of this is when mountains, cliffs or trees obscure the horizon, but it can also occur when a large area of the image is in shadow, while the rest is in bright sunlight. In these situations you may need to tilt the filter holder to align with this change between the light and dark areas of the image. Using the same technique as before, slide the filter down to position it correctly.

MASTERCLASS

DARKEN BLUE SKIES WITH A POLARIZER

A polarizer is one of the most useful filters you can own. Not only does it allow you to reduce glare to boost colour saturation and cut out reflections from non-metallic surfaces (such as glass, water and foliage), it also has the ability to darken blue skies and make white clouds stand out. This darkening effect can add loads of punch to sunlit landscapes and is very difficult to accurately simulate on the computer.

Light from a blue sky is polarized, which means the wavelengths are all aligned and travelling along the same plane. A polarizing filter can be rotated and aligned with that plane-polarized light to control how much of it enters the lens and reaches your sensor – allowing it all to enter, partially restricting it, or blocking it out altogether (thus producing a darker image). For best results, point the camera at right-angles to the sun's axis – this is the point at which the light from blue sky is most polarized.

WITHOUT POLARIZER

1 ATTACH THE FILTER Screw the polarizer directly into your lens's filter thread – common lens threads vary from 49mm to 82mm depending on which lens you're using, so check you've got the right size first. This can be a little fiddly so take your time and don't over-tighten it. Once the filter is in place, compose your shot. Try to direct the camera at right angles to the sun for the strongest effect.

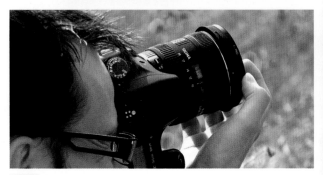

2 COMPOSE THE SHOT Slowly rotate the polarizer while looking through your camera's viewfinder to gauge its effect. You'll see that the sky darkens, clouds become more defined, and colours become slightly more saturated. Keep rotating to find the optimum position – too light and the impact is underwhelming, too dark and you've created Armageddon! Try shooting a before and after pair of pictures to see what a difference a polarizer can make to your landscapes.

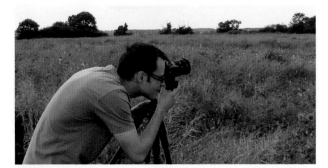

3 TAKE YOUR SHOT Using a polarizer will reduce your exposure by between one and three f/stops, depending on how far you rotate the filter, so if you're working in aperture-priority mode keep an eye on the shutter speed. You may find your exposures are too long for handholding the camera without risking camera shake. For anything slower than 1/60sec, a tripod is essential. Once you've composed, rotated the filter and checked your exposure, all you have to do now is take the shot.

WHAT TO LOOK FOR... POLARIZERS

There are two types of polarizer – linear and circular – though both are circular in shape. Circular polarizers are designed to work with modern AF systems, and they screw into the lens's filter thread. They rotate even after being screwed on, as the effect varies as the filter turns.

Camera bags and backpacks

Keep your gear safe and portable

WHAT YOU'LL LEARN
HOW TO CHOOSE AND
LOAD A CAMERA BAG

THERE ARE HUNDREDS OF DIFFERENT TYPES of camera bag on the market. When deciding on the right design for you, you're normally faced with two main choices – either a backpack or a shoulder bag.

Backpacks are great if you're going to be carrying a large amount of gear for a long period of time as the weight of the kit is evenly distributed across both shoulders. The trouble is, they don't offer easy access to your kit – you'll find yourself taking the backpack off, putting it on the ground, opening it up and then finally retrieving your gear and setting up the shot. Not ideal if you're in a fast-moving environment.

A shoulder bag is far quicker. Because the main compartment is situated next to your hip, you can just reach in, pull out your camera and start shooting without the hassle of taking it off your shoulder.

A medium-sized shoulder bag will swallow an astounding amount of gear. As well as a DSLR with a decent-sized standard zoom lens, there should be space for an additional telephoto zoom, macro lens, flashgun and a variety of shooting accessories. Some will even have space for a laptop.

Though shoulder bags are great for short trips and instant access, they can become uncomfortable when slung over one shoulder for a period of time. The benefit of using a camera backpack or rucksack design instead is that you're given two straps to distribute the weight evenly across both shoulders and this makes it much more comfortable for those longer all-day photo trips.

Backpacks often have sternum straps that link the shoulder straps together at the chest for extra rigidity, or waist straps that stabilize the load and reduce any side-to-side movement. If a backpack isn't supplied with either of these additional strap arrangements, it's totally reliant on the two main shoulder straps so they should be well-padded for increased comfort.

Some backpacks are fully adapted so tripods can be attached, giving you two free hands for scrambling up a hillside or holding onto walking poles. The only problem with attaching a tripod at the rear of the pack is that it can end up obscuring the entrance lid, again slowing down the process of getting at your camera when the muse strikes you.

EXPERT ADVICE

BACKPACK OR SHOULDER BAG?

CHOOSING THE RIGHT camera bag for your own requirements is a matter of deciding what sort of photography you will be doing most: considered landscape pictures on location requiring lots of walking and a tripod; or more "off-the-hip" handheld pictures, responding to situations as and when they arise.

Consider how you take pictures on holiday: do you get up early and visit a specific location to get a single great exposure, or do you go out all day and look for the little details?

If your shooting style is more geared to capturing a single great shot using a tripod then the backpack design is best for you, as you won't be trying to access your camera until you reach your final destination. Photographers who find inspiration everywhere will want more frequent, repeated access to their kit instead, making the shoulder bag a better option.

Another issue to bear in mind when buying a new backpack is size – especially if you're looking to take it on an international flight with you. It's imperative to take any camera bag as hand luggage on a plane, so you need to ensure a backpack isn't too large to be allowed in the cabin. The UK's Department of Transport recommendations (at time of writing) state that hand baggage should not exceed 56x45x25cm (22x18x10in), but it's well worth double-checking your airline's policy on this before you travel, as baggage rules can and do change.

CAMERA PROTECTION

Camera gear isn't cheap, so if you're going to lug it around with you, you want to know it's properly protected. For this reason, a good photo bag should have plenty of padding all round to take any knocks – shielding your kit from any expensive repair bills.

In addition, at some point you're probably going to find yourself caught out in the pouring rain, and you don't want to worry about your gear getting wet. Most bags aren't 100% watertight – they're especially vulnerable in areas such as zips, seams and drawstring lids – so don't go dunking them in that nearby stream.

However, if a bag is designated "weatherproof", the materials used do offer a little protection from the elements. And if you really want to be on the safe side, some bags even include a rain cover for extra protection in a downpour.

QUICK ACCESS

Alternatives to the conventional shoulder bags include the "sling-shot" and waist belt designs. To get at your camera even faster, some shoulder bags come with quick-access openings known as "Presstops" on top of the bag, allowing you to reach in and grab your DSLR without even having to open the whole lid.

Shoulder bags also have a smaller footprint than backpacks, so if space is an issue when travelling overseas, they can definitely be an advantage.

WHAT TO LOOK FOR... BAGS AND BACKPACKS

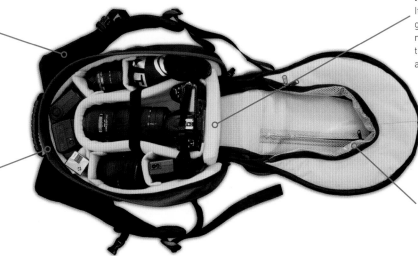

INTERIOR PADDING
It's vital that all your expensive gear is protected, so look for robust interior padding. Check also that the Velcro dividers are strong and durable.

SHOULDER STRAP
The backpack is going to be on your shoulders for long periods of time, so ensure the shoulder straps are well-padded for maximum comfort. They should also offer ventilation from any perspiration.

EXTERNAL ZIPS
These should glide around easily, increasing the bag's access speed. Some bags offer weather-sealed zippers to keep the elements out.

INTERIOR POCKETS
Make sure your backpack has roomy interior pockets that can be used for storing extras such as memory cards and photo filters.

PRESS TOP
Not every bag will have one, but a press top is a handy opening on the top of the bag, providing really fast access to your kit.

STRAP
You'll need a well-padded strap to distribute pressure across your shoulder, and a non-slip grip to keep it in place when walking.

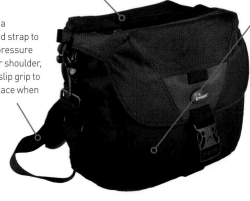

FABRIC AND BUILD
The base of the bag should be double thickness for added protection, while the stitching should be of a good quality.

PADDING
This is one of the last things you want to compromise on – you need protection from knocks, and dividers that stop kit clanking together.

CAPACITY
Work out how much gear you have (or are likely to take with you), and then make sure your bag can take everything.

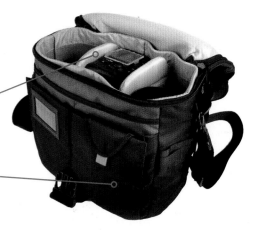

Flashguns

Moving on from pop-up flash

LIGHT IS PHOTOGRAPHY'S MOST ESSENTIAL INGREDIENT, so if there's not enough natural illumination for a shot you'll need to generate it artificially. One of the most useful and versatile ways to do this is with flash and it comes in several guises, from the neat little pop-up devices built in to your camera to accessory flashguns and studio flash units.

Pop-up flash can be a really powerful tool and a great introduction to the world of artificial light. Units are small, compact, portable and always attached to your DSLR just in case you need a quick blip of additional "fill-in" light. Because they are built into the camera, they're compatible with the camera's own automatic exposure metering system and you can access all manner of useful flash techniques – there's more about this in the next chapter.

However, if you want to take things further in terms of power, features and functionality, you'll need to buy an accessory flashgun – a great compromise between the ease of pop-up flash and studio flash heads, which are often simply too big and cumbersome for convenient everyday use.

Accessory flashguns represent a step-up in performance over pop-up flash, offering quicker recycle times and a greater number of continuous flash bursts. They also offer more versatility because they can be used either attached to your camera via the hotshoe, fired off-camera via a flash-sync cord, or triggered remotely by radio or infrared signal (see opposite page). The advantage of using off-camera flash, instead of keeping the flashgun mounted direct on top of your camera, is that it gives you more control over the way light falls on your subject, with the strength and spread of the light modifiable using a wide selection of diffusers or softboxes, available to buy separately.

Plus, unlike the fixed position of a pop-up flash, the burst of light from a flashgun can be directed up or down or side-to-side, thanks to their "bounce" and "swivel" design.

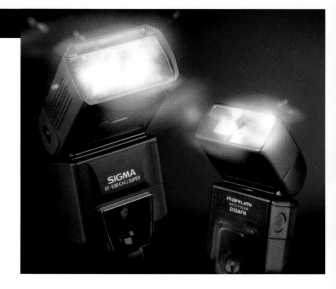

The main advantage flashguns offer over pop-up flash is greater power, described in terms of a "Guide Number". The greater the number, the more powerful the flash.

CHOOSING A FLASHGUN

Top-of-the-range flashguns can cost as much as a decent fast lens, but most people like to keep a reasonable lid on their flashgun budget, and it's entirely possible to get a great, versatile flashgun for half the price of the top spec models.

First thing to consider is that a flashgun has to be compatible with your camera system. So, just like lenses, a Nikon flash won't work on a Canon camera. This is because each camera's unique metering system needs to work in tandem with the flashgun, to set the correct flash exposure. You do have some choice between own-brand and third-party options however – many of them offering a viable alternative to your manufacturer's own flashgun, full automatic metering compatibility, plus a number of remote triggering options too.

WHAT TO LOOK FOR... FLASHGUNS

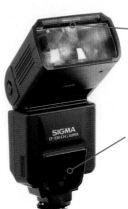

WIDEANGLE DIFFUSER
Pulls out and sits over the flash head to disperse the burst of light when shooting with wideangle lenses.

AF ASSIST BEAM
Emits a beam of light to help your camera focus in low-light conditions.

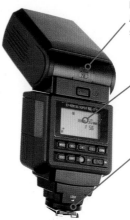

BOUNCE AND SWIVEL
Angle the flash light away from the subject for more natural results.

LCD SCREEN
Navigate the menus and change flash mode or power settings using the LCD screen on the rear.

HOTSHOE FOOT
Metal ones are more durable than plastic ones and the lock will ensure the flashgun is secure on the hotshoe.

FLASHGUN ACCESSORIES

Most flashgun accessories are designed to mimic the effects achievable with professional studio flash, only on a smaller scale. Many of the pitfalls of using on-camera flash – harsh, directional, frontal lighting that casts a stark black shadow on nearby backdrops – can be avoided by using bounce flash or diffusing accessories. The other more complex accessories – snoots, barndoors, honeycomb grids – are chiefly designed to modify the flash burst by channelling and directing it for more sculptural, three-dimensional effects.

It's worth noting however that flash accessories can reduce the amount of light reaching the subject, so it's best to conduct a test shoot first to check your camera's automatic metering sustem takes account of the drop in light or compensate by adding +1-2 stops exposure accordingly.

REMOTE TRIGGERS

Off-camera flash or "strobism" has become hugely popular in portrait and action photography. Here, vivid colours, bold shadows and theatrical lighting effects are achieved through the use of multiple flashguns or "strobes" placed carefully around a subject, allowing the photographer to take total control of the lighting.

Supporting, positioning and triggering the flash once it's off the camera present a number of dilemmas – tripod-style stands are available with flash hotshoe connectors, but when it comes to triggering your remote flash there are five main ways to do it:

1 Flash sync cord. This fits directly into your camera's hotshoe at one end and, via a length of coiled cable, provides a mount for your flashgun at the other end. This system can support multiple flashes but will need a host of cables, adapters and splitters to do so. TTL (Through the Lens) metering is preserved and no batteries are required, but your working range is restricted by the length of the cable.

2 Optical or "slave" trigger. Small and simple to operate, an optical flash trigger works by sensing the increase in light intensity caused by a flash or other light source as it fires and, in turn, responds by triggering the flash it is attached to. Often comprising a combined shoe mount and tripod thread block, with a hotshoe mount, these handy little items are often not a lot bigger than a sugar cube. The main downside here is that the flash response can be erratic in bright outdoor conditions, and can be triggered by the pulse of light emitted by your main flashgun when assessing exposure.

3 Manufacturer's own wireless systems. Most mid- to higher-end DSLRs have a built-in system to fire flashes off-camera using a "commander" flash unit. The majority of systems work using an infrared signal sent from either the camera's pop-up flash or the commander unit. You'll usually get full control of the flashes, including power adjustment, but you'll be limited to using flashes manufactured for your specific system.

4 eBay-style trigger/receiver kits. These are widely available from numerous online retailers and come in a variety of shapes, sizes and brand names. These are inexpensive, compact and compatible with a huge range of cameras. The price and compatibility of these kits makes them an attractive option, along with the ability to mix and match flashguns.

5 Pro-style trigger/receiver kits. Pocket Wizards, Radiopoppers and Elinchrom Skyports systems allow a high level of control, and some even support wireless TTL and power control from the DSLR's own commander unit. Pop the transmitter into your camera's hotshoe, attach the receiver to the flashgun, and you're ready to go. Controlling the flash may require a bit of trial-and-error if working manually. As a cost-effective approach, use cheap, secondhand flashguns and work in Manual mode.

EXPERT ADVICE

MODIFY YOUR FLASH

A wide range of accessories exists to help modify the burst of light from your flashgun.

■ **Softboxes:** these are fabric boxes which enfold the flashgun, with a layer of diffusing fabric between light source and subject to soften and spread the light more evenly.

■ **Diffusers:** usually of plastic or fabric construction, these soften harsh shadows and reduce "hot spot" flash highlights.

■ **Filter gels:** can be fixed over the front of the flashgun to light a scene or backdrop in colour.

Left: LumiQuest's Soft Screen – a diffuser for DSLR's own built in pop-up flash.

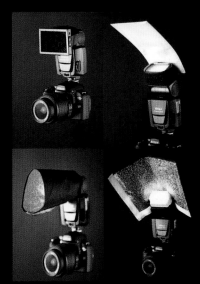

■ **Bounce cards:** these help bounce light from your flashgun, avoiding harsh and unflattering effects of directional on-camera flash and creating a softer and more even illumination.

■ **Barndors, snoots, honeycomb grids:** all designed to help channel the flash into a tighter beam, ideal for lighting backdrops. low key and fill-in effects

■ **Beauty dishes:** these will diffuse the flashgun's burst for soft, even lighting.

Left: a selection of Interfit's Strobie flashgun accessories.

Image storage and monitors

Accessories to store and view images

WITH DIGITAL CAMERAS OFFERING EVER-INCREASING resolution, there's a corresponding increase in the size of image files and electronic data to store. It's not so long ago that standard PC hard drives were around 10GB in capacity; you can now capture that amount of data in a few days' shooting. Add to that any other data you want to store and before long, even large-capacity hard drives will clog up.

A portable external hard drive allows you to store all your electronic data away from the internal hard drive, freeing up valuable space so software programs such as Photoshop can run more smoothly. They also have the added flexibility of allowing you to transport precious digital files around and accessing or modifying them wherever you are.

WHAT YOU'LL LEARN
STORING IMAGES ON A PORTABLE HARDDRIVE

PORTABLE EXTERNAL HARD DRIVES
There are plenty of good reasons why a portable external hard drive is an essential piece of kit: its smart design and technology means it'll hold incredible amounts of data so you'll be able to store all your files in a small, slick unit that takes up a tiny amount of desk or shelf space. And, because a portable drive draws power from your computer's USB port – not the mains – there are no bulky cables or power supply units to carry around, either.

It's never a good idea to move a hard drive while the disk is spinning as it's like playing Russian roulette with your data, but some portable drives offer features such as shock absorbers and armoured shells to provide extra protection. This is ideal if you work across multiple computers; perhaps a laptop on location and a desktop at home, because you'll really improve your digital workflow by having the same saved version of your images with you at all times.

BACKING-UP FILES
Portable hard drives are a cost effective and efficient way of backing-up your image files, too. Bearing in mind the relative fragility of electronic equipment, it's prudent to have at least two copies of irreplaceable images. Splashing out on two external hard drives may seem like a bit of an extravagance, but it really is a sensible back-up solution if one hard drive fails. Back-up software solutions, which save a copy of your entire system into compressed data files, will often come bundled with external hard drives. While these are great for creating a restore point in case your whole computer fails, when it comes to backing up image files we recommend ignoring the back-up software and just manually saving your images over at least two drives.

FORMATTING AND PARTITIONS
Many portable drives are pre-formatted "plug and play" devices that you connect up and start using, but some may need formatting. Formatting wipes all the data and sets what file structure the drive uses to store data. The most common file structures are currently FAT32 (File Allocation Table 32), NTFS (NT File System) or HFS+ (Hierarchical File System). If you're running Windows then format using the NTFS file structure. This is more secure for PCs but doesn't work fully on Apple Macs. Apple has developed HFS+ for Macs but it doesn't work on PCs, so if you need to share your portable hard drive across platforms, opt for FAT32 that works on both. FAT32 is limited to 32GB if formatted through Windows but you can create disk partitions to split the drive into several 32GB sections or use the Disk Utility on a Mac and select the MS–DOS File System that creates a single FAT32 partition.

BUYING ADVICE

HARD DRIVES

LOWER CAPACITY OPTION
If you think 500GB of storage is more than you'll ever need, it might make more sense to invest in a couple of smaller drives. Most models on the market come in a variety of smaller sizes and lower capacities.

MEGA CAPACITY OPTION
Mammoth 2TB (that's 2000GB) mirror drives provide plenty of space to save duplicate copies of your image files and back-up your entire computer. What's more, they'll automatically create a mirror copy of data to a partition, too.

ULTRA DURABLE OPTION
Body armour will protect the outer shell of your portable hard drive against serious bumps and knocks. If you think you'll give the drive some serious hard knocks, consider ultra-durable hard drives such as Lacie's "Rugged" design.

MONITORS

Your monitor is the most important component in your "digital darkroom" home printing set-up. If you want to produce the best results from your images, a good monitor is crucial. Conversely, a bad monitor will hamper you at every turn, because the poor colours, lack of detail and flat tonal range will lead to making poor decisions when you're editing your pictures.

Advancements in technology mean the old-style Cathode Ray Tube (CRT) monitors are fast disappearing in favour of Liquid Crystal Display (LCD) screens. The latter don't have a bulky cathode ray tube to accommodate, so you can have a much larger screen without taking up all the desk space behind it. LCD monitors are also easier on the eyes, leading to less fatigue if you're working on an image for some hours.

Colour calibration of your monitor is also less of an issue with modern LCD screens, the best of which will often represent colours faithfully straight out of the box, without having to download profiles or buy extra calibration tools.

Screen sizes are measured like a TV screen – diagonally. Widescreen monitors are popular as they allow plenty of room for your images, plus space for creative palettes when editing.

MONITOR JARGON BUSTER

VGA (VIDEO GRAPHICS ARRAY)
Also referred to as D-SUB or RGB, this was the common way of connecting Cathode Ray Tubes (CRTs). Less popular with LCDs as it only carries a lower quality analogue signal.

DVI (DIGITAL VISUAL INTERFACE)
Monitors connected via DVI require no compression to the digital signal sent by the computer and therefore the quality of the image is superior to VGA.

HDMI (HIGH DEFINITION MULTIMEDIA INTERFACE)
An alternative to DVI for sending an uncompressed digital signal. Not yet standard, but some graphics cards now include HDMI.

GRAPHICS CARD
A piece of PC hardware that sends the signal to your screen. Graphics cards can have a range of sockets including VGA, DVI and HDMI.

NATIVE RESOLUTION
The recommended optimum resolution setting. LCDs cannot scale images as well as CRTs and attempting to run one at a non-native resolution can lead to blurring around images.

PIXEL PITCH
Also known as Dot Pitch, it is the distance between colour elements in adjacent pixels. Generally, the smaller the Dot Pitch, the sharper the image.

RESPONSE TIME
How quickly a monitor reacts to changes, measured by how long it takes for pixels to change from white to black and back again. Less important for static pics, but crucial for smooth video.

CONTRAST RATIO
The variance between black and white pixels in the display. In theory, the higher the contrast ratio the wider the tonal range, but there are varying ways to measure this and environmental factors such as reflected light can lower the quoted ratio.

STANDARD
RATIO

◀— WIDESCREEN RATIO —▶

HDMI cables carry an uncompressed digital signal for audio and video.

A DVI cable is currently a common way of connecting LCD monitors.

A VGA cable transmits an analogue signal mainly used on CRT monitors.

With widescreen LCDs, use a 16:10 aspect ratio resolution, such as 1920 x 1200, to avoid problems with distorted images.

Printing at home

Don't let images languish on your hard drive — print them out

PHOTOGRAPHERS CAN SPEND HOURS out shooting with their cameras, investing time, money and effort on getting a great shot. Then it's back home to squeeze as much as possible out of their RAW files to produce an image to be proud of. For many of us, it's often easier to let the job end there, but that's a real shame. Some images may eventually be uploaded to an online gallery or forum, but many of them never see the light of day and remain on your hard drive, gathering metaphorical dust. But if you're passionate about your photography – why not show off your photos as prints?

You can upload your images directly to a pro-lab and leave them to run off some prints but, convenient though this may be, it doesn't match the satisfaction of shooting and producing your own finished print all in the same day.

There's a wide variety of A4 printers available and, while they're great for printing off standard snaps, they're a bit restrictive as far as size goes. For real impact – and to do your photos justice – an A3+ printer is the way to go. The "+" means that they actually print larger than standard A3 (420x297mm/16$^{1}/_{2}$ x11$^{7}/_{10}$in), at 483x329mm (19x12$^{9}/_{10}$in), at 483x329mm (19x12$^{9}/_{10}$in), and can produce gallery-quality prints in next to no time, with the technology and colour range (not forgetting their ability to handle monochrome prints) improving all the time.

If you've been using the same printer for four to five years, you'll be amazed by the results you can achieve with these modern-day technological beasts.

There are budget model A3+ printers available, and they do a solid job with the prints they produce, but for extra investment (and for those special images that warrant a frame and a place on the wall) you can't beat a top-of-the-range A3+ model offering the latest ink technology, guaranteeing the best image quality, colour fidelity and life expectancy.

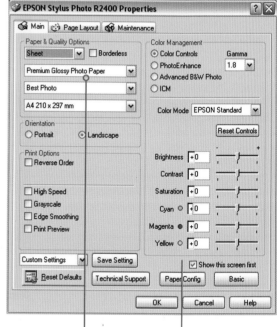

UNDERSTAND THE DRIVER
Get to know your printer's software "driver" window so you can tell the printer exactly what sort of media you've loaded. Most printers offer a wide choice of options here, from photo glossy papers to more textured "art" surfaces.

Once you've calibrated your printer for a particular type of paper or other media, it's useful to save those settings in the printer driver dialogue box. This will allow you to work more quickly next time.

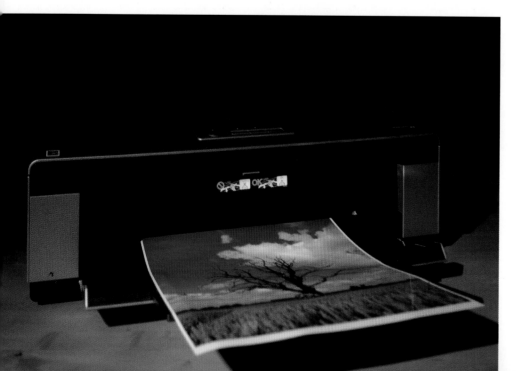

PRINT RESOLUTION OR PRINTER RESOLUTION?

These two terms are often confused, but refer to completely different aspects of the printing process.

■ **Print resolution** refers to the size of the digital image you're printing (eg 300dpi). This is determined by the number of pixels in the image recorded by your camera, and limits the size of print that can be produced from the image without showing some form of pixellation.

■ **Printer resolution** refers to the way that the ink is applied to the paper by the printer. This needs to be a much higher number than the print resolution to get high-quality prints, as the tiny dots of ink need to be very close together to avoid them being visible in the final image.

CHOOSING A PRINTER

The main advantages of printing out your pictures at home are that you can potentially save cash and retain more control over the output. Initial outlay is high – you'll need to buy a printer, cartridges and photographic paper, and you'll spend a fair amount of time calibrating your computer monitor to the same colour output as your printer.

Most office inkjet printers are fine for printing out your images, but if you don't already own one, reputable brands include Canon, Epson and Hewlett Packard. Consider paper size, printer resolution and the cost of replacement ink cartridges (printers have either combined cartridges or separate tanks, which can save you money if you print a lot of a single colour).

Alongside manufacturers' own-brand inks, independent companies make them too – often at a fraction of the cost. Although these can represent a good buy – if you're prepared to take the time to experiment and see how they work with different papers – it's best to stick with the manufacturer's own inks, at least to start with.

PRINTER SETTINGS

At the heart of getting a good quality print is getting to know the settings in your printer driver software (see typical printer driver interface, left). These settings are there to match the amount of inks to the surface of the paper, and to make sure the printer knows what size paper it's using.

It doesn't matter how good the printer, paper and ink are: the results will never match your expectations if the driver software thinks you're using a different type of media to the one that's actually loaded in the paper tray. Take time and conduct some tests to see the differences between settings.

CHOOSING THE RIGHT PAPER

With hundreds of different makes, surfaces and weights to choose from it's easy to assume all papers will give you perfect results. The easiest and most hassle-free option is to stick with the printer manufacturer's own-brand paper. While this isn't always the cheapest option, it does guarantee compatibility and consistent results.

Papers are generally available in a range of surfaces, from matte and gloss finishes to fancy "art" finishes such as textured watercolour paper. If you're just starting out we'd recommend using the more standard gloss or matte surface papers. Leave the special surfaces until you've mastered the basics of getting photo-quality prints.

Many independent paper manufacturers produce excellent materials, but it can take a little experimentation with your printer-driver settings to get the best results.

■ **Glossy:** this refers to papers with a shiny surface, similar to normal photographic prints. They're great for bright, punchy and colourful prints, but they show up marks such as fingerprints easily and can suffer from reflections.

■ **Photo matte:** this term covers a wide range of paper types including silk, lustre, pearl and semi-gloss, which vary slightly in texture and finish, but all give photo-quality results. The lower contrast and colour saturation suits more subtle images, and doesn't suffer from reflections as much as glossy paper. Results can look slightly less punchy and colourful than prints made on glossy paper.

■ **Fine art:** this is a general term for specialist media with textures and surfaces similar to traditional artists' materials such as watercolour paper. Surface textures and finishes can give your images a more artistic appearance, but the strong texture doesn't suit all images, and they can be expensive.

WHAT TO LOOK FOR... PRINTERS

When investing in a high-end printer, these are some of the features you should look out for.

CARTRIDGES
Expect to find up to 10 individual cartridges, each with a specific colour to achieve a life-like tonal range. There is often an interchangeable Photo/Matte Black cartridge depending on the media you're printing on.

CONVENIENCE
When the printer is not in use, it should fold away easily, leaving a minimal footprint on your desk.

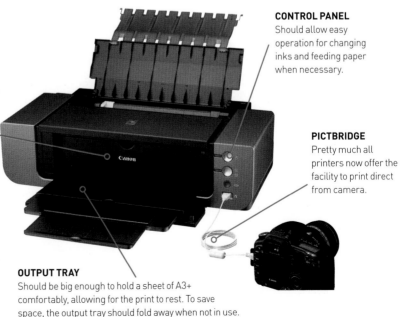

CONTROL PANEL
Should allow easy operation for changing inks and feeding paper when necessary.

PICTBRIDGE
Pretty much all printers now offer the facility to print direct from camera.

OUTPUT TRAY
Should be big enough to hold a sheet of A3+ comfortably, allowing for the print to rest. To save space, the output tray should fold away when not in use.

Getting the colours right

Set your colour space and run maintenance checks on your printer

IF YOU INTEND TO PRINT your pictures at home on an inkjet printer then the first thing you need to do is look at the colour space within which your camera, printer and monitor will work. First you need to set your DSLR camera to the correct colour space for your printer. There are two main DSLR colour spaces to choose from – Adobe RGB and sRGB. Adobe RGB colour space has a wider range of available colours than sRGB, but most inkjet printers are only capable of printing the colours within the sRGB range. So, even if you set your camera to Adobe RGB, when the colour information is eventually passed to your printer, the colours will have to be redefined so they fall within that device's printable range. This means you may as well have captured the image in sRGB to begin with.

If, however, you plan to send your images off to professional repro houses, which use top-end printers capable of accurately reproducing a wider range of colours, then there may be a small advantage in setting your camera to Adobe RGB, as this will give the resulting prints a slightly greater graduation of colour.

The next step is to make sure you have set up your image-editing software to be compatible with your camera's colour space. Photoshop's colour settings options (Edit>Color Settings) tell the software what range of colours to use when printing and editing pictures, and what to do when you open documents that have different embedded colour profiles. Using the Color Settings options, preferences can be set for both the RGB and CMYK colour modes, as well as the brightness of midtones and spot

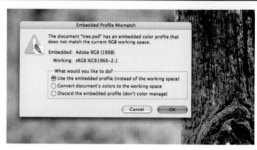

When you open an image with a different colour profile to that you're using in Photoshop, a warning box may be displayed.

colours under the Gray and Spot menus. In fact there's a wide range of options under each menu, but fortunately most can be ignored as they offer flexibility for professional printers working with multiple imaging set-ups.

Inkjet printers do use Cyan, Magenta, Yellow and Black (CMYK) inks, but they're actually RGB devices and images do not need to be converted to CMYK for printing on them, so we can ignore the options under the CMYK box. For the RGB colour space, pick the one your camera is set to (we recommend sRGB).

As for that annoying Profile Warning box (pictured above), you'll find options for that in the drop-down menus under Color Management Policies. Select Convert to Working from the lists, as this tells Photoshop to change the colour profile of documents you open – if they have a different embedded profile – to match the colour profile of your set-up.

PHOTOSHOP COLOUR SETTINGS

1 In Photoshop, go to Edit>Color Settings and under the Working Space menu set RGB to sRGB, Gray to Gamma 2.2 and Spot to Dot Gain 20%. You can leave CMYK to the default setting. Under Color Management Policies set the boxes to Convert to Working and tick the boxes underneath. Now when you open an image, if you're prompted to, convert colours to the working space you've set up here and then the colours you see on screen will be within the printable range of

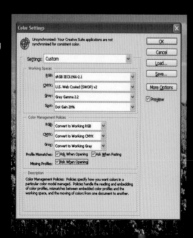

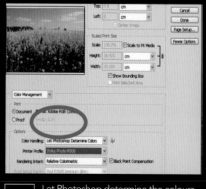

2 Let Photoshop determine the colours. Now go to File>Print with Preview and click the More Options button. Then, under the Color Handling menu select Let Photoshop Determine Colors. Next, under Printer Profile, select the profile for your printer

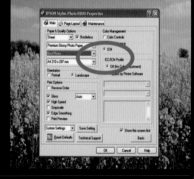

3 Disable print drivers. Next hit the Print button followed by Properties, to enter the printer drivers, and under the Advanced options tick the ICM box and then the Off (no colour adjustment) box to disable any

WHY DO I HAVE A COLOUR CAST?

If nothing else has changed in your digital workflow it's likely your printer is malfunctioning. The most common cause of this problem is a blockage or airlock within the printer heads, caused by dried ink clogging up the nozzles and stopping the flow of fresh ink.

When a cartridge's output becomes compromised, the printer is unable to distribute the correct combination of inks, resulting in a horrible colour cast. A heavy green cast for instance indicates the magenta cartridge isn't delivering ink. Don't panic though, there's no need to rush out and buy a new printer just yet! Within the print properties (File>Print with preview>Print>Properties) you'll find a tab called Maintenance, and from here you'll be able to produce a test print to check the nozzles and clean the heads if necessary.

The nozzle check prints a series of coloured lines for each of the cartridges. If the lines have gaps, it indicates the nozzle for that colour is clogged and needs a clean. Doing this is easy and doesn't involve dismantling your printer. Simply click the head cleaning button and let it run its course.

Sort out heavy colour casts using the nozzle check and head cleaning functions within the print drivers.

The process will use some ink so make sure you've got plenty left in the tanks and when it's finished, run the nozzle check again to see if you've shifted the problem. It could take a few attempts to unclog the nozzle so repeat the process until your test displays lines with no gaps. (Also note that the problem could be one of your ink cartridges is running low.)

EXPERT ADVICE

RESIZING FOR PRINT

The image on the left was shot and printed at its original resolution of 10Mp, while that on the right has been upsized from a lower-res starting point – note the difference in detail.

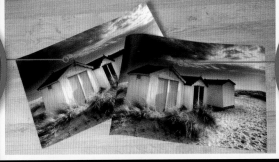

HIGH RES

LO RES

When resizing an image for printing, Photoshop presents you with an option to "Resample" the image. With the Resample box ticked, any adjustments made to the document's size – its physical width or height – or the image resolution, will affect the actual number of pixels that make up your shot when printed.

If upsizing, you need more pixels and the only way Photoshop can add these is by making up new ones – a process known as "interpolation". These new, interpolated pixels don't contain true image data, as they would if captured by a camera, but are in fact based on the data from the original pixels around them. If too many pixels are interpolated the resulting image can get quite soft and produce unsatisfactory prints.

In most cases, when resizing an image for printing you'll want to leave the Resample box unticked, so any adjustments you make to a document's size will only redistribute the true pixels, and not generate fake ones. When printing without resampling, Photoshop adjusts the image resolution, either spreading the existing pixels over a greater area for a larger

There are a couple of circumstances where resampling pixels is necessary. The first is to increase the number of pixels within an image so it can be printed larger, and the second is to lower the resolution of your image to 72ppi, which is adequate resolution for viewing images on screen, and reduces the document's file size, making it a more manageable size for uploading to the internet. To do this you'll need to tick the Resample box, and in the adjacent menu select a resampling method. There are four main options:
■ Nearest Neighbour. This is the fastest resampling option, but lowest quality, only recommended for line art graphics
■ Bilinear. This offers a medium quality and speed option.
■ Bicubic Smoother.
■ Bicubic Sharper. Both bicubic options are more precise methods of resampling and will copy data in a cube shape around the new pixel to create a smoother gradation of colour. Use Bicubic Smoother for enlarging image size and Bicubic Sharper for reducing image size.

The Bicubic options will create the best results but remember not to interpolate too many pixels or your printed

Optional extras

More handy little gadgets

WHAT YOU'LL LEARN
MORE USEFUL KIT AND
WHAT IT DOES

There are hundreds, perhaps thousands of gadgets and gizmos for photographers to use – from basic things like photographers' fingerless gloves, raincovers and kneeling mats to sophisticated flash triggers, GPS recording devices and radio remote control camera handsets. Step into any major camera shop and you'll be amazed at the ingenuity of manufacturers in helping us part with our hard-earned cash!

Some of the most useful devices are those which will protect and maintain your DSLR, and provide back-up image storage and battery power. Gadgets such as sensor-cleaning wands, lens wipes, memory cards, spare batteries and/or a spare charged battery are worth keeping in your camera bag at all times and are worth their weight in gold.

Also useful are a chamois leather (for wiping rain or salt sea spray off your lens) and a large black plastic bin liner (for lying down on or putting your bag on in muddy conditions). If you're holidaying abroad, a travel adapter plug will be invaluable too, plus your battery-recharging equipment. It has often been said that it's worth taking two of everything in case one of them breaks, but this is taking caution to the extreme. At some point you just have to take pot luck.

Beyond the core essentials, it's the little things that successful photographers often swear by: a hotshoe-mounted spirit level to keep horizons straight; a foldaway reflector to bounce sunlight onto a shaded foreground subject; an 18% grey card to help take exposure readings in tricky lighting conditions. Rootle around in a professional photographer's camera bag and you may be surprised by the unconventional and sometimes homemade gizmos that lie within: bull-dog clips, duck tape, rubber bands, petroleum jelly. We've even heard of photographers making flash accessories out of drinking straws! Of course, we haven't been able to feature all these gadgets here, but this is a small selection of the most useful "unsung heros" to keep in your gadget bag.

MACRO FLASHGUN
Macro flashguns like this are ideal for photographing small subjects in fine detail, providing a bright but shadowless light from dual flash tubes, one either side of the lens (not to be confused with ring flash). With this Sigma model you can also set the flash tubes to fire separately, so the subject casts a shadow and looks three-dimensional.

CIRCULAR POLARIZER
Attach a polarizing filter to your lens and rotate it against the plane-polarized light to cut through non-metallic reflections and glare off sky, water, glass and foliage. Its effect is to darken blue skies against white clouds and make colours look more richly saturated. Works best when orientating the filter at 90° to the sun's axis. Be sure to buy a filter with the correct filter thread (diameter) for your lens.

SPIRIT LEVEL
Fitting a spirit level into the camera's hotshoe before you shoot a landscape or seascape is the surest way to guard against a wonky horizon, thus saving you precious time straightening your horizons in Photoshop. This digital spirit level by Seculine fits just above the viewfinder, and literally gives you a green light as soon as the view is all straight and perpendicular.

GPS MODULE
Nikon's Global Positioning System unit attaches to compatible Nikon DSLR cameras in the camera's accessory shoe on the top plate, recording location information in the image data EXIF file. Data such as latitude, longitude, altitude and time are automatically recorded – all powered direct by the camera body. This is a huge boon to travel photographers when captioning images by location.

SPARE BATTERIES
It's always helpful to have more power to hand by keeping a ready-charged spare battery in your camera bag. Keep a spare battery charger in your luggage when you travel too, complete with travel adapter compatible with overseas plug sockets.

SPARE MEMORY CARD
It pays to keep a few spare memory cards to hand when holidaying abroad or out shooting on location. There are lots of different types and makes – CompactFlash (CF), Secure Digital (SD/SDHC), Mini and Micro SD, Memory Stick, Smart Media and xD cards. They offer different amounts of storage capacity, measured in gigabytes (GB).

SUN COMPASS
When making a reconnaissance trip on location, it can be hard to visualize where the sun will be at sunrise and sunset, and thus work out the best time of day to return. This sun compass from Flight Logistics gives all sunrise and sunset positions throughout the year – a huge help for travel and landscape subjects.

SENSOR-CLEANING WAND
Dust and dirt on your camera's sensor lead to marks and smudges on your images that can be a real nuisance to remove in Photoshop. It's a good idea to invest in a sensor-cleaning brush such as the Arctic Butterfly. Simply give it a whizz to generate static on the filaments then switch off before giving the sensor a gentle wipe over.

REMOTE CONTROL HANDSET

Invest in the correct remote control handset for your camera and you'll be able to take self-portraits and include yourself in group shots, triggering the camera from the posing position instead of from beside or behind the camera. Used in conjunction with the Mirror Lock-Up function on your DSLR, a remote control handset such as this Sigma device can also reduce the possibility of camera shake.

UNDERWATER HOUSING

Shooting underwater is an exciting proposition – not least for the sense of thrill you get as you gently submerge your precious DSLR under the waves... Make sure you invest in a guaranteed water-tight housing like this one from Ewa-Marine that's especially designed for your camera and gives you full control over its functions. Check the depth you can take the housing to, as well as which lenses and flashgun will fit.

POCKET WIZARD

This handy Pocket Wizard radio-controlled system from enables wireless flash triggering for off-camera TTL flash or manual remote control of flash zones. Slip the radio transmitter into the camera's hotshoe and attach the receiver(s) to your remote flashguns – the system will even work round corners. (See page 41 for more).

SILVER AND GOLD REFLECTORS

These are useful for adding warmth to outdoor portraits, bouncing the available light onto a shaded part of the subject. Look for a large fabric reflector design that can be folded away neatly. Silver reflectors provide a bright "zing" of light in dull conditions, while gold reflectors will warm up the light.

TRAVEL TRIPOD

When luggage space and weight are restricted on overseas flights, a small but sturdy tripod alternative such as the Joby Gorillapod proves a useful ally in combating camera shake on holiday. Its flexible bendy legs allow you to wrap the tripod around railings, chair backs and benches to secure a higher viewpoint – very helpful for night and other low-light scenes.

10-STOP ND FILTER

Landscape photographers are always using Neutral Density grads of various strengths (see page 34) to help balance exposures between land and sky. This type of ND filter works in a slightly different way – deliberately reducing the amount of light entering the lens in order to achieve long exposures even in broad daylight. For instance it can blur waves to mist or make people "disappear" in a busy street scene.

COLOUR CHECKER

Specifically designed for digital photographers, this colour calibration tool will help you keep your colours true. Take a test shot of the checker in the same shooting conditions as your subject and you can then check and compare the digital reproduction of the real scene and maintain a neutral colour balance, even in mixed lighting.

EXPERT ADVICE

LENSBABY

A Lensbaby is a creative optical device that fits onto the camera like a conventional lens, but which can be manipulated to alter the focusing point and depth of field. In principle it works in the same way that a specialist tilt and shift lens or bellows attachment might be used, twisting and angling the front element independently from the camera's focal plane (where the sensor sits). Such manipulations are impossible with conventional lenses because they have a rigid lens barrel, rather than the flexible one here. When the front element is angled away from the focal plane you can isolate the focus on one specific plane or "sweet spot", with blurred areas graduating away from it.

Right: The Lensbaby 3G, offering a focus lock and fine focus ring for improved

4 CORE CAMERA SKILLS

ONCE YOU'VE SET YOURSELF up with a basic DSLR and standard zoom lens, it's time to learn how to use them. Although in theory you could simply switch the camera's exposure mode dial to "Auto" and start snapping away, it's actually far more rewarding to fully understand what's going on inside the camera – in fact, it's the only way you'll ever progress as a creative photographer.

Chiefly you need to know how through-the-lens (TTL) light readings are made, what sort of errors can occur and why, what the aperture and shutter speed do in order to make exposures, and how they relate to things like ISO speed, image sharpness and subject movement. You also need to be able to recognize the tell-tale signs of under- and over-exposure, and understand how to correct the problem.

Armed with just a modicum of knowledge about the first principles of photography you will soon be making correct exposures and assessing them on your camera's LCD screen, working out how to improve composition and heighten visual impact.

Of course, the great thing about digital cameras is that you can experiment with exposure and composition to your heart's content, without spending any money on processing those images that don't work. Instant image playback on your LCD screen allows you to review images just seconds after taking them, so you're still in the right place to shoot the scene again and correct any mistakes as you go.

Master the basics

Learn how to set up the camera

WHAT YOU'LL LEARN
USEFUL SETTINGS TO
GET YOU STARTED

DELVE INTO THE MENU OF ANY DSLR and you'll uncover a bewildering array of options and settings to choose between. From the ISO speed setting to white balance and in-camera colour saturation, it can all sound a bit daunting. But don't let this first impression put you off – we'll be learning about all these settings in detail later in this chapter. First, let's take a look at some of the basic settings to help you get started. Don't worry if they don't look exactly like the menus below – every camera differs in menu layout, but the settings work in exactly the same way.

ISO SPEED

This controls how sensitive the camera is to light. The higher the ISO setting, the more sensitive it is, so the less light you need to take photos. Some DSLRs default to an automatic ISO setting, which you'll need to turn off if you're going to start taking full control of your camera. On most models, selecting one of the ISO values such as 100 or 200 is all you need to do. On some cameras you can also disable the automatic setting in the Custom Function menu.

RAW/JPEG

To practise most of the techniques and projects in this chapter you should set the camera to record in JPEG mode. This means that all of the changes that you make on your camera will be applied directly to the images you produce. To set your camera to JPEG mode, go to the Image Quality setting and choose the highest quality JPEG option available. We'll cover the advantages and disadvantages of RAW and JPEG files on page 86.

IMAGE REVIEW

The ability to see your results instantly on the back of the camera is one of the most useful features of your DSLR. Of the options available, there are two main set-ups you will find useful:
- If you want the image to be displayed immediately after you take every shot, select Image review – on and Auto image rotation – off.
- If you want to playback the images when you've finished shooting instead, select Image review – off and Auto image rotation – on.

IMAGE SIZE

Many cameras give you the option of recording images at various resolutions to save space on your memory card. Although you can use the lower resolution settings to practise some of the techniques in this chapter, you'll find it better to use the highest resolution offered by the camera to help assess the quality, sharpness and ultimately the success of the results that you get.

IMAGE ADJUSTMENTS

The default setting on most DSLRs will automatically make adjustments to sharpening, saturation and tone. While this is great for general shooting, these automatic adjustments are not good when you're learning how the different settings work. So, in the Custom Function menu, change these functions so they're on the normal or unadjusted settings rather than Automatic.

BEEP

This is an audible signal to confirm your autofocus has locked onto the subject. It can also indicate other camera functions are in progress. But when you're practising your photographic skills you'll find that the continual beeping of the camera is more of an irritating distraction than a help. Turn it off by finding the relevant part of the Custom menu and selecting the Off option.

HOLD YOUR DSLR THE RIGHT WAY

It's surprising how few people know how to hold their cameras properly. Technology such as image stabilization will help you achieve sharper shots, but it's no excuse for poor technique. To learn to handle your camera like a pro, use the following checklist:

- Hold the camera in your right hand with three fingers on the handgrip, placing your index finger on the shutter button and your thumb pressed against the rear.

- With the palm of your left hand, cup the camera from underneath, freeing your index finger and thumb to control the lens's zoom and focus rings.

- Tuck in your elbows and rest them against your midriff to support your camera from below.

- Hold your breath for a second while squeezing the shutter gently, rather than jabbing at the shutter button aggressively which will jog the camera.

CORRECT HANDLING: HORIZONTAL SHOTS
By holding your DSLR like this you'll really reduce the chance of the camera moving as you press the shutter button.

CORRECT HANDLING: VERTICAL SHOTS
Hold the camera in the same way but use the "overhand" grip with your right hand at the top and left hand supporting from underneath.

INCORRECT HANDLING
You really don't want to be holding your DSLR like this because such a fragile grip on the camera body and lens is an invitation to camera shake.

LEAN ON SOMETHING
When handholding the camera (working without a tripod), look out for props that might offer extra stability. Leaning against walls or trees will help stabilize you, and railings or fences can be used to support your camera directly. Any of these options will help to give sharper pics, so before shooting, see if there's a support nearby.

USE A TRIPOD
The age-old and perfect way to prevent camera shake is to use your three-legged friend! A sturdy tripod may feel awkward as a constant companion, but stick with it and it'll soon become second nature. If you don't have one yet, invest in a pro-quality model – it'll last you a lifetime if you look after it.

Using the mode dial

Get to grips with the semi-automatic exposure modes

THE LARGE CIRCULAR MODE DIAL on top of your camera is one of the first controls you'll notice. The dial lies at the very heart of the creative options of your DSLR, and it's here that you can start to take control over key aspects of picture taking, such as the aperture and shutter speed settings, when making exposures.

Selecting new settings can be pretty daunting at first, but with a little practice you'll find that this one dial will open up a whole new realm of photographic skills.

So, if you've never ventured off the fully automatic settings before, here's what each letter means and how you can use them for better picture taking.

WHAT YOU'LL LEARN
HOW THE MODE DIAL
WORKS; AUTO MODES
TO AVOID

MANUAL MODE
With this mode you have to set both aperture and shutter speed yourself. Because of this it's probably best to leave this mode until you've mastered the controls in the semi-automatic modes.

APERTURE-PRIORITY
Usually indicated by A or Av (Aperture value), this semi-automatic mode allows you to select the aperture manually, but tells the camera to automatically select the appropriate shutter speed to make a correct exposure. This gives you control over the amount of the image that will be in sharp focus, known as depth of field.

SHUTTER-PRIORITY
Usually indicated by T or Tv (Time value), this semi-automatic mode allows you to select the shutter speed manually but tells the camera to automatically select the correct aperture. This gives you control over how subject movement is recorded – whether frozen sharp or allowed to blur. It also helps you to avoid camera shake.

PROGRAM MODE
This mode is similar to Full Auto mode, in that it sets the shutter speed and aperture automatically, but does allow you a little more creative control. On most cameras you have control over settings such as exposure compensation and autofocus, plus you also have limited control over the combination of shutter speed and aperture the camera will use. Although this gives you some control, it's still not ideal when you're learning about photography.

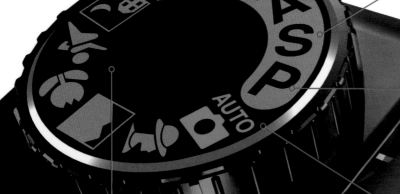

SCENE MODES
These fully automatic modes are normally indicated on the mode dial by small icons showing different photo subjects (here we've got sport, macro, landscapes and portraits in daylight and at night-time). They're popular with many DSLR users as they offer the most foolproof way of getting appropriate settings for a whole range of subjects, without having to think about it. Instead, using these modes instructs the camera to select subject-specific values for shutter speed and aperture etc, according to how the manufacturer has programmed the camera. If you want to learn more about photography, it's best to avoid them.

FULL AUTO MODE
This mode is usually indicated by the word Auto or A on the dial, or a setting highlighted in green. In this mode the camera takes control of most of the exposure settings for you, so you can't direct proceedings. Some models also lock settings such as the autofocus, ISO and exposure compensation. Although the mode is great for happy snaps, if you want to learn how to control exposure it's best to avoid using Auto mode from now on.

APERTURE-PRIORITY

This is probably the most useful semi-automatic mode to master when you're learning how exposure settings affect your images. This mode gives you control over the size of aperture used to take your images, which has a major effect on the amount of the image that is in sharp focus from near to far away. This is known as controlling the depth of field – one of the key skills that will make your images more creative and eyecatching.

Move the mode dial to the A or Av position and point your DSLR at a subject. Press the shutter release button halfway down until the display illuminates in the viewfinder and the autofocus lens brings the subject into pin-sharp focus. Turn the aperture input dial (usually found on the right-hand grip), while looking through the viewfinder or at the LCD. As you turn the input dial you'll see the f-numbers change. These are your aperture settings, given in increments known as f/stops.

In this mode the correct corresponding shutter speed is automatically selected according to the aperture you select, so with the metering switched on you'll also notice the shutter speed changes as you turn the dial, too.

Thanks to the semi-automatic nature of this mode, you can avoid under- and over-exposure, so try taking two pictures of the same subject at apertures f/2.8 and f/22, then compare the results.

SHUTTER-PRIORITY

After experimenting with aperture-priority, you'll find that shutter-priority (Tv) works in a similar way. The main difference is that in this mode you're controlling the shutter speed, while the camera automatically sets the correct corresponding aperture. The length of time the shutter remains open will affect how moving subjects are recorded in your image. Remember that the shutter speed also determines whether you will be able to hold the camera steady enough to get a sharp image, or whether you'll need to steady it using a tripod.

Turn the mode dial to the S or Tv setting and this time use the input dial to alter the shutter speed. Shutter speeds are given in seconds and fractions of a second, and you can see them changing as you turn the input dial. As you change the shutter speed you will also notice that the correct corresponding apertures are set automatically by the camera.

When you scroll through all of the shutter speeds on your camera you'll see that the aperture display will change at some settings. At the faster and slower shutter speeds the aperture display will either read "Hi", "Lo" or the number will flash. This is because the range of shutter speeds is much greater than the number of apertures available on most lenses. When this happens you won't be able to use this shutter speed in the available light conditions, so you will need to select a faster or slower shutter speed.

SHALLOW DEPTH OF FIELD
With the camera set to aperture-priority, a wide aperture such as f/2.8 has the effect of minimizing depth of field and rendering only a small section of the image sharp (here, just the heather). Thanks to the semi-automatic nature of the mode, the camera will set the correct shutter speed (here, 1/160sec at ISO 100).

GREAT DEPTH OF FIELD
This time, with the camera still set to aperture-priority, selecting a narrow aperture such as f/20 has maximized depth of field. Note how the zone of sharpness extends all the way from the heather to the tree and horizon beyond. The camera simultaneously set the shutter speed to 1/15sec at ISO 100 to avoid under-exposure.

SLOW SHUTTER SPEED
With the camera set to shutter-priority you can set the shutter speed to a slow setting such as 20 seconds, to turn moving water into a soft blur. Here the camera automatically set the aperture to f/22 at ISO 100.

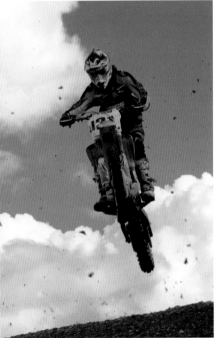

FAST SHUTTER SPEED
In shutter-priority mode you can select a fast, action-freezing shutter speed such as 1/250sec, while the camera sets the aperture automatically (here, f/9 at ISO 100).

Aperture, shutter speed and ISO

Understand how to make and control exposures in any situation

THE CORE COMPONENTS of any exposure are light and time. These two variables are governed by the camera's aperture and shutter speed, but also by the sensitivity setting in use, the ISO setting.

It's the aperture window, located inside your lens, that controls the amount of light that reaches the camera's sensor. By varying the size of the aperture, we can also creatively control the depth of field of the shot.

The shutter curtain meanwhile, located inside the camera body just in front of its sensor, controls the length of the exposure. It opens up for a specific number of seconds (or fractions of seconds) as you press the shutter release button, controlling the amount of time the sensor is exposed to the image-forming light.

The amount of light available changes according to the brightness of each scene and the aperture in use, so the shutter speed you select will need to vary accordingly. Match the correct shutter speed with the aperture you're using, and you'll make a correct exposure.

If your shutter speed is too fast for the aperture, your image will be under-exposed as you're not allowing enough time for the light to be recorded properly by the sensor. Conversely, if your shutter speed is too slow, too much light will get through to the sensor and your shot will be over-exposed, blowing out the highlight detail.

If you wish, you can control both the aperture and shutter speed via the Manual mode on your DSLR. This gives you complete control over the exposure, but being in charge of both light and time can be a bit daunting if you're just getting into photography. So, along with a full Manual mode, every single DSLR (and some compacts) offer aperture-priority and shutter-priority modes. As we saw on the previous pages, these are semi-automatic exposure modes. In aperture-priority mode (A or Av on the mode dial), you can set the aperture to your desired value, and the camera will automatically work out and set the correct shutter speed for you. In shutter-priority mode (S or Tv) – you set the shutter speed and the camera will select the aperture value required to achieve the correct exposure.

WHICH "PRIORITY"?

Speak to most photographers and they'll say they use aperture-priority far more than shutter-priority, and there's a good reason for this. Though there will always be a few exceptions, your main decision after composing a shot will be how much of the scene do you want to record in sharp focus – how much depth of field do you want?

Since depth of field is determined by the aperture setting, aperture-priority is the best mode to use. And, as the range of shutter speed options is always much greater than the range of apertures available on your lens, it's the apertures that usually dictate your exposure settings.

In truth, there will be plenty of times when there just isn't an aperture value to be paired with the shutter speed you've

WHAT YOU'LL LEARN
HOW EXPOSURES
ARE MADE

SHUTTER SPEED COMPARISON
Here's some typical shots and their corresponding shutter speeds.

FAST SHUTTER SPEED

1/2000SEC 1/500SEC 1/250SEC 1/125SEC

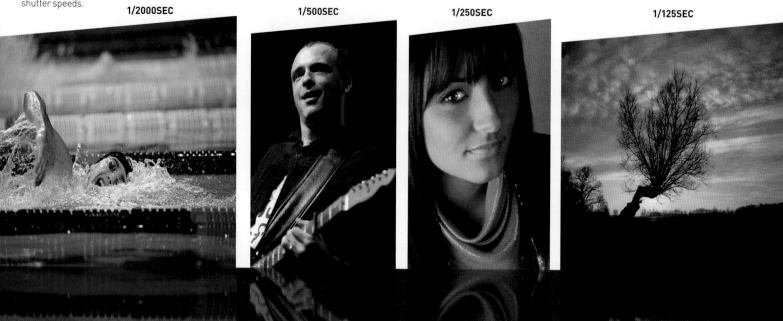

selected. In the viewfinder, this will result in a "Hi" or "Lo" warning and you won't get a picture. This is never the case when you work in aperture-priority mode, because, apart from some very extreme situations when it's impossibly bright or dark, you'll always be able to find a shutter speed to match your aperture and take the shot.

This isn't to say that shutter-priority is entirely worthless however. If you're into sports or wildlife photography, your main worry may well be securing a shutter speed of 1/500sec to freeze the action, though you may need a fast lens (with a wide maximum aperture) to achieve it. But for most general shooting scenarios, aperture-priority offers the most convenient and fastest route to finding the combination of light and time that you want.

SHUTTER SPEEDS AND THEIR EFFECTS

We've explained how shutter speed is used to complement a selected aperture to make a correct exposure, but understanding the creative effects shutter speed can bring to an image is just as important as knowing how aperture controls depth of field (see the sequence of images, below).

Most DSLRs offer a range of shutter speeds from slow (30 seconds) to fast (1/4000sec, and in some cases even as fast as 1/8000sec). This range goes up in a neat, calibrated sequence of increments that are called "stops". For example, an increase from 1/125sec to 1/250sec is a one stop increase, as is 1/1000sec to 1/2000sec. Increasing the shutter speed by one stop halves the amount of light reaching the sensor.

Sometimes you want to be even more precise in your exposure-making, so modern DSLRs allow you to increase the shutter speed by a half or a third of a stop, too. Most cameras incorporate shutter speeds in third-stop increments simply because they offer more control.

If it's an incredibly bright day and you've selected a wide aperture, you'll need a very fast shutter speed to avoid over-exposing the shot, owing to the vast amount of light coming through the lens. The key benefit of using a fast shutter speed is that it allows you to freeze the action, stopping even fast-moving subjects in their tracks. This happens because the sensor is exposed so quickly, there's no chance to record any motion at all.

As you select slower shutter speeds, more and more subject movement will be recorded, because the shutter is open for longer. When you reduce the shutter speed down to 1 second or longer, any movement that's recorded will appear as a blur. (Note that it's essential to support the camera during such long exposures, so that at least some of the scene records sharp.)

Long exposures have some excellent creative merits: subject blur adds a sense of movement to a shot. Use a long exposure for landscapes which have some form of movement in, such as running water or reeds blowing in the breeze, and these elements will be blurred nicely against their static surroundings, adding some real mystery and intrigue to the image.

SENSITIVITY

There will be occasions when the available light prevents you from securing a fast enough shutter speed to freeze the action and/or avoid camera shake. Even with your aperture wide open, your shutter speed may still be too slow. Without resorting to flash or a faster lens you're stuck.

Fortunately, there is a third variable that we can control along with light (aperture) and time (shutter speed), and it's how sensitive the camera's sensor chip is to light. This sensitivity, commonly known as the ISO setting, is adjustable too and we'll be looking at that aspect shortly.

Using a fast shutter speed such as 1/4000sec will freeze even the fastest-moving subjects.

A slow shutter speed such as 1 second (shown here as 1") will turn anything moving into a blur. It's crucial to use a tripod for best results.

SLOW SHUTTER SPEED →

| 1/60SEC | 1/8SEC | 8 SECONDS | 16 SECONDS |

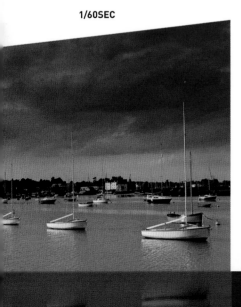
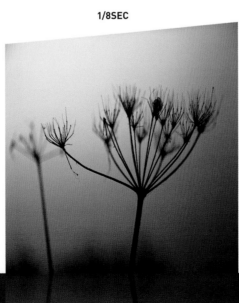
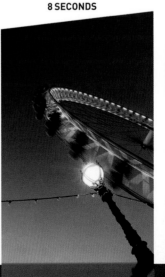

APERTURES AND F-STOPS

We have already seen how apertures control the amount of image-forming light reaching the camera's sensor. The aperture itself is an adjustable "window" that can be opened or closed to let a maximum or minimum amount of light through.

In the past, aperture was controlled mechanically by rotating a ring on the lens, but nowadays the f-number is selected by an input dial on the camera. The f-number in use is displayed in the viewfinder along with the shutter speed, and both can be found on the top-plate LCD if your camera has one. Inside the lens, aperture size is varied by a number of blades making up the diaphragm and these move in and out to create the size of the window in the middle.

Just like shutter speeds, the range of aperture settings on a lens is calibrated in a regular sequence of increments that are called "f-stops". Depending on how wide your lens's maximum aperture is, the standard full f-stop sequence goes: f/1.4, f/2, f/2.8, f/4, f/5.6, f/8, f/11, f/16, f/22, f/32.

Half and third-stop increments will also show on most DSLR displays – which is why you'll encounter settings such as f/3.5 and f/6.3, too. This is not something to worry about, even though it may seem confusing at first. Suffice it to say that as you move the input dial to make the aperture smaller by one full f-stop (according to the standard sequence above), you are exactly halving the amount of light reaching the sensor. For example, stopping down the lens from f/5.6

to f/8 is a one stop decrease in light, reducing the amount of image-forming light by exactly half.

The fact that altering your shutter speed and aperture can be done in neat, measured f-stop increments to halve and double the light in turn is no accident. The relationship between shutter speed and aperture settings is "reciprocal" – open up the aperture one stop and increase the shutter speed one stop and you keep the same, correct exposure.

Another thing that often confuses photographers is the fact that the larger the f-number (eg f/22), the smaller the aperture becomes, when it would seem more logical the other way around. Sadly this is just something you'll have to remember: hopefully the pictures opposite will help.

MAXIMUM APERTURE

Of the full aperture sequence offered by your lenses, there's one aperture in particular that's more significant than the others. This is the lens's maximum aperture, which is always etched on the barrel itself. This could be anything in the region of f/5.6, f/4, f/2.8, f/2 or f/1.4 – what you need to remember is the lower the f-number, the larger the maximum aperture, and the more light the lens can let in. In turn, this affects how fast your lens is, and how easy you will find it to freeze action in low-light (see the panel on fast lenses on page 21).

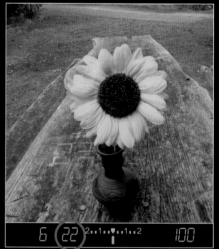

The maximum aperture of a lens is always etched on its barrel, and shows how "fast" the lens is. Here, the 1:1.4 marking on the barrel tells us the lens has a maximum aperture of f/1.4.

APERTURES & DEPTH OF FIELD

Here we've set up a really simple shot you can try for yourself out in the garden, or in an open space, that lets you experiment with apertures, shutter speeds and ISO settings.

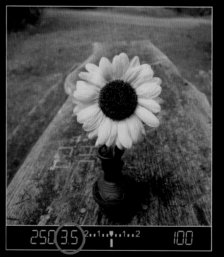

1 SET UP THE SHOT Set up your camera on a tripod using a standard zoom lens and place a still life subject, such as a flower, about 30cm (12in) in front of the camera. Zoom out to around 18mm then frame up the flower with the camera in the vertical, portrait format so the subject fills the bottom half of the frame. Now switch over to Manual Focus and focus on the flower in the foreground.

2 SET THE APERTURE Set the exposure mode to aperture-priority (A or Av on most cameras) using the mode dial on the top plate. Now set the ISO sensitivity to the lowest value (normally 100) and make sure your camera's metering mode is on its multi-segment setting. Now set the aperture to the maximum value, usually f/3.5 on a standard zoom lens. Gently press the shutter and take the shot.

3 TAKE SECOND SHOT Next, stop down the aperture value to the minimum possible, usually f/22, and take the shot again. Later on, when you've downloaded the images to your computer, zoom in to 100% and you'll notice how in the first shot, where we've used a wide aperture, the background is out of focus compared to the sharp background in the second shot. This shows how aperture affects depth of field.

F-STOPS

APERTURE: F/1.4

APERTURE: F/2

APERTURE: F/2.8

APERTURE: F/4

APERTURE: F/5.6

APERTURE: F/8

APERTURE: F/11

APERTURE: F/16

ISO AND SENSITIVITY

The ISO setting on your camera governs the sensitivity of the camera's sensor to light. The term ISO refers to "International Standards Organization" – the governing body that created a standard for film sensitivity back in the days when photographers used film to record their images.

Rather than all film types having the same degree of light-sensitivity, different film "speeds" were developed which had improved levels of sensitivity to light. The higher the film speed, the more sensitive it was to light, allowing you to use faster shutter speeds in lower light conditions. ISO 100 became the baseline speed, though ISO 50 was very popular too. ISO 200 was twice as sensitive as 100, ISO 400 twice as sensitive as 200, and so on.

What has this to do with digital photography? ISO is still the term used when referring to the sensitivity of the recording medium – in the case of DSLR photography, the image sensor inside the camera. Just as before, low ISO settings (ISO 100 and 200) are best for fine resolution and optimum image quality, while faster ISOs (ISO 400, 800, 1600) are great if your maximum aperture is too slow and you're stuck for a faster shutter speed to use in low-light.

For instance, if you need an exposure of 1/125sec at f/5.6 for a scene at ISO 100, setting the camera to ISO 200 instead will halve your exposure time – thanks to its extra sensitivity – allowing you to increase your shutter speed to 1/250sec and maintain the same aperture. What's more, ISO changes can be made from one frame to the next.

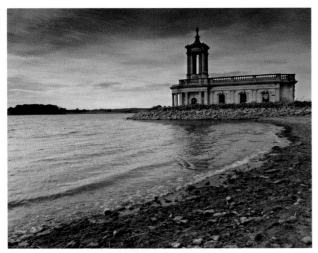

ISO 100 1/30sec

ISO 3200 1/1000sec

NOISE COMPARISON AT HIGH ISO
For all the shots here we used an aperture of f/11. As the ISO was increased, the shutter speed reduced to compensate. When enlarging the tower section to compare results (right) you can see the high ISO picture (taken at ISO 3200) shows more "noise", in the form of errant colour pixels.

Metering and making exposures

Average reading and metering modes

AS IN-CAMERA METERING SYSTEMS become ever-more sophisticated, and with new software available to "rescue" the odd duff exposure, it's easy to underestimate the importance of getting your exposures right. Understanding how your camera assesses the light and sets exposure is a fundamental part of photography. Not only will it help save you time processing your images, it will also increase your chances of getting great shots every time – even in contrasty lighting and tricky low-light conditions.

Metering systems are all based on the same principle. A light-sensitive cell in the camera measures the amount of light reflected by the scene and generates an average reading. This translates into exposure settings required for the scene you're shooting. The meter doesn't know whether you're shooting a particularly bright or dark subject – the meter's reading will only give you the correct exposure settings to record the scene as an average midtone.

Most basic in-camera metering systems take their exposure from a wide area of the image, and rely on the fact that most typical scenes average out to give an overall midtone.

Because they contain a whole range of tones from bright highlights to dark shadows, if you were to blend the whole image together in a theoretical liquidizer and remove any colours, it would become a mass of midtone grey – sometimes referred to as "18% grey".

While this bias towards the average works for many situations, if you point your camera at a completely dark or light scene, the meter will still assume you want to record it as a midtone, and give a meter reading accordingly. It's in these non-standard lighting conditions – very dark and very light – that you need to take control of your camera to expose the scene correctly – retaining some of that atmospheric contrast lighting that appealed to you in the first place.

There are three main types of metering option offered by your DSLR. While they all use the basic principles outlined below, they each measure the light from different areas of the image to arrive at the exposure. Having a choice of metering modes offers maximum flexibility so you can match the mode to the type of situation, subject and lighting you're shooting. Here's how they work and when to use them.

MULTI-SEGMENT OR MATRIX
This is the default metering mode on most DSLRs, but is one of the most sophisticated. It works by dividing the image into equally weighted segments of about the same size, and taking a separate reading from each of the segments. These separate readings are then electronically analysed by the camera to arrive at the final overall exposure. This analysis is where the clever bit comes in, as it allows the camera to try to automatically compensate for any specific bright or dark areas of the scene, darkening them down and brightening them up respectively, thus giving more useable results across a wide range of different lighting conditions.

CENTRE-WEIGHTED AVERAGE
This is the most basic of the metering modes. It takes a reading from the whole image, but the exposure is biased towards the centre of the frame. This helps prevent the exposure being affected by any dark or light areas in the foreground or background. In most situations, multi-zone metering is more likely to give a useable result, but once you've learned how to use centre-weighted metering it's easier to predict whether the camera is likely to over- or under-expose in difficult conditions, as it can give more consistent results. Some photographers prefer to use this metering mode when using filters such as Neutral Density grads.

SPOT OR PARTIAL
Unlike the other two metering modes, this one only takes a reading from a small part of the frame – normally the centre, though some DSLRs can take a spot reading from the focus point you're using. The difference between spot and partial metering is the size of the area they assess – spot meters normally use around 1–5% of the frame, while partial meter patterns use a larger, 10–15% area. The key to success is to make sure you select a midtone to take your reading from. It's usually necessary to make your exposures manually too, re-framing the shot after metering in case your subject is off-centre. This is potentially the most accurate method, but also requires the most practice.

SPOT METERING IN ACTION

In this simple high-key still life shot, the multi-segment metering mode is fooled by the expanse of white background and under-exposes the shot, providing a backdrop that looks grey. Spotmeter from a midtone, however, and you can get a much more accurate exposure. We took a spotmeter reading off the red flower petals to get the finished picture, where the background is perfectly white, just as we wanted.

1 SELECT THE SPOTMETER Turn your camera's metering mode from your default multi-segment metering mode to spotmetering. On some cameras, this can be done simply by rotating a button on the body of the camera to point at the white dot symbol. On other models, however, it may be necessary to navigate the camera's menu system to change the metering mode there instead.

2 TAKE A READING Point your camera towards the subject, and position your central autofocus target over a midtone. The midtone you choose to position the AF target on will have great bearing on the light reading – and final exposure – so make sure it has the same amount of light falling on it as the area of the shot you want correctly exposed.

3 LOCK THE EXPOSURE As soon as you move your central autofocus target away from the midtone, the lightmeter reading will change, so before you recompose to take the shot you need to store that spot reading in the camera's memory. To do this, simply press the Exposure Lock button, marked AE-L (on Nikon/Pentax), AEL (on Sony/Olympus), or * (on Canon models).

4 RECOMPOSE AND SHOOT Keeping the Exposure Lock button depressed you can now recompose, frame up properly and take the shot. Check the image and histogram on the camera's LCD screen to make sure the exposure is spot-on. If you've blocked out the shadows or blown the highlights unintentionally in the picture, spotmeter off a different midtone and take the shot again.

CHECK YOUR EXPOSURE ON THE LCD SCREEN

The best way to check whether your camera is metering the scene correctly is to use your camera's viewing screen and the accompanying histogram. Get into the habit of checking this screen because that's what it's there for – helping you see where pixels have been recorded in the tonal range and if the picture is under- or over-exposed.

How you activate the histogram varies depending on your camera model, but usually involves pressing a button when you're in image preview mode. On Nikon DSLRs, tap the up button on the D-pad; Canon users need to press the zoom out button; Sony users press the DISP (display) button; and for both Pentax and Olympus users, it's the INFO button.

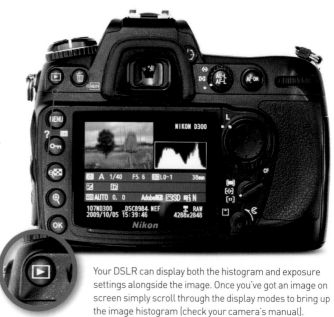

Your DSLR can display both the histogram and exposure settings alongside the image. Once you've got an image on screen simply scroll through the display modes to bring up the image histogram (check your camera's manual).

READING THE HISTOGRAM

| UNDER-EXPOSED | CORRECTLY EXPOSED | OVER-EXPOSED |

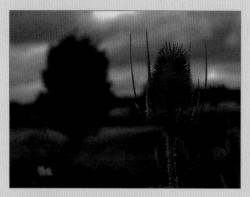

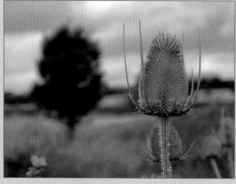

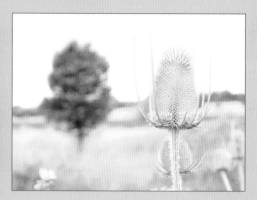

In this histogram you can see all the pixels are bunched up on the left and no bright tones are recorded, which, for this subject, means an under-exposed shot.

Here you can see a technically correct exposure that has all the pixels recorded in the visible range, evenly distributed across the histogram.

With too many pixels recorded at the brighter end of the tonal range, the histogram display shows a slope of tones that are all bunched up on the right.

If your camera's metering sets the exposure values so that the shutter fires too fast or the aperture is set too small for the amount of light in the scene, you'll get an under-exposed image. This will give a shot that's too dark and a histogram that shows no pixels have been recorded in the brighter end of the tonal range.

In the example image above, the camera's metering is spot-on, and has set the shutter speed and aperture to record the light in the scene correctly. As you'll see from the histogram, there's a full range of tones in this picture from the highlights to the shadows, with none of its fine details burnt-out or lost in blackness.

Here the camera's lightmeter has incorrectly exposed the scene, letting too much light fall on the sensor, either by leaving the shutter open for too long or by using too wide an aperture. This has resulted in the picture being too light and burnt-out in places, so that all the cloud detail in the sky is missing. It's time to meter again.

SPOTMETERED IMAGE

MULTI-ZONE METERING

Choosing which type of metering system to use is a matter of getting used to recognizing the tonal range in a scene, and noticing how contrasty conditions create dark highlights and shadows that might fool your camera's light meter into under- or over-exposure. Snow is particularly awkward – keep it looking white by taking a spotmeter reading from a midtone part of the scene.

MULTI-ZONE METERING

SPOTMETERING

With multi-zone metering, this shot would have been over-exposed, but spotmetering has generated a much better result.

EXPERT ADVICE

HOW TO FIND A MIDTONE

Midtones are not always obvious at first, but look hard and you'll find one in most locations. All nature's reds are midtones, so they're great but, failing that, a blue sky at a 20° angle is good, too. If all else fails, the old trick of spotmetering off some grey Tarmac on the road will do. The thing to remember, though, is to make sure you use a midtone that has the same intensity of light falling on it as your main subject. On a sunny day, metering off a midtone that's in the shade will result in an over-exposed shot. Alternatively, take an 18% grey card with you on shoots, keeping it handy in your camera bag.

ACCURATE SPOTMETERING

METER OFF A HIGHLIGHT
Spotmeter from this cloud and the camera assumes this bright tone is a midtone and so under-exposes the shot.

METER OFF A MIDTONE
Spotmeter off a midtone such as these grey pebbles for the best exposure. Look out for red or green tones to spotmeter off, too.

METER OFF A SHADOW
Try to record this dark shadowy area as a midtone and the camera over-exposes the scene, leading to burnt-out highlights.

Using depth of field

Creativity with the aperture

WHAT YOU'LL LEARN
HYPERFOCAL
DISTANCE;
DIFFERENTIAL FOCUS

YOUR APERTURE SETTING controls the zone of sharp focus in your picture – its depth of field. Getting as much depth of field as possible in your shot, so the image is as sharp as possible all the way from the nearby foreground to the distant horizon, is made easier when you understand how to use hyperfocal distance. This is the focus point that gives maximum depth of field for the aperture and focal length you're using. When you focus on this point, depth of field extends all the way to infinity.

Once commonly used to maximize depth of field in landscape photography, especially for medium-format and large-format cameras, hyperfocal distance can be calculated mathematically from your focal length and aperture numbers. This reveals the distance where you should manually focus the lens for maximum depth of field. Nowadays, however, modern zooms rarely have a distance scale marked on the focusing ring, so it's not as easy to work out hyperfocal distance or set the focus point to match it.

This doesn't mean the theory is completely useless though. Because depth of field extends around a third in front of the focus point and two-thirds behind it, you can still estimate hyperfocal distance simply by focusing the lens to a few metres away, rather than focusing at infinity.

DIFFERENTIAL FOCUS

The opposite of using maximum depth of field is using differential focus – essentially, using shallow depth of field to make your subject stand out from its background (see right). It refers to the fact that the subject is in sharp focus, while other areas of the scene are rendered out of focus (beyond depth of field) and you're exploiting this difference so the subject is the main focal point of the image. Any picture where depth of field is shallow requires you to use differential focus.

USING DIFFERENTIAL FOCUS

Shallow depth of field effects can be achieved using any kind of lens, but the wider the maximum aperture available, the more the background will look diffused. On a standard zoom kit lens, this is likely to be around f/3.5, though "faster" lenses are available, such as those which offer maximum apertures of f/2.8, f/1.8 and so on.

Later on in this book we'll show you how to exaggerate background blur in Photoshop, but when shooting it's also worth zooming in on your subject and making sure there's a good clear distance between the subject and its background.

GET CLOSE TO YOUR SUBJECT
You want your detail shots to feature a nice bold subject, so get in close to it and force it to fill up a large portion of the frame.

1 SET UP YOUR CAMERA Set your camera to aperture-priority mode (A or Av on the mode dial), then dial in the lowest f/number that your lens will allow. This will give the shallowest depth of field possible from your lens. For this shot we went for a wide angle approach, zooming the lens out to pack in as much of the scene as possible; normally the blurring effect will be more pronounced if you zoom in.

2 COMPOSE AND FOCUS Hover your active AF point over the part of the scene you want to be in sharpest focus – the details in the foreground – then half-press the shutter button to lock your focus there. Now, without moving from your shooting position, recompose the picture so your subject is placed on a third of the frame, ensuring the composition is nicely balanced.

3 EASIER FOCUSING To minimize the amount of movement between locking the focus and reframing, try moving your active AF point in the viewfinder, so that it covers the subject. There'll be a button on the back of the camera to allow this. Now take the shot and check it on your camera's viewing screen. Zoom right in to check that the details you wanted to be sharp are nice and crisp.

4 CORRECT THE FOCUS If the subject itself looks a bit blurred, check whether your focus is off (you'll see sharper areas in front or behind it). If the blur is due to camera shake the whole image will look fuzzy. If it's the former, reshoot and try not to move between locking the focus and firing the shutter. If it's the latter, increase the ISO sensitivity so the shutter speed increases (or use a tripod).

Maximizing sharpness

Master correct shooting technique to get pin-sharp results every time

WHAT YOU'LL LEARN
DIFFERENCE BETWEEN
CAMERA SHAKE AND
SUBJECT MOVEMENT

BLURRED PHOTOGRAPHS are the number one problem for most novice photographers. It's astounding how many pictures aren't critically sharp when you look at them closely, so it's important to use the screen on the back of your camera, and check each shot right after you've taken it.

To check for sharpness, review the image on the playback setting and zoom all the way in on the part of the picture you focused on. If it's not razor-sharp, you need to delete the file and take the picture again – no dithering. It's much better to do this now when you're out shooting than to wait until later and be disappointed when you open the image up on the computer monitor at home.

If you're finding that a good 70–80% of your pictures are too soft, you need to get to the root of the problem – finding out the exact cause and how to fix it.

The principal causes of image softness are camera shake, subject movement or poor focusing technique.

CAMERA SHAKE

Camera shake can be subtle or severe but, on closer inspection, you'll see that the whole image is unsharp from the foreground right the way through to the background. It happens because, when you hold a camera in your hand to make an exposure, the camera is always moving a little (even breathing will move it) and if your shutter speed isn't fast enough, then this movement will translate as motion blur that affects the entire image.

Minor camera shake can be avoided by good handheld technique (see page 53) and bracing yourself or your camera against a solid object. But once the shutter speed

CAMERA SHAKE
Nothing is sharp in this picture as a result of camera shake.

SHARP SHOT
That's better! A faster shutter speed fixes shake.

gets too slow for handholding, you really need more reliable support from a tripod to guarantee sharp pictures.

How slow is too slow for handheld exposures? There's an old rule that states you should only attempt to handhold a camera where the shutter speed matches, or is faster than, the focal length of the lens on the front. This means that if you use a 28mm lens, you need at least 1/30sec to get a sharp shot, and if you use a 200mm lens, you need at least 1/200sec. With all the different sensor sizes and crop-factors in DSLRs, this rule can become quite confusing, as you have to multiply the focal length by your camera's crop-factor to determine the minimum shutter speed. But because this gives a bare minimum, the easiest thing to do is simply double the focal length and you're covered for all DSLRs. So, if you're at the 55mm end of your 18–55mm zoom, you need at a shutter speed of at least 1/110sec (or realistically 1/125sec) to get a sharp image.

If your exposure meter gives you a shutter speed slower than this, you need to either choose a wider aperture to let more light into the camera (eg by opening up from f/8 to f/5.6) or to increase your ISO setting (say, from 100 to 200 or 400), which will make your camera more sensitive to light.

POOR FOCUSING

Here the subject (usually in an off-centre position) is blurred but the background is pin-sharp. This happens because the lens's autofocus system has locked onto the background, leaving the much closer subject out of focus.

To fix the problem you need to refine your focusing technique. When framing up, select the AF target point that's nearest to your subject. There are normally a number to choose from; pick the one you want by using the D-Pad selector on the back of the camera, or pushing the AF point button and rotating the thumbwheel on Canon models. With the appropriate target point positioned over the subject's face or eyes, half-press the shutter release and hold it in this position to keep the focus distance locked. Now, if needed, adjust your composition without releasing the pressure, and when you're happy, press the shutter all the way home to take the shot.

SUBJECT MOVEMENT

You can easily identify unwanted subject movement in a scene because the rest of the scene will be sharp. Subject movement occurs when the exposure records movement as blur, but all the static items remain sharp.

Subject movement is normally an intentional creative effect in photographs, since it usually involves you using a tripod to hold the camera still and a slow shutter speed to allow subject movement to be recorded. Occasionally, a very fast-moving subject will blur at shutter speeds quick enough to successfully handhold a camera, but the solution to each and every subject-blur problem is to use a faster shutter speed. Just as with the camera shake cure, this usually means using a wider aperture (say, going from f/8 to f/5.6 or f/4) or increasing the ISO (say, from ISO 100 to 200 or 400). If the light is dim, then an ISO increase will be the only solution on offer, because you're likely to have exhausted your lens aperture options.

OUT OF FOCUS
AF has locked onto the background, so the subject isn't sharp.

IN FOCUS
Background is soft, as a small aperture of f/2.8 has been used.

Here the subject is moving too fast for the set shutter speed. Creative motion blur is the result, but this can make a shot more dynamic.

Freezing movement

Select a fast shutter speed to arrest moving water droplets

WHAT YOU'LL LEARN
HOW FAST SHUTTER
SPEEDS FREEZE
MOVEMENT

LEARNING HOW TO CONTROL SHUTTER SPEED and freeze the movement of an object in your pictures is the first step on the way to taking creative control over your photography. The faster the shutter fires, the clearer and more blur-free your shots will be, but use it creatively and you'll get really exciting images, too.

Using a very fast shutter speed setting (1/500sec or faster) will literally stop a moving object in its tracks, so you can freeze the motion of your subject and reveal a view of the world that's invisible to the human eye. This is ideal for sporting events where you can stop a ball in mid-air, or for wildlife photography, where you can record the individual beats of an insect's wings. Fast shutter speeds can work wonders with the elements, too: droplets of water, naked flames, wafts of steam or smoke from a fire... even the sea's waves can look magnificent frozen in time, and they're all accessible subjects to tackle.

Using a fast shutter speed usually requires shooting in bright, sunny conditions – so save this project for the right day. Alternatively, crank up your camera's ISO setting to a speed of 400, or even 800.

1/8SEC **1/200SEC**

These two shots show the same subject at slower shutter speeds than the main picture, right. Far less detail is revealed in the droplets, which have turned into a constant stream of water.

FREEZE MOVEMENT WITH A FAST SHUTTER SPEED

To freeze movement in the frame you need as fast a shutter speed as possible. Anything above about 1/500sec will do a good job of freezing water droplets in mid-air.

First, set your camera to shoot in RAW, then pick aperture-priority mode (A or Av). Next set the lowest f/number possible, frame up the shot and check the shutter speed.

If it's not fast enough, your scene doesn't have enough light to make the shot work. All you can do is wait for brighter conditions, or increase the ISO sensitivity to force the issue. Be aware though, that increasing ISO will introduce an extra degree of "noise" – like film grain – into your images.

1/500SEC
Though not as fast a shutter speed as we could have used, this speed has frozen the droplets nicely, while keeping the shot full of dynamic energy.

Blurring movement

Select a slow shutter speed to turn moving water into a smooth blur

WHAT YOU'LL LEARN
HOW SLOW SHUTTER
SPEEDS BLUR
MOVEMENT

WE'VE JUST SEEN HOW A FAST shutter speed can be used to freeze movement in a photograph, so it's no surprise that a slow shutter speed will do the opposite – blur movement. Shooting a "flowing" water picture like this one has become a rite of passage for budding landscape photographers, because it's a technique that demonstrates to everybody that you know your stuff!

If you leave your camera on Auto or Program mode, you'll get a sharp shot with no trace of motion, so on this occasion you need to take control to get the results you're after.

Slow shutter speeds help to blur movement because the water moves during the exposure, while the shutter is open. A tripod is essential in this scenario because it will prevent any other form of movement – notably camera shake – from spoiling your results. Any tripod will do, but if you're serious about your photography, go for a pro model as the investment will more than pay for itself.

You don't need a pretty stream for this shot – any body of moving water will make a good subject: waves at the seaside, a waterfall or even an outdoor tap.

START

1 SET UP YOUR CAMERA Set your camera's exposure mode dial to aperture-priority (A or Av) and dial in your highest f/number (normally f/22 on most kit lenses). By using this shooting mode, your camera's built-in meter will assess the light in the scene and work out the correct shutter speed for you.

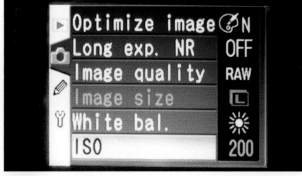

2 CHOOSE THE LOWEST ISO SETTING Set your ISO rating to its lowest speed (ISO 100 or 200 on most DSLRs); you'll be able to do this via the ISO button on the camera body, or by navigating the menus on your viewing screen. This takes the camera sensor to its minimum light sensitivity, which will give you the best quality and allow the longest exposure time. Set your White Balance to Daylight, too.

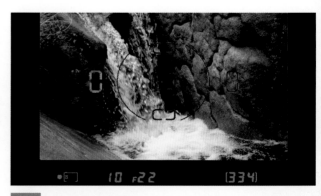

3 COMPOSE YOUR SHOT Place your camera securely on a tripod and frame up on your watery subject. Once you're completely happy with the composition, lock the tripod head firmly in place so that the camera can't move during the exposure (this is vital!). Set your focus on any detail that's around one-third of the way into the scene to maximize depth of field. Here, we've gone for the rock on the left.

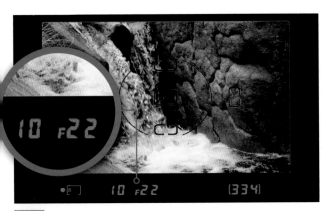

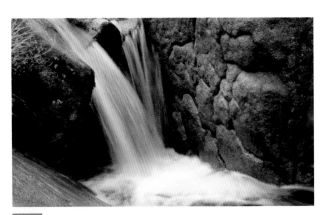

4 CHECK SHUTTER SPEED In the viewfinder, check what shutter speed you're getting. Ideally, you need around 1/10sec or slower. If conditions are really bright and it's faster than this, either wait until it gets darker, or place a Neutral Density filter over the lens. These filters act like sunglasses by reducing the light entering the camera (see pages 34 and 49).

5 TAKE THE SHOT Set your self-timer so you don't nudge the camera when pressing the shutter, then take your shot. Check your shot on screen and if it's too dark, hold in the exposure compensation (+/-) button and dial in a positive value of +0.3 to +0.7 stops and try again. If it's too bright, dial in a negative value in the same way.

FINISH

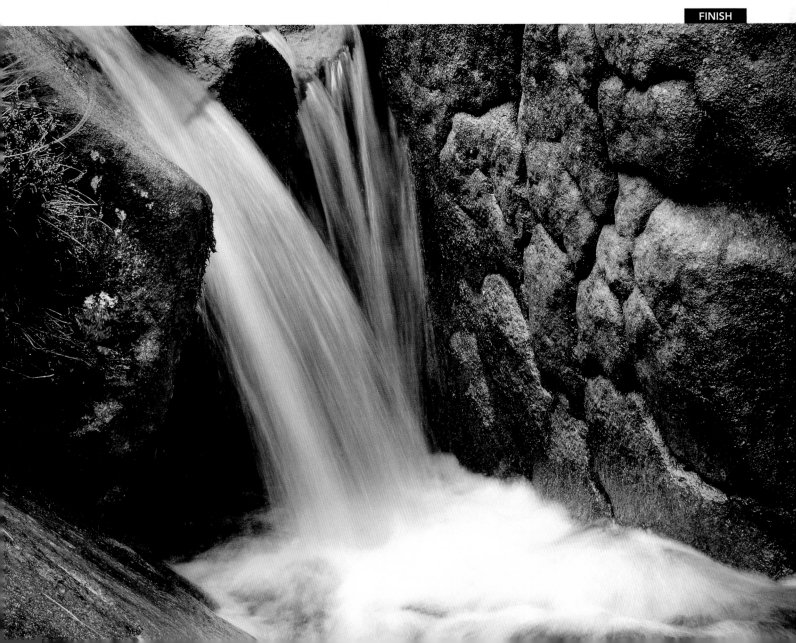

Panning

Convey action with blur

WHAT YOU'LL LEARN
HOW TO TRACK
MOVEMENT

IN MANY PHOTOGRAPHS, a blurred background is caused by setting a low f/number, thereby creating shallow depth of field. But in a panning shot it's different – it's the movement of the camera that causes the blur, made possible by using a slower-than-normal shutter speed and intentionally moving the camera to follow the subject – it's like a controlled form of camera shake. Try to track your subject accurately for the duration of the exposure and you'll be on the path to great panning shots.

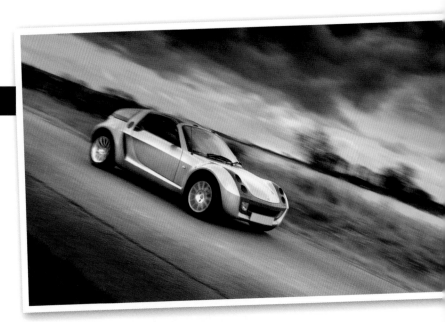

1 ASSUME A PARALLEL POSITION First make sure that the position you're shooting from is roughly parallel to the subject of your panning shot. This will make it a lot easier to track the motion of the subject – be it an athlete, car, plane – and the background will blur more easily, too.

2 SET SHOOTING MODE, METERING AND ISO Now set your camera to aperture-priority mode (A or Av on the dial), then change the metering to multi-segment. Next change the ISO sensitivity to its lowest setting – that's usually 100. Here our aperture is set to f/8.

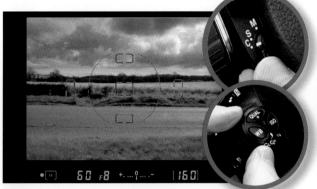

3 CHECK EXPOSURE Now take a look through the viewfinder and check the shutter speed. Depending on the subject of your panning shot (see panel, right), you'll usually need between 1/10sec and 1/250sec (if the shutter is faster than this, dial in a smaller f/number). Now you've got an acceptable shutter speed for your subject, change the camera's drive mode to Continuous and the AF mode to Continuous, or Servo, too.

4 BODY SHAPE Before you shoot, it pays to get your body shape right. Start by standing with your feet pointing in the same direction as the subject is moving, then twist your torso back to frame up on the approaching subject. If you're using a long telephoto lens, hold it near the front for better results. A shorter lens, with a wider angle of view, means you'll have more chance to get the subject in frame.

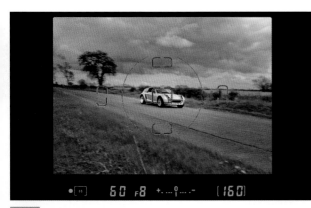

5 FOCUS AND SHOOT Frame up on the subject and keep your active AF point on it as it moves. Half-press and hold the shutter and the Continuous AF will keep the subject in focus. Finally, while still tracking it, fire off a few shots (it helps to keep your non-shooting eye open as the viewfinder will go black).

6 ASSESS RESULTS On the screen, assess the background for blur and the subject for sharpness. If the background is still sharp your shutter speed is too fast, so use a higher f/number. In bright conditions, this may not be possible, so you'll need to fit an ND filter or return in gloomier light.

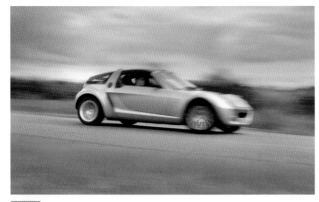

7 ADJUST SHUTTER SPEED If the subject is very blurred, it's likely that your shutter speed is too slow, so open up the aperture by using a slightly lower f/number (don't go too far, though, or the shutter speed may rise too much and the background sharpen as a result – use 1/3-stop increments).

8 PRACTISE YOUR TECHNIQUES. Your panning technique will play a large part in the success of your shots, so practice really does make perfect. Try to keep your movement lateral to the subject and follow through, continuing to track the subject after you've taken the shot.

EXPERT ADVICE

SHUTTER SPEEDS FOR PANNING

WHICH SHUTTER SPEED you use will depend entirely on your subject. As a general rule of thumb, the slower the subject, the slower the shutter speed required to capture any blur in the background. To point you in the right direction, take a look at the examples here. If you can't achieve a slow enough shutter speed, you can either stop down the aperture – say from at f/8 to to f/11 or f/16 or you can add a Neutral Density filter to make the scene darker for your camera. For less blur and a quicker shutter speed, set a larger aperture or increase your camera's ISO sensitivity.

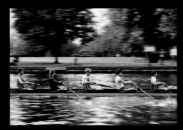

With fast human-powered action such as this group of rowers, increase the shutter speed to between 1/45sec and 1/90sec.

For ultra-fast action, such as this Ferrari F1 racing car, you'll need to use a fast shutter speed of around 1/250sec.

For fairly fast-moving subjects – cars, motorbikes and, in this case, a steam locomotive – try using a shutter speed between 1/60sec and 1/125sec.

For human subjects in motion, try a shutter speed of 1/30sec–1/60sec.

White balance

Recognize the colour temperatures of different types of lighting

WHAT YOU'LL LEARN
COLOUR TEMPERATURE;
COLOUR BALANCE;
SETTING WHITE BALANCE

THOUGH OUR EYES SELDOM NOTICE IT, different light sources produce different-coloured light. Some produce cool blue light while others are much warmer-looking, more red or yellow. Daylight itself can produce different colours at different times of day. Human vision adjusts automatically to see only a neutral output from most types of light. We only tend to notice the colour when the light source quickly changes from one to another, or there are two different light sources visible at the same time. When it comes to photography, however, the light source you use to illuminate a subject can make a huge difference to your results.

COLOUR TEMPERATURE

These differences in the colour of light are expressed on what's known as the colour temperature scale, in degrees Kelvin (abbreviated to K). The lower the colour temperature, the more red light is present and the warmer the light will appear. The higher the value, the more blue light is present, making the light look cooler. Typically you'll find that the colour temperature ranges from around 1000K for candlelight to 10,000K for shady conditions, lit only by a clear blue sky.

PRE-SET OR CUSTOM WHITE BALANCE

Along with the other automatic and manual settings, DSLRs also allow you to customize your white balance setting to get very accurate colours. This involves taking a picture of a white or grey subject filling the frame that's in the same lighting as your main subject. This neutral image can then be used to calculate the pre-set white balance and, so long as the lighting doesn't change, you'll get more accurate colours in every shot.

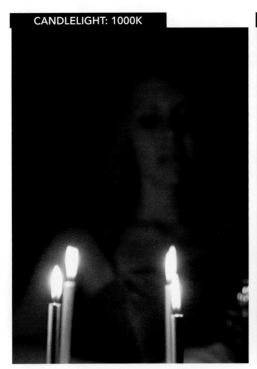

CANDLELIGHT: 1000K

Candlelight occupies the very warm, red end of the colour temperature scale. Here you can see how the camera's Auto White Balance setting has corrected any colour casts for a more naturalistic skin tone.

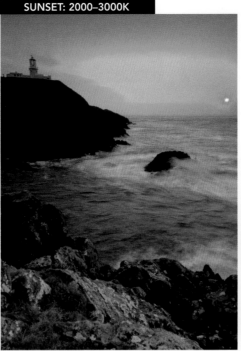

SUNSET: 2000–3000K

Sunset registers at around the 2000–3000K mark on the Kelvin scale, and can present a problem if your camera is set to its automatic white balance default... To keep the warm orange colour of the light, set to the white balance to the Daylight preset option instead.

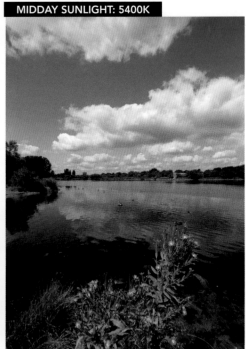

MIDDAY SUNLIGHT: 5400K

With a mixture of light from the sun and blue sky, daylight lies at around the middle of the Kelvin scale. While many cameras will give good results on the automatic white balance setting in these conditions, using the manual daylight setting can give more consistent results.

COLOUR TEMPERATURE SCALE

Candlelight
1000K

Sunrise or sunset
2000–3000K

Household light bulb
3000–3500K

Studio photo flood
bulbs 3200–4000K

Early morning or late evening
sunlight 3500–4000K

HOW TO CUSTOMIZE WHITE BALANCE

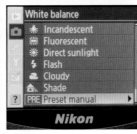

1 SHOOT A NEUTRAL SUBJECT Place a white or grey object, such as a piece of paper or an 18% grey card, in the same light as the subject you want to shoot, then fill the frame with this neutral object. Switch to manual focus if the AF on your camera struggles to focus on a plain subject filling the viewfinder.

2 MEASURE THE WHITE BALANCE In the custom settings menu, find the pre-set or custom white balance option, then scroll through to find the option where you can use the image you've just shot to update the white balance. Some cameras can take a white balance direct from the paper, so check your manual.

3 APPLY THE CUSTOM WHITE BALANCE With the custom setting loaded into your camera's memory, you now need to tell the camera to use your image as the new white balance setting. Go to the list of pre-sets and select the custom setting. Now, so long as the light stays the same, you can be confident you'll get accurate colours in this new location.

CLOUDY: 6000–7000K

The cooler-coloured light present in cloudy conditions like this can produce very unflattering results if you use a Daylight white balance setting. Instead, try setting a cooler colour temperature around 6000K.

WHICH SETTING?

WHITE BALANCE is the system cameras use to compensate for the different colour temperatures. This system can be set to work in several different ways, depending on the effect you're after and the prevailing lighting conditions.

AUTOMATIC WHITE BALANCE

The default white balance on most DSLRs is the automatic setting where the camera analyses the colour of the image and sets the appropriate colour temperature. This setting is good in many lighting conditions but, like all automatic systems, some lighting conditions or subjects can cause it to give inconsistent or incorrect results.

For instance, the automatic white balance system can struggle to differentiate between the colour of the light falling on the subject and the colour of the subject itself. This is especially difficult if the subject has a strong single colour, as this can fool the camera into adjusting the white balance to compensate for what it assumes is a colour cast.

MANUAL WHITE BALANCE

To simplify the task of matching the white balance setting to the lighting conditions, most cameras have a range of preset options for the most common light sources. While they aren't the most accurate way of setting the white balance, they are sufficient for most lighting conditions and will give a more predictable result than using the automatic option.

The exact white balance settings vary between different cameras and manufacturers, but here are some typical options to help you out.

■ **Incandescent** Use this option for shooting interiors lit by household light bulbs with a colour temperature of around 3000K.

■ **Fluorescent** Although fluorescent lights don't have a precise colour temperature, this setting uses a colour temperature of around 4000K to correct for most types of strip light.

■ **Direct Sunlight** The digital equivalent to daylight film, this setting uses a colour temperature of around 5500K.

■ **Flash** Although electronic flash has almost the same colour temperature as daylight, some cameras have a separate setting with a colour temperature of around 6000K to compensate for the slightly cooler light given out by many flash units.

■ **Cloudy** For shooting under cloudy skies, set a colour temperature of around 6000K.

■ **Shade** To compensate for the blue cast created when shooting in light shade, the camera sets a colour temperature of around 7000K.

Midday sunlight
5400K

Electronic flash
5500–6000K

Cloudy or overcast
6000–7000K

Open shade
7000–8000K

Composition

Learn the basic rules to add drama and intrigue to your pics

LIKE ANY RULES AND THEORIES, the rules of composition won't work for every picture and shouldn't be followed slavishly, but they are an excellent starting point for improving composition. The main thing to remember is, keep things as simple as possible and always consider what you're trying to show.

WHAT YOU'LL LEARN
BASIC RULES OF COMPOSITION

FRAMING AND FORMAT

The very first decision you need to make is whether the shot is going to look best framed in a horizontal or upright format. Traditionally subjects such as portraits would be shot with the camera upright, while landscapes would be shot with the camera horizontal. This has given rise to upright shots being called "portrait" format and horizontal ones called "landscape" format.

However, this doesn't mean you have to use landscape format when shooting landscapes or portrait format for shooting portraits. In fact, including things such as foreground interest in your landscapes is often easier if you shoot in an upright format. The best advice is to choose whichever format suits the subject best and if in doubt, try both.

PORTRAIT FORMAT

LANDSCAPE FORMAT

LEAD-IN LINES

These are naturally occurring linear elements in a scene that can be positioned to lead from the edge of the frame in towards the main area of interest (such as the cracks in these rocks, above). They work because they draw the viewer into the picture, directing attention onto elements or subjects within it. In landscapes, typical lead-in lines might be a wall, stream, road or other man-made linear structure. Rocks and even clouds can produce a more subtle, broken lead-in line.

FOREGROUND INTEREST

Having something in the foreground of your picture acts as a stepping stone to lead the viewer into the picture. It also helps to balance the composition if there's a strong element in the background, such as the mountain in this shot. Foreground interest can also provide a sense of scale and distance, inviting viewers to compare the size of objects close to the camera with those further away. They can also provide a thematic contrast or colour comparison.

NATURAL FRAMES

Composing an image so that one element of the composition surrounds the edges of the viewfinder frame can help concentrate attention on the main subject. Looking for a frame within the viewfinder – such as an archway or tree bough – lends natural emphasis toward the subject in the centre of the frame and prevents the viewer's attention from wandering elsewhere.

FOCAL POINTS

All too often a beautiful rolling landscape simply fails to translate into a two-dimensional image – largely because important emotional cues (the smells, breeze, sunshine, sense of space, etc) are absent in the finished image. Concentrate your senses on what can be seen and look for focal points to act as visual anchors that give the scene weight.

CLOUDS
The lines in the cloud create diagonal lines into the frame, working as lead-in lines to direct the eye.

BOAT
This has been positioned around a third in from the edge of the frame, using the rule of thirds grid (see below).

HORIZON
Without the boat as a focal point, the empty horizon would look flat and boring.

PATH
This leads from the bottom-right corner to lead the eye into the frame, acting as a lead-in line and balancing the clouds above.

EXPERT ADVICE

HOW TO USE THE RULE OF THIRDS FOR BETTER FRAMING

DEVELOPED BY THE ANCIENT GREEKS 2,500 years ago, think carefully before you ignore the rule of thirds! In essence, the rule involves imagining your scene divided into thirds, both vertically and horizontally, like a noughts and crosses grid with nine equal segments (see above). The rule then suggests you place your main point of interest on any of the four points where the lines intersect for a balanced and pleasing composition. It's also not a bad idea to place the horizon on one of the horizontal lines, too.

The rule – or rather, "compositional aid" – helps photographers to avoid positioning their main subject matter slap bang in the middle of the image, which can make it look too static. Arranging elements off-centre creates a sense of heightened tension.

To check your pictures measure up, you can make a thirds grid in Photoshop. Just follow the instructions right, and go to View>Show>Grid to toggle it on and off.

Have a look at the photographs in this book to notice when the rule has been used. Don't follow it too slavishly; look for opportunities to break the rule. Framing a bold subject centrally can

WEAK COMPOSITION
The horizon isn't straight, and the church is too central in the composition.

STRONG COMPOSITION
The framing now follows the rule of thirds, with the subject on the intersection and the straight horizon on the upper third. With the diagonal leading in from the bottom left to the subject, the whole scene is more pleasing to the eye.

To make a thirds grid in Photoshop, go to Edit→Preferences, select Guides, Grid & Slices, and under Grid, key in 33.3% in "Gridline every" and 1 in "Subdivisions".

Using flash

Easy techniques to start with

Flash is an incredibly versatile tool. An artificial source of light specially designed for photographers, it allows you to control the light quality, quantity and direction whatever the conditions, indoors and out. It can be used as a source of fill-in illumination to boost portraits outdoors (see right); it can create a twinkling catchlight in a model's eyes, bringing a portrait alive; it can be used to help freeze action and isolate a subject from its setting – the creative possibilities are almost endless.

It's never been easier, either. One of the problems with flash in the past was that you never knew if you'd got the exposure right until you got your film back. With digital photography, we're now able to quickly assess whether we've got our exposure spot-on thanks to the LCD on the back of the camera. The way the camera communicates with the flash has improved dramatically too, resulting in ever-more sophisticated flash meters that make our lives so much easier.

WITH FILL-IN FLASH

WITH NO FLASH

Using a touch of fill-in flash has lightened the subject nicely, and added a pleasing catchlight to the eyes.

FLASH SYNC SPEED

Often taken for granted, a key part of using flash is your camera's shutter. DSLRs have what's known as a focal plane shutter, comprising two curtains. As you take a shot, the first curtain of the shutter starts to travel across the sensor, followed by the second curtain. For short exposures, the two curtains allow a travelling slit of light to reach the sensor; for longer exposures there'll be a period when the entire sensor is fully exposed to the incoming light before the second curtain starts to follow the first, to curtail the exposure.

As such, a DSLR has what's known as a flash sync speed. This is the fastest shutter speed you can use when the entire sensor is exposed to the flash's pulse – and for most modern DSLRs, a flash sync speed of 1/250sec is the norm. Any faster

and the second curtain would be recorded as a black line across your shot, but you'll find that your camera will automatically recognize this anomaly and refuse to fire.

If you're using flash as your primary light source, the shutter speed used (as long as it's slower than your flash sync speed) will not affect the main subject, only the ambient light in the background. This is because the flash pulse is delivered incredibly quickly – far quicker than even the camera's flash sync speed, with the power output controlled via the camera's flash meter to achieve a correct exposure. So it doesn't matter whether you shoot at 1/250sec or 1/60sec, it'll still retain the same exposure, only the surrounding ambient light will differ.

To control this, set your camera to shutter-priority. For a dark background, use the highest shutter speed possible. If you prefer to bring more of the ambient light in and a more natural look, experiment by slowing the shutter speed to achieve a longer exposure for the natural light. Remember to check your screen regularly to see if you've got it right.

GUIDE NUMBERS EXPLAINED

THE FIRST MISTAKE people make when using flash is to assume their camera's built-in pop-up flash unit will light up an entire football stadium. Sadly, a single flash unit just isn't powerful enough to do that, and will always result in a disappointing shot.

Even so, your pop-up flash unit is still very useful – you just need to work within its limitations. First off you need to know that its maximum output is determined by its guide

vary from camera to camera, but as an example, a Nikon D60's built-in flash unit has a GN of 13/43 (m/ft) at ISO 100.

How does knowing the flash's GN help you? Well, if you can roughly guess the distance to your subject in metres and you know the aperture (f/number) you're using, you can work out whether the flash is powerful enough to reach your subject using the equation:

DISTANCE FROM SUBJECT x F-NUMBER = GN

For instance, with a D60 set to ISO 100 and an aperture of f/4, a subject 3m (10ft) away would be fully illuminated, as this gives a GN of 12.

If you were 5m away, however, you would find that your flash's burst wouldn't reach, as you'd need a GN of 20 instead – surpassing the camera's built-in flash GN of 13.

Dedicated and accessory flashguns offer much higher guide numbers (often up into the 40s), so they offer better reach. See page 80

HOW TO USE SLOW SYNCH FLASH

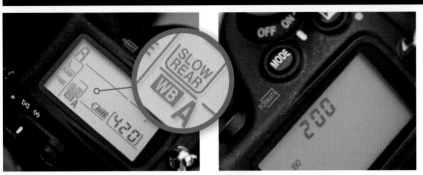

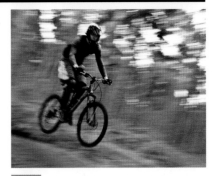

1 SET FLASH MODE AND METER Set your camera's flash mode to SLOW REAR and then select aperture-priority mode. Roughly frame-up, then stop down your aperture so you have a shutter speed between 1 second and 1/15sec depending on how much blur you want to achieve.

2 REDUCE ISO IF NEEDED It's best to try this technique when there's limited light – late afternoon or when you're indoors, for instance. If you find your shutter speeds are too fast, take the ISO down as low as you possibly can – ISO 100 or 200 – setting this via your camera's menu.

3 PAN AND FIRE Frame up the shot again and track your subject into the picture area, firing off your shutter, while continuing to track your subject until the flash has fired at the end of the exposure. It may take a couple of attempts to get the effect you want, but it's worth the perseverance.

If the fill-in flash effect is too harsh, you can knock back the power of the flash using your DSLR's flash exposure compensation.

EASY POP-UP FLASH TECHNIQUES

It may seem a bit daft using flash in broad daylight, but it can be really useful – especially with portraits. Trying to get a good shot in the full glare of the sun is often impossible – the harsh light can result in unflattering shadows and, as your subject will more than likely be squinting, they'll be uncomfortable, too.

The answer is to have the subject turn their back to the light, creating a pleasing halo effect round their hair. Now, to light their shaded face, add a bit of fill-in flash. Not only will it lift your subject, adding a bit of sparkle to your shot, it'll also add some appealing catchlights in their eyes. Simply pop your built-in flash up and, making sure your shutter speed isn't faster than your flash sync speed, fire away. Your camera's advanced flash meter will balance the exposure but if it's too bright, most DSLRs have a flash compensation button, allowing you to reduce the flash by one to two stops.

Another arty pop-up flash technique to master is slow sync flash (see above). Most DSLRs include this option in the flash menu, normally with a couple of options to choose from (see below): front curtain slow sync, with the flash firing at the start of the exposure, or rear curtain slow sync, with the flash firing at the end of the exposure. If your DSLR only offers one slow sync option, it'll be front curtain sync.

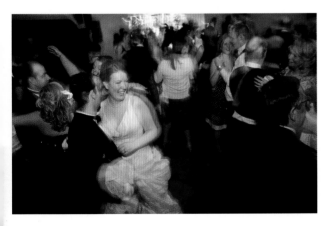

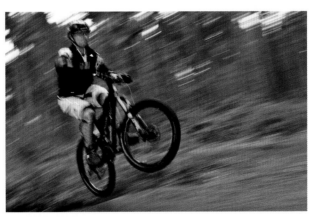

FRONT CURTAIN SLOW SYNC

This is great for low-light portraits using a tripod, where a blip of flash at the beginning of the exposure will highlight your subject, and the shutter will then remain open to expose for the darker background. It can also be used creatively too, as above, in mixed lighting at a wedding. With the exposure continuing after the flash has fired, the camera records any after-flash motion as a blur, conveying a real sense of movement.

REAR CURTAIN SLOW SYNC

Because the flash is fired at the end of the long exposure, it makes it more suitable for panning with your subject, especially if there are lights involved, as any movement leads up to the subject. If you used front curtain slow sync in this scenario, it would make the subject look as though it were moving backwards. This blend of movement and static main subject can create some really dynamic shots.

OFF-CAMERA FLASH

ON-CAMERA FLASH

OFF-CAMERA PORTRAITS

Let's see how to use off-camera flash on a simple portrait set-up. Shooting with the flash pointed directly at the subject produces an acceptable shot, but the lighting is quite flat and unappealing. By positioning your flashgun just to the left of the model, we can get some subtle directional light into the image to produce a much more pleasing result. Line up your flashgun with your subject by popping it on a tripod, then position it just to one side. Try not to place it directly on the floor as the lighting will be pointing up at the subject, producing quite a harsh light.

Manufacturers' flashguns (right) offer complete dedication, but there are some great third-party options to choose from.

OFF-CAMERA FLASH

Don't restrict your creativity by confining yourself to your built-in pop-up flash. As you become more proficient and confident with flash, you may feel restricted by the pop-up unit's size, power output (GN) and creative options.

There are many types of off-camera flashgun available, offering more power and advanced, creative features. Choosing which one is best for you can seem daunting, but they're easily categorized to make the decision easier.

BUYING A FLASHGUN

Moving up from a built-in flash is the accessory flashgun, made by third-party manufacturers such as Metz, Sigma, Sunpak and Vivitar. Packing in more power than your built-in flash, they slot onto your camera's hotshoe, and lock in place.

These varieties can be split into two camps – those which are dedicated and those which aren't. A dedicated model is designed to work with a specific camera brand, such as Canon or Nikon. Although most manufacturers share a physically identical hotshoe (with the exception of Sony DSLRs which have their own unique design), the contacts vary from brand to brand. As such, a dedicated model has contacts on the bottom that allow it to communicate with a specific camera brand's TTL (Through The Lens) flash metering system to get balanced-looking exposures.

Non-dedicated models offer more basic controls as there's usually just a single contact, which restricts you from taking full advantage of your DSLR's own sophisticated flash system. The other thing to watch out for with non-dedicated flash (especially older, pre-digital models) is compatibility with your DSLR. Some flashes should never be directly attached to the hotshoe of your camera as they can fry the circuitry of a DSLR through their high-voltage output. If you still want to use an old, non-dedicated flash, invest in a Wein Safesync. This slots onto your hotshoe and will regulate the degree of voltage from the flash mounted on top of it, keeping your camera safe from high-powered older guns.

MANUFACTURER FLASHGUNS

Moving up another notch are fully dedicated manufacturer flashguns (known as Speedlites/Speedlights on Canon and Nikon systems), which are incredibly versatile pieces of kit. Designed to offer a complete flash solution, they work seamlessly with your DSLR's advanced flash metering system to offer a range of creative options, including remote flashgun control. There are usually two or three models in each manufacturer's range, varying in power and features.

SPECIALIST FLASHGUNS

Specialist flashguns, mainly macro and twin flash units, are engineered to work at extremely close range. Designs vary from a single ring flash or as a series of miniature flash tubes arranged around the front of the lens controlled via a separate commander unit. Each tube can be controlled independently for tailor-made lighting effects. While these kits provide bags of light for macro work, they can also produce some interesting results with portraits, too.

STUDIO FLASH

This is where your camera's own complex flash-monitoring system becomes redundant. Studio flash is completely separate from your camera, controlled manually and triggered either by a sync lead connected from your camera to the flash unit, or via a wireless trigger (see page 41).

Studio flash systems comprise one or more flash heads on stands, positioned round your subject, usually with a variety of flash modification units on the front to variously reflect the light, diffuse or channel it.

Each flash unit can produce plenty of power, so studio flash kits require a mains power supply or a (reasonably bulky but still portable) power pack if you need to shoot on location.

Studio flash offers the ultimate in lighting control, producing stunning results – but at a price. Amateur kits are available too, with generally smaller flash heads, lighter weight stands and generally less output.

HOW TO TRIGGER REMOTE OFF-CAMERA FLASH

1 SET UP FLASHGUN In this step-by-step, we're using a Nikon DSLR and dedicated flashgun, but the principle remains the same for other camera systems. Refer to your camera/flash manual for specific menu options. First, set your flashgun to its Remote mode via its menu. This tells the flashgun that it's not attached to the camera and will be triggered remotely.

2 NAVIGATE THE FLASH MENU Pop-up your DSLR's built-in flash unit, which can be used as a trigger for the off-camera flashgun. Go into your camera's menu and find the Bracketing/Flash sub-menu. Select Flash ctrl for built-in flash, then Commander mode. This is the part of the camera's menu where you can control, not only the built-in flash, but also a series of off-camera flashguns, too.

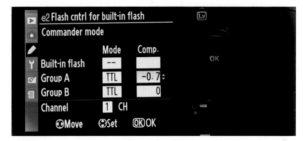

3 CONTROL FLASH Set the built-in flash mode to --. This will force the built-in flash unit to fire a pre-flash to trigger the off-camera flashgun, but won't affect the exposure of the shot. Now set Group A's Mode to TTL and Comp to 0. Make sure you select OK and then set the camera to aperture-priority mode, with an aperture of f/5.6. Increase aperture if the shutter speed is above the flash sync speed (normally 1/200sec–1/250sec).

4 TAKE THE SHOT Frame-up and fire the shutter. With the off-camera flash triggering, check the rear screen to review your results. If the light is too intense, either move the flash away fromthe subject or go back to the camera's Commander mode and dial in –0.3 or –0.7 flash exposure compensation for the Group A flash. Once you've got the hang of it, don't be scared to move the flash around to experiment with different lighting positions.

HOW TO BOUNCE AND DIFFUSE FLASH

THERE ARE MANY ADVANTAGES to using a dedicated accessory flashgun over a built-in model – not least the extra power, but also the ability to direct the light. Most dedicated flashguns allow you to rotate the head – upwards or to the side, known as "bounce" and "swivel" – both of which can have a dramatic impact on your lighting.

There is a risk of colour casts, so to avoid this, always bounce the flash off a plain white surface.

Some flashguns also come with attachable diffusers, fitting over the flash window and softening the flash, but still putting out plenty of power. The pictures shown right demonstrate the various effects of the different on-camera flash positions and what happens when you use a diffuser to soften the light.

DIRECT FLASH
Flash pointed direct at subject = harsh light with hard shadow

BOUNCE FLASH
Flash bounced off ceiling = softer effect with softer shadow

DIRECT DIFFUSER
Flash pointed direct with a diffuser = softer effect, slight shadow

BOUNCE DIFFUSER
Flash bounced with diffuser = softest, smoothest result

5 PHOTOSHOP AND ELEMENTS TUTORIALS

AT LAST IT'S TIME TO get to grips with the image manipulation software that will help give full rein to your photographic creativity. Whether you want to make small-scale tweaks to exposure and colour in your images, or whether you fancy creating ambitious montages and fantasy scenes on the computer, the possibilities really are endless.

Like it or not, Photoshop has certainly revolutionized the way photographers work. Giving your images a digital tweak to improve them is no longer considered "cheating" as it was in the early days of digital. Photoshop and its streamlined sister software, Elements, are now an integral part of the creative process, so it makes sense to learn what these sophisticated software packages can offer you as an image-maker.

First off in this chapter we'll look at the basic Photoshop tools – for cropping and adjusting contrast, correcting and improving colour, cloning and healing, and using the Brush tool. Next we move on to making Selections and transforming them, then we progress onto Layers, Layer Masks and Adjustment Layers – with practical projects to try all along the way.

We finish up with some clever colouring tricks to try – changing colours and toning – plus a few other useful techniques on adding text and generating shallow depth of field effects by selective blurring.

To get most from this practical chapter, follow along with each of the step-by-step projects using copies of your own photographs.

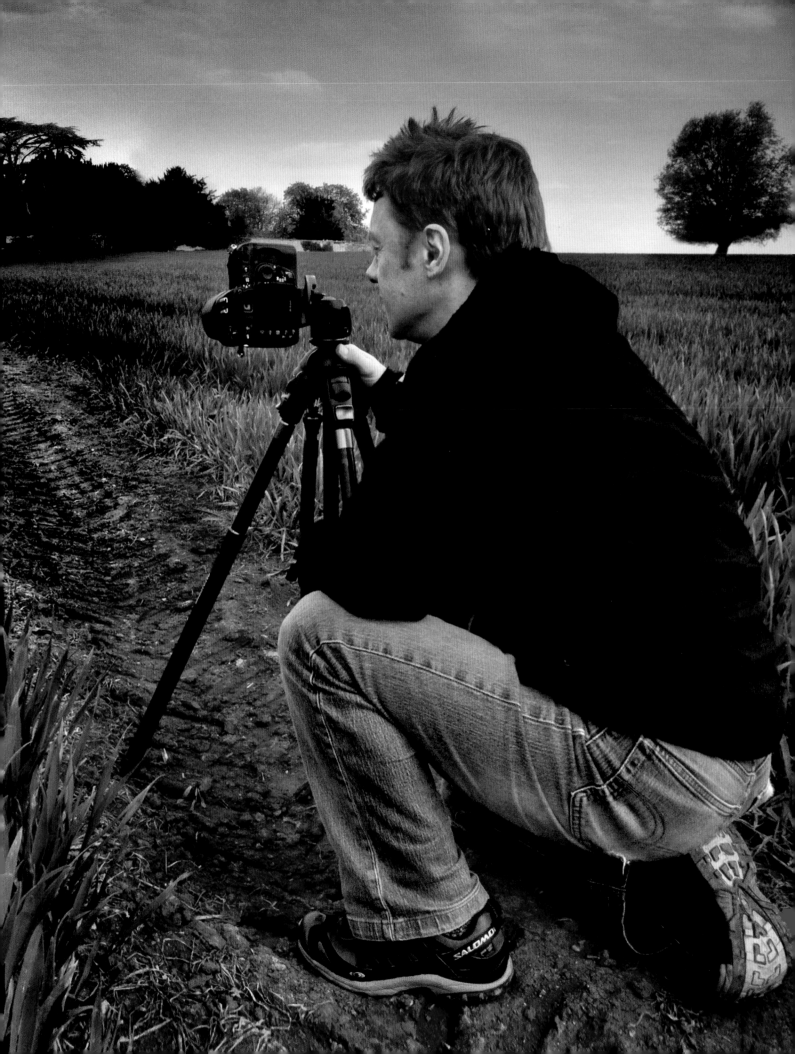

Getting started

Understand the Elements interface

WHAT YOU NEED
PHOTOSHOP OR
ELEMENTS SOFTWARE

WHAT YOU'LL LEARN
HOW IT WORKS

IF THE SCREEN BELOW looks daunting, don't worry. Photoshop and Elements software programs are surprisingly intuitive once you've worked out how to access the tools you need. Like any new technology, it will take some time to get used to, but practice always makes perfect.

Start off by organizing your work space. Individual windows and palettes can be shifted from one side to the other and moved around just like a regular Windows display. But, if you want something a bit more ordered, they can also be locked in place at the sides of the screen. Click and drag

the toolbox to the edge of the screen to see this happen. One top tip is to press the Tab key to make all the other windows disappear so you can have a better look at your image without distractions. Just press the Tab key again to bring them back. And, if you're looking at a more streamlined display than the one below, click on the Edit tab (top right) and then select Full instead of Quick or Guided.

Whatever tools you choose, don't be afraid to experiment. If you lose anything, just go to the Window menu and pick Reset Palette Locations.

ELEMENTS OVERVIEW

Here's an overview of the basic components of Elements.

OPTIONS BAR
The options here change depending on which tool you have selected in the toolbox. Selecting the Eraser tool, for example, will bring up options to change its size, shape, opacity and more.

TOOLBOX
This contains shortcuts to many of the major tools you need for image-editing, including those that control Selections, cropping and cloning. Tools are activated by a single click of the mouse and remain active until another tool is selected.

THE PHOTO BIN (ELEMENTS ONLY)
All the images you currently have open will be displayed in here. This makes it easy to swap between them at will. Right-click on any of the thumbnails to access information about the image, rotate or duplicate it.

MENU BAR
Gives access to a multitude of options – everything from opening and closing pictures with the File menu, to changing their size, lighting and applying special filters. Just click on one of the options and a drop-down list will appear.

DISPLAY ICONS
If you're struggling to see two pictures on screen at the same time click the two small squares next to the Minimize button or go to Window→Images→Cascade or Tile.

LAYERS PALETTE
One of the most important palettes you'll ever use in Photoshop and Elements, this controls how the different Layers of the image interact with each other through Opacity, Adjustment Layers, Blending Modes and Layer Masks (Photoshop only). JPEG files and converted RAWs will open with a single Background Layer, while Photoshop (.PSD) files and TIFFs can contain multiple Layers. To open the Layers palette press F7 (Photoshop) or F11 (Elements) or go to the Window menu and pick Layers.

HISTOGRAM
Gives a "live" graph, showing how light and dark pixels are distributed throughout your image. This will change as you make adjustments; the histogram also responds to any Selections you've made and which Layer you're on, showing the pixel values within the selected area.

UNDO HISTORY
The saviour of many a frustrated image-maker, the Undo History (History palette in Photoshop) allows you to "step back" through the adjustments you've made. The number of History States you can work back through depends on what you've set in the Preferences (Edit→Preferences). Just click on them to move back, a bit like pressing Ctrl+Z on the keyboard (or Edit→Undo in the menu).

IMAGE WINDOW
This displays the picture you're working on and any changes you make to it. The size your image is displayed (its magnification) can be changed by pressing Ctrl and the + or - keys on the keyboard, and you can zoom in to anything up to 3200%, depending on your version of Photoshop or Elements. However, most people find it comfortable to work on their images at 25% or so, only zooming in to make very fine alterations. Various Guides, Grids and Rulers can be overlaid on your image to help composition or layout (find them in the View menu). In the full version of Photoshop you can press the F key to toggle between Full Screen mode and the regular view.

RECOGNIZE THE TOOLS

The toolbox is one of the most useful aspects of Photoshop and Elements. Here's an overview of how the tools work.

THE MOVE TOOL
Literally moves parts of the image around, but can't be used on the Background Layer or you'll get a "Locked pixels" warning.

THE HAND TOOL
Used to scroll around the image. This icon can be double-clicked to make the image fit on screen.

THE MARQUEE TOOLS
Used to make broad Selections, usually covering a lot of pixels. Clicked and dragged over an image, these can be Rectangular or Elliptical.

THE MAGIC WAND TOOL
Used to select lots of similarly coloured pixels, such as a clear blue sky. The accuracy is based on a given Tolerance, set in the Options bar.

THE TYPE TOOL
Used to add text to your images. Selecting this and clicking on the image will create a new Type Layer onto which you can write.

COOKIE CUTTER TOOL
Cuts pre-set shapes from your image using Vector-based paths.

RED-EYE REMOVAL TOOL
Drag this tool over any people with red-eye in your shot and it'll be quickly removed.

CLONE STAMP TOOL
Used to sample pixels from one part of the image and paint over another, removing distractions.

THE BRUSH TOOLS
These work just like a regular paintbrush, allowing you to paint onto your picture (or a Mask) just as you would a real canvas. The Brush tool can be any size or shape you like.

THE GRADIENT TOOL
Lets you draw a gradient; very useful in conjunction with Adjustment Layers and Layer Masks (in Photoshop).

BLUR TOOL
Allows you to blur small, individual parts of the image by hand, using a brush. Also contains the Sharpen and Smudge tools which act in a similar way.

THE ZOOM TOOL
Allows you to click directly on the image to zoom in, or drag the tool over the exact area you want to magnify. Press and hold Alt to zoom out.

THE EYEDROPPER TOOL
Lets you sample colours directly from the image, just by clicking on it.

THE LASSO TOOL
Used to make finer, more accurate, Selections than the Marquee tools. The regular Lasso tool lets you draw over the photo like a pen, while the Polygonal Lasso offers a more precise, point-and-click approach.

QUICK SELECTION TOOL
Allows you to paint a Selection using an adjustable brush. The Selection will expand as you drag following any defined edges in the image.

THE CROP TOOL
Allows you to trim images, cut out dead space, and resize them to whatever dimensions you like using presets in the Options bar.

STRAIGHTEN TOOL
Drag this tool out to follow the horizon in your image and the shot will be automatically straightened up.

HEALING BRUSH TOOL
Paint over any imperfections with these brushes to remove them. The Spot Healing Brush tool does this automatically, while the Healing Brush tool requires you to select pixels first, using the Alt key.

ERASER TOOL
Used to delete pixels from the image, the size of the Eraser tool can be controlled like a brush using the Options bar.

THE PAINT BUCKET TOOL
Lets you flood a chosen colour into an area of the image – this could be based on a Selection or on a Tolerance value.

THE SHAPE TOOL
Allows you to quickly create a vast array of Vector shapes, which can be very useful for more graphical styles of work.

THE DODGE TOOL
Used to lighten parts of the image by hand and can be set to alter Shadows, Midtones or Highlights by various Exposures. Also accesses the Burn and Sponge tools, darkening and desaturating the image respectively.

Transferring images and file formats

Get the image from your camera onto your computer

WHAT YOU'LL LEARN
HOW TO TRANSFER
IMAGES FOR
SOFTWARE
MANIPULATION

TO GET THE MOST from your digital photography, at some point you'll start shooting with the end image in mind: anticipating a little Photoshop or Elements work along the way. This will affect how you set your camera to record your images – and in particular, which file format you choose.

Because JPEG files offer good quality and don't take up a lot of space on your card, all modern digital cameras are able to shoot using JPEG compression. In the camera's Quality settings, you can set different amounts of compression, and these are usually called NORMAL, FINE and SUPERFINE, or similar. Unless you're really short on card space, it's always best to use the maximum quality setting, which will compress the JPEG by the least amount, therefore giving the best pictures, but reducing the number of pictures that you can save to your card.

If you don't want any compromise in quality and are prepared to fill up your card even faster, all DSLRs and some creative compact cameras also offer a RAW mode.

This is the shooting format of choice for discerning photographers who want to take full control of their pictures. RAW files are much bigger than even the largest JPEG size, so you won't get as many shots on your memory card, but they have a number of real advantages for photographers which we'll cover later, in Chapter 7.

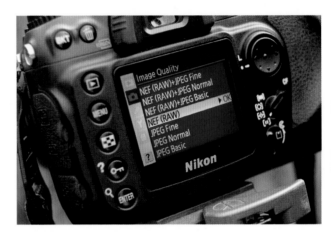

RAW mode is used by discerning photographers – it takes up more space but images are of a higher quality.

Before you can start enhancing your pictures in software, you first need to transfer them from your camera's memory card onto your computer's hard drive. Once you've done this – and backed up the pictures – you can then wipe the camera's memory card, freeing it up for further use.

All digital cameras have a port which allows them to be plugged into a USB socket on a computer, but this can be time-consuming and fiddly, so a better way to transfer shots is to use a card reader. These devices only cost a few pounds, and can be left attached to your computer. To use them, simply switch off the camera, take the card out, and push the card into the designated slot on the card reader.

To access the card's contents, double-click My Computer (Computer in Vista or Windows 7) and find the card, which will show up as a separate drive on your PC; if you're on a Mac, it'll appear on the desktop. Once you've found your card, double-click on it to see your image files and then select the ones you want by highlighting them with your mouse. Once that's done, simply drag them across to a new folder on your PC. Name the folder by the name or location and date of the shoot, before backing it up to another hard drive or a CD/DVD.

Backing up your pictures is important, because if your computer's hard drive goes wrong, or if your computer is stolen, you will at least have a copy of your precious images. CDs and DVDs are good forms of back-up, though for speed and convenience, many photographers now prefer to use external hard drives for image back-up. These are essentially large filing cabinets offering up to 2000GB capacity.

Once the images are saved on your PC, try to delete any identical shots or those you don't like – otherwise you'll soon have drives full of images you don't need.

RAW files will fill your memory cards more quickly; take large cards and spares when holidaying abroad.

KEYSTROKE GUIDE

Speed up your digital workflow with these easy-to-use toolbox shortcuts for Photoshop and Elements.

EDIT

Copy	Ctrl+C
Cut	Ctrl+X
Paste	Ctrl+V
Clear (a Selection)	Backspace
Free Transform	Ctrl+T
Undo	Ctrl+Z

LAYERS

Make a new Layer	Ctrl+Shift+N
Paste Layer/Selection to new Layer	Ctrl+J
Merge Layers	Ctrl+E
Merge all visible Layers	Ctrl+Shift+E
Control Layer Opacity (10–100%)	Numeric keypad 1-0

DISPLAY

Fit on screen	Ctrl+0
View at 100%	Ctrl+Alt+0
Zoom in / Zoom out	Ctrl++ / Ctrl+ -
Hide all palettes	Tab
Cycle to Full Screen mode (PS only)	F
Show/Hide Grid	Ctrl+'
Show/Hide Guides (PS only)	Ctrl+;

TOOLS

Brush tool	B
Crop tool	C
Set Default Colours	D
Eraser tool	E
Gradient/Paint Bucket tool	G
Hand tool (toggle)	H (SPACE)
Lasso tool	L
Marquee tool	M
Dodge/Burn/Sponge tool	O
Clone Stamp tool	S
Move tool	V
Switch Colours	X
Zoom tool	Z
Increase / Decrease Brush Size] / [
Increase / Decrease Brush Softness (25%)	Shift+] / Shift+[
Set Tool Opacity	Numeric Keypad 1–0

SELECTIONS

Select All	Ctrl+A
Deselect / Reselect	Ctrl+D / Ctrl+Shift+D
Feather	Ctrl+Alt+D
Inverse of Selection	Ctrl+Shift+I

ADJUSTMENTS

Open Levels palette	Ctrl+L
Auto Levels	Ctrl+Shift+L
Open Curves (PS only)	Ctrl+M
Open Hue/Saturation palette	Ctrl+U
Open Color Balance palette (PS only)	Ctrl+B
Desaturate	Ctrl+Shift+U
Invert colours	Ctrl+I

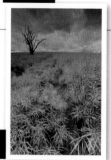

START

FINISH

Basic adjustments

Although the original image was well exposed, using a Levels adjustment to add contrast and adding a small amount of Saturation creates a more punchy-looking result.

Learn how to make quick image alterations

WHAT YOU NEED
PHOTOSHOP OR ELEMENTS

WHAT YOU'LL LEARN
QUICK ALTERATIONS

WE'VE ALREADY COVERED how to get your shots right in-camera, but there will always be times when you need to use your image manipulation software to make some basic adjustments and improvements. Photoshop offers enormous scope to improve exposure, colour, crop and composition.

Later in this chapter we'll be covering each of these features in greater detail, but for now let's look at those first basic Photoshop commands that will help you to get the initial aspects of your photographs looking better – fine-tuning contrast and colour.

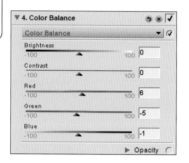

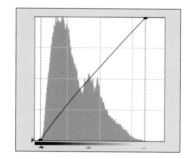

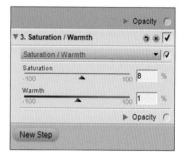

COLOUR BALANCE

In Chapter 4 we covered the basics of mastering White Balance in-camera, so you shouldn't have to alter the colour of your images once you've downloaded them. However, most software gives you the option of adjusting the colours to fine-tune your images. You should only have to move the sliders a small amount to correct the colours. Keep a close eye on the image on-screen to watch the effect.

Some software offers a simpler option for making colour adjustments – using a grid of thumbnails that show the same image in variations of colour. With these it's best to set the smallest amount or intensity, then click on the thumbnail that looks the most accurate.

CONTRAST

Contrast is controlled using Levels or Curves adjustments; the standard way of using the Levels controls is to match the arrows to the histogram display (shown above).

First drag the left arrow so it meets the point where the histogram starts to rise. This controls the density of the shadows. Next, drag the right arrow so it meets the point where the histogram graph just touches the baseline on the right. This makes the highlights as bright as possible, without losing any highlight detail.

Once the shadow and highlight points are set you can move the middle slider to the right to increase midtone contrast or to the left to reduce it – also see the panel below.

SATURATION

If you've got the colours right in-camera, you'll find the saturation controls more useful than adjusting colour balance. Although the standard JPEG images from most cameras have some saturation added for extra impact (and offer controls to adjust the amount in-camera), imaging software offers users much more control and versatility over colour selection.

The amount of saturation you need for your shots will vary depending on the original image. But try to increase saturation slowly and watch how all the colours look, as it's easy to overdo it and end up with blocks of colour where there's too much saturation.

EXPERT ADVICE

COMPARING LEVELS AND CURVES

Most imaging software offers two main options for adjusting the contrast of your shots – Levels and Curves.

LEVELS

We've already seen how the histogram is used to display the exposure of your images – the Levels control simply takes this display and gives you some extra controls. Under the histogram in the Levels window are three small arrows, one at either end of the graph and another in the middle. Dragging these arrows along the graph allows you to control the contrast of your image. The arrow on the extreme left controls the shadows while the right-hand one controls the highlights and the middle

CURVES

While Levels is a great tool for adjusting overall contrast and tonal range, it only allows you to adjust the shadows, highlights and midtone contrast. The Curves option allows you to adjust more points along the continuum of tones in the image. To use it, simply drag points on the main diagonal line (running across the graph) up to lighten them, and down to darken them. Like the Levels control, the left corresponds to the shadows, the right to the highlights. A useful effect to give a subtle increase in contrast is to click on the middle of the curve to lock this in position, then drag the top part of the line up slightly and the lower part down slightly. This gives the curve a slight "S" shape, and can

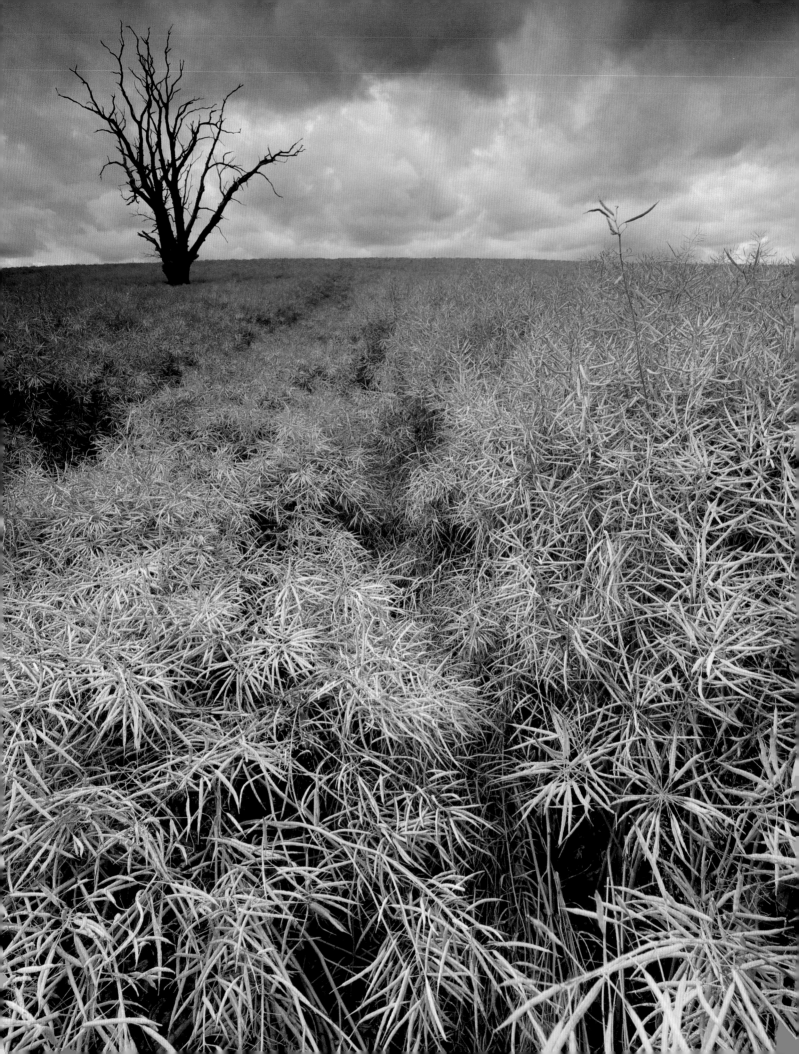

The Crop tool

Crop images – and get creative

CROPPED VERSION

WHAT YOU NEED
PHOTOSHOP OR
ELEMENTS

WHAT YOU'LL LEARN
HOW TO CROP
CREATIVELY

THE CROP TOOL IS EASY-to-use – just click on the tool (which looks like a pair of overlapping Ls) in your toolbox palette, click on the image and drag out the shape and size of image you're after – removing any distracting details in the process. Go to Image>Crop.

But the crop tool isn't just confined to making horizontal and vertical shapes – as you'll see from the cropped image above it can also be used to give your pictures a more dramatic, edgy slant. Not all pictures will respond to this deliberately tilted treatment, but you'll find that many urban scenes and action shots work really well. Angling the cropping marquee results in a slanted image, but make sure you don't push the marquee over the edge of the original or you'll get a portion of new (usually white) blank canvas.

1 OPEN THE IMAGE Open a suitable image in either Elements or Photoshop, hold the Ctrl key and press the minus (-) key once or twice to create some space around the image. Now go over to the toolbox and pick the Crop tool. In the Options bar select Use Photo Ratio under the Aspect Ratio menu (or in Photoshop click the Front Image button).

2 LINE UP A CROP Next go to View>Rulers and once the Rulers are up, right-click with your mouse on one of the Rulers, ensuring Centimetres is ticked. Next hover the Crop tool over the image and position your cursor 4cm in from the left-hand side and 2cm down from the top of the image. Now click and hold your left mouse button.

3 START THE CROP Continuing to hold down your left mouse button, drag a Crop Marquee over the image until the right-hand edge is 26cm in from the left-hand side of the image (as shown). Now release your mouse button. For a strong composition with a road scene like this, the figure should be placed on the right-hand third, with the white road markings framed just within the Crop Marquee.

4 ROTATE THE CROP Now hover your cursor just outside the bottom right-hand corner control handle until you see the Rotate symbol – a curved, two-headed arrow. Now click and drag to rotate the Crop Marquee clockwise until the top left-hand corner reaches the top of the image. Now release your mouse button and hit Return or click the tick to apply the crop.

CROP TO CONTROL
PERSPECTIVE DISTORTION (PHOTOSHOP)

As you'd expect, Photoshop gives you more advanced Crop tool options than its streamlined sibling, Elements. These extra options include a Perspective control option to distort your images while cropping and to correct problems such as converging verticals on buildings – the "falling over backwards" look you often get when angling your lens upwards to take in high structures, or other subjects with strong horizontal or vertical lines.

Adjusting Perspective might sound complicated, but it's easy: just follow this step-by-step project.

BEFORE

AFTER

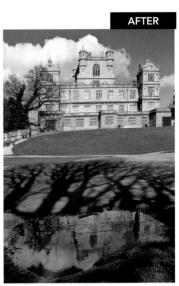

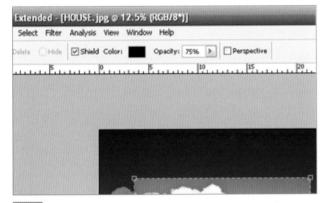

1 CREATE A SHIELD Open up your image and drag a Crop Marquee over the entire picture. In the Options Bar, make sure Shield is ticked. If you want to change its colour to make it more obvious, click on the colour swatch and you can set it to your own preference (we've left ours black). Next, drop the Shield's Opacity to 75%, which means your Shield isn't opaque and you can see some of the image below it.

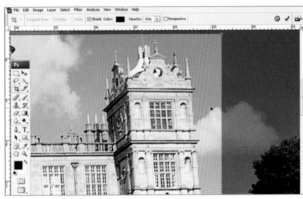

2 SHIFT THE MARQUEE Next use the Zoom control in the bottom-left corner and enter a figure of 100%. Hold down the space bar and scroll across the image until you can see the right-hand edge of the building. Release the space bar, click with your mouse within the Crop Marquee and drag the Crop Marquee left so its edge is adjacent to the left-hand edge of the building.

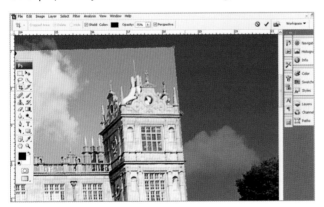

3 CORRECT THE PERSPECTIVE Now in the Options Bar tick the Perspective box and hover your cursor over the control handle in the top right-hand corner. When you see a grey arrow icon, hold down your left mouse button and drag the Crop Marquee outwards to the left until its edge is parallel with the left-hand edge of the building.

4 MAKE THE CROP Now scroll across to the left side of the building, drag the Crop Marquee right until the edge is adjacent to the building on the left. Now adjust the top left corner control handle so the Crop Marquee is parallel on the left. Zoom out and reframe the building by dragging the Crop Marquee into the correct position and then hit Return to make the crop.

Levels and Curves

Control contrast and tonal range

WHAT YOU NEED
PHOTOSHOP OR
ELEMENTS

WHAT YOU'LL LEARN
HOW TO USE LEVELS

CONTRAST IS ONE OF THE MOST IMPORTANT FACTORS in separating good pictures from poor ones and one of the quickest and easiest ways to control it in your shots is by using the Levels palette.

Images with poor contrast generally look flat and washed out and this is because they lack proper highlights and shadows – the very things that give an image a full range of tones. Levels will help you correct and modify the tonal range of a photo and, like most of the tools in Photoshop and Elements, it's very simple to use, involving nothing more than a few sliders. Here we'll look at the theory of both the Levels palette and its accompanying histogram and provide a guide to assessing and improving contrast in your pictures.

TONAL RANGE

An image with a full range of tones will contain both pure black and pure white pixels somewhere within it – ie those with an RGB value of 0 or 255, respectively. Anything less represents an incomplete tonal range. Most modern cameras are pretty good at producing files with a complete tonal range, but even if the picture looks OK, it's still worth checking its histogram via the Levels palette just to make sure. It's not just about getting a complete tonal range, though – the Levels palette can also be used to alter the distribution of tones in your image, making it darker or lighter overall, or selectively to add contrast to individual parts of a scene.

THE LEVELS PALETTE

HISTOGRAM
This chart shows the amount of pixels of each tone that are currently making up the image. Imagine them stacked on top of one another and you'll see which tones in the image are represented most strongly. If the histogram runs from one end of the scale to the other there's a full range of tones in the image from 0 (black) to 255 (white).

INPUT LEVELS
These correspond to the positions of the Black point, White point and Gamma (middle) sliders, representing them numerically. When you open the Levels palette, the Black will be set to 0, the White to 255 and the Gamma to 1.0. Moving the sliders inwards will make Photoshop stretch the tonal range of the image.

OUTPUT LEVELS
The Black and White Output Levels can be pushed inwards to compress the histogram above. This has the opposite effect to moving the Black and White point sliders inwards, lightening the shadows and dulling the highlights. Look directly above the Output levels bar and the histogram will show you where the tones in the images are congregated.

CHANNEL
This button allows you to show and edit either the composite RGB histogram (the one containing an average of the red, green and blue pixels in the image) or the Red, Green or Blue channels independently.

OK BUTTON
Press this to confirm the changes you've made to the tonal range of the image.

CANCEL BUTTON
If you press this you'll reject any changes you've made in the Levels palette and return to the image as it was previously.

RESET BUTTON
This will reset the positions of any sliders you've moved. To get this button in Photoshop, press the Alt key and the Cancel button will change to Reset.

AUTO BUTTON
This will automatically set the White and Black points of the image to the ends of the histograms.

EYEDROPPERS
The Set Black Point and Set White Point eyedroppers can be used to manually pick the lightest and darkest part of the image – very useful for high or low-key shots. The Set Gray Point eyedropper is used to manually colour correct an image.

PREVIEW BOX
Tick this to see the results of your changes take place live on the picture you're working on. After you've made some changes, click this on and off for a better idea of how they look.

BLACK POINT SLIDER
This sets the Black Input Level of the image. Moving it to the left edge of the histogram will mean there's "true" black in your image, so try to make sure there's no gap between it and the graph area.

GAMMA SLIDER
This controls how light or dark the midtones in the image are. Moving it left will make the image brighter, while moving it right will make the image darker.

WHITE POINT SLIDER
This sets the White Point of the image. Move it in to the right hand edge of the histogram and you'll get pure white in the image. Don't push it too far though or you'll start to burn out areas of the shot.

Levels

Learn more about: Levels

Channel: RGB

Input Levels:

30 1.00 194

Output Levels:

0 255

OK
Cancel
Reset
Auto

Preview

CURVES AND CHANNELS (PHOTOSHOP)

On page 88 we looked at the basics of Curves and saw how you can use this useful tool to adjust contrast in your images, by creating a simple "S" curve. It's also possible to use Curves to alter the colour balance of your images too, making selective Curves adjustments so you can affect specific areas within an image, rather than making "global" changes (ie affecting the whole image all at once).

Altering the colour balance and contrast in specific areas like this gives you the opportunity to really get the best from your shots; all of these changes can be done in one palette.

To make a selective Curves adjustment, simply select the area you want to change using one of Photoshop's Selection tools, and then soften the edge of that Selection using the Feather command from the drop-down menu bar (Select>Feather in Photoshop versions up to CS2, or Select>Refine Edge in version CS3).Now you can use Curves to selectively adjust each of the separate colour channels in that Selection.

How does this work? Every colour image consists of three colour Channels – Red, Green and Blue – and, as well as allowing you to adjust all three of these channels at once, Curves also lets you tweak each channel individually. This is all done via the Channel box of the Curves palette. With RGB selected, you can adjust all Channels together and make contrast changes too. But, if you click the arrow next to RGB, you can select Red, Green or Blue, and access the Curve for that single Channel only.

The result is, you can push or pull the Red Channel to introduce more Red or more Cyan (the opposite of Red) into the image. Similarly, the Green Channel allows you to boost Green or Magenta, and the Blue Channel lets you tweak Blue or Yellow.

Best practice is to use a Curves Adjustment Layer (we'll cover Adjustment Layers later) so you can make all of these changes without affecting the pixels in the original image. This means you can fine-tune your Curves until you're happy you have the perfect result.

CORRECT TONAL RANGE IN LEVELS

Correcting the tonal range of an image means we need to set the Levels so there's at least some white and some black pixels in the scene, by adjusting the Black and White points. Pictures without a complete tonal range look very flat, grey and dull – usually, they're either short of highlights or shadows, but in this image we had to deal with both ends of the histogram.

First find a suitable image, open it and go to Enhance>Adjust Lighting>Levels (Image>Adjustments>Levels in Photoshop) or press Ctrl+L to open the Levels palette. Immediately, with any tonally flat image, you'll see that the histogram is bunched in the middle. Looking below the histogram at the Output Levels bar, there'll be an absence of pixels over the black or white parts.

To restore the complete tonal range, simply click and drag the Black point slider to the right until that it meets the edge of the histogram. Now do the same with the White point slider. Click on and off the Preview box to see the difference that's being made between the original and adjusted tonal range.

Our image still looked a bit lifeless, so we introduced some shadow areas using the Black point slider. Press the alt key as you move the slider along, so you can see which areas are turning totally black – it's not always easy to see where the image falls into complete black and therefore loses detail. Try to avoid too many of these dense black shadow areas as the image will look too contrasty. The same goes for the highlights: to get a preview of them, use the Alt key as before, but this time using the White point slider.

In a regular image, the trick is to get the highlights in the image as close to white as possible without there being too much pure white (again you'll lose detail here). When you're done, just press OK.

AFTER

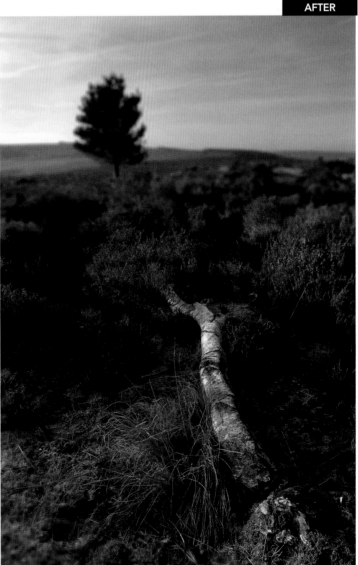

BEFORE

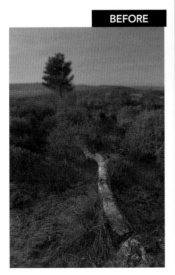

Hue/Saturation

Make colour changes and warm-up your landscapes

WHAT YOU NEED
PHOTOSHOP OR
ELEMENTS

WHAT YOU'LL LEARN
HOW TO ALTER
COLOURS

WHEN IT COMES TO COLOUR CHANGES, the Hue/Saturation palette will always be your first port of call. In one, easy-to-use interface, it offers a huge range of control and gives you the opportunity to boost or reduce the intensity of colour in an image, or alter the actual colours themselves. On top of that, it also allows you to make toned black and white versions of a pic with any colour you can imagine, and if that's not enough, you can even use it to change the colour of an individual item in a scene, or fix a common colour problem such as red-eye.

At the heart of the palette are three sliders – Hue, Saturation and Lightness – and these govern the actual colour used, the intensity of the colour and the luminosity or brightness of that colour.

Hue is measured in degrees, and takes us on a journey round the colour wheel, while Saturation allows you to go from minimum (no colour at all) to maximum (100% colour). Once your Hue and Saturation are confirmed, Lightness allows you to adjust the luminosity, taking the colour towards black or nearer to white.

What follows is a quick guided tour of the most useful aspects of the Hue/Saturation palette.

THE HUE/SATURATION PALETTE

EDIT
With Master selected, all the colours will be affected by the changes you make. If you opt for Reds, Yellows, Greens, etc, only colours from those groups will be adjusted. In this mode, custom colours can be picked by using the teet pipette eyedroppers.

✓ Master	⌘~
Reds	⌘1
Yellows	⌘2
Greens	⌘3
Cyans	⌘4
Blues	⌘5
Magentas	⌘6

SATURATION
This slider controls the volume or intensity of colour between -100 and +100. At the extreme left end of the scale (-100), all colour is removed, so the image becomes black and white, and at the right end (+100) the image will become grossly oversaturated.

LIGHTNESS
This controls the brightness or luminance. Like Saturation, Lightness is on a scale from -100 to +100, and at its minimum it will produce black, as no luminance is present. At the other end of the scale, Lightness will give maximum luminance, which is white.

COLOUR BARS
The top bar shows the original colours in the picture; the bottom bar shows what they have been changed to via the controls (ie, set Hue to 180º, and Cyan will appear under Red in the spectrum). When anything other than Master is in the Edit box, sliders between the bars appear, and these indicate the extent of the colours that will be affected by the changes.

HUE
This changes the actual colours in the image on a scale between -180º and +180º. When Colorize is ticked, Hue operates between 0º and 360º and runs through the colour wheel starting with Red at 0º.

OK
Clicking this button will confirm any changes made in the Hue/Saturation palette and apply them to your image. To save time, you can hit Return on the keyboard to achieve the same end.

CANCEL/RESET
Cancel quits out of the Hue/Saturation palette and restores the image to the state it was in prior to opening the palette. Hold Alt and Reset appears. This takes the image back without quitting the palette.

EYEDROPPERS
When Edit is set to anything other than Master, the eyedroppers allow you to sample colours directly from the image. The sampled colours will be the only ones affected by the changes to the Hue, Saturation and Lightness sliders.

PREVIEW
This shows you the effects of the Hue/Saturation palette in real-time on the actual image. It's normal to have Preview ticked all the time, and the common use is to toggle the button on and off to see the "before" and "after" effects of the changes you've made.

COLORIZE
When ticked, Colorize turns the palette into an extremely fast mono-toning machine! Move the Hue slider through a 360º spectrum of colours (starting with Red at 0º), and adjust the Saturation to get the intensity of toning you require.

BEFORE

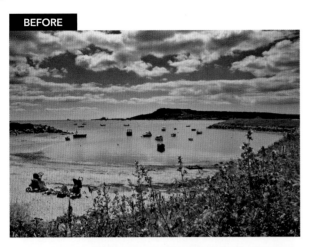

AFTER

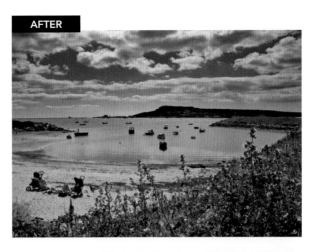

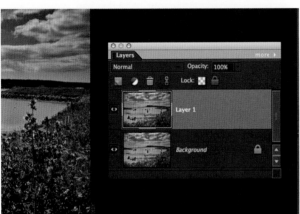

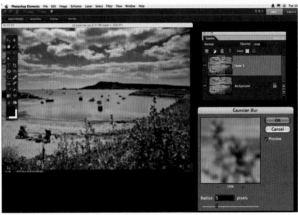

1 COPY THE IMAGE Open up a slightly under-saturated image from your archives and then go to Window>Layers to open the Layers palette. Drag the Background Layer over the Create a new Layer icon to make a Background Copy Layer, or hit Ctrl+J to make a copy called Layer 1.

2 BLUR THE COPY LAYER. With the new, top Layer active in the Layers palette, go to Filter>Blur>Gaussian Blur and in the dialogue box, enter a Radius of around 5 pixels or so. The whole image will soften and appear quite unusable, but don't worry, we'll fix that in the next step.

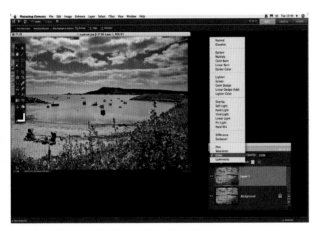

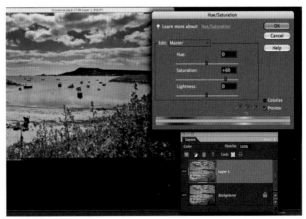

3 CHANGE THE BLENDING MODE In the Layers palette, click where it says Normal and select the Color Blending Mode from the bottom of the drop-down list. The blurred effect will disappear, as this special Blending Mode only allows the colours in the Layer to transfer through to the one beneath.

4 INCREASE SATURATION Hit the shortcut Ctrl+U on the keyboard, and the Hue/Saturation palette will appear on screen. Now crank up the Saturation slider, and you'll find you can push it much harder than you could before. When you get to an intensity you like, click OK to confirm the changes. Now Save.

BEFORE

Clone Stamp and Healing Brush

Improve your shots by removing unwanted distractions in minutes

WHAT YOU NEED
PHOTOSHOP OR
ELEMENTS

WHAT YOU'LL LEARN
TO USE THE HEALING &
CLONING TOOLS

THERE'S NOTHING MORE FRUSTRATING than returning home only to find a large blob of sensor dirt spoiling your shot. Distractions can be difficult to notice at the point of capture, so it's vital they're removed in your software if you want to achieve a flawless photograph.

Photoshop offers a range of great tools designed for getting rid of those irritating problems and the good news is they're easy-to-use and put into practice.

RE-TOUCHING TOOLS

The four main re-touching tools in Photoshop are the Clone Stamp tool, Spot Healing Brush, Healing Brush and the Patch tool. They all work on a slightly different principle, so it's important to know which tool to choose when it comes to removing an imperfection.

For blemishes and sensor dirt the Healing Brush gives the most seamless results. They can allow you to match the texture, lighting, transparency and shading of the sampled pixels to the pixels you're trying to heal.

For larger, more extensive distractions, the Clone Stamp tool is a safer bet as it allows you to sample and paint specific pixels over the area that needs fixing.

The main difference between them is that, instead of just cloning the pixels from the sample area and dropping them on top of the blemish you're correcting, the Healing Brush uses the texture of the sampled area and applies the tonal characteristics of the area around the flaw too. You still need to sample an area with the same basic colour, but you needn't worry about matching the colour exactly as you would with the Clone Stamp tool.

When you need to be precise with your Cloning and Healing it's important to use Selections around the blemish before you start removing them. Selections "fence in" the task, highlighting the area with a flashing line of dashes, or ring of "marching ants" that prevent you from damaging any of the pixels outside the area you're working on. Selections can quickly and easily be made with any of Photoshop's Selection tools (see page 102).

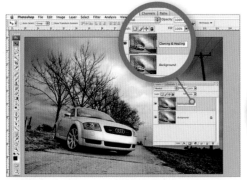

1 OPEN YOUR IMAGE Choose any image you want to "repair" and load up the Photoshop Layers palette by going to Window>Layers. Create a copy of the Layer to work on by going to Layer>Duplicate Layer. (We'll be covering Layers in more depth on page 114). Double-click on the new Layer's title and rename it "Cloning and Healing". Zoom in to your image 100% by tapping Ctrl+Plus, then hold down the spacebar and drag to scroll down to the flawed image area. There are lots of distractions to remove here: pits in the concrete road and the unsightly telegraph pole.

2 HEAL SMALLER BLEMISHES Select the Healing Brush from the toolbox, and in the Options bar set the Hardness of the brush to 100% and go for a small Diameter of 20px, to start with. Hold down Alt and sample a clean area of the image (here, the unblemished foreground concrete) lying close to the image flaw. Now release Alt and paint over the blemish to remove it seamlessly. If you make a mistake don't worry. Just hit Ctrl+Z to take one step back and try again. Move through the foreground at high magnification (Ctrl+Plus) to spot and remove any further blemishes in the same way.

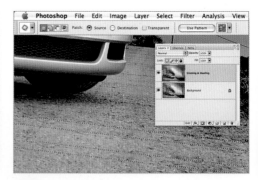

3 PATCH LARGER AREAS The gap in the road was rather distracting. To remove it, we hit Shift+J to switch the Healing Brush to the Patch tool. Check you've got New Selection and Source selected in the Options bar, then draw around larger distractions like this with the Patch tool. Holding Alt helps if you want to create straight lines. When "marching ants" surround the blemish, hover the Patch tool inside the Selection, dragging it downwards to choose the pixels for replacement. When the area has been patched, switch back to the Healing Brush to tidy up any remaining areas.

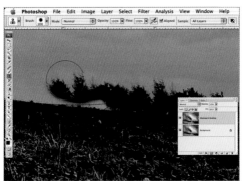

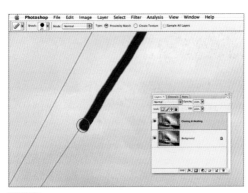

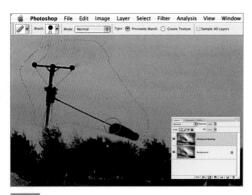

4 CLONE TO FILL SPACES To build up the hedge on the horizon, we selected the Clone Stamp tool. We set the brush size to 50px in the Options bar with Opacity set to 100% and Flow to 60%. We then moved to the base of the telegraph pole and Alt+clicked to take a Sample point from the dark hedge to the left. We slowly brushed over the base of the pole to remove it and replaced it with new hedge pixels. Increasing brush size to 100px, we took a sample point from the furthest right point on the hedge, then brushed along the ridge extending the hedge towards the car. Remember to take frequent sample points when cloning like this.

5 REMOVE HARD-EDGED ITEMS To get rid of the telegraph pole here we used the Healing Brush with a 50px diameter hard-edged brush to remove the rest of the main telegraph pole. Using a hard edged brush allows you to make neat edges that look sharp to the eye after any cloning and healing procedures. Again, it's important to take regular sample points by Alt+clicking as you go, otherwise you'll generate a mottled, patterned effect. We then switched over to the Spot Healing Brush to remove the wires, choosing a small 25px diameter brush from the Options bar, and brushing directly over the wires to take them out of the image.

6 USE A SELECTION AS A BARRIER To remove the wires right next to the hedge, we selected the Lasso tool from the toolbox to draw a Selection around them. A Selection will act as a barrier, preventing you from spoiling your earlier cloning work (for example here, by brushing too close to the hedge). We used the Spot Healing Brush again to clean up the pylon and wires inside the Selection. Finally, we scrolled round using the Spacebar to remove any other specs of sensor dirt with the Spot Healing Brush. Save your image with a new name, then flick the Cloning and Healing Layer visibility eye icon off and on to compare before and after.

AFTER

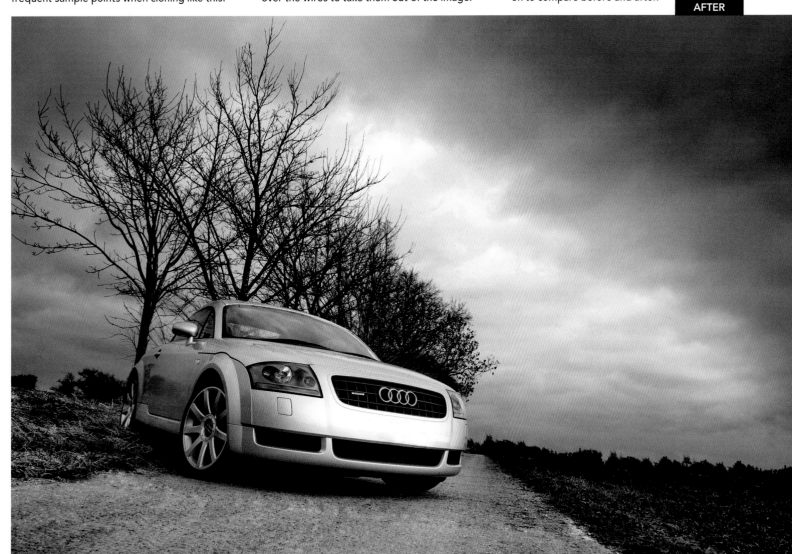

The Brush tool

Master the Brush tool for artistic cloud effects

BEFORE

WHAT YOU NEED
PHOTOSHOP OR
ELEMENTS

WHAT YOU'LL LEARN
HOW TO CONTROL
THE BRUSH TOOL

PHOTOSHOP'S TOOLBOX OFFERS a variety of painting tools, which are ideal for when you want to edit your shots or add new effects to an image. The main tool for painting effects is the Brush tool, which can play a number of different roles in day-to-day editing. It not only allows you to paint new pixels into your images using a variety of brush shapes and sizes, it also doubles up as an editing tool, which can be used to amend Adjustment Layers when you come to use Layer Masks.

BRUSH TOOL CONTROL

When using the Brush tool, the majority of the brushes and controls you need are found in the Options bar; the Opacity and Flow sliders are invaluable for fine-tuning how much "paint" (or rather, how many pixels) you want to put down, and the 27 different Blending modes govern how those effects are applied to the image. Brush sizes are also governed here: a brush has to be at least 1 pixel wide, and can be a maximum of 2500 pixels wide. You can either type a value into the box, or use the slider to alter size.

The real fun begins when you start experimenting with Photoshop's own brush pre-sets, located beneath the Brush Preset Picker in the Options bar. There's an astonishing range of shapes and sizes to use, but if you want maximum

control, it's vital that the Brushes palette (Window>Brushes) is opened at the same time. Here you'll be able to adjust thinks like tip shape, texture and smoothing.

From time to time it can be tricky to find the perfect brush for the image you're working on, so it's handy to know how to construct custom brushes should the need arise. The beauty of Photoshop is that it allows you to make brushes from any digital file, using your own digital images.

Useful tips include holding the Shift key as you draw to force the brush to stay on a straight horizontal or vertical line. Also, try holding shift and clicking on several different points of the canvas – the brush will draw straight lines between the points at which you click. On older versions of Photoshop, Refine Edge won't be there. Go to Select>Feather and use an 80px Feather Radius instead.

BRUSH TOOL KEYBOARD SHORTCUTS

] Increase brush size
[Decrease brush size
Shift +] Makes edge harder
Shift + [Makes edge softer

1 CREATE SOME CUSTOM BRUSHES Load up Photoshop and go to File>New. Set the Preset to International Paper and the Size to A4 then hit OK. Go to Filter>Render>Clouds. Select the Lasso tool (L) and input a 30px feather in the Options bar. Draw a circular Selection in a light area of the cloud document before going to Edit>Define Brush Preset. We named our brush "Steam Brush" and hit OK, then repeated the process in a dark area of the cloud document, naming the second, darker brush "Smoke Brush". You can use this same procedure to create clouds for any landscape scene.

2 DARKEN THE SKY For our steam train picture here we opened the train image and selected the Magic Wand tool (W), setting the Tolerance to 45 in the Options bar at the top of the screen. We then clicked on the sky to Select it and load the "marching ants" then went to Select>Refine Edge. We set Smooth to 15, Feather to 80px and Contract/Expand to –5%, then hit OK. Next we went to Layer>New Adjustment Layer>Levels and set the Black point slider to 65 and the midpoint slider to 0.65. Then we hit OK. This procedure will darken the sky so the steam looks more effective.

3 CREATE A NEW LAYER Next we created a new Layer on which to add the steam, by going Layer>New Layer, and naming it "Steam Effect". Tapping D on the keyboard brought our Foreground/Background colours to the default black and white. Tapping X, set white as the foreground colour. Selecting the Brush tool (B) from the toolbox we clicked on the Brush palette toggle icon in the Options bar to load the Brushes palette alongside the Layers palette, making sure we had the Brush Presets heading highlighted at the top of the palette.

4 SET UP THE STEAM BRUSH Scrolling through the brush menu we found our two custom Steam and Smoke brushes created in step 1. Clicking on the Steam Brush, we set Master Diameter to 300px, ticking Smoothing. Next we clicked on the Brush Tip Shape, made sure Spacing was ticked and set it to 30%. We reduced the Brush tool's Opacity to 10%.

5 ADDING THE STEAM Here we slowly painted above the chimney with the Brush tool to build up the steam effect. After applying a little steam, we hit the right square bracket key three times, increasing Brush Size to 600px, reducing Opacity to 6% before adding more white steam into the sky. This gave us a haze of white steam across a majority of the sky area. To define the plumes of steam, we increased the Steam Brush to 700px and painted white steam using a 10–12% Opacity.

6 ADD BLACK SMOKE To finish off, we hit X on the keyboard to switch our colours around. Moving into the Brushes palette we selected the Smoke Brush. Starting off with a Diameter of 500px and Opacity of 6%, gradually we started painting smoke out of the chimney and into the sky area. Using the square bracket keys helps vary the size of the brush, and we also varied Opacity between 4–6%. To soften the effect, select the Steam Brush and return to White (X). Use a 500px brush size in and around the smoke.

7 BRING BACK DETAIL Selecting the Steam Brush again, we set Brush Diameter to 90px, Opacity to 7% and Spacing to 50%. Painting around the engine cylinder and smoke box made it look as if there are a few steam leaks. Moving into the Layers palette, we selected the Steam Effect Layer and clicked the Add Layer Mask icon, at the bottom of the palette. Choosing a soft-edged Brush, we ensured the foreground colour was set to Black, then set the Opacity to 20% and the size to 65px. Zooming in to 100% (Ctrl +) we painted back any details, such as the chimney, that had been affected by the steam and smoke brushes. Finally, save the file as a .PSD to retain your Layers.

AFTER

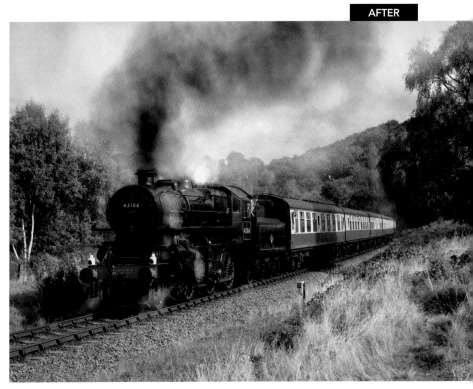

Sharpening the image

The Unsharp Mask v the High Pass Filter

WHAT YOU NEED
PHOTOSHOP OR
ELEMENTS

WHAT YOU'LL LEARN
HOW TO SHARPEN
IMAGES

OF ALL THE controlled sharpening techniques offered by Photoshop, Unsharp Mask (or "USM") is the most popular. The name itself may sound as if it's doing the opposite of what you want it to do but this isn't the case – the name is simply a term that has been carried across from the traditional darkroom.

The Unsharp Mask filter works by increasing contrast between light and dark pixels along defined edges within a picture and the intensity of this is controlled via three sliders: Amount, Radius and Threshold.

AMOUNT
This controls the amount of contrast between pixels at an "edge". The more you increase it, the stronger the contrast between darker and lighter pixels becomes. For hi-res images, somewhere around 100–150% is about right, but don't push it too far or you'll get a halo effect.

RADIUS
This determines how many pixels surrounding the edge pixels are affected during sharpening. The higher the value, the more pixels are affected. It's less evident on a print than on screen, so if a print is the desired outcome, make a test print and adjust the sharpening according to the results you get.

THRESHOLD
Threshold controls how different the pixels have to be in order to be classed as "edge" pixels and be affected by the Unsharp Mask. At a value of 0, every pixel is affected, but increase the value and adjacent pixels with similar tonal values remain unaffected, depending on the intensity chosen.

1 START BY CROPPING Open your image and crop it so it's ready to print at A4 size. Select the Crop tool and in the Options bar, enter a Width of 297mm, Height of 210mm and a Resolution of 300ppi. Now drag the Crop tool out from the top left of the photo to the bottom right – some cropping will occur – and then hit Enter.

2 MAKE SELECTION With the image ready to print, you can apply some sharpening but you don't want to sharpen the entire image – usually, sky can be left alone. With the Polygonal Lasso tool, make a quick Selection from just above the horizon, running downwards to take in the entire foreground. Feather this by 125px.

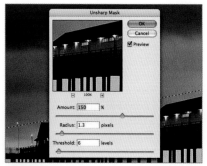

3 SHARPEN To get a clear idea what you're doing, zoom in so the image is at 100% and then go to Filter>Sharpen>Unsharp Mask. In the dialogue box, enter 150% in Amount, 1.3px in Radius and finally adjust the Threshold to 6 Levels. Once done, hit OK. Now hit Ctrl+D to get rid of the "marching ants" and you're ready to print!

THE HIGH PASS FILTER

The High Pass isn't grouped with the other sharpening filters, so this superb sharpening technique could well pass you by unless you know where to find it. It's actually hidden away under "Other" in the Filter menu. Whereas the Unsharp Mask is applied directly onto the image, the beauty of the High Pass filter is that it's applied onto a duplicate Layer and then blended, so it leaves the original image completely untouched.

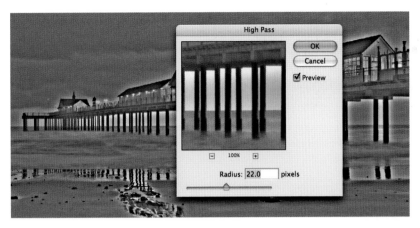

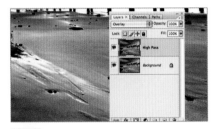

1 CROP AND COPY As with the Unsharp Mask technique, open your image and resize to A4 using the Crop tool. Now duplicate the Layer by going to Layer>Duplicate Layer and name this new Layer "High Pass". Hit OK. Bring up the Layers palette (Window>Layers) and change the Blending Mode from Normal to Overlay. You'll notice how the image contrast increases quite a bit.

2 APPLY SHARPENING Zoom in tight (around 100%) to get a clear view of the detail and, with the High Pass Layer highlighted in the Layers palette, go to Filter>Other>High Pass. In the dialogue box, enter a Radius of 5px and hit OK. It's probably still looking a bit too intense and over-the-top, so change the Opacity of the High Pass Layer to around 65%.

3 GET SELECTIVE We've made a sharpening adjustment over the entire image, but in reality we only want to apply the sharpening effect where it's needed. To make a Selection, hit the Add Layer Mask icon at the foot of the Layers palette and hit D then X to set Black as your foreground colour. With a large, soft-edged brush, paint out the areas where sharpening isn't required.

SHARPENING: HOW MUCH IS TOO MUCH?

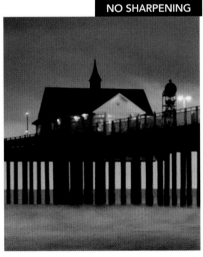
NO SHARPENING

Images with no sharpening will display slightly fuzzy edges when viewed at close quarters.

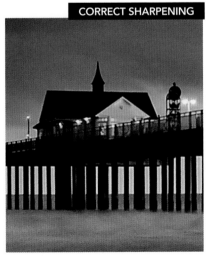
CORRECT SHARPENING

The correct amount of sharpening varies from image to image, but will show a crisp, tidy result.

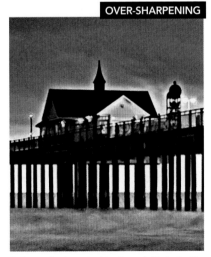
OVER-SHARPENING

If sharpening is pushed too far, ugly "halos" will appear around the edges within the picture.

Making Selections

Use the Selection tools to "fence off" image areas

IF YOU'VE FOLLOWED OUR PROJECTS SO FAR, you'll already have a good idea about what Selections are, as well as Layers, since these two heavyweights of imaging tend to work together.

In the simplest terms, a Selection involves choosing an area of an image to modify or mask. Once you've done this, and completed the Selection, the area will be surrounded by dotted lines known affectionately as "marching ants". When these appear, you've successfully made a Selection, and that means you can now change the part you've "fenced off". You can delete it, copy it, flood it with colour, turn it into a new Layer, adjust its colour and contrast, or even drag it into an entirely new image. You can also change its size and shape by hitting Ctrl+T and dragging the handles that appear on the Transform command's bounding box.

Selections can be made using a variety of specific tools. These work either manually, where you effectively draw around the area you want using your mouse, or they can be made using pixel values, for instance allowing you to select all the white or black areas in an image simultaneously.

To make a Selection, you need to decide which part of the pic you want to fence off first, then use your knowledge and experience of the Selection tools to decide which one is the most appropriate. In all cases, the "most appropriate" is always the tool or method that gives the best results in the shortest possible time!

If you've made a Selection you're unhappy with or have "marching ants" still active after making an adjustment, just press Ctrl+D on the keyboard, or go to Select>Deselect to get rid of them.

THE SELECTION TOOLS

RECTANGULAR MARQUEE TOOL
Select this tool and you'll be able to make a rectangular Selection over a section of your image simply by clicking with your left mouse button, dragging the mouse and then releasing. The shape can be as small or as large as you like and you can keep it square by holding down the Shift key as you drag. The keyboard shortcut for this tool is N.

ELLIPTICAL MARQUEE TOOL
Usually found by clicking the left mouse button on the Rectangular Marquee tool and holding it down until the menu appears, the Elliptical Marquee tool functions in much the same way, but draws an ellipse instead. If you want a perfect circle, just hold down the Shift key as before.

LASSO TOOL
The Lasso tool works just like drawing onto the image with a pencil, so it's great for making loose, sweeping, freehand Selections. For more fiddly work, the Polygonal Lasso is better.

MAGNETIC LASSO TOOL
The Magnetic Lasso tool lets you make a Selection based on the contrast within your images. On picking the tool, run it over part of the picture and you'll see it "stick" to any edges it finds based on the settings you make in the Options bar.

Rectangular Marquee Tool — M
Elliptical Marquee Tool — M

Lasso Tool — L
Magnetic Lasso Tool — L
Polygonal Lasso Tool — L
Quick Selection Tool — A
Selection Brush Tool — A

MAGIC WAND TOOL
The Magic Wand tool lets you select individual colours or tones in the image using a Tolerance setting. Just click on any part of the picture and "marching ants" will appear based on your preferences.

SELECTION BRUSH TOOL
This functions just like a regular brush, but instead of painting in a colour, you paint a Selection. The brush can be changed in size and shape, and by applying softness to its edge you'll get a pre-Feathered Selection.

QUICK SELECTION TOOL
Functioning a bit like a real-time Magic Wand tool, the Quick Selection tool will produce an intuitive Selection wherever you apply it to the image. Sweep it over a blue sky, for example, and the whole area will be quickly surrounded by "marching ants".

POLYGONAL LASSO TOOL
A very accurate and easy-to-use Selection tool, the Polygonal Lasso lets you click around whatever part of the image you want to select, making even complex shapes and objects easy to adjust.

THE MARQUEE AND LASSOO TOOLS

Despite the inclusion of automated Selection tools such as the Magic Wand tool and Quick Selection tool in Photoshop and Elements, it's fair to say that the manual selection methods offered by the Marquee and Lasso tools offer the most flexibility and best results for photographers.

Making Selections is all about taking control and these manual tools offer you the ability to fine-tune the areas you've selected by hand, rather than relying on the computer to "guess" which parts of the image should be within the "marching ants". The Marquee and Lasso tools are 100% controlled by you, so you can be sure you're getting exactly the size or shape of Selection that you want.

These manual Selection tools are encompassed by the Rectangular Marquee tool, the Elliptical Marquee tool, the Lasso tool, the Polygonal Lasso tool and, to a lesser extent, the Magnetic Lasso tool. They're all useful in their own different ways, so the real question is, which method should you use in which circumstances? The answers lie in these illustration diagrams. We'll also look at the importance of Feathering your Selections – a very important step in making photo-real adjustments.

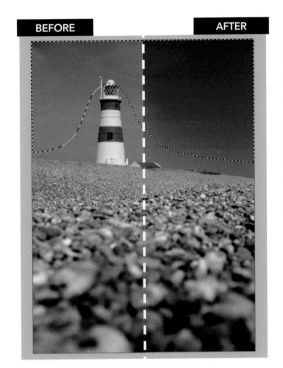

BEFORE | AFTER

THE LASSO TOOL
The Lasso tool is best used to make broad Selections, but unlike the Marquee tools, there's no predefined shape it has to follow. This makes it a good choice if you want to quickly select a portion of the image which won't respond well to a straight line. For example, if you want to darken a sky that has a building projecting into it (as shown here) you can simply draw around it in a smooth freehand curve.

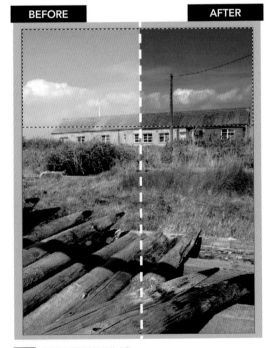

BEFORE | AFTER

THE RECTANGULAR AND ELLIPTICAL MARQUEES
Click and drag out one of the Marquee tools to make broad Selections over large parts of your image. The Rectangular Marquee is great for selecting skies to darken, while the Elliptical Marquee lets you add creative vignettes and other circular effects.

BEFORE | AFTER

THE POLYGONAL LASSO
The Polygonal Lasso tool is a bit of a mixture between the Marquee tools and regular Lasso tool. You can use it to select complex objects, but with a lot more control than the Lasso tool, because the process is controlled by single clicks of the mouse instead of being freehand. This is great for precision, but don't click too fast or the Selection will be completed.

THE MAGIC WAND
Ideal for quick
Selections based on
colour or tone. Be
sure to set the Wand's
Tolerance correctly,
and check whether
you want to select just
those Contiguous
tones close by, or all
areas of the same
tone throughout the
picture.

MAKING SELECTIONS USING COLOUR AND TONE

Quick and easy Selection methods can work wonders – as long as you know how to use them the right way. Although most photographers favour the control and flexibility offered by the Marquee and Lasso tools, there can be times when the automated options within Photoshop and Elements will work just as well.

A great example of this is the Magic Wand tool which, although limited in its usefulness on many pictures, can really come into its own if large areas of flat colour need to be selected quickly.

Clear blue skies are an obvious candidate for this and in the picture below, we managed to select the whole sky with a single click using the Magic Wand tool, even negotiating the tricky lighthouse that's cutting into it.

Getting an accurate selection using the Magic Wand tool is all about setting its Tolerance correctly. Too low a setting and not enough pixels will be selected – too high and the Selection will "creep" into unwanted areas of the image.

WHAT'S CONTIGUOUS?

Another important setting for the Magic Wand tool is the Contiguous box. If ticked, the selected pixels will be grouped around the point where you clicked, but if unticked, every pixel in the image within the set Tolerance will be selected – all the blues, for instance, when you only wanted to pick out the sky. So, make sure you give the Magic Wand a try, but be aware of its limitations.

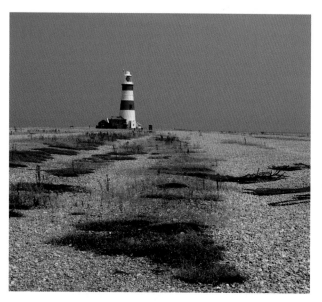

IMAGE AS SHOT

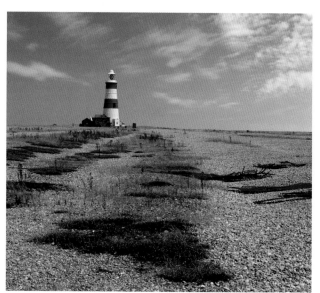

FINAL MANIPULATED IMAGE WITH ENHANCED SKY

MAGIC WAND OPTIONS

TOLERANCE
This setting controls how sensitive the Magic Wand tool will be when you click on a pixel in the image. Low Tolerance will only select colours close to the one you clicked on, while high Tolerance has the opposite effect.

CONTIGUOUS
This button allows you to choose whether all similar colours and tones in an image will be selected, or only those "joined on" to the first pixel you clicked.

ALL LAYERS
If you're working on a multi-layered image, this option allows you to select pixels other than those on the Layer you're working on.

FEATHERING

As soon as you've mastered the basic Selection tools such as the Lassos and Marquees, you're ready to learn about Photoshop's most valuable Selection feature – Feathering. This is all to do with softening the edge around an area you've cordoned off, and it's a crucial part of the Selection technique if you want to blend one area into another after you've made some imaging adjustments.

Feathering is something that you need to get the hang of because if it's disregarded you'll end up with unsightly, hard edges on your Selections. This is often the biggest give-away that an image has been retouched, so it's good to get into the habit of adding some feathering immediately after a Selection has been made. Get into this routine and you'll be on the right track to making seamless adjustments to your shots.

There are three ways of feathering a Selection. The quickest is by inputting a Feather amount in the Options bar (provided you have a Selection tool highlighted in the toolbox). As soon as you've made a Selection, the feathering will be automatically applied. This is fine if you know you've got lots of Selections to make and you want all their edges softened by the same amount, but for most uses, it's better to keep this option set to 0px, and head to Select> Modify> Feather (Select>Feather in pre-CS3 versions), adding the specific amount you want for each Selection.

The third way is by using the Refine Edge command in CS3 and CS4. This uses a Feather slider and actually shows how the feathering affects the Selection.

FEATHERING DIFFERENT SELECTIONS

Different Selections require different amounts of Feathering. For highly detailed Selections that have been made using the Pen tool or Polygonal Lasso, a Feather Radius of 0.5 pixels is just enough to soften the edge and prevent the adjustment bleeding into the non-selected area.

When making Selections around general objects, a Feather of around 30–40 pixels is enough to soften the edge. It's only when we want a more graduated softened effect, such as between a sky and a foreground, that a much larger Feather Radius (200 pixels or above) needs to be used.

The Feather Radius can be set anywhere between 0 and 250 pixels in the Options bar, in the Feather dialog and with the Refine Edge slider.

0 PIXELS **10 PIXELS** **30 PIXELS** **60 PIXELS** **100 PIXELS**

USE FEATHERING TO PRESENT YOUR PICS
Feathering can be used creatively, as well as being used to soften a Selection's edges. If you're looking for a slightly different way of presenting your pics, try making a stylish vignette effect. Just use the Elliptical Marquee tool with a large Feather Radius.

BROAD OR FINE?

THE FEATHERING COMMAND gives you the option of having a hard edge to the Selection you've made, or a soft, fuzzy one. And unless you're doing purely graphical work, you'll normally need to apply at least a little feathering to your Selection, so that any changes you make don't look out of keeping with the rest of the photo. Feathering can be set from as little as 0.5 pixels all the way up to 250 pixels and this broad range means there'll always be the correct amount for whatever picture you're editing. Just go to Select>Refine Edge to bring up the options.

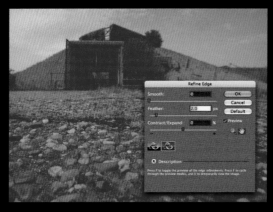

FINE FEATHERING
Here, the red Feathering mask (selectable at the bottom of the palette) shows there's very little Feathering being applied to this Selection. In this case we're just using 1px, which means that the softening will be applied 1 pixel either side of the Selection. Use small amounts like this if you're making Selections along the edges of in-focus objects and match the Feathering to the fuzziness of the edge, guaranteeing any adjustments you make won't look out of place in your picture.

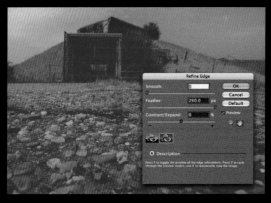

BROAD FEATHERING
Here the mask shows a lot of Feathering has been applied. This kind of broad feathering is vital for graduated effects that you apply to your images and here we've set it to the maximum of 250px. There are lots of times when using broad Selections will lead to better, more realistic editing – darkening a sky or lightening a foreground for instance is the perfect time to bump up the Feathering and get a subtle blend. The amount you need to use will depend on the resolution and pixel dimensions of the picture, but only small, low-res files will need less than 100–250 pixels.

EDITING SELECTIONS

Once you've made a Selection of one part of your image it can still be amended and fine-tuned to suit your needs. We've already looked at adding softness to the edge of your Selection using Feathering, but there are lots more options on offer.

Pick one of the Marquee or Lasso tools, then check out the Options bar and you'll see some similar settings to those below. The most important and useful of them are the four icons that modify how your Selection is made and whether you can add or remove from it.

With the New Selection option set, using any of these Selection tools will start a new Selection and discard any "marching ants" that were already active. However, if you set Add to Selection or Subtract from Selection, you'll be able to increase or decrease the areas covered, just by running the right tool over it. Adding and subtracting from the Selection can also be done by holding the Shift or Alt keys respectively, as you use the tool.

If you want to assess how good your selective adjustment is looking at any point, just press Ctrl+H key on the keyboard and the "marching ants" will be hidden. To reveal them again, just press Ctrl+H once more.

THE SELECTION-EDITING OPTIONS

FEATHER
This is a pre-set Feathering option that will be applied to the Selection as soon as you make it. However, this is best left at 0px and Feathering set after making the Selection.

MODE
Selectable between Normal, Fixed Aspect Ratio and Fixed Size, this option lets you constrain the selected area if you're using one of the Marquee tools. Settings can be made in the Width and Height boxes to its right.

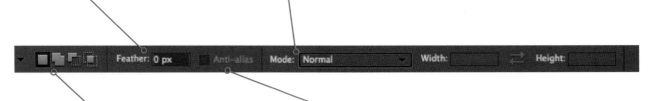

MODIFYING BUTTONS
Click on any one of these buttons and you'll be able to edit the way your Selection is made. Working from the left: New Selection cancels any previous "marching ants" and fences off a whole new area of the image; Add to Selection, Subtract from Selection and Intersect with Selection each allow you to modify existing areas fenced in by "marching ants".

ANTI-ALIAS
If turned on, this option will add a little extra softness to the edge of the Selection you've made. For work on photos it's best turned on as this automatically gives a more natural look to any adjustments you make.

MODIFYING AND SAVING SELECTIONS

Even more refinements can be made to your Selection using the Select>Modify command. Once the Selection is active, it can be contracted or expanded by a given amount of pixels (1 to 100) and this is very useful for shaving a couple of pixels off your Selection and making it fit more seamlessly to a subject. Select>Modify also allows you to smooth any unrealistic hard edges and even make a border along the selected pixels. Even more handy is the ability to save your Selections for use later in the editing process. You can do this by going to Select>Save Selection..., but you'll need to then save your image as a Photoshop document (.PSD) if you want the Selection to be available after you close and reopen the image. To restore the "marching ants", just go to Select>Load Selection...

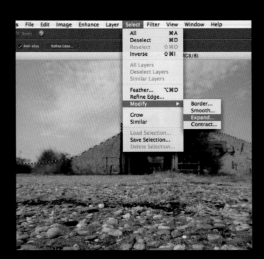

Using the Select→Modify command allows further fine-tuning of your Selections

EDIT A SELECTION (ELEMENTS)

Becoming better acquainted with the Selection tools will help you make selective adjustments to your images that are seamless and hard to spot. Here we've taken a simple landscape and applied several different techniques – using the Marquee and Polygonal Lasso tools, and Feathering Selections via the Select>Refine Edge command – to mask the landscape (in red) before darkening the sky using Levels.

BEFORE

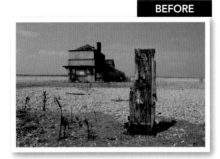

1 MAKE A SELECTION Open an image like the one above, which has a building jutting into the sky. Now pick the Rectangular Marquee tool and drag it out over most of the sky. Go to Select>Refine Edge and use a broad Feather amount of around 200 pixels. You'll see a nice even blend between the sky and the land. Now press OK.

2 CUT INTO THE SELECTION Now pick the Polygonal Lasso tool from the toolbox and set it to Subtract from Selection in the Options bar. Next click along the line of the building and back around the bottom of the image to where you started. Go back to Select>Refine Edge but now set Feathering at 0.5–2.5px and you'll see a harder edge mixed with the soft one.

3 MAKE YOUR ADJUSTMENTS Press OK to exit the palette, then Ctrl+L to bring up the Levels palette. Click and drag the Black and White point sliders in to meet the ends of the chart and the middle slider to the right. You'll see the sky gets darker, but the rest of the image remains untouched. Finally press OK, then Ctrl+D to deselect.

AFTER

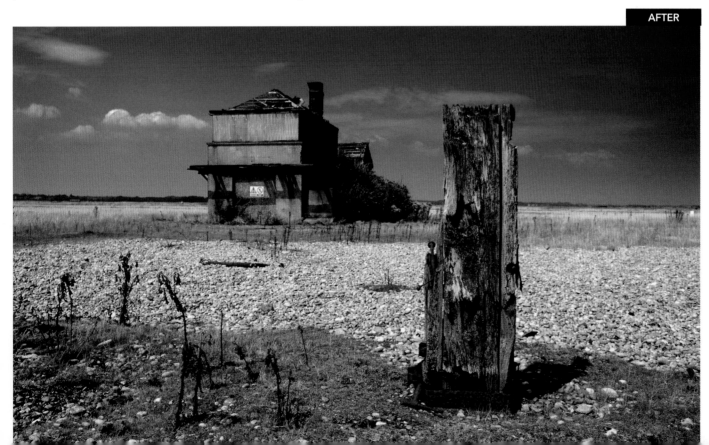

THE PEN TOOL (PHOTOSHOP)

When it comes to making Selections in your images, it's easy to be overwhelmed by the number of tools on offer inside the toolbox. The Lasso tools are great for making quick Selections but they're not always 100% accurate and require a super-steady hand on your mouse (or graphics tablet) if you're to avoid jagged edges. If you want to achieve the very best Selections when isolating the subjects in your images, it's vital you master one of the most precise tools Photoshop has to offer – the Pen tool.

If you've never experimented with the Pen tool before, it's important to understand that it works on a different principle to all of the other Selection tools in the toolbox. Instead of creating the usual "marching ants", the Pen tool lays down a Path, allowing you to make sweeping lines and adaptable curves around the outside edges of a subject. Once a Path is complete it can then be turned into a regular "marching ants" Selection by using the Paths palette (Window>Paths).

CREATING A PATH

To start a Path around your subject, you need to place what's known as an Anchor point (a small grey square) between the pixels of your subject and the pixels of the background with the Pen tool. By adding more Anchor points and using the Control points attached to them you'll be able to curve the Path to the contours of your subject and you'll soon find it's easy to manoeuvre your Path and bend it to whichever shape you wish.

It's so flexible and accurate that the Pen tool is often the first tool that professional photographers and retouchers turn to when it comes to making precise Selections. So, to start using it to its full potential, follow our step-by-step project opposite, and you'll soon be creating Paths and Selections around your subjects like a pro.

Once you've made a Path around the outside of a subject with the Pen tool, it will show up in your Paths palette. To access the Paths palette, head up to Window in the Menu bar and select Paths.

This palette offers all the options you need to save your Path and turn it into a precise Selection. Also, if you want to save your image with a Path attached for later use, the Path will be included with all file types, including TIFF, PSD and even JPEG.

If you want to retain the Path you've drawn after saving, you'll need to click in the Paths palette menu and select Save Path... You can then save the image as a JPEG and still return to the Path at a later date.

EXPERT ADVICE

CREATING A PATH USING THE PEN TOOL

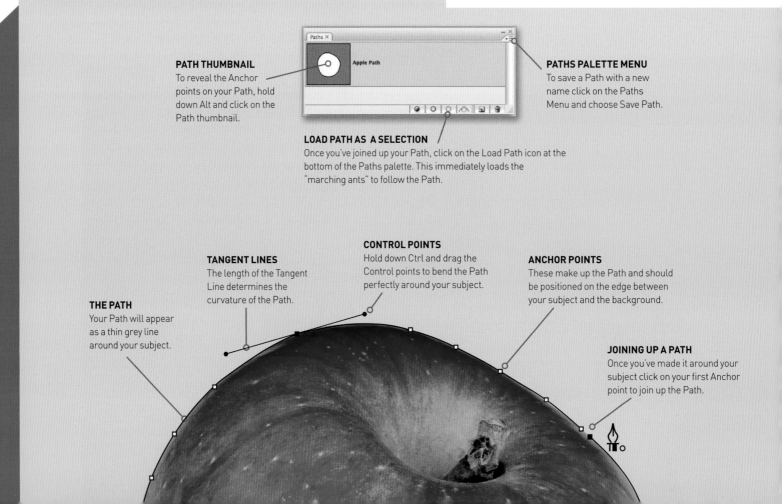

PATH THUMBNAIL
To reveal the Anchor points on your Path, hold down Alt and click on the Path thumbnail.

PATHS PALETTE MENU
To save a Path with a new name click on the Paths Menu and choose Save Path.

LOAD PATH AS A SELECTION
Once you've joined up your Path, click on the Load Path icon at the bottom of the Paths palette. This immediately loads the "marching ants" to follow the Path.

TANGENT LINES
The length of the Tangent Line determines the curvature of the Path.

CONTROL POINTS
Hold down Ctrl and drag the Control points to bend the Path perfectly around your subject.

ANCHOR POINTS
These make up the Path and should be positioned on the edge between your subject and the background.

THE PATH
Your Path will appear as a thin grey line around your subject.

JOINING UP A PATH
Once you've made it around your subject click on your first Anchor point to join up the Path.

HOW TO USE THE PEN TOOL

Many photographers are slightly intimidated by the Pen tool, thanks mainly to its roots in graphic design and the awful mess you can get yourself in if you don't know how it works! All those Anchor points, Paths and Bézier curves make it seem terribly complex, but, with just a little practice, you'll find it's a very useful tool to use, especially if you want to make Selections along subtle curves or organic shapes – the Polygonal Lasso tool can leave unsightly angles, but the Pen tool tackles those curves with ease. It's only available in the full version of Photoshop, but it's certainly one of the tools that makes the extra outlay worthwhile.

START

1 PICK THE PEN TOOL To use the Pen tool, open up an image with a smooth curve in it, such as this historic church interior, then pick the Pen tool from the Photoshop toolbox. Next, in the Options bar, make sure the tool is set to Paths (the middle of the three boxes on the left), and Add to path area (+). Next, go to Window>Paths and zoom in on the curved object. Now you're ready to start using the Pen tool.

2 MAKE A PATH Click on the edge of the curve – here the rim of the foreground bowl at the left of the picture, and an Anchor point will appear. Now click again, a little further along the curve, but this time, keep the mouse button held down and drag the cursor to the right. A Control point will appear. Release the mouse button, then hold Ctrl and pull the Control points, altering the path's shape to match that of the curve.

3 CONTINUE THE PATH Before you add another Anchor point, hold the Alt key, click on the second Anchor point and the right Control point will disappear. Continue your path in this way all along the curve, down the side and back to where you started. If you need to amend any of the Anchor points or curves, just hold the Ctrl key and click on them to make them active.

4 MAKE THE PATH INTO A SELECTION Once the path is complete, click on the down-facing arrow in the Paths palette and choose Make Selection... set its Feathering to 0.5px and press OK. Your ultra-accurate selection is now ready for use: we used ours to darken and blur the background, without altering the bowl in the foreground.

Using the Pen tool to select around the shape of the bowl allows us to blur and darken the background.

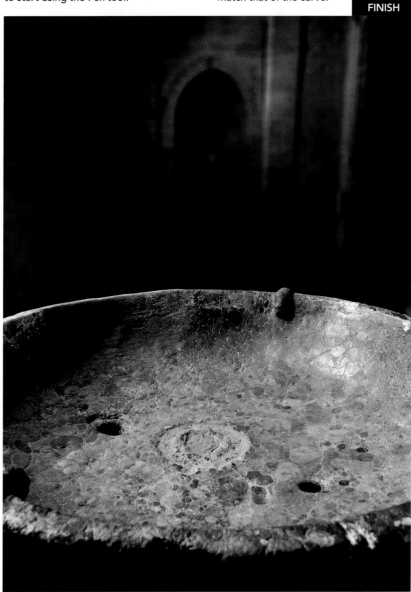
FINISH

RETOUCHING A DIGITAL PORTRAIT

Pretty much every portrait you see in a magazine or advert has had some kind of retouching done on it – even some of the world's top models have a retouch list that would easily fill a couple of A4 sheets – and that's after a professional make-up artist has been at work. Every element has been controlled and adjusted to create the perfect image.

In our everyday photography there's no need to go to those extremes, but digital retouching techniques are very useful to master and will soon become integral to your digital workflow.

Though removing skin blemishes and marks is probably what most people think of when you refer to retouching, there are other tricks of the trade that you can apply to your shots, too – anything from removing the reflection of the flashgun to getting rid of stray hairs.

You might find the thought of re-touching portraits of friends or family slightly strange, but you're not going to be dramatically changing their appearance – just improving the image as you might with any other type of subject matter.

With this shot, we've got a great start image with a very attractive model, but we can still do a few things to improve the final image – and these techniques can be applied to any portrait.

1 OPEN THE IMAGE This portrait was a RAW file, so when we clicked on it, it automatically launched Photoshop's RAW file converter. These first four steps are alterations made using the RAW conversion software: first we adjusted the Temperature to warm the shot up, as it was looking a little cool. We warmed up the portrait by dragging the slider to the right until it read 4900, and left the Tint as it was.

2 ADJUST FILL LIGHT Leaving the Exposure slider where it was, we adjusted the Recovery slider (available in Camera RAW 4 or higher) to bring back some detail on the model's shaded cheek. Tap O on your keyboard, and the patches of red show where highlight detail has been lost. Enter 6 on the Recovery slider to bring this back. With the shadows, tap U and set the Fill Light slider to 15 – reducing it dramatically.

3 CLARITY AND VIBRANCE Leaving Brightness and Contrast alone we moved onto Clarity and Vibrance (again, only on Camera RAW 4 or higher). Clarity boosts the contrast in the midtones of the image, so we increased this to 10. Moving on to Vibrance, this increases the colours that are the least saturated in the image, so we bumped this up to +21.

4 INCREASE SATURATION Finally, we increased overall Saturation to +8 then clicked on Open Image. Once the image has opened up in Photoshop, go to Image>Adjustments>Levels. In the pop-up box, drag the arrow on the right inwards until it reaches the start of the histogram and click OK. We can now begin re-touching in Photoshop.

5 HEAL THE PICTURE Zoom in and from the toolbox, select the Healing Brush. Pick a brush size of 40px and find a blemish. First thing to do is hold down Alt and click on a smooth area of skin near the blemish – this will act as a source point. Now release Alt and then paint over the blemish. Do this over the rest of the image, until all minor skin blemishes have been removed.

6 BRUSH OVER Pick the Brush tool and set a Brush size of 175px, with an Opacity of 20%. In our shot, the flash has reflected off the bridge of the nose; to remove the highlight, we held down Alt so the eyedropper icon appeared. Now, select a skin tone on the nose, release Alt and then lightly brush over. You can also brush over other areas too – remember to use the eyedropper to match the skin tone.

7 CLONE OUT HAIRS To remove stray hairs, it's easier to use the Clone Stamp tool, as it deals better with contrast. Select it from the toolbox and use a Brush size of 25px. In the same way that you used the Healing Brush, hold down Alt and click on an area you want to clone from, release and then click on the hair. You may have to continually select areas to clone from.

8 LIGHTEN EYES Finally, we'll lighten the eyes a little. Select the Dodge tool from the toolbox – often hidden underneath the Burn tool. You'll need a Brush size of 90px. Set the Range to Highlights and Opacity to 15%. Zoom in on one eye and lightly run round the iris and the white of the eye.

FINISH

Transform Selections

START

Use Transform to manipulate foreground and background

WHAT YOU NEED
PHOTOSHOP OR
ELEMENTS

WHAT YOU'LL LEARN
RESIZE IMAGE
COMPONENTS

YOU CAN'T ALWAYS GET THE PERFECT ANGLE or shooting position when you're out with your camera because many subjects don't allow it. First, you may be restricted by the nature of the location itself – a few steps to the left is impossible if you're on the edge of a cliff, and finding a lower angle is equally inappropriate if you can only shoot from the roof of a Land Rover. Second, you may have no control over the position of the main focal point in your shot.

By trimming off pixels with the Crop tool, you can recompose a scene in a basic way, but you're always limited to the way elements are fixed in relation to one another.

This great digital technique is different, because it allows you to resize and reposition different parts of a scene using the Free Transform command. We'll start from scratch with a

RAW conversion and, after we've squared up the image, we're going to resize and reposition the subject and the background separately. After that, we're going to improve the contrast to give the image more "bite". Finally, we're going to apply a warm-up effect using Levels to make the image more attractive.

Though we've used a shot taken on safari in Kenya, these techniques can be applied successfully to a wide range of different images, from landscapes to portraits. Once you've mastered the techniques, you'll be more likely to take shots that don't quite work, because you'll be safe in the knowledge that you can adjust them later.

1 CONVERT THE RAW FILE Clicking on a RAW file will automatically launch your conversion software. We're using Adobe Camera RAW. First, rotate the image if need be, then adjust the sliders to get the image looking just how you want it. We went for settings of 6000, +14, +0.75, 10, 67, +25, +6. Click OK or Open and the image will launch in Photoshop.

2 STRAIGHTEN UP Open the Layers palette and copy the Background Layer by dragging it over the New Layer icon. Create some space round the image by holding Ctrl and tapping minus, then hit Ctrl+T to enter Transform mode. To straighten the horizon here, we held the Ctrl key and pulled out the corner "handles". Click Enter when done.

3 SELECT THE FOREGROUND To select the bottom half of the image we used the Rectangular Marquee tool and went to Select>Feather. We entered a Radius of 150 pixels and clicked OK. By tapping Ctrl+J, the selected area was placed into a separate Layer at the top of the layer stack.

4 ENLARGE THE FOREGROUND Tapping Ctrl+T gave us an Options bar at the top of the screen. Linking Width and Height together using the link icon, by entering 160% in the Width box we then moved the zebra to one side to make it more dominant in the foreground.

5 PERFECT THE BLEND To create a seamless join we used the Eraser tool and a soft-edged brush of about 800 pixels (use the square bracket keys to adjust brush size). In the Options bar, we reduced Opacity to about 50% then swept along the join in a straight line to get a realistic blend between the original background and the enlarged foreground.

6 ENLARGE THE BACKGROUND In the Layers palette, we clicked on the Background Copy Layer and selected the top part of the image with the Rectangular Marquee tool. Feathering 100px we hit Ctrl+J to put it in a new Layer. Tapping Ctrl+T, we enlarged Width and Height to 150%. We put the mountain on the skyline and tidied its edges with the Eraser tool.

FINISH

7 DARKEN THE SKY By selecting the top part of the sky (down to the mountain summit), then Feathering using a large Radius of 250 pixels we created a Levels Adjustment Layer and moved the Black point slider gradually inwards until we had a darker sky with a nice, smooth blend. For this image, we used a setting of 77 in the first Input Levels box.

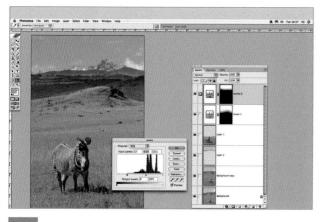

8 BOOST CONTRAST Selecting just the sky and mountain, we Feathered the Selection by 150 pixels, and made another Levels Adjustment Layer. We moved the sliders to get Input Levels of 57, 0.93 and 255, then clicked OK. This increased contrast a little more in the selected area and reduced some of the haze that's in the shot. Click on OK and you're done.

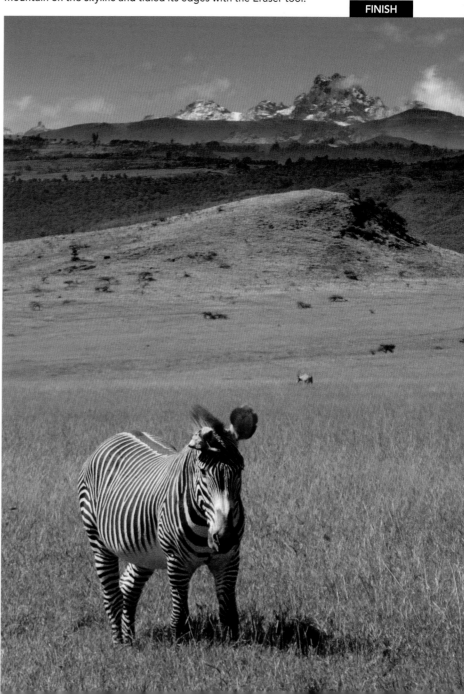

Understanding Layers

The concept of Layers is the key to getting to grips with Photoshop

WHAT YOU NEED
PHOTOSHOP OR
ELEMENTS

WHAT YOU'LL LEARN
HOW TO USE LAYERS

THINK OF A PICTURE AS A SERIES OF SEPARATE PARTS making up the whole, and you'll be well on the way to understanding what Layers are all about. Digital imaging is about changing the way a picture looks (hopefully for the better!), and to make changes to a particular area of a picture, you first have to isolate it from the rest of the scene you've got up on screen.

If you don't do this, then the changes you make will affect the whole image. Of course, some changes are global, and if you want to make a contrast or colour adjustment to the entire picture, then you don't need to use Layers. But as soon as you want to affect just one specific area and not the whole thing, then Layers become vitally important. What's more, Layers allow you to change the size and position of certain parts of an image independently.

Think of Layers simply as a way to isolate and change parts of your picture so you can adjust them separately, and suddenly they're not quite as scary.

If you're having trouble seeing the thumbnails, click on the flyout arrow at the top right of your Layers palette, pick Palette Options and increase their size.

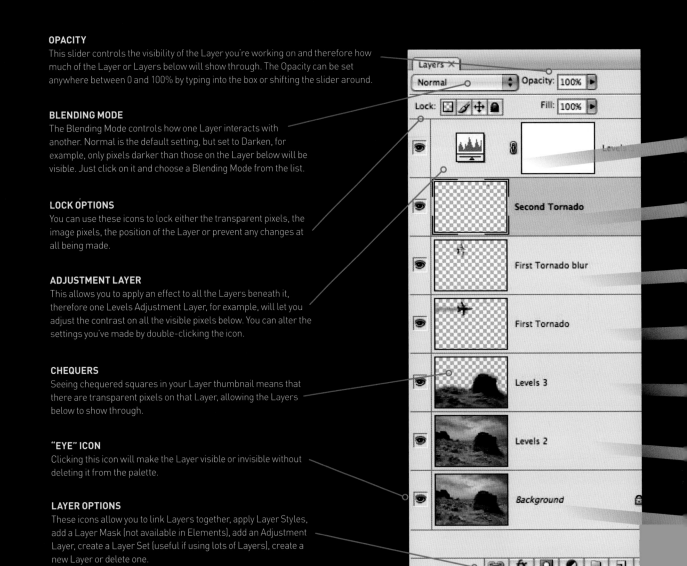

OPACITY
This slider controls the visibility of the Layer you're working on and therefore how much of the Layer or Layers below will show through. The Opacity can be set anywhere between 0 and 100% by typing into the box or shifting the slider around.

BLENDING MODE
The Blending Mode controls how one Layer interacts with another. Normal is the default setting, but set to Darken, for example, only pixels darker than those on the Layer below will be visible. Just click on it and choose a Blending Mode from the list.

LOCK OPTIONS
You can use these icons to lock either the transparent pixels, the image pixels, the position of the Layer or prevent any changes at all being made.

ADJUSTMENT LAYER
This allows you to apply an effect to all the Layers beneath it, therefore one Levels Adjustment Layer, for example, will let you adjust the contrast on all the visible pixels below. You can alter the settings you've made by double-clicking the icon.

CHEQUERS
Seeing chequered squares in your Layer thumbnail means that there are transparent pixels on that Layer, allowing the Layers below to show through.

"EYE" ICON
Clicking this icon will make the Layer visible or invisible without deleting it from the palette.

LAYER OPTIONS
These icons allow you to link Layers together, apply Layer Styles, add a Layer Mask (not available in Elements), add an Adjustment Layer, create a Layer Set (useful if using lots of Layers), create a new Layer or delete one.

FINISHED COMPOSITE

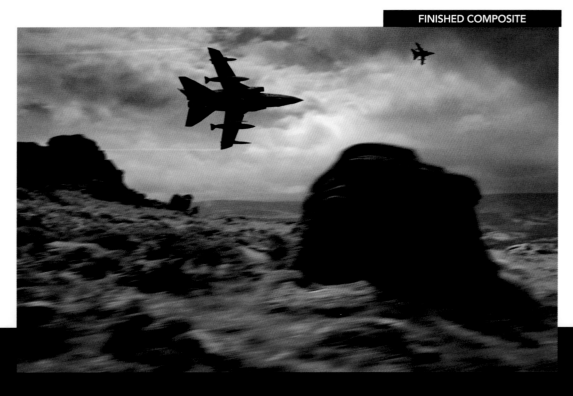

ADJUSTMENT LAYER
This Levels Adjustment allows us to fine-tune the contrast in all the Layers below it.

SECOND AIRCRAFT
Most of this Layer is taken up by transparent pixels allowing all the Layers below to show.

BLURRED AIRCRAFT EFFECT
Blurring the plane on this Layer, then deleting some of it, lets us apply a motion effect.

FIRST AIRCRAFT
Having the Tornado on a Layer above the background allows you to change its position.

BLURRED FOREGROUND
More blurring has been applied to this Layer than the one below, building up the effect.

BLURRED BACKGROUND
The Background Layer has been copied letting us blur it without damaging the original.

BACKGROUND LAYER
The original Layer, as shot, forms the base to the stack of Layers in the palette.

Working with new Layers

How to adjust specific areas of your image

WHAT YOU NEED
PHOTOSHOP OR
ELEMENTS

WHAT YOU'LL LEARN
HOW TO MAKE
NEW LAYERS

TURNING A SPECIFIC PART of an image into a new Layer couldn't be easier, and it's something you'll need to do time and time again, so it's worth practising now. The reason for turning a particular area of a picture into a new Layer is so you can make changes to it without affecting the rest of your image. In effect, you're isolating the Layer's content and letting it "float" above the background. It will sit on a transparency, and the Layer underneath will show through any transparent areas surrounding it.

1 SELECT THE FOREGROUND Here we opened up our image into Photoshop or Elements. In our example the sky is too bright and the foreground is way too dark, so we need to adjust them. By choosing the Lasso tool we drew all the way around the foreground area. Once back at the starting point, the "marching ants" appeared: we've made a Selection.

2 FEATHER THE EDGE To avoid the Selection having a really hard edge, we wanted to soften it so it blended imperceptibly into the rest of the image. Using the Feather slider (Select>Refine Edge in Elements 6/CS3, or Select >Feather in earlier versions) we chose a Feather amount of around 150 pixels and clicked OK to confirm this.

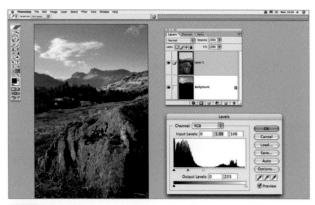

3 CREATE A NEW LAYER Next we wanted to transport the selected area into its own Layer. By tapping Ctrl+J on the keyboard, it's done. To see a new Layer, open the Layers palette (Window>Layers) and it'll be floating in a chequered window above the Background Layer. To brighten up the foreground we opened Levels (Ctrl+L) and moved the sliders until the detail appeared. Clicking OK confirmed the changes.

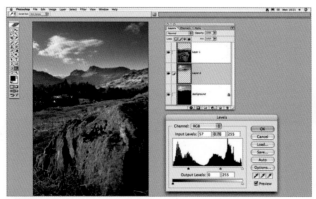

4 ADJUST THE SKY Clicking on the Background to make it active, this time we selected the sky. Feathering by 150 pixels, we transported the sky Selection into a new Layer (Ctrl+J). Tapping Ctrl+L brought up Levels again, and this time we adjusted the sliders to make the sky a little darker. The composite image has a brighter foreground and a darker sky, by creating and adjusting two Layers from our original pic.

FINISH

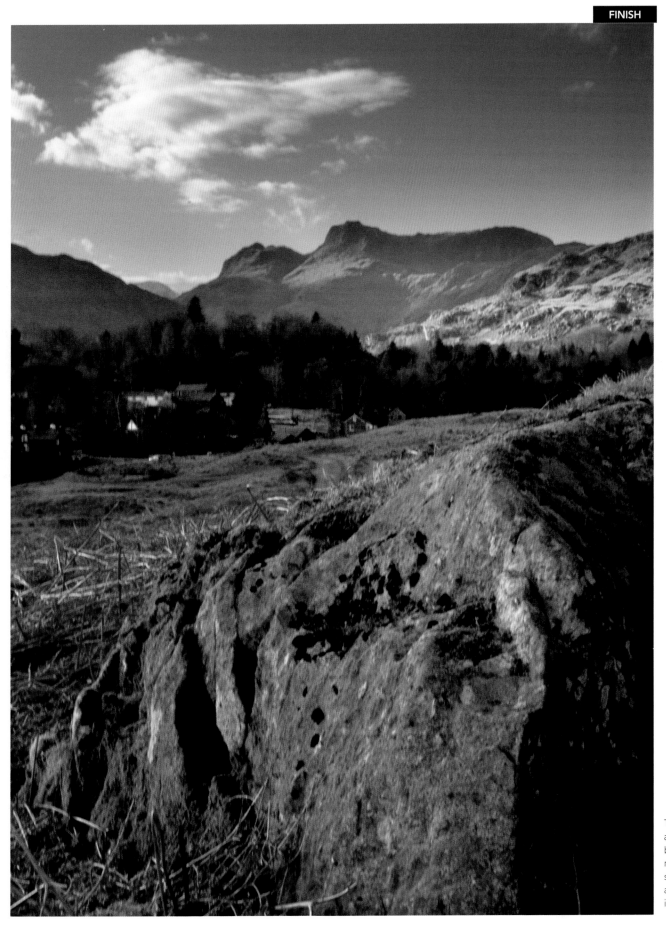

The foreground and sky are balanced by making them into separate layers and adjusting them independently.

Adjustment Layers

...for changes you can keep changing

WHAT YOU NEED
PHOTOSHOP OR
ELEMENTS

WHAT YOU'LL LEARN
HOW TO MAKE
ADJUSTMENT LAYERS

NOW WE'VE SEEN HOW LAYERS can be used to improve an image, let's look at a more flexible and efficient way of using them. The last exercise showed how we can isolate and adjust particular areas of an image by transporting selections into new Layers, but there's a much smarter way to get the same result. Adjustment Layers offer all the standard methods of changing a Layer's contrast and colour, but instead of employing pixels and using up lots of memory, they just contain data.

What's more they're really flexible because you can not only go back and change the adjustments you've made, you can also even change the part of the image you've selected. Learning how to use Adjustment Layers is a key skill to master, so let's run through the process.

START

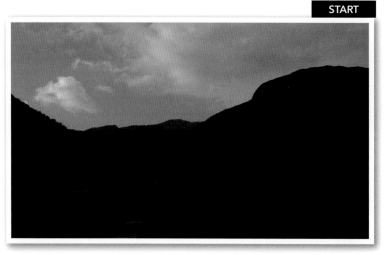

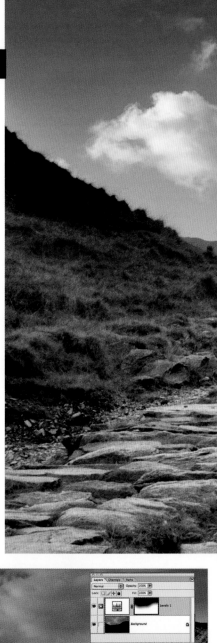

Our start image has a typical set of problems: the foreground is very dark because the exposure is dominated by the bright sky above.

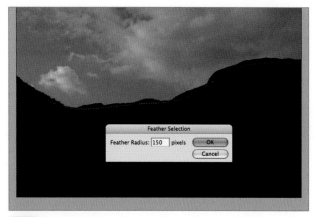

1 OPEN THE IMAGE For this exercise you'll need an under-exposed landscape like ours. Open it up and make sure your Layers palette is on-screen by going to Window>Layers. With the Lasso tool, make a rough Selection around the dark foreground area and Feather it by 150 pixels to soften the edge, just as we did in the last exercise. Click OK.

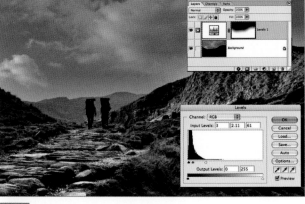

2 CREATE AN ADJUSTMENT LAYER In the Layers palette, click on the Adjustment Layer icon at the bottom (half black/half white circle) and select Levels from the drop-down list. In the palette, move the sliders underneath the histogram to the left to boost the brightness of the foreground, and when you're happy with the effect, click OK.

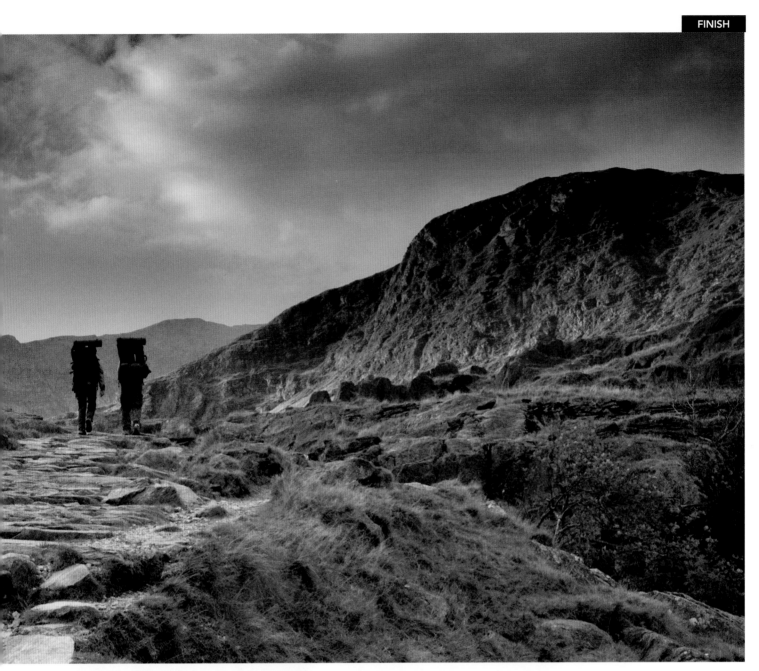

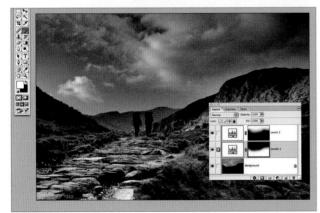

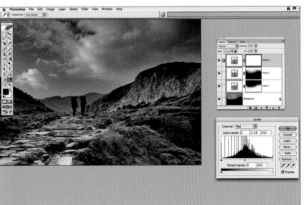

If you save your image in Photoshop's native .PSD format, you'll keep all your Adjustment Layers intact, so you can reopen the pic and re-edit them in the future.

3 ADJUST THE SKY Make another Selection of the top of the sky and Feather as before. Create another Levels Adjustment Layer and move the sliders to boost contrast. Now pick up the Brush tool and paint black or white to fine-tune the position and feathering of the Adjustment Layer. Do the same for the foreground Adjustment Layer if necessary, until you've achieved a good blend.

4 WARM UP THE IMAGE The extreme "push" we've given to our foreground has affected the colours in the pic, so to warm it up, make another Levels Adjustment Layer. Pick Red from the Channel box and move the middle slider a little to the left, and then pick Blue and move it a little to the right. Double-click on any Adjustment Layer to make any further refinements to the pic.

Layer Masks

Create basic composites with Layer Masks

WHAT YOU NEED
PHOTOSHOP OR ELEMENTS

WHAT YOU'LL LEARN
HOW TO MAKE LAYER MASKS

LAYERS CAN TAKE TIME TO GRASP, but once you've learnt the basics of how to create, arrange and re-name a few in your Layers palette, you're ready to explore one of the most powerful tools that Photoshop has to offer – Layer Masks. Once you understand how these work you'll soon be using them all the time to hide or reveal different areas of a Layer and to create really impressive composite images.

WHAT IS A MASK?

Before we get into the depths of how we use Layer Masks, let's start off with the basics and understand what a Mask is. A Mask defines an area of an image that's either visible or invisible. To picture this, imagine a car that's gone into a paint shop for a respray. Paint isn't applied to every section of the car; areas like the windscreen and wheels are masked off, leaving those beneath the Mask completely untouched and unaffected by the paint.

Photoshop Layer Masks work in the same way. They can be bolted onto any Layer in the Layers palette and used to reveal or conceal pixels. The Mask is comprised of black and white areas and this simply dictates whether pixels are visible or not. For example, using black, the Layer you're working on is concealed, showing through the Layer below, while using white, the active Layer is visible (and hence hides any Layers beneath).

Layer Masks are indispensable because they can be used in a variety of ways. If you want to replace the sky in an image, for example, you can drag a new sky into your original shot and "paint away" any of the pixels that overspill using a black brush on your Layer Mask.

WHY USE A LAYER MASK?

The bonus of using Layer Masks is that they're non-destructive. You can paint back any pixels of the Layer you've hidden with the black mask by painting with white, and you can also return to a Layer Mask and edit it at any time (providing you save the file in .PSD or Photoshop format) if you want to make any further adjustments.

They're also great for creating multi-layered montages and composite pictures. Just drag all the shots into your image and paint away the unwanted edges with a black brush, seamlessly combining multiple Layers to create a new image.

Having touched on the theory behind Layer Masks, it's time to put them into practice using two start images of your choice: one needs to be a portrait shot against a clean, pale backdrop, the other a landscape image. Here we're going to take our portrait image and blend the model into the landscape image so it looks as if she is actually on the beach. Whether you're a beginner to Layer Masks or a confident user, give this technique a try.

1 LOAD UP YOUR TWO START IMAGES Arrange them side by side on your Photoshop desktop. Click on the portrait and use the Lasso tool to draw a rough Selection around the outline. Use the Move tool to drag the Selection into the landscape image. Tap Ctrl+T on the keyboard to enter Free Transform mode and resize the portrait to a more appropriate scale. Hold down Shift to keep the image in proportion.

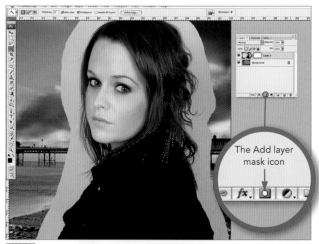

The Add layer mask icon

2 MAKE A NEW LAYER MASK for Layer 1. Click on the Add Layer Mask icon – a grey square with a white circle inside. Make sure your Layer 1 thumbnail is highlighted, then use the Magic Wand tool with a Tolerance of 50 and click on the model's clothing. Invert the Selection (Shift+Ctrl+I) and contract the edge of the Selection (Select Modify>Contract) by 1px. Click OK.

3 HIGHLIGHT THE MASK THUMBNAIL Click on the Mask thumbnail to select it and check the foreground colour is set to Black. Choose the Brush tool and set a soft brush with a diameter of 150px and Opacity of 100%. Start by painting away the unwanted white edge around the model's jacket, brushing up against the "marching ants". The inverted Selection prevents you brushing into the edge of the clothing.

4 DESELECT THE "MARCHING ANTS" Once you've masked around the subject's clothes, tap Ctrl+D. Zoom in to 200% and reduce the brush size to 6px. Reduce Opacity to 40% by tapping the numeric keypad (4 gives 40%, 6 gives 60%, etc). Begin to slowly brush around and in-between the hair where the subject's original backdrop shows through. If you accidentally brush over an incorrect area tap X on the keyboard to change the colour to White and simply paint it back in.

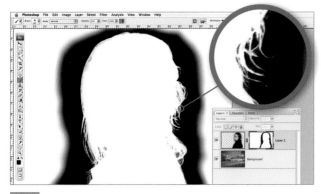

5 BRUSH ROUND TRICKY BITS OF HAIR A rough brush from the Brushes palette will help. Then, hold down Alt, click on the Layer Mask thumbnail and use a soft brush with the foreground colour set to black with Opacity at 10% and a brush size of 100px. Run the brush around the outside of the hair to create a natural blend.

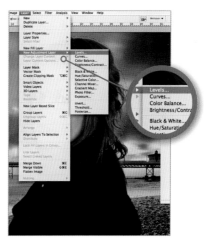

6 HIGHLIGHT LAYER 1 Click on the Layer 1 thumbnail and make a Selection around the subject's face. Refine the edge of the Selection from the Options bar with a Feather amount of 70px. Create a Levels Adjustment Layer (Layer>New Adjustment Layer>Levels) and move the Black point and Midtone sliders to the right to darken the subject's face slightly to make her look as though she's outdoors at dusk.

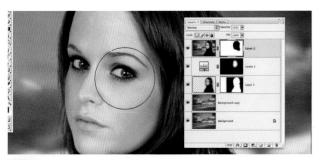

7 BLUR THE BACKGROUND Copy your Background Layer (Layer>Duplicate Layer) and go to Filter>Blur>Gaussian Blur using a 5.5px Radius. Highlighting your Layer 1 thumbnail, hold down Alt and go to Layer>Merge Visible. Move this new Layer (Layer 2) to the top of the Layers palette and add more Gaussian Blur to the image with a Radius of 3px. Next, add a new Layer Mask to Layer 2 and brush away the blur on the face with your foreground colour set to black. Use a large soft brush with 70% Opacity. Save the file as a .PSD to preserve your masks.

FINISH

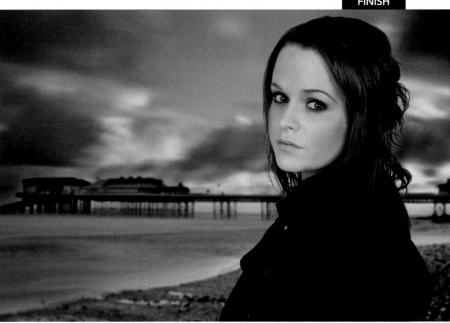

Blending Layers

Create textured effects by blending Layers

WHAT YOU NEED
PHOTOSHOP OR
ELEMENTS

WHAT YOU'LL LEARN
HOW TO BLEND
LAYERS

IF YOU WANT TO GET CREATIVE WITH LAYERS, then Blending Modes are a great place to start. In the Layers palette, click where it says Normal and you'll see a long list of options split into five groups. These are Layer Blending Modes, and they change the way a Layer interacts with the Layer immediately beneath.

You don't really need to fully understand the science behind Blending Modes, because it doesn't take long to experiment using a trial-and-error approach, but, essentially, how they work depends on the pixel values (or the RGB numbers) between the Layer the Blending Mode is applied to, and the Layer beneath.

Rather than work out which one to use, though, most photographers simply select the Layer, and then try a few Blending Modes to see which one gives the best results. Follow the project below, and you'll soon get the hang of it.

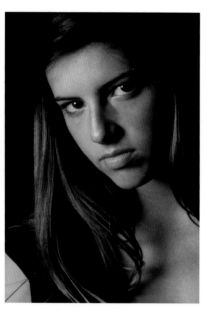

For this project you'll need three start pictures: a portrait, a texture shot and a raggedy background selection to form the border.

1 GET THE PICS TOGETHER Open the portrait and the texture image. If you can't see both images on screen, go to Window>Images>Cascade in Elements or Window>Arrange>Cascade in Photoshop. Now select the Move tool from the toolbox. Click on the texture pic and then drag it into the portrait. Now close down the original texture picture.

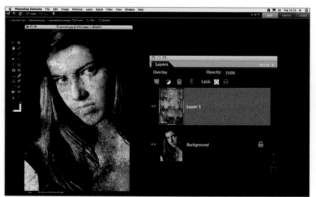

2 BLEND THE IMAGES Open the Layers palette (Window> Layers) and you'll see the texture pic sitting above the portrait in the Layers stack. With the texture Layer active, click where it says Normal and change the Blending Mode to Overlay. As you do this, you'll see parts of the texture Layer revealed on the portrait, generating a creative effect.

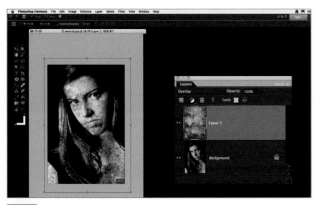

3 RESIZE THE TEXTURE Hold down Ctrl and tap the minus key once or twice to create some room around the image, and then hit Ctrl+T to put the texture Layer into Free Transform Mode. Pull the "handles" around the bounding box to reshape the Layer so the texture works well with the portrait. Double-click inside the Transform bounding box when you're happy.

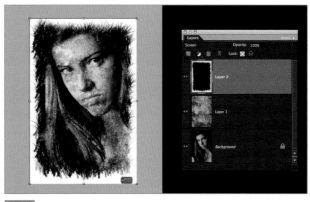

4 ADD A BORDER Open the border image and drag it into the image with the Move tool. In the Layers palette, select the Screen Blending Mode and you'll see all the lighter areas of the border show through. To adjust the size of the border, hit Ctrl+T and drag the handles until it fits the image. Double-click inside the bounding box to confirm the changes you've made.

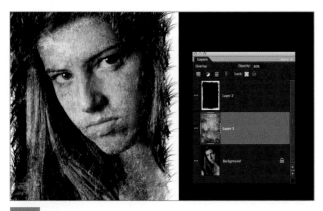

5 REFINE THE TEXTURE If your texture is too strong, it's time to fine-tune it. First, make the texture Layer active by clicking on it, and then move the Opacity slider to about 80%. Now, pick up the Eraser and set an Opacity of about 30% in the Options bar at the top of the screen. Gently knock back the texture where you don't want it.

6 FLATTEN THE IMAGE When you're happy with the overall result, save the image. Because you're using Layers, you can only save it as a .PSD file, which will take up loads of space. If you're not going to edit it any further, go to Layer>Flatten image to crunch all the Layers into one. You'll now be able to save the file as a JPEG.

FINISHED IMAGE

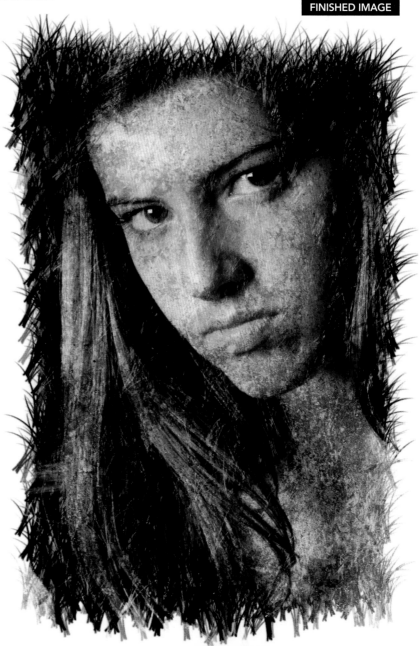

RED CHANNEL	GREEN CHANNEL	BLUE CHANNEL

Understand Channels

Use Channels to control colour and contrast

WHAT YOU NEED
PHOTOSHOP OR
ELEMENTS

WHAT YOU'LL LEARN
HOW TO CONTROL
COLOUR CHANNELS

TO MANY PHOTOSHOP USERS, Channels are even more intimidating than Layers. True, they're a complex part of the Photoshop software, but Channels are the place where all the important decisions about colour and contrast in your image are made and, even if you're not dealing directly with the Channels palette, they're always there in the background. So, when you use Color Balance, Curves or Levels to make an image warmer, or cooler (or darker or lighter) or correct a colour cast, it's just a user-friendly short-cut to using Channels.

So, how do Channels control colour and contrast in your image? Well, in any RGB picture (like those you see on your TV or PC screen) there are three Channels that make up the image – Red, Green and Blue, which are also known as the primary colours of light. It's the way these Channels are mixed in various proportions that create the millions of colours and tones you see in your digital photos.

A little ironically, each Channel deals with colour by displaying one of 256 different shades of grey (in an 8-bit image) or 4096 (in a 16-bit image), but don't let this confuse you. Very simply, the intensity of this grey determines how much Red, Green or Blue is shown in each pixel and therefore its colour. So, where a specific Channel is dark or black it means there's hardly any of that colour, and where it's light or white it means there's a lot of that colour.

Finally, where the three Channels all feature light pixels, you'll see light shades; conversely, where all three Channels show dark pixels, you'll see shadows.

USING CHANNELS

Channels are commonly used with Levels and Curves to correct colour casts, but there's no reason why you should restrict yourself to using them for one purpose. They're also great for generating some spectacular special effects on your images, such as the vibrant tri-colour treatment shown right.

The technique involves breaking up the separate Channels from a series of images and combining one Channel from each into a new photo. To apply this technique you'll first need a series of three images with an element of movement that makes them differ. We've used three separate shots of a fan with streamers attached.

EXPERT ADVICE

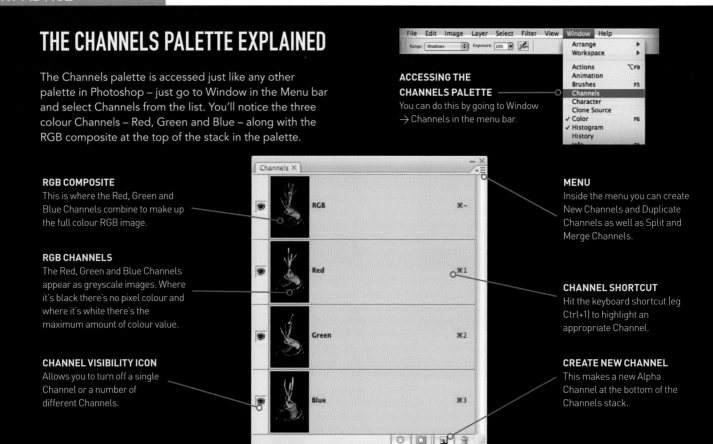

THE CHANNELS PALETTE EXPLAINED

The Channels palette is accessed just like any other palette in Photoshop – just go to Window in the Menu bar and select Channels from the list. You'll notice the three colour Channels – Red, Green and Blue – along with the RGB composite at the top of the stack in the palette.

**ACCESSING THE
CHANNELS PALETTE**
You can do this by going to Window
→ Channels in the menu bar.

RGB COMPOSITE
This is where the Red, Green and Blue Channels combine to make up the full colour RGB image.

RGB CHANNELS
The Red, Green and Blue Channels appear as greyscale images. Where it's black there's no pixel colour and where it's white there's the maximum amount of colour value.

CHANNEL VISIBILITY ICON
Allows you to turn off a single Channel or a number of different Channels.

MENU
Inside the menu you can create New Channels and Duplicate Channels as well as Split and Merge Channels.

CHANNEL SHORTCUT
Hit the keyboard shortcut (eg Ctrl+1) to highlight an appropriate Channel.

CREATE NEW CHANNEL
This makes a new Alpha Channel at the bottom of the Channels stack.

CREATE AN EYECATCHING TRI-COLOUR PHOTOGRAPH

1 OPEN THE THREE START IMAGES Open your three start images, prioritizing one of them (Image 1) and minimizing the other two. Open up your Channels palette by going to Window> Channels and you'll see the three RGB channels with the RGB composite at the top of the Channels stack.

2 SPLIT THE CHANNELS To split Image 1 into its three constituent Channels, click on the Channels menu and select Split Channels. You'll now have Image 1.jpg.Red, Image 1.jpg.Green and Image 1.jpg. Blue. Close down the Green and Blue documents and save the Red. Next open your second JPEG (Image 2) and repeat the process, but this time closing down the Red and Blue versions. Repeat for Image 3, saving only the Blue version.

3 MERGE CHANNELS Select Image 1.jpg.Red and click again on the Channels drop-down menu, this time selecting Merge Channels. Set the mode to RGB Color and the number of Channels to 3. Under Specify Channels, check you have the correct Channels matched up. Hit OK to confirm.

4 FINISHING TOUCHES The three separate Channels have now been merged to create the vibrant tri-colour effect and you'll notice pure Red, Green and Blue pixels where the Channels differed. To finish off, we wanted to extend our colour streamers – ensuring the RGB composite Channel was highlighted on the Channels palette and using the Rectangular Marquee to draw a selection down towards the top of the fan. We hit Ctrl+T and dragged the top centre control point upwards. We double-clicked inside the bounding box to confirm.

5 APPLY SOME SHARPENING To finish off, you can sharpen the entire image. Go to Filter>Sharpen>Unsharp Mask. Set an Amount of 100% with a Radius of 1.0 and a Threshold of 0 Levels. Hit OK to apply the sharpening.

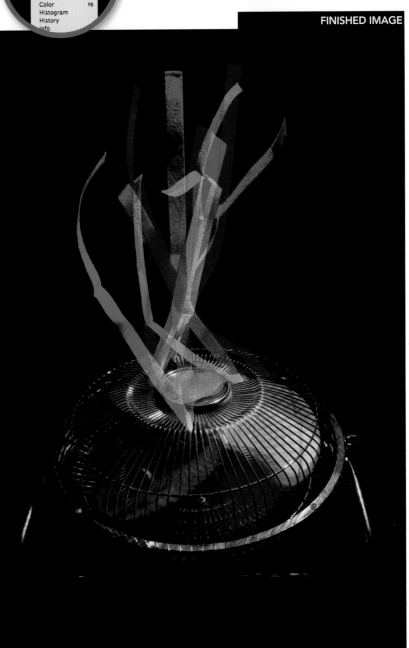

FINISHED IMAGE

Convert to mono

Compare the different routes to mono

WHAT YOU NEED
PHOTOSHOP OR
ELEMENTS

WHAT YOU'LL LEARN
HOW TO MAKE
MONO PICTURES

THERE ARE LOTS of different ways to convert your colour images to black and white. Here and overleaf we've provided a round-up of some of the many options available. Compare the images and see which effect you like best.

DESATURATE (ELEMENTS AND PHOTOSHOP)

This method converts colour files to mono by applying equal red, green and blue pixel values, so pure colours will appear the same shade of grey. Use it whenever you want an instant preview of how an image will look in mono. It's incredibly quick to use, especially using the keystroke shortcut Ctrl+Shift+U. However, it's arguably the weakest of all mono conversions, as it doesn't differentiate between colours and can produce rather flat-looking images. **How to use it:** Go to Image>Adjustments> Desaturate (or Ctrl+Shift+U), and you'll remove all the colour from your picture. It's actually the same as opening the Hue/Saturation palette and moving the Saturation slider all the way to the left. It's by far the quickest way to convert to mono but the trade-off is it's not always the best option. Because of its speed, it's always worth a try, and if your subject looks really good after applying the Desaturate command, and you're happy with the contrast in the grey tones, your mono conversion is speedily completed.

GRAYSCALE (ELEMENTS AND PHOTOSHOP)

This method converts colour files straight to mono, using the luminosity of the existing colours to determine the grey tones produced. It's perfect for when you want to make a quick black and white conversion from a JPEG or a TIFF file, or want to check an image's potential in mono before using a more precise method. It's fast to use, makes decent conversions, and creates files one-third the size of the colour original. However, the parameters are fixed, so there's no control, and images must be converted back to RGB Color to apply toning or colour effects. **How to use it:** For Elements users, this was the best option until the arrival of Elements 6 with its Black and White controls (see overleaf) which makes for more precise conversions. If speed is of the essence, and you don't want to fuss with the Channel Mixer, then a quick Grayscale conversion is always worth a try – simply go to Image>Mode and click on Grayscale. A warning will pop up regarding your colour information being discarded. Click OK to this, and you'll have a mono pic.

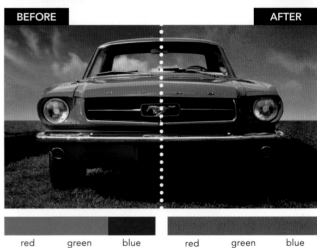

BEFORE · AFTER

red · green · blue · red · green · blue

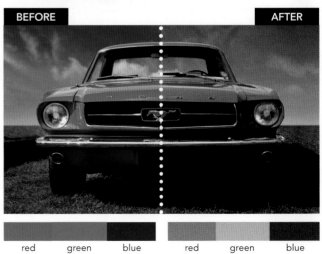

BEFORE · AFTER

red · green · blue · red · green · blue

CHANNEL MIXER (PHOTOSHOP ONLY)

This method allows you to control and adjust the balance of the Red, Green and Blue Channels in the mono mix. Use it when converting JPEGs and TIFFs, and colour scans from negs, trannies and prints. The Channel Mixer was the undisputed king of mono conversions until RAW became available, and it's still the best option if you have JPEGs or TIFF files to convert. **How to use it:** Open Channels (Window>Channels) and click on each of them individually. Look closely at the different mono images and see if there's one that produces the aesthetic effect you're after. If so, simply go to Image>Mode>Grayscale, and you're done. In most cases, though, you'll want a mix of two of the Channels, so see which ones are closest (eg Red and Green) and then go to Image>Adjustments >Channel Mixer. Tick the Monochrome box bottom-left, and move the Red and Green sliders to get the effect you want. 50, 50, 0 will give a balanced Red/Green Channel mix. It's customary but not compulsory to get the percentages to add up to 100, as this usually avoids burning out the whites in the scene, but let your eyes be the judge.

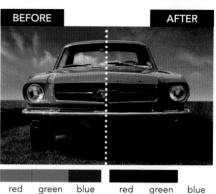

red green blue | red green blue

CHANNEL CALCULATIONS (PHOTOSHOP ONLY)

This route to mono converts colour files by blending one of the image's Channels with another (or with itself). This tends to give very dramatic conversions: Red-Red-Multiply commands can work wonders with the right kind of landscapes, giving near-black skies and punchy highlights. It's fairly quick for those in the know, and great for dark, moody scenics but all the permutations derived from three Channels and 19 Blending Modes can be a bit overwhelming for newcomers. **How to use it:** For those who simply want to try something new, it involves blending one Channel either with itself or with another Channel. Open up the Channels palette and take a look at the mono effects from the three individual Channels. If you want to blend the Red with the Green channel, using the Multiply Blending Mode, then Calculations gives you a quick way to do it. Similarly, you might want to Multiply the Red channel with itself – further darkening all the darker pixels. Mono conversions in Calculations are often referred to as Red-Green-Multiply, or Red-Red-Multiply, which denotes the two channels used, and the Blending Mode chosen.

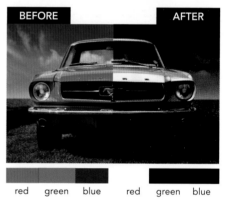

red green blue | red green blue

LAB COLOR (PHOTOSHOP ONLY)

This works by extracting the black and white Lightness information (the L Channel) from Lab Color Mode. It's always worth a try if a Grayscale or Channel Mixer conversion isn't hitting the spot for you, and many photographers like the effect Lab conversions give with portraits. However, it's a little slow to apply as you have to change colour modes, and then either delete the two channels, or convert to Grayscale with the L Channel selected. **How to use it:** Lab color is a special colour mode that has three Channels. One is Lightness (L) which represents the luminance of the image on a black-to-white scale, and the colour comes from the other two – called "a" and "b" – where "a" is the green-to-red axis and "b" is the blue-to-yellow axis. Because the Lightness Channel is already on a black-to-white scale, you get a mono result by deleting the "a" and "b" channels. Go to Image>Mode and select Lab Color, then open the Channels palette (Window>Channels). Click on the L Channel so it's the only one selected, then go to Image>Mode>Grayscale. This is quicker than deleting the "a" and "b" Channels.

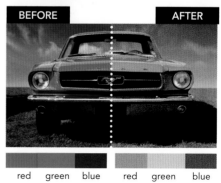

red green blue | red green blue

HSL/GRAYSCALE (PHOTOSHOP CS3 AND CS4)

The latest versions of Photoshop have some extra tricks up their sleeve for mono enthusiasts. One of the most exciting comes as part of the Camera RAW interface, for use when you convert RAW images. It's called the HSL/Grayscale tab and by using it correctly you can create some top-notch mono conversions, tweaking the individual tones in the image by shifting their colour values. This helps generate bags of contrast and it's really easy to do – much like using the Channel Mixer, but with a wider range of options. All you need to do is push and pull a few sliders around until you get the results you want.

Because all the colour information that goes to make up the finished mono conversion can be controlled individually, it helps to pick an original colour image with lots of bright punchy colours. If you compare our start and finished images (right and below), there's been a dramatic shift in the bright blue sky and fluffy white clouds, simply by taking the Blues slider to -100. The influence of other sliders is conditional on the amount of their specific colour in the photo, but flat and overcast shots won't generally work as well. The main thing is to experiment, because all pictures will respond to the sliders in subtly different ways.

START

Nice light, but the sky is dull. To rescue it, turn it black and white and bump up the contrast.

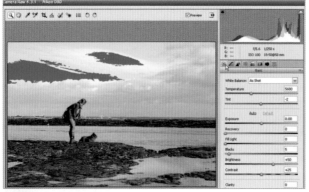

1 OPEN YOUR RAW FILE Load the image into Photoshop CS3 or later and the Camera RAW interface will launch. Now click on the right-facing arrow above the Temperature slider and pick Camera Raw Defaults to view the picture as shot by the camera. Also, turn the Shadow and Highlight clipping warnings on, above the histogram in the top right, so you can see any burn-out or solid clumps of shadow.

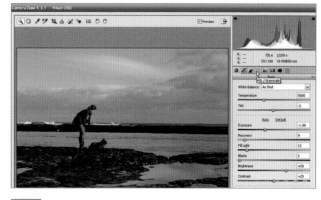

2 TWEAK CONTRAST Here we kept the Temperature at 5600 and the Tint at -2. We moved the Exposure to -1.00, Recovery to 9, Fill Light to 12 and Blacks to 2. We left the Brightness and Contrast at +50 and +25 respectively, then moved the Clarity slider to 19. There's no need to move the Saturation slider to -100 as we'll take care of that next.

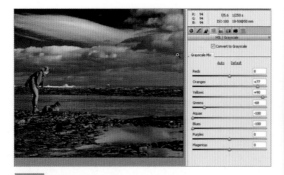

3 CONVERT TO MONO Now click on the HSL/Grayscale tab and tick the box marked Convert to Grayscale. Click on Default; we left Reds at 0; moved Oranges to +77, Yellows to +90, Greens to -68, Aquas to -100 and Blues to -100. We left Purples and Magentas at 0 and clicked Open Image. Once the shot has opened into Photoshop, further tweaks can be made to the contrast. We'll also added a little blur to the foreground.

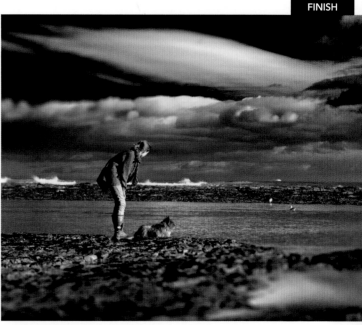

FINISH

CONVERT TO BLACK AND WHITE (ELEMENTS 6)

Elements users can sometimes feel a bit short-changed when it comes to mono options – features like the Channel Mixer and Calculations as favoured by mono enthusiasts are absent. Traditionally, the only black and white routes available have been Image>Mode>Grayscale or moving the Saturation slider to 0 in the Hue/Saturation palette. With the latest Elements software there are some exciting new options in the shape of Enhance>Convert to Black and White. Here you can pick a preset, or, better still, use the sliders to control the amount of Red, Green or Blue light used to make up the image. This works just like the Channel Mixer in Photoshop and although there are no values for each slider, you can still create some great effects. Try using it with a Selection, too, as we have done here.

START

Here the subject looks a bit flat and lacking in detail. Using the "convert to black and white" option we can boost contrast.

1 MAKE A SELECTION Choose a suitable landscape image like our beach hut, open it and select the Rectangular Marquee tool. Drag the Marquee out over the sky before going to Select>Refine Edges (not Select>Feather). Move the Feather slider to 250px then press OK. Now bring up the Info palette (Window>Info).

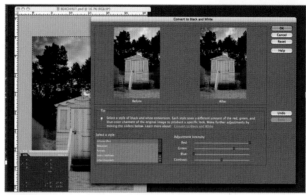

2 REMOVE THE COLOURS Go to Enhance>Convert to Black and White... You'll get a choice of picking a preset or moving the sliders yourself. We went for Red +200, Green +170, Blue -200 and Contrast 0. To avoid burn-out, hover the cursor over bright areas and look in the Info palette, making sure the RGB values don't all read 255.

3 MORE MONO Now go to Select> Inverse and then back to Enhance>Convert to Black and White... You'll now see we can input different values for the lower half of the image. Here, we've gone for Red -150, Green +50, Blue +200 and Contrast 0. Again check the Info palette, then press OK and go to Select>Deselect.

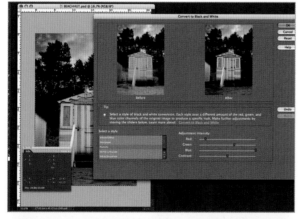

4 DODGE AND BURN Now pick the Burn tool from the toolbox, and in the Options bar, set Range to Shadows, and Exposure to 3% and ply it over the parts of the sky you want to darken for a brooding effect. Next, pick the Dodge tool (Range to Highlights and Exposure to 3%), and use it to lighten the foreground. Click to save!

FINISH

"Popping" colour into black and white

START

Bring colours back with Adjustment Layer Masks

WHAT YOU NEED
PHOTOSHOP OR ELEMENTS

WHAT YOU'LL LEARN
HOW TO SELECT AND "POP" COLOURS

MIXING COLOUR AND MONO TOGETHER is really easy using Layer Masks. Creating a mask is a concept that's even more confusing than Layers on first acquaintance, but if you skirt round the technical-sounding name and look at what masking actually does, things become so much simpler.

A mask is a black and white picture that's bolted on to a particular Layer. Where it's White in colour, everything works as normal and the Layer underneath is hidden. But where the mask is Black, the Layer beneath can be seen though the Layer above it. Full Layer Masks can only found in the full version of Photoshop, but Masks are a standard part of an Adjustment Layer, so you'll find them in Elements, too.

In this easy project we'll show not only how to use Layer Mask techniques to make selections, but you'll also learn how to create a classic Photoshop effect that "pops" colour out of a mono background.

1 CONVERT TO MONO Open your start image and make sure the Layers palette is up by going to Window>Layers. We're first going to turn the image to black and white, so click on the Adjustment Layer icon (half black/half white circle) and select Hue/Saturation from the list. In the palette, move the Saturation slider all the way to the left to turn the pic mono.

2 PAINT IN THE COLOUR The Hue/Saturation Adjustment Layer is doing the work regarding the mono effect, but our original colour image remains untouched underneath. By painting into the Mask that's attached to the Adjustment Layer we can bring the colour back in selected areas, so pick up the Brush tool, set Black as the foreground colour, and paint directly onto the part you want to be in colour.

3 GET SMART WITH BRUSHES For a really accurate mask, zoom in to the image using the Zoom tool. You'll also need to change Brush size; the best way to do this is via the [and] bracket keys. Depending on your subject, you may also want to vary the softness of the brush, so use Shift+[and Shift+] to make the Brush softer or harder.

4 REFINE THE MASK Paint around the subject until your image looks good. If you go over the edge or paint out the wrong part, don't worry – to revert, just paint with White instead of Black. You can quickly swap from one to the other by clicking on the double-headed arrow next to the foreground and background colours, or for the quick way, press X on the keyboard.

FINISH

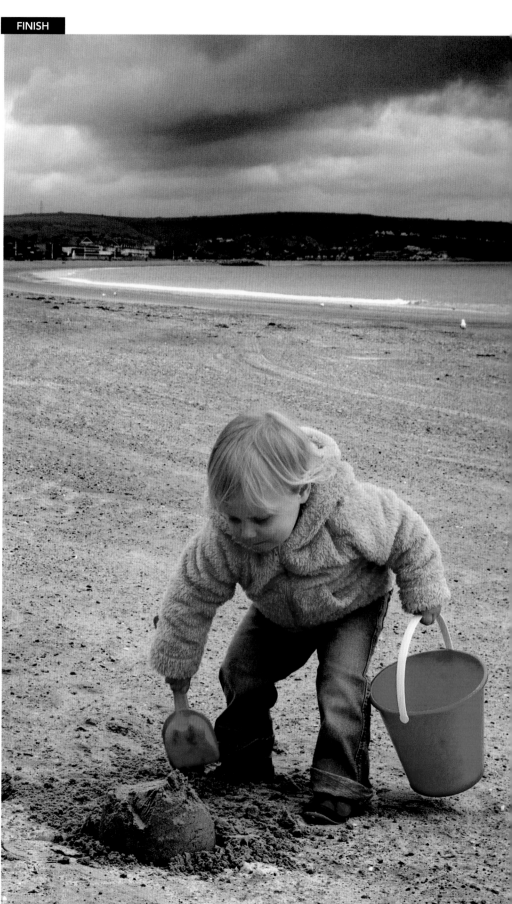

5 CHECK THE MASK It's really easy to miss out parts of a subject when masking in this way, so to check you've got everything, hold Alt and click directly on the Mask's thumbnail in the Layers palette. The Mask will be shown instead of the image, and you can paint straight into this view if it makes life easier. Hold Alt and click on the thumbnail again to return to the main view.

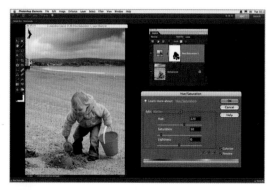

6 FINE-TUNE THE IMAGE When the effect is complete, see if your pic needs any other adjustments. One thing that's always worth a try is a little mono toning. Double-click on the Hue/Saturation Adjustment Layer's thumbnail, and tick the Colorize box in the palette. Move the Hue and Saturation sliders to 30 and 10 for a warm tone, or 220 and 10 for a cool tone. Don't forget to Save.

START

Changing colours

Select and alter image colours at whim

Whether you want to perform a digital respray on your car, check out how your front door would look with a fresh paint job, or adjust the colour of a model's clothes to match her eyes, there are all sorts of reasons why photographers need to change specific colours in a scene. It's a core skill for Photoshop users, with hundreds of different applications, though like so many important techniques, which method you use to achieve it – and how successful the results are –

depends entirely upon the image you're starting with.

Changing a colour can be a relatively simple affair involving some special features in the Hue/Saturation palette, or it can be a more intensive process involving a careful manual Selection. In more difficult cases, the most efficient way will be to repaint the part of the image you want to change, after first creating a new Layer and employing the right Blending Mode in the Layers palette.

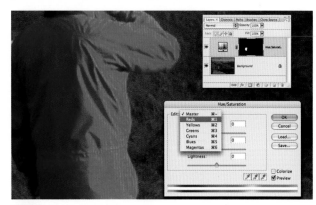

1 CREATE A NEW ADJUSTMENT LAYER Click on the half black/half white circle icon in the Layers palette, and select Hue/Saturation from the list. In the Edit section of the dialogue box, click where it says Master, and select any individual colour. We've gone for Reds but it doesn't matter which one you choose.

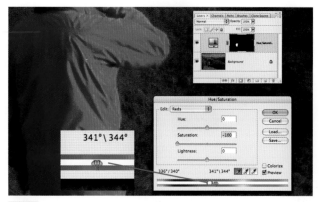

2 CRUNCH THE COLOURS Take the two extreme ends of the sliders underneath the colour bars, and crunch them together so they're all occupying the same space. After that, move the Saturation slider all the way to the left. Initially you'll see no change to the image, but you will with the next step.

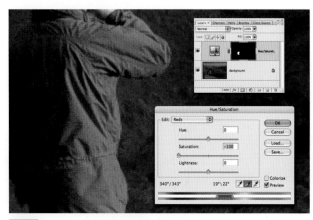

3 SELECT THE MIDDLE EYEDROPPER Choose the eyedropper icon with the + next to it and drag the cursor over the colour you want to change. The bits you've covered will turn to grey. Continue clicking on the colour until you have it all, and then move the Saturation slider back to its starting point in the middle. You'll see the original colour return.

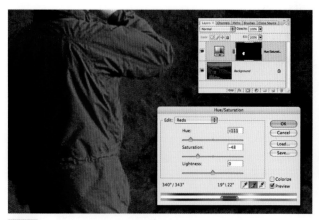

4 NOW MOVE THE HUE SLIDER This will change the colour of the items that were initially red to whatever you want. You may also need to tweak the Saturation slider to get the best effect. When you're happy, click OK, and then clean up any edges by painting Black into the Adjustment Layer's Mask with a paintbrush.

CHANGE COLOUR WITH A MANUAL SELECTION

1 OPEN YOUR IMAGE Pick up the Polygonal Lasso tool from the toolbox. Zoom in really tight and click around the very edge of the item you want to change. Take your time, and in just a few minutes, you'll return to your starting point. At all costs, avoid double-clicking while you're going round the edge, as this will complete the Selection with a straight line back to your first point!

2 FEATHER THE SELECTION Go to Select>Refine Edge and enter a Feather amount of between 0.5 and 2 pixels, depending on the item you're selecting. It's also worth previewing the Selection on White and Black to check it for accuracy. In versions earlier than CS3, use Select>Feather and enter a similar Feather Radius value. Click OK and the feathering will be applied.

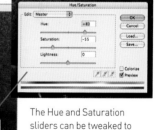

3 CREATE A HUE/SATURATION ADJUSTMENT LAYER Use the Layers palette to do this and move the Hue and Saturation sliders to mix up the colour of your choice. Click OK once you've done this, then zoom in really tight to check there's no "fringe" of the original colour remaining. If there is, paint into the Adjustment Layer's Mask using White or Black to tidy up the edge and remove the fringeing.

4 SAVE THE LAYERS Save the file as a .PSD format to save the Layers in your document. This means you can drop back in and change the item's colour at any time, simply by double-clicking the Adjustment Layer's thumbnail, and moving the sliders on the Hue/Saturation palette. Here, we've dropped back in and mixed up an alternative jacket colour by moving the Hue to +83 and Saturation to -55.

The Hue and Saturation sliders can be tweaked to your heart's content, but leave the Lightness slider alone or results will look odd.

Adjustment Layers have a Mask built in, and you'll often need to trim this around the edges to get a really convincing colour change.

FINISH

START

Creative hand-colouring

Apply colour tones on a new image Layer

WHAT YOU NEED
PHOTOSHOP OR
ELEMENTS

WHAT YOU'LL LEARN
HOW TO HAND-
COLOUR IMAGES

GIVE SHOTS A COLOURFUL TWIST with this quick and easy technique. Hand-colouring is a fun way to make your shots stand out from the crowd and is particularly effective on still life images, floral pictures and portraits (used sparingly). All you need to do is set the Brush tool up in the right way and opt for a natural look, or something more graphic and stylized.

Here we've got a few tricks you can use to make things easier, including applying the colour to a separate Layer, which will let you quickly correct any mistakes. As you'll see in

the step-by-step guide below, it's also best to apply fairly strong colours in the first instance and then tone them down using the Layer's Opacity. If you use muted colours from the outset it can be difficult to gauge the effect and dark tones may not show up.

Try this technique with your own shots: we've picked a moody, low-key outdoor portrait.

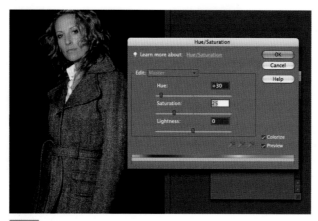

1 TONE THE IMAGE Start by opening up your picture in Photoshop then press the Ctrl+U shortcut on the keyboard to open the Hue/Saturation palette. Click the Colorize button at the bottom right of the box and move the Hue slider to 30. Move the Saturation slider to 25 and press OK. Now press Ctrl+Shift+N to create a new Layer. Call the new Layer "Colour" and press OK.

2 SET THE BLENDING MODE Now go to Window>Layers and click where it says Normal, choosing Color from the list. Next pick the Brush tool, set its Size to 200 pixels, Opacity to 100% and soften its edge a little using Shift+[on the keyboard. Now click on the foreground colour swatch and set Red to 255, Green to 200 and Blue to 150. Press OK and you're ready to paint.

3 PAINT IN THE COLOUR Now click on the model's face to start painting in colour. Reduce the size of the Brush for more detailed areas. Next, use the Eraser tool (10px, 100% Opacity) to remove the colour from the whites of the eyes and subject's teeth. Now choose the Brush tool again, and pick a colour for the coat and hair (as in Step 2). Paint over those parts of the image.

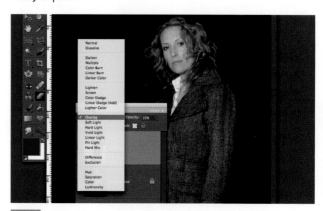

4 ALTER THE OPACITY Once you're done painting in the parts of your image (remember to colour the pupils, lips, etc), click on the Opacity slider and reduce it to around 30–35% for a more muted feel. At this stage it's also worth experimenting with some of the other blending modes to see which other effects you can achieve. For example Overlay gives a more earthy look compared to the colours here.

FINISH

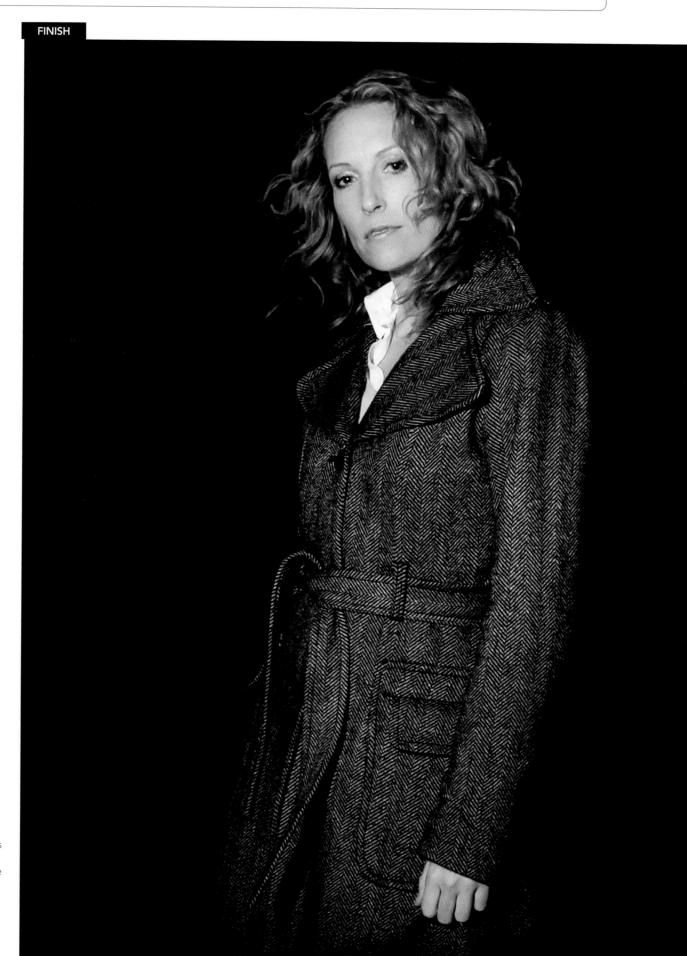

Try altering the Opacity and Hardness of the Brush tool as you colour your image for a more natural-looking, even effect – especially when colouring hair.

Stylish toning effects

Apply a gentle colour wash

A GREAT WAY TO ENHANCE A BLACK AND WHITE IMAGE is to apply a little colour toning. From warm sepia effects through to cool blue cyanotypes, a toning treatment can really lift your pictures. Here are three ways to do it.

HUE/SATURATION TONING

The quickest and easiest of toning recipes, the Hue/Saturation method is hugely popular with both newcomers and professionals and rightly so. The main bonus is speed and accuracy, with "recipes" for toning treatments that soon become second nature.

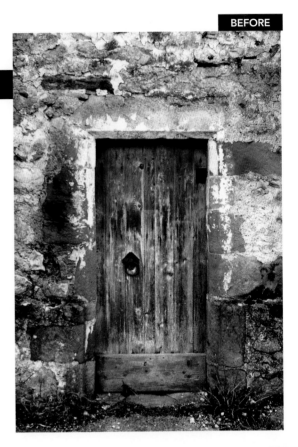

BEFORE

1 SET TO RGB COLOUR Your image can be black and white or colour, but if it's black and white, go to Image>Mode and check this is set to RGB Color. Now open the Layers palette (Window>Layers) and click the Adjustment Layer icon (half black/half white circle). From the list, select Hue/Saturation.

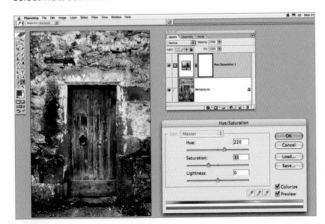

2 TICK THE COLORIZE BOX When the palette pops up on screen, tick the Colorize box in the bottom right corner, and then move the Hue and Saturation sliders to mix up the colour tone of your choice. A good tip is to set Saturation to 50 and then adjust the Hue to pick the colour you want. After you've done this, reduce the Saturation slider to get the required intensity, and click OK when you're done.

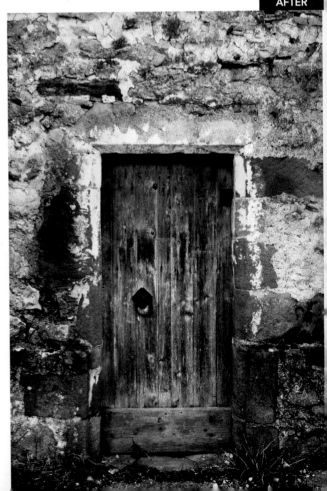

AFTER

SOLID COLOUR TONING

This is a neat toning technique that allows you to choose your toning colour straight from the colour picker. It's a little more involved than the first method, but it's a winner if you prefer picking your colour directly, rather than mixing it up with sliders.

BEFORE

1 OPEN THE LAYERS PALETTE Check you're in RGB Color mode as you did in the Hue/Saturation method, then open the Layers palette and create a Solid Color Adjustment Layer by clicking the Adjustment Layer icon and picking Solid Color from the drop-down list. Your image will be obscured by a block colour, but don't worry, we'll sort that out next.

2 CHOOSE A BLENDING MODE In the Layers palette, click where it says Normal and choose the Color Blending Mode. This will tone the image the same as the solid colour. To change the colour used, double-click on the Adjustment Layer's thumbnail and pick the toning colour of your choice from the Color Picker.

AFTER

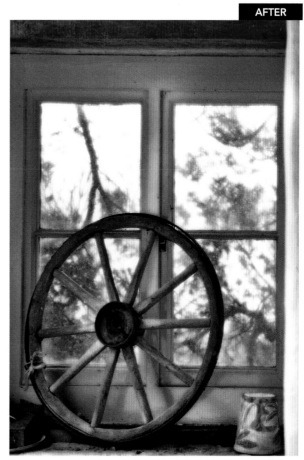

GRADIENT MAP TONING

This is a great method that not only lets you choose the toning colour in an easy, intuitive way, it also lets you fine tune the tonal range that the colour occupies between the shadows and the highlights. A connoisseur's choice!

BEFORE

1 CREATE THE GRADIENT MAP Check you're in RGB Color mode, then tap D on the keyboard to set the Foreground and Background colours to Black and White. In the Layers palette, create a Gradient Map Adjustment Layer (about two-thirds of the way down the list), and in the dialogue box, click on the Gradient itself to open the Gradient Editor.

2 ADD A COLOR STOP Click directly under the black-to-white gradient graphic, and you'll add what's called a Color Stop. Now double-click the Color Stop itself, and choose the colour you want from the Color Picker. You can keep clicking around the Picker (or moving the vertical Hue slider) until you have the toning effect you're after. Click OK, then OK again in the Gradient Editor to complete the toning effect.

AFTER

Get the "Toytown" look

Fake shallow depth of field effects

WHAT YOU NEED
PHOTOSHOP OR ELEMENTS

WHAT YOU'LL LEARN
HOW TO USE SELECTIVE BLUR

TO CONTROL THE WAY BLUR GRADUATES through an image, it's best to use a Depth Map. This is an extra Channel for your image, controlled using the Gradient and Brush tools in Photoshop. These can determine which areas the lens blur should affect, allowing you to keep certain areas of the image pin sharp for dramatic effect. In this step-by-step project we've constructed a graduated Depth Map to create

a shallow depth of field effect, with a plane of focus running diagonally across the image area.

The end result will be similar to the effect created by using a specialist tilt and shift lens, tilted at about 45° and shooting at its widest aperture. The image thus created looks a little bit like a Toytown model train, when in fact it's a real-life full-sized one.

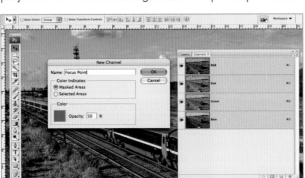

1 ADD A NEW CHANNEL Open up a suitable scenic image in Photoshop, shot from slightly above. Go to Layer >Duplicate Layer and rename it "Lens Blur". Open the Channels (Window>Channels) and click on the Channels Palette menu to select New Channel. Rename this "Focus Point" and check under Color Indicates that it's set to Masked Areas, Color Red, Opacity 50% then click OK. Click on the Focus Point Channel's eye visibility icon in the Channels palette and the original image will show through a red mask.

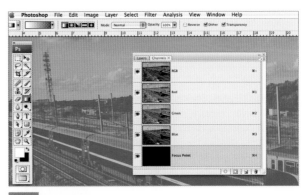

2 SET UP THE GRADIENT TOOL Select the Gradient tool (G) from the toolbox. Tap the letter D to set your Foreground and Background colours to Default and tap the letter X to switch the colours, setting the foreground colour to White. Go up to the Options bar and inside the Gradient picker choose Foreground to Transparent. Make sure Linear Gradient is selected, Mode is set to Normal, Opacity set to 100% and both the Dither and Transparency boxes are ticked. The Reverse box should remain unticked.

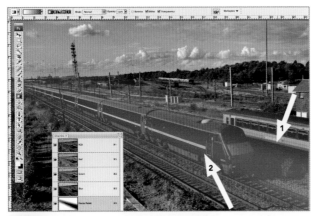

3 DRAW THE GRADIENT LINES To define the graduated edges of your sharpness zone, draw a steep right-to-left diagonal line across the image area (arrow 1), aligning with zone of sharpness (here, our train). Draw another steep Gradient line to define the opposite edge (arrow 2). This should leave the diagonal path of the train remaining in red. Looking at the Focus Point Channel thumbnail (inset), anywhere that's black will remain in focus, anywhere that's white will be blurred.

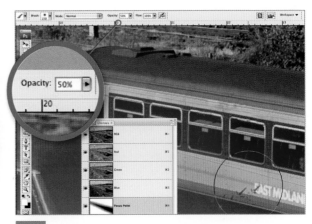

4 BRUSH INTO THE CHANNEL To refine your red sharp zone mask, choose the Brush tool (B) from the toolbox. Check the foreground colour is set to White, and choose a soft-edged Brush with a size of 150px. Lower the Opacity to 50% and carefully paint over the edges of the red mask. This area will now appear as White in the Focus Point Channel thumbnail, meaning it'll be blurred once the Focus Point Depth Map is selected under the Lens Blur tool.

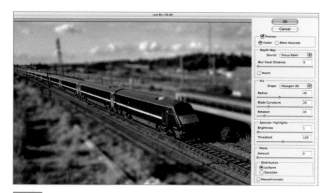

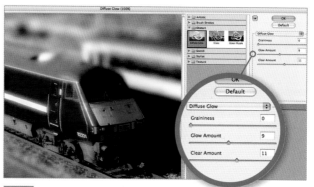

5 SELECT THE DEPTH MAP Select the RGB Channel from the list. Go to Filter>Blur>Lens Blur. Under Depth Map, click on the drop-down list next to Source and choose Focus Point as your Depth Map. Set Blur Focal Distance to 0 and under Iris set the shape to Hexagon (6). Set Radius to 40, Blade Curvature to 20 and Rotation to 45. Under Specular Highlights set Brightness to 1 and Threshold to 120. Leave noise Amount at 0.

6 ADD A DIFFUSE GLOW Move back into the Channels palette and turn off the Focus Point Channel visibility. In the Layers palette, highlight the Background Copy Layer and go to Layer>Duplicate Layer. Move up to the menu bar and go to Filter>Distort>Diffuse Glow. Set the Graininess to 0, Glow Amount to 9 and Clear Amount to 11. Click on OK to confirm.

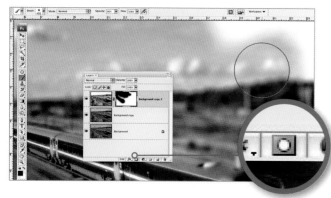

7 PAINT BACK WITH A LAYER MASK With the Background Copy 2 Layer selected, move to the bottom of the Layers palette and click on the Create Layer Mask icon. Choose the Brush tool (B) from the toolbox, and set the foreground colour to Black. Choose a soft brush from the options bar with a brush size of 400px. Reduce Opacity to around 90% and brush over the entire image with the exception of the sharp areas. If there are any other areas in the image that you'd like to return to sharp focus, run the Brush tool over them, ensuring the foreground colour is set to White.

AFTER

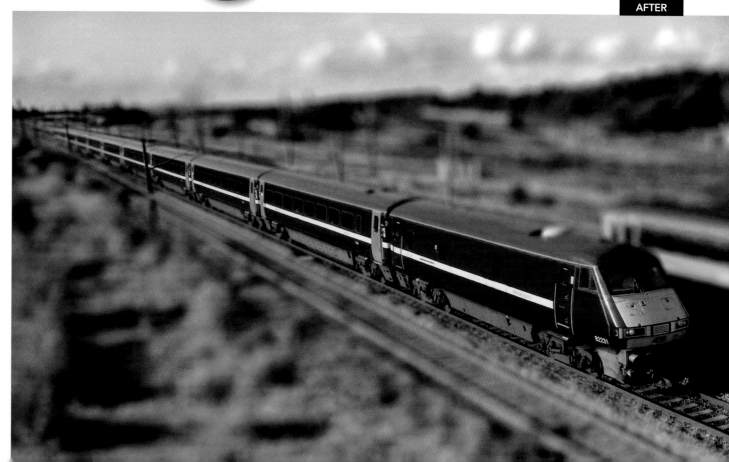

Add borders and text

Simplicity is key to finishing work neatly

WHAT YOU NEED
PHOTOSHOP OR
ELEMENTS

WHAT YOU'LL LEARN
HOW TO ADD
CAPTIONS AND TITLES

A SIMPLE BORDER AND TEXT will give your photographs a more professional finish and to help you create a striking portfolio piece. This step-by-step guide demonstrates how easy it is to use Photoshop's Stroke command to create a simple border around an image, so there's no need to buy special mountboard. A digital border is not only quicker and cheaper, it often looks more effective than the real thing.

As one final refinement, why not try adding a simple caption or title, too? It looks great and will give others a little extra information about your shot.

1 PREPARE TO PRINT A4 Go to File>New and select A4 in the Preset box. This will give you the correct dimensions for printing an A4 page. Go for 300ppi Resolution, RGB Color as the Color mode and White as the Background Contents. Click OK. This will bring up a virtual A4 canvas on screen.

3 CREATE THE BORDER Select the Move tool (V) and use the cursor key on the keyboard to move the image higher. This will allow some extra room for the text later. Making sure you're still on Layer 1, go to Edit>Stroke. Select a Width of 12px then choose your colour, and under Location make sure you select Inside. Hit OK and your new border will appear.

4 ADD THE TEXT Select the Horizontal Type tool (T) and click in the white margin underneath the image. Select the size and font in the Options bar, as well as your text colour. Now write your chosen caption or title. Use the Move tool (V) to move this new text into your desired position – centre, left or right. Finally go to Layer>Flatten Image.

2 MOVE THE IMAGE INTO POSITION Open your JPEG file and, while holding Shift, drag it across onto the A4 page using the Move tool (V). Make sure the new Layer is highlighted and hit Ctrl+T to launch Free Transform. Hold down Shift+Alt and drag the bottom right bounding box corner towards the middle of the image, creating a white surround, then hit Enter or click the tick symbol.

FINISH

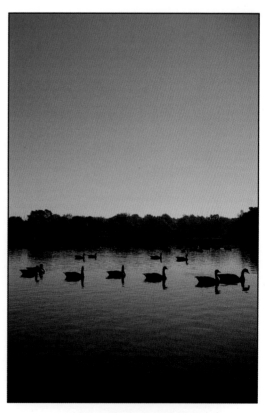

Morning Swans, Petersfield

ADD A SIGNATURE TO YOUR IMAGES

Every artist should sign their work – not least because it helps guard your copyright and shows you're proud of your achievements. It's a lot more personal than simply labelling or captioning images using the Horizontal Type tool we used in the project opposite. Besides, adding a signature in Photoshop is really easy, and looks very professional.

Here we're going to show you how to import your own signature into Photoshop, then save it as a special brush, so you'll be able to use the same mark over and over again on any image you like. This is a really handy way of doing things, but it means you need to be happy with the signature you're using, so practise before importing it and make sure you pick the best one.

Once you're done, follow the steps below to see how easy it is to add your signature to all your very best shots – and sign your work with one click.

1 IMPORT AND LEVEL UP First sign your name on a clean sheet of white paper and scan it into your computer at 300ppi. Or, if you prefer, you can photograph it from above at your camera's highest-quality JPEG setting, making sure the signature is in sharp focus. Once it's in Photoshop, open the Levels palette (Ctrl+L). Push the White point slider to the left and the Gamma and Black point sliders to the right so that the writing turns black and the paper completely white.

2 DEFINE BRUSH PRESET Now use the Rectangular Marquee tool (M) to make a Selection of the signature. Go to Edit>Define Brush Preset and then save the brush name as "My Signature". Open the photo you want to add your signature to and create a new Layer (Ctrl+Alt+N). Click on your Foreground Color box and use the eyedropper to select a colour from the pic. Here, we chose a sandy rock colour.

3 SELECT THE BRUSH Select the Brush tool (B) from the toolbox. Now open the Brush Preset Picker from the Options bar to open your range of brushes. Scroll down and click on My Signature. You can use the [and] bracket keys to decrease or increase the size of your signature brush and to sign your name, simply click once on the image. To finish off, go to Layer>Flatten Image and save your signed pic under a new name.

6 INSPIRATIONAL PHOTOGRAPHY

NOW YOU'RE ACQUAINTED with some of the key Photoshop tools and techniques, it's time to put them into practice. Skills such as making, editing and transforming Selections will be useful in so many of the projects you want to tackle, that it pays to hone those skills now, to improve the quality and impact of your results. Other techniques – such as using Layers, Channels and making Layer Masks – will soon become second nature, an integral part of your photographic approach. The more you use their keyboard shortcuts, the less daunting they'll seem and the more adept you'll become.

Over the next chapter we'll take you through a wide variety of inspirational photographic projects that use all these techniques, giving you an opportunity to try your hand at things like digital solarization and making montages and joiners. There are photographic projects that focus more on the picture taking part of the process, too – for instance using off-camera flash, painting with light and making time exposures. Some of the projects require a combination of photographic techniques and digital manipulation on the computer to get the best, most polished-looking results.

We hope you'll find some inspiring projects to try for yourself in this next section, but don't forget that photographic inspiration can come from anywhere: favourite films, books, dreams, even everyday scenes you pass on the way to school or work. Seeing things as a creative digital photographer can really give you a new perspective on life and a fresh way of seeing the world around you. So – don't feel restricted to directly copying the images in this chapter: use your own ideas and you'll be well on your way to creating some unique works of art to be justly proud of.

Make silhouettes from scratch

Make dramatic silhouettes from scenes shot in daytime

WHAT YOU NEED
PHOTOSHOP OR
ELEMENTS

WHAT YOU'LL LEARN
HOW TO MAKE
SILHOUETTES

IF YOU'RE LOOKING TO CREATE PHOTOS with lots of impact, you won't go wrong with a silhouette. This most striking form of photography is sure to get your pictures noticed, and in this project you'll find out how to get a perfect silhouette the digital way, using either Photoshop or Elements software.

Of course, silhouettes can be created quite easily in-camera, simply by pointing the light meter at the brightest part of the sky and allowing the subject to fall into extreme shadow. However, the best thing about creating silhouettes from scratch the digital way is that it allows you to use any shapely foreground subject, set against any gorgeous sunset, shot in any part of the world.

Here we'll be using simple tools such as the Magic Wand and Layers palette to make a silhouette from a daytime scene looking across the River Thames in London. All you need is a subject with a strong recognizeable outline (such as an iconic landmark or city skyline) that's clear enough to be recognized when you've turned it black.

Silhouettes can work well against simple blue skies and even plain white backgrounds, but for maximum atmosphere, find a nice, fiery sunset among your photographic files so the two elements will offset each other really well. The result will look more realistic, too. Load up both the pictures into Photoshop and follow the steps below.

START IMAGE 1

START IMAGE 2

1 MAKE A SELECTION Open up your skyline landscape (or foreground shape) image and pick the Magic Wand tool from the toolbox. In the Options bar, set it to New Selection with a Tolerance of 20 and tick the Anti-alias and Contiguous boxes. Now keep clicking on the sky to make a Selection of it, and hold down Shift before clicking on the chinks of light between the buildings to add them to the Selection.

2 MAKE A SILHOUETTE When you've selected the whole sky, go to Select>Modify>Expand and use 1px. Hit OK, then go to Select>Modify>Feather and use 0.5px. Hit OK again, then press Ctrl+Shift+I to invert the Selection. Now, go to Layer>New Layer… call it "Silhouette" and click OK, then use Edit>Fill and pick Black. Press OK and you'll have an inky-black skyline.

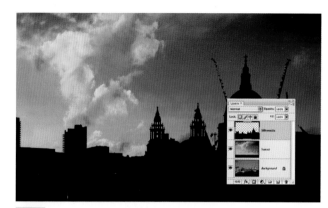

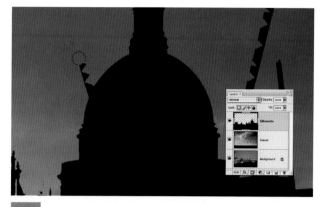

3 ADD THE SKY Press Ctrl+D to get rid of the "marching ants", then open your sunset image. Go to Select>All, then Edit>Copy. Close the sunset image and, back on the skyline, go to Edit>Paste. Now go to Window>Layers and click and drag the sky under the Silhouette Layer. Next, click on the Silhouette Layer and, after selecting the Move tool, click back on the image and drag the skyline downwards.

4 CLEAN IT UP Now let's remove some of the scrubbier elements from the silhouette. Choose the Eraser tool and, in the Options bar, set its Size to 40px and its Opacity to 100%. Now, either using the slider in the brush picker or by pressing Shift and] a few times on the keyboard, make sure it has a hard edge. Make sure you're still on the Silhouette Layer and just paint away the parts you don't want.

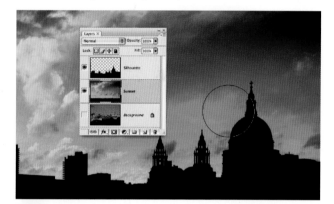

5 LIGHTEN THE SKY To get a little more separation between the silhouette and the sunset, click on the Sunset Layer then pick the Dodge tool from the toolbox. In the Options bar, set its Size to around 700px, its Range to Highlights and its Exposure to around 3%. Now run it over the sky behind the silhouette to lighten those areas and make the black of the silhouette really stand out.

6 FLATTEN AND SAVE Once you're done working on the separate Layers in your image and have a silhouette you're really proud of, you can either save it as a Photoshop (.PSD) file, retaining all the Layers, or go to Layer>Flatten Image to take it back to a single Background Layer. Now go to File>Save As… and use a new name to make sure you don't record over the original pic.

FINISH

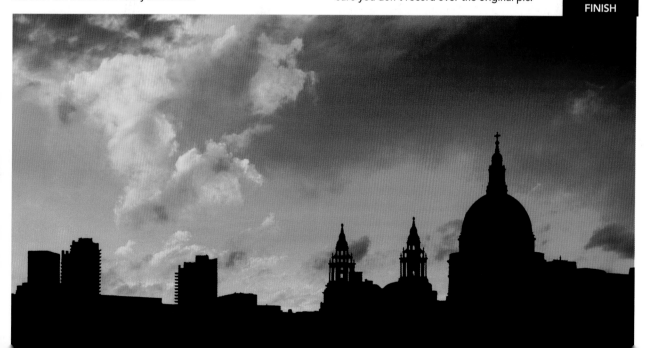

Panoramas

START IMAGES

Shoot a great panorama, then stitch it together automatically

WHAT YOU NEED
PHOTOSHOP OR
ELEMENTS

WHAT YOU'LL LEARN
HOW TO STITCH
PANORAMAS

PANORAMIC IMAGES offer a much wider angle of view than a standard photographic frame – something which makes them perfect for showing off your favourite locations. You can really pack in the detail, too, so people will spend ages poring over them and inspecting the scene you've captured.

Making panoramic images is easy – you simply need to shoot a number of overlapping pictures and then stitch them together. Imaging software such as Photoshop and Elements makes stitching them together really easy – they'll do it automatically for you so long as you give them a fighting chance. That's why the most skilled part of making a good panorama is in how you shoot it.

To guarantee success you need to capture a series of images that share consistent lighting, which are all shot from a very similar position, and that overlap just enough for the software to be able to recognize where one shot starts and the next begins so it can blend them all together next to each other, in the correct order.

You'll need to get out on location for this project, shooting your start pictures in RAW mode.

1 SET UP AND READ THE LIGHT Set your DSLR to RAW mode, then set a low ISO (100–200 is best). Next, set it to aperture-priority (A or Av on the mode dial) and pick the aperture you want to use (we've gone for f/11). Point the camera at the lightest part of your panoramic scene. Make a mental note of the shutter speed (1/200sec here) because you'll need it in the next step.

2 GO MANUAL Switch the shooting mode to Manual (M on the dial) and input the same aperture and shutter speed from Step 1 – f/11 at 1/200sec in our case. Keeping the shutter speed and aperture consistent will mean there's no shift in the exposure between your separate shots, making them easier to blend together in Photoshop. It's best to focus the lens manually too, so the subject stays sharp throughout.

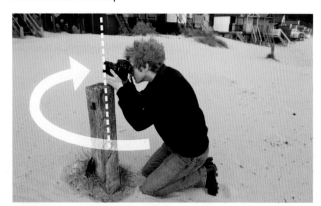

3 PAN ACROSS THE SCENE, SHOOTING ALL THE WAY Point the camera at one end of the scene and take the shot. Make a note of what's on the edge of the frame and move this to the centre of the next shot to ensure there's enough overlap. Make sure you move your body, rotating around the lens, rather than twisting from the waist. To help, try keeping the centre of the lens over a fixed point such as your tripod head.

4 PROCESS THE RAW FILES Open the first of your RAW files into Photoshop. In our case we wanted to bring back some detail in the sky and perk up the colours, so under the Basic tab, we set Temperature to 5500°K, Exposure to -1.00, Recovery to 100, Fill Light to 19, Blacks to 16, Clarity to 50, Vibrance to +40 and Saturation to +10.

5 KEEP IT CONSISTENT To apply the same settings to all our images we clicked Open Image, then opened the other RAW files. Click Select All at the top-left of the palette and then click on the fly-out menu on the right, choosing Previous Conversion. All the files will be updated, so click Open Images. This ensures that all the converted images in the set match up seamlessly as possible.

6 MERGE THE SHOTS In Photoshop go to File>Automate >Photomerge (File>New...>Photomerge Panorama in Elements). Under Layout select Auto, make sure that Blend images together is ticked. Now click Add Open files, then hit OK and the shots will be stitched together. It's worth experimenting with the different Layout options, but the Auto setting is usually the best.

7 CROP AND FLATTEN Choose the Crop tool and drag out a small marquee near the horizon. Move the cursor outside the box and click and drag so it lines up with the slant of the landscape. Now drag out the corner handles to cover the scene and click the tick to make the crop. You may need to clone over some empty areas at the edge of the frame, but first go to Layer>Flatten image. Don't forget to save your shot.

FINISH

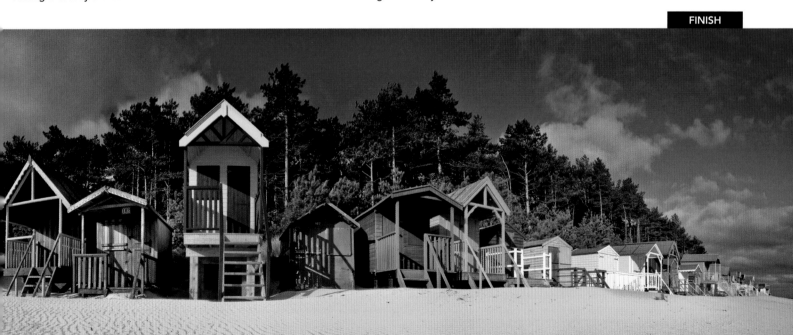

Create an upright panorama

Give tall subjects the pano treatment

WHAT YOU NEED
PHOTOSHOP OR
ELEMENTS

WHAT YOU'LL LEARN
HOW TO MAKE
VERTICAL PANORAMAS

WE'VE JUST SEEN HOW TO MERGE multiple shots into a single, stunning panoramic landscape, but all too often people neglect the opportunity to shoot upright panoramic subjects, too. These tall and elongated views pack in so much detail that they're perfect for showing off tall subjects such as mighty trees, cliffs, mountains, skyscrapers and lighthouses. Because you're stitching several high-resolution pics together, you can produce huge, highly detailed images, print them out and hang them on the wall.

Panoramas are easy to produce – Photoshop and Elements both include Photomerge, a feature that stitches multiple images into one automatically (see previous project). However, on occasion this feature can struggle to recognize which image goes where, so you'll also need to know how to do it manually, too.

With this upright panorama, taken at the Chrysler Building in New York, we've merged a series of three images together manually, by eye.

1 **MAKE A NEW CANVAS** Open your start images and make sure you can see them all on screen by going to Window>Arrange> Tile. We've restricted our panorama to three images for simplicity, but you can use more start images. Now go to File>New... and call it "Upright Panorama". Input a Width of 40cm, a Height of 90cm and a Resolution of 300ppi. The Color mode should be RGB and the Background Contents – White. Now click OK.

2 **COMBINE PICTURES** Using the Move tool, click in the first image and drag it into the new file you've made, then release the mouse button and close down the original. Do the same with the second and third images. Next go to Window>Layers, and you'll have four Layers – Background, Layer 1, Layer 2 and Layer 3. Now click on the eye icon next to Layer 3 to hide it.

3 **ADJUST OPACITY** Click on Layer 2's thumbnail to select it (it'll turn blue) and then click next to where its says Opacity, dropping it to 50%. Now, in the Options bar, make sure Show Bounding Box is ticked and a frame with small squares will appear around Layer 2. Next, click inside the frame and drag the Layer so it roughly lines up with the Layer below.

4 **DISTORT** Hold down the Ctrl key and drag the bottom-right and left handles inwards so the subject detail starts to line up. Don't drag them in too far or it will distort the top of the Layer. Double-click inside the frame and select Layer 1. Do the same here until the Layers are lining up well. Use the centre handles to alter the size.

5 **SOFTEN THE JOIN** Keep swapping between the two Layers until you get a good match. Now select Layer 2, increase its Opacity to 100%, and pick the Eraser tool from the toolbox. Using a 50px soft-edged brush, run the Eraser tool along the join between the two Layers so that any hard edges are removed and neatened up. Don't erase too far or you may show up inconsistencies between the Layers.

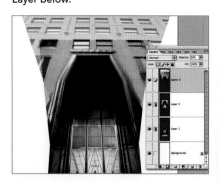

6 **CARRY ON ALIGNING** Pick the Move tool again and click on Layer 3 to make it reappear. Drop the Opacity of the Layer to 50%, then click and drag it roughly into position at the top of the image. Distort it and blend the edge in the same way as in Steps 4 and 5. For more room, click in the Link icon boxes (next to the eye) and drag the linked Layers down.

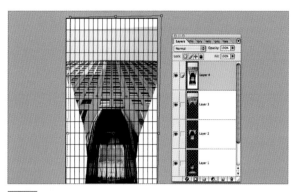

7 STRAIGHTEN AND CROP Once you're done aligning, bring Layer 3's Opacity back to 100%, then press Ctrl+Shift+N and hit OK. Hold Alt, then go to Layer>Merge Visible. Click back on the Move tool, then drag the corner handles to square up the shot (use Window>Show>Grid to help). Now pick the Crop tool, drag it over the image so you lose the white and click the tick.

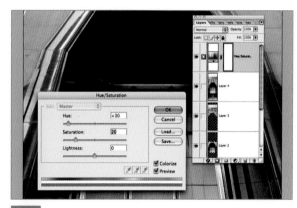

8 GO MONO AND ADD SKY In the Layers palette, click on the black and white circle, choosing Hue/Saturation from the list. Tick the box marked Colorize, then move the Hue slider to 30, the Saturation slider to 20 and click OK. Open an image of clouds and drag it into the panorama as in Step 2. It'll appear above the Hue/Saturation Layer, so just click on the Layer and drag it down.

9 BLEND SKY AND ADD CONTRAST In the Layers palette, click where it says Normal and choose Multiply then, using the Eraser, blend the sky in, as in Step 5. Now go to Layer>Flatten Image, then use the Dodge and Burn tools set to a low Exposure of 3% to add contrast to the image. For more on using Dodge and Burn tools see page 186.

Capture natural portraits

Take portraits outdoors in natural light

WHAT YOU NEED
DSLR AND STANDARD ZOOM

WHAT YOU'LL LEARN
HOW TO TAKE A NATURAL PORTRAIT

ALTHOUGH PHOTOSHOP IS GENIUS at re-touching blemishes and perfecting skin tone in portraits, there's a lot more to taking great people pictures than simply loading up any old JPEG and re-touching it on the computer. Great portraits demand a little time and effort, plus a few basic skills at the picture taking stage – which is why we've returned to camera work for this next project.

To ensure a great portrait, a lot of it has to do with your approach. Successful portraits aren't snaps, they're considered studies of character. Think about how to convey your subject's personality before you pick up the camera, and if it's to be an environmental study – showing the subject in their typical context – think about the location, clothing and props too.

For starters though, let's keep things simple – and that includes your camera gear. Getting a good rapport going with your subject is crucial to catching them looking relaxed and natural; if you're fumbling around with your exposure dial you'll lose any connection with them (unless they're very patient). So prepare beforehand, as this will give your subject confidence and trust in you as the photographer. Clear communication is key.

In this step-by-step we used a clutter-free location offering a neutral backdrop in fairly flat, low-contrast lighting: bright but overcast conditions like this provide a nice, soft illumination. The subject held a white reflector to bounce a little reflected light onto her face from the front.

EQUIPMENT

GEAR YOU'LL NEED

Though pro portrait photographers seem to use a lot of impressive gear, even a modest DSLR with a standard zoom lens is capable of taking brilliant people pics if you use it the right way. But there are certainly some accessories that'll make shooting portraits easier and allow you more creative options.

"FAST" LENSES
Many portraits rely on keeping the subject sharp while the background falls out of focus, so access to wide apertures can help you out. These "fast" lenses allow access to lower f/numbers than a standard zoom lens (f/1.8 versus f/5.6 for example), and can be quite affordable.

REFLECTOR
Getting balanced light on your subject is important, but lugging studio lights around all the time is fairly impractical. That's where a simple reflector comes in, allowing you to "bounce" light onto the subject and fill in shadows.

FLASH
Most DSLRs come with a pop-up flash which, though handy, has its limitations in power and flexibility. Add a flashgun though and you'll have a lot more control – it's a great investment for your kit.

EYES ON OR OFF?
Staring into the lens, the subject really connects with the viewer, but try having them look into the distance or cast their eyes downward for a more enigmatic feel.

1 SET UP YOUR CAMERA
First set your camera to aperture-priority (A or Av on the exposure mode dial), and set the widest aperture on offer (that's the lowest f/number). If you're using a standard zoom, zoom in to about 55mm or 70mm (the long end of most kit lenses) as this will minimise any distortion in facial features. Next, set your ISO to a low sensitivity – 100 or 200 will give the smoothest results.

Focal lengths from 50mm to 70mm are perfect for portraits as they minimize distortion.

2 SORT THE EXPOSURE Switch your exposure mode to Centre-weighted so the camera will base its reading on the centre of the frame (containing your subject's face). Now frame up and check your shutter speed – if it's less than about 1/100sec you may get some unwanted blur from camera shake, so increase the ISO sensitivity to compensate. Also, if your camera or lens has it, turn on its image stabilization feature to minimize shake.

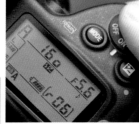

At 50 or 70mm you'll want at least 1/100sec to offset camera shake.

4 CHECK THE RESULTS Check the picture on screen, zooming in to check the point of focus is sharp. If the background is still too sharp and not blurring as much as you'd like, try moving the subject away from it. If the model's face is too dark or light, try pressing the Exposure Compensation button (the +/- on the camera body) and dialling in either +0.7 EV or –0.7 EV accordingly. Don't worry about the background – it's the face that's important.

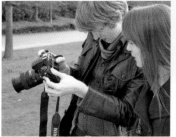

If you need to lighten or darken the model's face, use the Exposure Compensation button on your camera's body.

3 SET UP AND FOCUS THE SHOT Hover your AF point over the model's closest eye and half-press the shutter button to lock the focus there. Next, reframe slightly placing the model's eyes just off-centre and slowly press the shutter all the way to take the shot. Don't move the camera towards or away from the model before you shoot or you'll need to refocus. To make reframing easier, you may want to switch your active AF point to one nearest the model's eye in your composition.

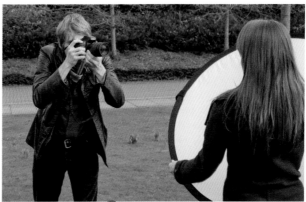

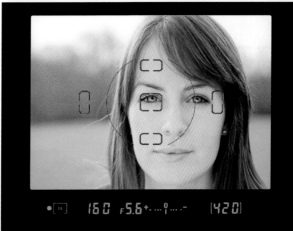

LET THE BACKGROUND BLUR
Just by zooming in and using the largest possible aperture (the lowest f/number), we've got a nicely blurred background – even at f/5.6.

FINISH

Set up a multiple self-portrait

Picture yourself in a multiple-exposure

WHAT YOU NEED
DSLR AND TRIPOD;
PHOTOSHOP OR
ELEMENTS
WHAT YOU'LL LEARN
HOW TO MERGE
EXPOSURES

WHETHER YOU'RE NEW TO PHOTOGRAPHY or an old hand, this project is simply irresistible for anyone who likes to get creative with their camera. Because it's a multiple self-portrait, you don't even need anyone else to help out. So, provided you have a tripod, you can set your self-timer and enjoy the project whenever you have a little spare time.

After measuring the light levels with our camera, we're going to switch to Manual mode and input all the camera settings ourselves. This includes ISO, White Balance, focus, aperture and shutter speed; setting all these manually ensures that they're fixed in place and are unable to change between shots.

Make sure you work fast, though, as you don't want ambient light levels to change... The more time and attention you give to shooting the steps carefully will make the Photoshop post-production work a breeze.

A DSLR is ideal for taking the pictures, but a compact will work, too, provided you can control the aperture and shutter speed in use. The other essential item is a tripod, as the camera mustn't move between the series of shots.

Pick a suitable setting – indoors or out – and think about how you're going to position your two (or more) selves in the frame. You might want to tell a story with your image, or simply play on the fact that your twin is starring alongside you. You may choose to wear different clothes in each constituent shot, or go for a more obvious "clone" of yourself instead.

For our shot we chose an interior passageway lit with fluorescent lights, so we set our White Balance to the camera's Fluorescent pre-set in the menu. Match your own White Balance setting to the lighting you're in, then select a low ISO of 100 or 200 for best, least "noisy" results.

1 SET UP YOUR CAMERA Select aperture-priority (A or Av) on the main mode dial, and pick a medium aperture of f/8 to f/11 if you're outdoors, or a larger aperture such as f/4 if you're indoors. Frame up your shot and make sure your shutter speed is 1/30sec or faster.

2 SET YOUR FOCUS Once your shot is composed, switch to manual focus and focus on the point where the nearest "you" is going to be in the shot. You obviously won't be there yet, so pick something that's at the same distance.

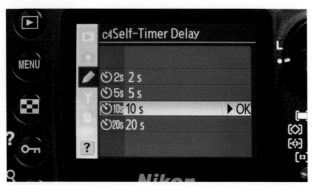

3 SET THE SELF-TIMER Find your self-timer control (either on the body or in the menu) and make sure it's set to give a delay of 10 seconds (you'll be able to do this in the menu). This delay will give you time to get into position and act out your multi-portrait scene before the camera shutter fires.

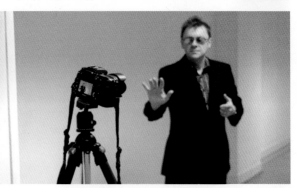

4 TAKE THE FIRST SHOT Press the shutter and walk over to your first position in the frame. Pose for the shot and when the camera has fired, carefully check the screen to see if it's successful. Take care not to move the camera when doing this. Repeat as many times as necessary to get it right.

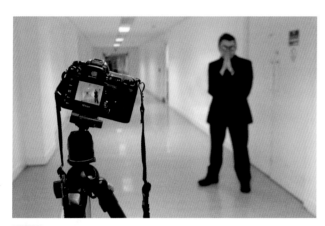

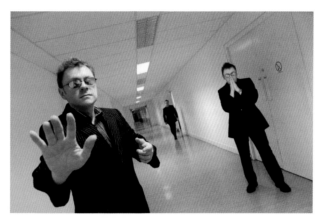

5 TAKE THE SECOND SHOT Now repeat Step 4, only this time, change your clothes (if that's your idea) and take up your second position in the frame. Repeat this as many times as you need to get a good result, but don't alter the camera's position or settings. Try a third position too, if you want.

6 BLEND THE PICS Load the images in Photoshop or Elements, open up the best "takes". Select the Move tool and, while holding the Shift key, drag one into the other. Make a Selection of the figure in the top Layer, hit Ctrl+Shift+I, and then hit Delete. Save when you're done.

FINISH

START

Add selective blur to backgrounds

Draw attention to subjects by blurring what's behind them

A STRONG PORTRAIT PICTURE concentrates the viewer's eye on the human subject within it, most often by throwing the distracting background out of focus. In travel portraits like this, however, the settings and environment can be just as important, helping to tell a story of where and when the image was taken, giving the subject context and interest.

This poses a dilemma: how can we keep the background yet deliberately diminish it at the same time? Fortunately Photoshop offers us a neat way of softening the background yet at the same time keeping some of these important contextual clues. By using a combination of the Gradient tool

and Quick Mask mode, you can make an intricate Selection and turn any distracting areas soft using selective lens blur, but keeping the subject – and other areas of interest – nice and sharp.

What's more, once you've made this Selection you can also use it to boost the saturation and sharpening in the key areas of interest and really make your travel portrait come to life.

All you need for this next step-by-step project is a full-length street portrait with a "busy" backdrop.

1 CROP THE IMAGE Open the image and select the Crop tool from the toolbox. In the Options bar, enter Width 21cm, Height 29.7cm, Resolution 300. Draw a crop box over the subject that doesn't crop into them but removes any "dead" space above their head and below their feet as well as any backdrop distractions emerging on the left or right. Double-click in the bounding box to apply the crop.

2 ADD A REFLECTED GRADIENT Go to Window>Channels and press Q on the keyboard to enter Quick Mask mode. Select the Gradient tool from the toolbox and in the Options bar choose the Reflective Gradient which is the fourth icon along. Starting at the centre of the subject, draw a straight line across to the right-hand side of the image and then release the mouse button.

3 ADD A SECOND GRADIENT Go to Window>Channels and, holding down Ctrl, click on the thumbnail icon of the Quick Mask channel. With the Gradient tool still selected, we drew a second gradient line starting from the centre of the car over to the centre of the man – around one of his shirt buttons – and released the mouse button.

4 PAINT INTO THE MASK Press on the keyboard and then select the Brush from the toolbox. In the Options bar select a 200px soft-edged brush with Opacity of 100%. Hit D on the keyboard to set Black as the foreground colour and paint over the areas where you need to keep the focus – in this image we chose the car, the man's face and his newspaper.

5 APPLY LENS BLUR Hit Q on the keyboard to exit Quick Mask mode and a "marching ants" Selection will appear. Now go to Filter>Blur>Lens blur and under the Iris menu select Hexagon from the Shape drop-down list, a Radius of 40px and leave all other values at 0. Under the Distribution menu ensure Gaussian is ticked and click OK.

6 ADD NOISE Go to Window>Layers to activate the Layers palette. The "marching ants" selection will still be active, so to make the Lens blur effect look more natural, go to Filter>Noise>Add Noise and enter an amount of 4%. Under the Distribution menu tick the box for Gaussian, and ensure the box at the bottom for Monochromatic is also ticked. Click OK.

FINISH

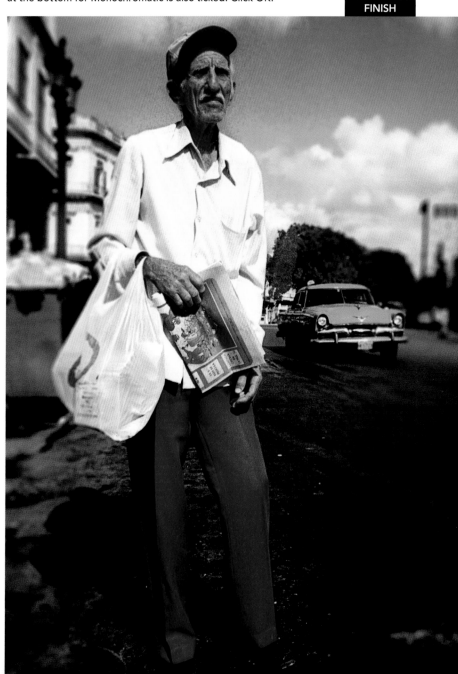

7 ADJUST SATURATION Now go to Image>Adjustments> Hue/Saturation and move the slider for Saturation to -40. Click OK, then go to Select>Inverse and back to Image> Adjustments>Hue/Saturation. Under the Edit box we selected Yellows from the list and increased saturation to +60. Adjust the Saturation for your image according to the dominant colours (here, Cyans +60 and Reds +30) and click OK.

8 APPLY SHARPENING The "marching ants" will still be active so tap Ctrl+J on the keyboard to transfer the selection into a new Layer. In the Layers palette change the Blending mode to Overlay, then go Filter>Other>High Pass and enter a Radius of 4px. Click OK. If you're happy with the effect, go to Layer>Flatten Image, otherwise save it as a .PSD.

Take portraits of children

Generate high key studio effects at home

YOU DON'T NEED TO VISIT a professional studio for high key portraits like the one here. All you need is a plain white bedsheet as a backdrop to create a "wall of light" effect. Pick a bright but overcast day to take the picture and set-up the scene in a room with large windows. You'll have to dial in exposure compensation (say +0.7) to avoid under-exposure – the camera's light meter will try to turn the white sheet an average grey. With young children, the attention span is short, so keep talking, work fast and take plenty of shots! Here we've merged three of them into one image.

Here our young model sat on a clear storage box to pose. Then, in aperture-priority mode, we dialled in +0.7 exposure compensation to ward off under-exposure. At ISO 400 and aperture of f/5.6, this gave a nice handholdable shutter speed of 1/125sec for the shoot.

1 CREATE A NEW CANVAS Go to File>New and create an A3-sized document (420 x 297mm/16^1/$_2$ x 11^7/$_{10}$) with a Resolution of 240 pixels/inch. Make sure RGB Color and 8 bit is selected in Color Mode and Background Contents is set to White. Click OK, and a blank A3 canvas will appear on screen.

2 DRAG IN THE FIRST PIC Open up your first JPEG to merge and tap in Ctrl+A to select the image. Now tap Ctrl+C to copy it, and then Ctrl+W to close down the image. Hit Ctrl+V to paste the pic into your new canvas, and then Ctrl+T to enter Transform. Hold Shift and drag out the corners till the image is nicely sized on the left, then hit Return.

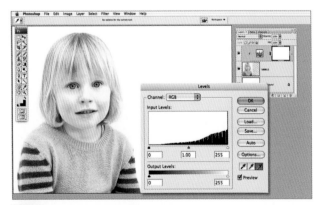

3 WHITEN THE BACKGROUND In the Layers palette (Window>Layers), hold Alt and click the Adjustment Layer icon, selecting Levels from the list. Tick the Clipping Mask box, and click OK. In the Levels palette, click the white eyedropper and then click on the backdrop until the whole thing turns pure white and blends into the new canvas.

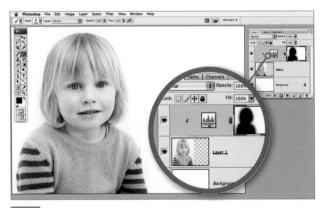

4 RESTORE THE DETAIL The subject will be a little bleached out. To restore detail, pick the Brush tool and, making sure Black is selected as the foreground colour (tap D then X), paint over the child with a large, soft-edged brush to mask out the effect of the Levels adjustment. This will leave the original exposure the same but keep the background white.

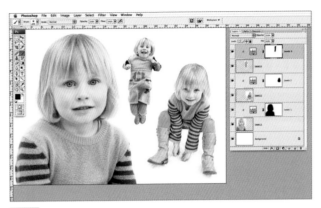

5 BRING IN THE SECOND PIC Open your second child picture and paste it into the main pic in the same way as the first one, using Ctrl+A, Ctrl+C, Ctrl+W and Ctrl+V. Next tap Ctrl+T and, while holding Shift, drag a corner handle to resize the pic to fit. Whiten up as before in Steps 3 and 4. Hit Return to confirm, then use the Eraser tool with a soft-edged brush to tidy up any overlapping edges or distractions.

6 BRING IN THE THIRD PIC Click on the top Layer in the Layers palette, and then open your third child picture. Add it to the main image using Ctrl+A, Ctrl+C, Ctrl+W and Ctrl+V. Transform it down using Ctrl+T until it's about 60% of its original size, then hit Return to confirm. Use the Eraser tool to remove the overlapping edges of the Layer, then whiten the background using a Levels Adjustment Layer and Mask.

7 CHECK IMAGE AND FLATTEN Zoom in and check the image closely for any blemishes or inconsistencies. Fix any masking or overlapping edge problems by sorting out the appropriate Layer, and when you're happy with the whole thing, go to Layer> Flatten image to crunch it into a single Background Layer.

8 DODGE AND BURN Select the Burn tool and, in the Options bar at the top of the screen, set Range to Shadows and Exposure to about 4%. Gently work over the eyes with a small, soft-edged brush. Now switch to the Dodge tool, and set Range to Highlights and Exposure to 4%. Work over the eyes again, bringing up the catchlights and the whites of the eyes.

KEEP IT BRIGHT
High key effects like this are easy using Photoshop to help keep things looking pristine white. Using an A3 canvas means it's the perfect size for framing.

9 SHARPEN AND SAVE Use the Lasso tool to make a rough Selection around the child's eyes in the largest portrait. Hold Shift to include the whole the face. Go to Select>Modify>Feather (Select>Feather in older versions of Photoshop) and enter a value of 25 pixels. Go to Filter>Sharpen >Unsharp Mask and enter values of 140, 1.0 and 4 to add an extra degree of crispness to the selected areas.

Shoot fun and funky teenagers

Capture the fun and freedom of being a young teen

WHAT YOU NEED
DSLR AND
STANDARD ZOOM

WHAT YOU'LL LEARN
HOW TO STYLE UP A
TEEN PORTRAIT

TRYING TO KEEP TEENAGERS AMUSED is no easy job, but try shooting them at the same time and you've got your work cut out. The secret to getting great shots of this age group is knowing that all teenagers want to look cool, so use this to your advantage!

You don't need piles of expensive kit or exotic locations, and using available light is perfect. What you do need is the ability to break the ice and entertain your subject, while having some fun at the same time.

SHALLOW DEPTH OF FIELD

With any portrait photography, there are two key things to remember about your camera technique: one is to control your aperture settings for shallow depth of field; the other is to maintain sharp focus, especially on the subject's eyes.

Aperture control is the easy part, because you can set your camera to aperture-priority and then select the desired number. An aperture around f/5.6 is perfect for most portraits and is ideal for keeping the background detail nicely out of focus so it doesn't take the emphasis away from the main subject.

It's the shutter speed that can prove more difficult, especially on gloomy winter days when the available light is poor. Ideally you want to keep shutter speeds above 1/125sec if you can, to allow for handholding the camera and to avoid shots blurred by subject movement. One solution to securing fast shutter speeds in low-light – and it's perfect for gritty-looking, grainy, stylized portraits of teenagers – is to use your ISO settings to increase the camera's sensitivity to light.

It's quite common to shy away from using higher ISO settings in general photography, because noise levels (image interference) increases and in turn the sharpness of your images starts to drop off. With newer DSLRs, however, noise performance is a lot better, so in extreme low-light situations you can push towards ISO 1600, but a more practical target is ISO 400. This is just enough to give you a faster shutter speed but doesn't push the camera too far and ruin your shots.

PROPS AND STYLING

The other thing you should consider is props. Avoid using them unless you think they really add to the portrait. These can be obvious items such as a bike or skateboard, or fashion details such as different styles of shoes or jewellery. In our first shot below we've used an umbrella as it protected our teens from the rain, but also became a useful way of hiding a "busy" garden background.

For styling inspiration it's a great idea to look at fashion magazines and watch music videos. These are filled with trendy pop culture images that teenagers love. Encourage your subjects to make a collection of their favourite pictures torn from magazines to inspire your own shoot. Get them to consider their outfits with assistance from mum or dad, which should dissuade them from anything too inappropriate.

1 CROP IN You can't always pick a clear background, so this is where you need to get a bit inventive. The best thing to do is to get in close to the subject so that any background distractions don't interfere with your image. In this case, the backgarden had a number of items in view that weren't hugely distracting, but were be best avoided as they spoiled the mood of the shot. Because the girls were holding an umbrella as a shield from the rain, we zoomed in closer to use it as our backdrop. The resulting shot has more impact and you're focused on the girls, not the garden.

2 STYLING AND POSING Teenagers will have their own views on styling, but if they want guidance, strong colours are always good, especially against earthy or urban backdrops. Sometimes the styling will be dictated by a special event, such as going to their first music gig or school prom.

Posing needs to be a fun experience. Joking will always help to break the ice, but the most important element is to keep things moving. Teenagers get bored very quickly, so you need to pre-plan your ideas so you can zip from one shot to another. Involving two teenage friends is a great idea, because they'll lark about together. You can also have one encourage the other to laugh and pose, or even hold your reflector. The more shots you do, the more they'll relax.

3 KEEP GEAR SIMPLE
We had the luxury of two lenses for this shoot, a standard 24–70mm zoom and a 70–200mm lens. A standard zoom is all you need, but a longer zoom can be very effective for portraits, especially when used to crop in from a distance. The only trouble with moving further back from your subject is that it makes communication with them more difficult.

Aside from lenses, a reflector is possibly the most useful accessory you can own for portraits. Use it to bounce light back onto your subject – even in gloomy conditions it can boost light levels quite nicely.

4 LOCATIONS Choosing where to locate your teen portrait shoot can be tricky. Look for locations where teenagers hang out, so they feel comfortable, but don't pick places that are too busy, as they're less likely to relax in front of their peers or when they think someone else is watching. It was raining on the day of our shoot, so we needed a sheltered area: an underpass proved perfect, as there was plenty of light at each end. The concrete walls gave an excellent "urban" backdrop.

Other suggestions might include city walls covered in colourful graffiti, park benches and skateboard parks. For Steps 2 and 3 we used a wooden bus shelter, with a fair amount of "urban decoration".

If shooting indoors, choose a room with plenty of attractive window light and use a reflector to bounce reflected light back on to the subject. Try to avoid rooms that are too cluttered – unless shooting a contextual portrait of the teenager in their own bedroom environment.

HAVING A LAUGH
It's important that shoots with teenagers are fun. Encourage experimental poses and don't try to control the shoot too much as you'll crush any creative spontaneity.

Add texture effects

Create a wintry "ice queen" portrait

WHAT YOU NEED
PHOTOSHOP OR
ELEMENTS

WHAT YOU'LL LEARN
HOW TO ADD
TEXTURE LAYERS

IF YOU'RE LOOKING FOR A GREAT WAY to improve your portraits next winter, why not give this frosty textured look a try? Here we've taken a regular portrait and applied an effective wintry look so, in a few simple steps, we turn our original portrait subject into a frosty ice queen.

This icy effect has been achieved using Adjustment Layers, a toning effect, some basic Masks and a fern-like frosty texture from a car windscreen. But as the effect is built up in stages, it's really easy to apply – even if you're not very experienced in Photoshop or Elements. Perhaps best of all, the technique will work on virtually any portrait, so once you've had a practice with the icy texture, you can apply the same texture to any of the portraits in your collection, or apply different textures to them for different results – all using the same basic technique.

SHOOTING THE START IMAGES

Though you can use pretty much any portrait shot for this wintry effect, it helps to start with a good quality image and if you're planning on shooting one specifically, here are some tips to help:

■ To conjure up a feeling of the Arctic tundra, it's important that the model's stance and clothing are appropriate. You're not shooting a documentary image here – it's a constructed portrait, a fantasy image – so don't be afraid to experiment and tell the model exactly what you're after.

■ Think about an appropriate pose. As you'll see in our example image, the model's hands are tucked up under her chin and she's wearing a furry-collared winter jacket – two simple visual clues to the cold temperature that, combined

with the Photoshop work, will sell the shot as a freezing character study.

■ The heart of any portrait is always the eyes, so it's here that you want to fix the focus in your shot. To get the eyes nicely in focus, hover your AF point over that area, then half-press the shutter button. Keep it held, then recompose the portrait and shoot. Don't move from your shooting position though, or you may need to refocus – especially if you're using a lens that offers very low f/numbers such as f/2.8 or wider.

■ Portraits have more impact when shot with shallow depth of field, allowing the subject to stay sharp while the background is diffused. Set your camera to aperture-priority mode (A or Av on the exposure dial), then set the lowest f/number possible. Then, if you're using a standard zoom kit lens, set it to about 50mm – you'll probably get an aperture of about f/5.6.

■ To create some wintry sparkle in the eyes, use a reflector, or pop up your DSLR's built-in flash for a bit of extra twinkle.

To shoot the ice texture, add a little positive exposure compensation to keep the image nice and bright. Fill the frame with the texture and shoot it from directly above if possible, so you keep the entire image flat and graphic, with all the texture on the same plane of sharp focus.

Other elemental portrait textures you might like to use could include fur, wood, sand, clouds, leaves, woven fabric, rusty metal, slate or water... keep your eyes peeled for inspiration around the house.

There are lots of graphics websites on the internet offering free texture images to share, too.

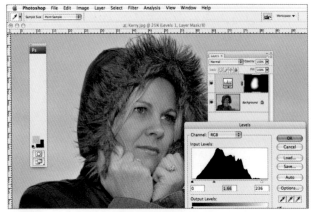

1 LIGHTEN THE MODEL Open your start portrait and pick the Polygonal Lasso tool from the toolbox. Make a Selection around the subject's face, then go to Select>Feather. Input a Radius of 150px and click OK. Now go to Window>Layers and click the Add Adjustment Layer icon (the small black and white circle), choosing Levels. Move the White point and Midtone sliders to the left and click OK.

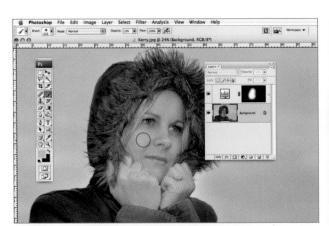

2 EVEN THE SKIN TONE Now click on the Background Layer, pick the Brush tool and hold the Alt key on the keyboard. Click on the subject's cheek to select a skin tone colour, release Alt, and, using a soft-edged brush of about 250px in size, with its Opacity set to 10% in the Options bar, paint over her face, avoiding the eyes. Do this a few times until the skin tone is nice and even.

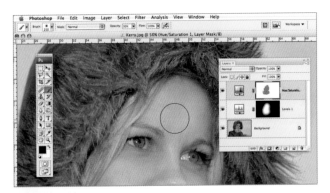

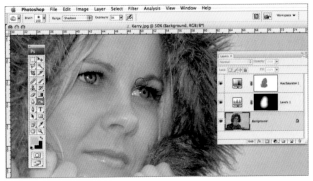

3 MAKE IT COLD Now click back on the Levels 1 Layer and add another Adjustment Layer, this time choosing Hue/Saturation. Click the Colorize box and set the Hue to 205. Leave Saturation at 25 and Lightness at 0 and press OK. Now pick the Brush tool again and, making sure Black is set as the foreground colour and its Opacity is 30%, paint over the subject's face a few times to bring back some skin tone.

4 REFINE THE MASK Now drop the brush size to 50px and increase its hardness by pressing Shift and the] key a few times. Next press X on the keyboard to swap the foreground colour to White and bring the Brush's Opacity up to 100%. Now paint over the subject's irises to bring back their natural colour before clicking back on the Background Layer once more.

5 ENHANCE THE EYES Pick the Dodge tool, set its Size to 50px, Range to Highlights and Exposure to 40%. Run it over the irises to lighten them, then use the Burn tool, set to Shadows, 3% to darken the pupils. Now use the Lasso tool to select the eyes, Feather by 20px and go to Filter>Sharpen>Unsharp Mask (Enhance>Unsharp Mask in Elements) using Amount: 100%; Radius: 1px; Threshold: 0.

6 ADD THE FROST Press Ctrl+D then open your frost texture image. Press Ctrl+A, then Ctrl+C, and then in the portrait file, press Ctrl+V. In the Layers palette, click and drag the frost to the top, then click where it says Normal and pick Multiply. Press Ctrl+T and drag out the corner handles to resize it. Finally use the Eraser tool (400px size, 30% Opacity) to remove it near the model's face. Now you can save the image. **FINISH**

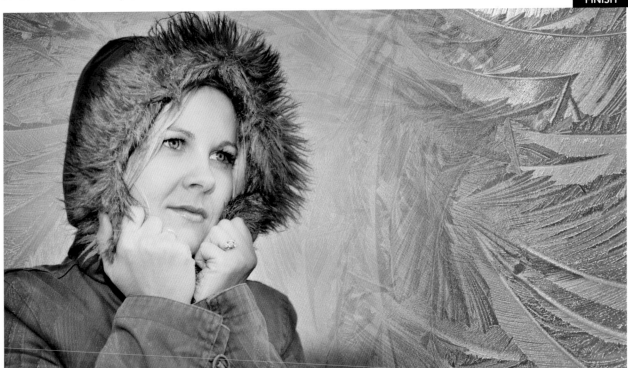

Lift your summer landscapes

START

Use basic adjustments to boost your views

WHAT YOU NEED
PHOTOSHOP OR
ELEMENTS

WHAT YOU'LL LEARN
HOW TO IMPROVE
LANDSCAPES

IF YOU'VE FOLLOWED ALL THE GOOD ADVICE on shooting techniques in chapter 4, your landscape compositions will be spot-on every time! However, there are some excellent ways to improve your landscapes in Photoshop, too.

Here we'll look at improving your results using Selections, Levels and the Dodge and Burn tools. First though, we'll make sure that your landscape is straight and level and that composition is spot-on. Then we'll add extra contrast so the shot becomes really eyecatching rather than flat and dull. Finally we'll apply a warm-up effect.

1 STRAIGHTEN UP Open your start image and, if the image horizon is at all wonky, zoom out by pressing Ctrl and the minus key. Go to Select>All, then Edit>Free Transform. Position your cursor just outside one of the corner handles, then click and drag to rotate the photo clockwise. An angle of 4° works for this shot, but as a reference, go to View>Show>Grid (View>Grid in Elements).

2 REPOSITION Either holding the Shift key or making sure Constrain proportions is ticked in the Options bar, click and drag the corner handles out so you lose the space around the edges of the picture. You can also reposition the photo by clicking and dragging on it. When you're done, click the tick box and then go to Select>Deselect. To remove the Grid, go to View>Show>Grid once more.

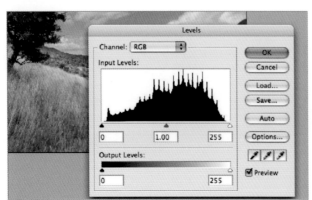

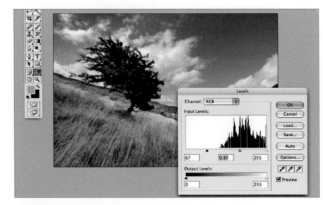

3 CHECK THE LEVELS At this stage it's a good idea to check the overall exposure of your photo and make sure it has a full range of tones. Bring up the Levels palette by pressing Ctrl+L and take a look at the histogram. In our example image, the histogram doesn't fill the whole length of the chart, so we need to click and drag the Black and White point sliders inwards to meet it. Press OK to exit the palette.

4 DARKEN THE SKY Make a Selection of the sky – we're going to darken it for extra drama. Hit Refine Edge and apply 200px of Feathering. Press OK, then Ctrl+L and drag the Black and Middle sliders to the right again, but this time try holding the Alt key as you do. This will generate a clipping warning, so when you see lumps of cyan appearing it's time to stop, lest you lose detail. Hit OK to exit and Ctrl+D.

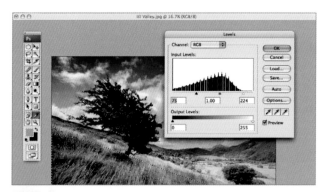
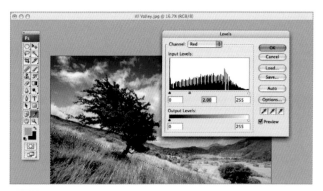

5 IMPROVE FOREGROUND Make a Selection of the foreground and press the Refine Edge button. Set the Feather Radius to 250px and hit OK. Open the Levels palette once more and drag the Black point slider to the right, and the White point slider to the left, adding some rich contrast to the grass. Again, hold Alt and stop moving the sliders when you see the clipping warnings grow too large.

6 WARM UP THE FOREGROUND Before pressing OK, click at the top of the palette where it says RGB and change the Channel to Red. This time, click and drag the Middle slider to the right – somewhere around 2.00 worked here. Now change the Channel to Green, moving the Middle slider right to 0.90. Finally, pick Blue as the Channel and move the Middle slider right, again to about 0.90. Hit OK, then Ctrl+D.

7 SEPARATE ANY FOREGROUND INTEREST To lighten up the area behind our tree here, we picked the Dodge tool from the toolbox and, in the Options bar, set its Size to about 200px, its Range to Midtones and its Exposure to 3%. We made sure it had a soft edge by pressing Ctrl+Shift+[a few times. We ran it over the hill behind the tree to lighten this area, helping the dark tree trunk to stand out.

FINISH

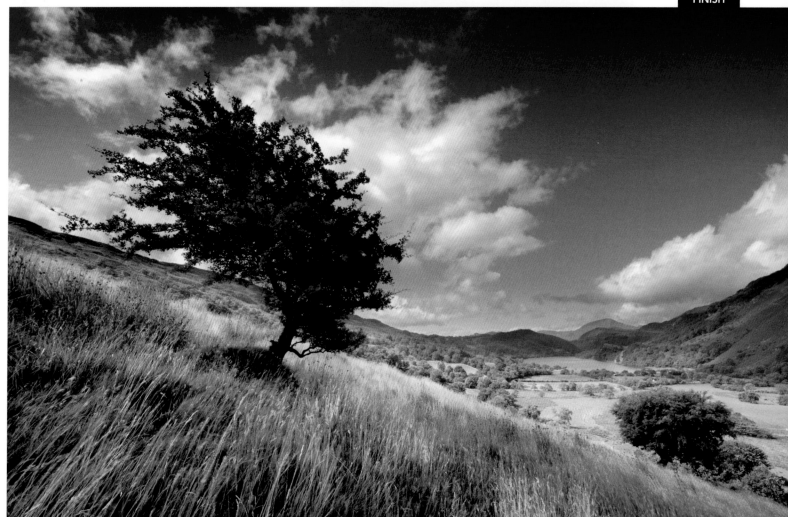

Replace a boring sky

Revive photos by improving the sky

START IMAGES

WHAT YOU NEED
PHOTOSHOP OR
ELEMENTS

WHAT YOU'LL LEARN
HOW TO MOVE
AND SWAP SKIES

GREAT LANDSCAPES NEED GREAT SKIES, and nowadays, thanks to Photoshop, you can replace dull ones in an instant. Of course it's easy to balance up the exposure differences between a bright sky and a dark landscape using a Neutral Density filter, but what happens when the sky that nature gives you simply isn't good enough? Photographers with a purist streak might head for home and save the location for another day when the heavens are putting on a better performance. This is fine, but if the light falling on the foreground and everything else is working, it seems a shame not to make the most of it. And on top of that, what if you're a long way from home and aren't able to revisit the place? On these occasions it's better to come back with something than nothing at all.

This technique shows you how to turn an "if only" pic into a top-notch image. It reveals how to strip out a featureless sky and put something better in its place. Of course, the result is not a "real" image, but this is the technique advertising creatives use all the time to enhance their scenic shots, so it makes sense to make it work for your images, too.

To make it look convincing, the trick is in selecting the right kind of sky – one that's lit in the same way as the subject – and then making sure the join on the horizon is carefully blended.

To try it for yourself, load up a landscape with a featureless sky, and a sky image with perfect clouds. Get used to shooting great skies whenever you see them – you never know when they might come in handy.

START IMAGES
In the picture on the left, taken at Red Rocks Canyon in Nevada, USA, the subject is great but the sky is dull and lets the image down. By adding the sky from the pic above (taken in Devon), we've given the Nevada scene a huge dramatic boost.

1 SELECT THE BLAND SKY Open your bland sky landscape image and select the Magic Wand from the toolbox. In the Options bar set Tolerance to 32 and ensure that both the Anti-alias and Contiguous boxes are ticked. Now click on the bland sky, then hold Shift and click again until the entire sky is selected, and you have "marching ants" running all the way round it.

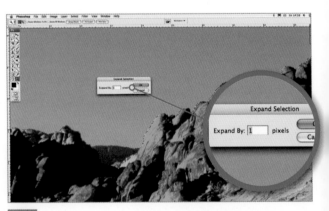

2 REFINE THE SELECTION Go to Select>Modify>Expand and enter a value of 1 pixel. Click OK and the Selection will "grow" to take in the whole of the skyline. Now open the Layers palette (Window>Layers) and while holding Alt, double-click the Background Layer to turn it into an editable Layer 0. Hit the Backspace key and the selected sky will disappear. Now hit Ctrl+D to remove the "marching ants".

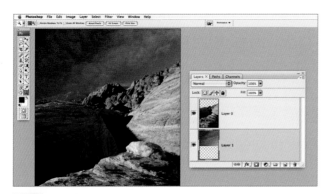

3 ADD THE NEW SKY Open your new improved sky. Hit Ctrl+A on the keyboard to select the entire image and then hit Ctrl+C to copy it. Close down the original sky pic (Ctrl+W) and then hit Ctrl+V to paste in the image. These shortcuts are worth learning if you want to speed up your imaging! Now in the Layers palette, drag the sky underneath the rocks so it shows through the hole you've made.

4 FLIP AND RESIZE THE SKY For naturalism, we had to "flip" our sky. We went to Edit>Transform>Flip Horizontal so the lighting in the new sky corresponded with the sky we'd replaced. To reposition the sky, hit Ctrl+T and drag in the corners to shrink and position it. When you're happy, hit Return to confirm the changes. In Elements go Image>Rotate>Flip Layer Horizontal, then Ctrl+T to shrink and position.

IMAGE WITH NEW SKY
Gone is the bland, featureless slab of blue, and in its place is a much more interesting sky dappled with clouds. The two pics were actually taken over 8,000 km (5,000 miles) apart, but who's to know?

FINISH

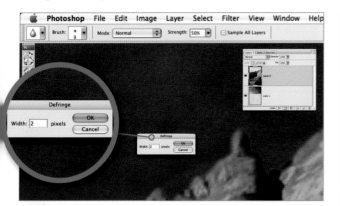

5 BLEND THE PICS To get a realistic join, click on the landscape Layer, and then select the Blur tool. In the Options bar, pick a soft-edged brush with a Size of around 9-13px and a Strength of 50%. Carefully work along the skyline, blurring the edge as you go. When you're done, go to Layer>Matting>Defringe, use an amount of 2 pixels and click OK. In Elements go to Enhance>Adjust Color>Defringe Layer.

6 FINISHING TOUCHES Create a Levels Adjustment Layer for the landscape and tweak the sliders to improve contrast. Select the Red Channel and move the middle slider to the right to enrich the colours. Click OK, then do the same for the sky. Finally, do a little dodging and burning to fine-tune the contrast.

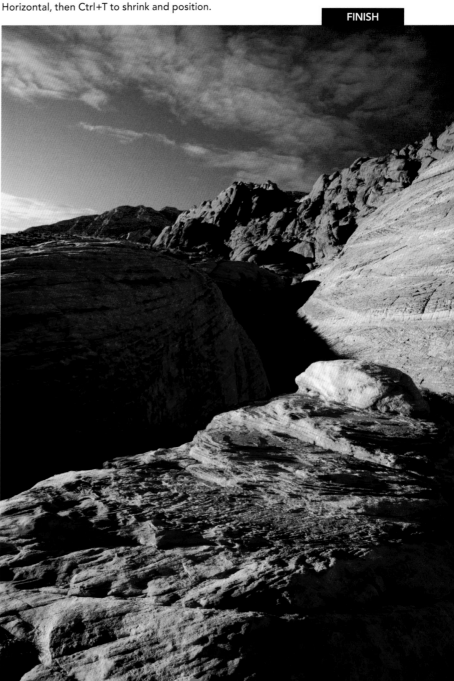

Shoot frosty winter landscapes

Winter is best for dramatic landscapes

WHAT YOU NEED
PHOTOSHOP OR
ELEMENTS

WHAT YOU'LL LEARN
HOW TO SHOOT
WINTER SCENES

THE SHORT DAYS OF WINTER are a great time for landscape photography. Though many photographers only feel the need to rush out with their camera in the blazing summer sunshine, if it's great landscapes you're after, ignore winter at your peril. Yes, the conditions aren't as comfortable to work in as the summer or spring months, but with shorter daylight hours and the fact that the sun is lower in the sky all day, you'll find there's a lot of great light about – perfect for scenic shots.

This low-angled sunlight is perfect for picture taking, thanks to the way its long shadows make scenes look more three-dimensional. The low-angled sunlight is also warmer in colour temperature, helping to warm up their landscape images. Plus, with the sun rising as late as 8am and never reaching very high in the sky, you'll find great shots are possible all day long.

Then there's all that lovely frost and snow – a great addition to any landscape – and in our example here you can see how frost can perk up an otherwise dull foreground. Just be sure to get up early to catch it.

For this step-by-step project we're starting out with a fairly drab RAW file and, using a few basic controls, turning it into something much more pleasing. We're going to boost the contrast in our shot by combining two separate RAW conversions of the same image – one for the sky and one for the foreground – adding a little Saturation to improve the colours in the sky, enlarging the foreground to give it more impact and finally sharpening the whole shot to make the most of our silhouetted tree and frosty details.

It's all simple to do, and in the space of a few minutes you'll find out how to create a really effective and successful winter landscape.

HOW TO SHOOT A FROSTY LANDSCAPE

Once you've found a nice frosty scene, it's important that you make the most of the conditions. The details you're after – the tiny spines of hoar frost that accumulate on the foliage and ground – will all be lost if they're not featured quite large in the foreground, so you need to take steps to ensure some beefy detail. Zooming in will get you closer to the frost, but won't allow much else in the scene to be visible – fine for studies of the frost, but not great for a striking landscape.

The solution is to get your camera as low to the ground as possible and use your lens's widest angle – 18mm on most standard zooms. This will pack in the detail close up while still allowing you to get a good view of the rest of the scene.

METERING AND SHOOTING

If you're handholding the camera and shooting low, it's a good idea to take a bin liner to lie on. However, the real answer is to use your tripod – not only will it ensure sharper shots than you'll get by holding the camera yourself, it will also allow you to keep it positioned low to the ground without you having to constantly bend down.

When it comes to metering, you'll find that snow and frost may trick the camera into thinking the scene is brighter than it really is, giving darker results and "grey snow" as the camera under-exposes the scene. To combat this, either use RAW mode and tweak the exposure in your conversion software, or else change your metering mode to Spotmetering and take a reading from the white frost or snow. Next press the small +/- Exposure Compensation button on your camera and add +1.5 to 2 stops to get your whites looking white.

Crop in your RAW conversion using this tool.

1 EXPOSE FOR THE SKY Open your RAW landscape file and click on the Crop tool icon. Next, drag it out over the image so you've removed any dead or vacant space. Now we're going to expose for the sky. Use a Temperature of 5500 and leave Tint at –10. Leave Exposure, Recovery and Fill Light at 0. Blacks should be set to 10, Brightness +50, Contrast +25, Clarity +50, Vibrance +25, Saturation +40. Click Open Image, then go to File>Save as and save this first conversion.

2 EXPOSE FOR THE FOREGROUND Now re-open the same image again and this time set Exposure to +2.00, Blacks to 5 and click Open Image. Now, using the Move tool, hold Shift, click in the new conversion and drag it across your desktop into the first image. Go to Window>Layers, and you'll see the second RAW conversion sitting above the Background Layer.

3 BLEND THE EXPOSURES Click on the Add Layer Mask icon in the Layers palette and pick the Brush tool. Set the foreground colour to Black, then set the brush size to 500px and its Opacity to 100% and sweep it across the sky. Next drop the Opacity to 20% and sweep it along the horizon line a few times to soften the join. Elements users, just use the Eraser tool instead of Layer Masks.

4 ENLARGE THE FOREGROUND Go to Layer>Flatten image, then pick the Polygonal Lasso tool. Make a Selection of your frosty foreground and press Ctrl+J to transport it into a new Layer. Now press Ctrl+T and, in the Options bar, increase Height and Width to 120%. Press Return, then add another Layer Mask, this time using a smaller brush to paint black along the cropping lines to blend the two Layers.

FINISH

5 WORK THE CONTRAST Next, go to Layer>Flatten Image again. Now pick the Dodge tool, set its size to 800px, Range to Highlights and Exposure to 3%, then run it over the foreground and the lighter parts of the sky. Next, switch to the Burn tool (Range Shadows, Exposure 3%) and run it over the top of the sky and the shadows in the foreground to create greater definition.

6 SHARPEN THE IMAGE To make the most of the frosty details and, in our case, the silhouetted tree, go to Filter>Sharpen> Unsharp Mask. Use settings of 100% for Amount, 1px for Radius and 0 for Threshold. If you're using a recent version of Elements (6 or 7, for example) you'll find Unsharp Mask under the Enhance menu. Press OK to exit the palette and you're done.

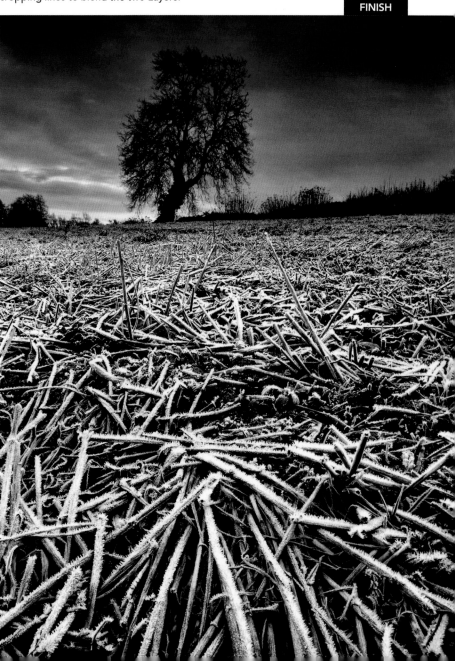

START

Add seasonal sunrays

Create mist and dappled sunlight

WHAT YOU NEED
PHOTOSHOP OR ELEMENTS

WHAT YOU'LL LEARN
HOW TO MAKE MISTY SUNRAYS

MOST PHOTOGRAPHERS WOULD RATHER capture a wonderful autumn (fall) landscape entirely in-camera, but with the vagaries of the weather and the sad fact that not all of us have time to sit and wait for the perfect combination of colour and light, it's not always going to happen.

Using this digital technique it's possible to give Mother Nature a helping hand in the drama stakes, applying an autumnal makeover to virtually any woodland image. You'll find out how to turn green leaves into some blistering autumnal reds and then add a convincing misty sunray effect, just like you'd get first thing on a sun-kissed autumn morning.

For the most part here we'll be using Layer Masks to refine the sunray effect, but these are only available in the full version of Photoshop. Elements users can use the following work-around: once you arrive at Step 4 (where Photoshop users can remove certain parts of the sunrays to add depth to the image using a Layer Mask) Elements users can use the Eraser tool.

Simply pick the Eraser tool from the toolbox and select a soft brush with a Size of 60px and an Opacity of 70%, then gently brush over the areas of the tree trunks where the sun rays cross over.

If you go wrong remember you've got the Undo History palettes so you can click back and carry on.

1 MAKE A SELECTION Open your woodland landscape image and select the Rectangular Marquee tool from the toolbox. Now drag out a Selection over-the-top two-thirds of the image (the tree tops), so the "marching ants" are just above the horizon. Click on Refine Edge (Select>Feather in CS2 or earlier) and enter a Feather amount of 100px, then hit OK. Now go to Window>Layers.

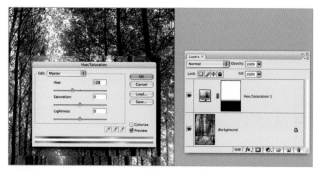

2 REDDEN THE LEAVES Click on the Create New Fill or Adjustment Layer icon and from the drop-down options, select Hue/Saturation. In the pop-up box, reduce the Hue slider to -28 and then hit OK. Now go to Layer>New>Layer and in the pop-up box name the Layer "Rays 1", then hit OK. We can now start to create our sunrays, so go to the toolbox and select the Polygonal Lasso tool.

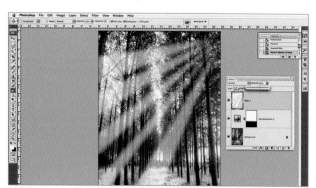

3 CREATE SUNRAYS Make a triangular Selection down across the image from top right. Holding Shift, make another four Selections beneath the first, with a similar triangular shape. Set White as your Foreground Color and select the Paint Bucket tool. Click on one of the selected areas. Hit Ctrl+D to get rid of the "marching ants" then go to Filter>Blur> Gaussian Blur. Enter a Radius of 35px and hit OK before changing the Opacity to 60% in the Layers palette.

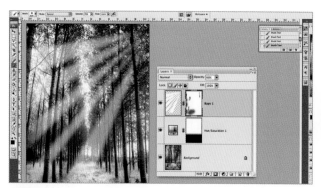

4 CREATE DEPTH To make the sunrays look like they're shining through the trees, mask the parts of the rays that overlap the trunks, but leave some untouched. With the Rays 1 Layer highlighted, click on the Add Layer Mask icon. Set Black as your Foreground colour (D then X) then pick the Brush tool (Size 60px, Opacity 70%). Brush over some of the sunrays that overlap the trunks. Finally, increase Brush Size to 800px and then brush back the ends of the sunrays.

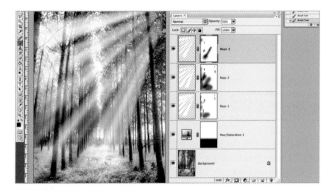

5 ADD MORE SUNRAYS We need to build-up the sunrays, repeating steps 3–4 on another two Layers. For a natural look, vary the size of the sunrays (make your Selections narrower/shorter/wider), alter the Opacity of the different Layers (between 50–70%) then mask off the tree trunks differently. You'll end up with two new Layers, so to make life easier, name them "Rays 2" and "Rays 3".

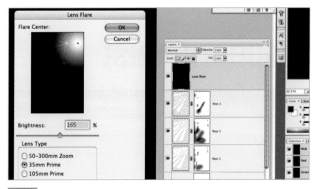

6 LENS FLARE We want to finish off the sunrays by adding some artificial lens flare in the top right-hand corner. Go to Layer>New>Layer and call it "Lens Flare". With the Paint Bucket tool, Fill the Layer with Black and then go to Filter>Render>Lens Flare. In the pop-up box, set the Brightness to 165% and the Lens Type to 35mm Prime. Finally, position the Flare Center in the top right as shown and hit OK.

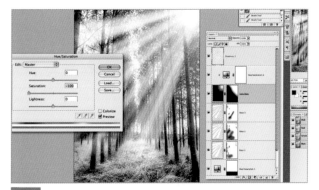

7 REMOVE CAST There's a slight pink tinge to the flare, which can be removed by clicking the Adjustment Layer icon and selecting Hue/Saturation, then reducing the Saturation to -100. Hit OK and then hold Alt and click on the line between the Layers to add a Clipping Mask. We now need to add some shadows coming from the trees, so go to Layer>New>Layer and call it "Shadows".

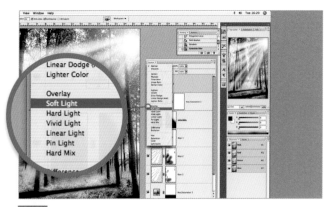

8 ADD SHADOWS As we did with the sunrays, use the Polygonal Lasso tool to make a Selection of where the shadows should be fanning out from the bases of the first two trees. Then, fill the Selection with Black, hit Ctrl+D, and apply a Gaussian Blur of 20px. Moving over to the Layers palette, change the Blending Mode to Soft Light and knock the Opacity back to 90%.

FINISH

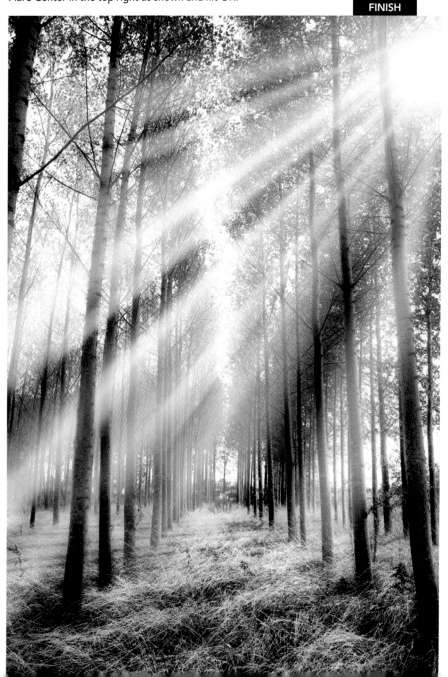

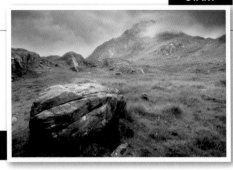

START

Add atmospheric mist

Create trails of mist for added drama

WHAT YOU NEED
PHOTOSHOP OR
ELEMENTS

WHAT YOU'LL LEARN
HOW TO
ADD MIST

AS PHOTOGRAPHERS, MOST OF THE TIME we like to steer clear of mist and fog, heading out on nice clear days to give us the best view possible of the landscape we're shooting. But there are times when some subtle mist or fog can really improve a scene, giving it a more mysterious atmosphere.

Mist is fleeting, though, and if you do find some, it'll seldom be in the right place at the right time! In this step-by-step project we'll show how to put some convincing digital mist right where your composition needs it.

Because this system revolves around using Photoshop or Elements' Adjustment Layers, you can control the amount and

thickness of the mist very easily, and define where you want it to go using the Brush tool.

In our example, we've built up the effect using two separate Layers, which means we can get some real depth to our mist. Using the masks that come with all Adjustment Layers you can make very precise choices about where the mist sits on the landscape, so while the foreground rock and top of the mountain remain unaffected, we've let it creep around the rest of the valley.

To follow the steps, find a suitable mountain landscape that deserves the mist treatment.

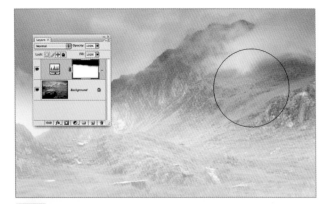

1 ALTER THE LEVELS Open your mountain landscape image and then open the Layers palette by going to Window>Layers. In the Layers palette, click on the Create New Fill or Adjustment Layer icon (the black and white circle) and choose Levels from the list. This will bring a Levels palette up on screen so we can start adding the mist effect to our mountain image.

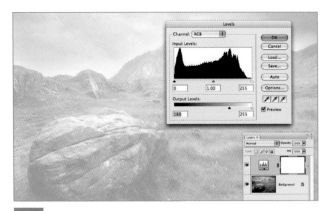

2 ADD THE FIRST LAYER OF MIST In the Levels palette, move down to the Output Levels and drag the Black slider to 180. This will give the landscape a very washed-out look, as though it's covered in mist. However we need to bring back some parts of the scene to make it look more realistic, so hit OK to exit the palette then, from the toolbox, pick the Brush tool.

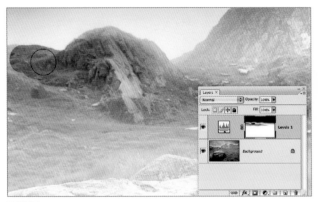

3 MASK AWAY THE MIST Set the Brush size to about 600px and press Shift+[a few times to give it a soft edge. Set the Opacity to 100%, then press D and X to set Black as the foreground colour and sweep it along the top of the scene, revealing your mountain top and any sky. Reduce Opacity to 30% and sweep down further to even the join.

4 KEEP MASKING Now reduce the Brush size to 150px and paint just below the mountain ridge. Do this a few times, building up the effect. Bring Opacity up to 100% and increase the hardness of the Brush edge using Shift+]. This time paint along the very top of the ridge allowing its outline to show through. Avoid masking off valley areas: these are naturally misty.

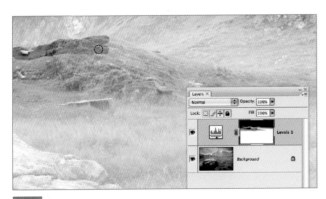

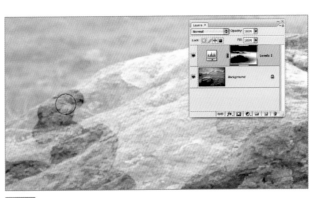

5 PAINT BACK THE MIST Press X on the keyboard to switch your foreground colour to White and give the Brush a soft edge again using Shift+[. Set Opacity to about 30% and paint back along the ridge to blend the join. Keep painting black or white into the mask at low Opacity settings until you're happy with the mist in that part of the image.

6 REVEAL THE FOREGROUND Now, using a large soft-edged brush set to Black (Opacity 100%), paint over the middle of your foreground. Reduce Opacity to about 10% and paint around the same area, again softening the join. Next, using a harder, smaller 100% Opacity Brush, reveal the detailed edges of any sharp foreground rocks.

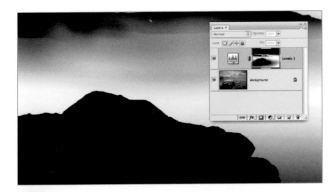

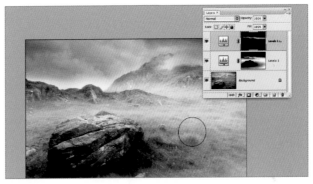

7 CHECK THE MASKS To make sure you haven't forgotten to delete any of the mist on the foreground, press the Alt key and click on the mask to the side of the Levels Adjustment Layer. This will show a full-scale preview of your mask, so you can see any areas you've missed. To fix things, just paint into the mask as normal. To exit this preview mode, Alt-click again.

8 ADD TO THE EFFECT To deepen the mist effect in the distance, click and drag the Levels Adjustment Layer onto the Copy Layer icon in the Layers palette. Next, double-click on the new Levels icon and drag the Black output slider back to about 90. Click OK and then paint black into the lower half of the mask to hold back the effect there.

FINISH

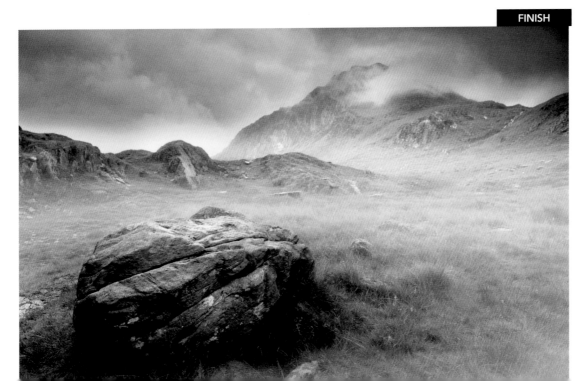

Blur waves with a long exposure

Compare waves shot at different shutter speeds

WHAT YOU NEED
PHOTOSHOP OR
ELEMENTS

WHAT YOU'LL LEARN
HOW TO
BLUR WAVES

INSTEAD OF CAPTURING SCENES with a fast shutter speed and rendering everything pin-sharp all the time, a slow shutter speed can provide a fresh perspective to landscape scenes. Slow shutter speeds, used to make long exposures, will turn any movement into a blur with the result that photos take on a dream-like quality very different to how we see normally. Compare the images above for instance: the image above left was shot at 1/90sec, freezing the wavelets sharp; the image above right was shot at 3 seconds, allowing the waves to blur smooth as silk.

You can try making long exposures pretty much anywhere – all you need is a part of your scene to be moving, for comparison against a strong static component in frame.

Because long exposures require a slow shutter speed, they're not always possible. Bright midday sun, for instance, makes it impossible to achieve a shutter speed slow enough to capture any blur; it's far easier to shoot long exposures in the early morning or at dusk. Or, you can always use a Neutral Density (ND) filter to reduce the strength of the light hitting your sensor. This allows you to choose a slow shutter speed without any risk of over-exposure.

For this step-by-step you'll need to get out there with your camera to have a go at using slow shutter speeds, before making some post-production tweaks at home.

1 USE A TRIPOD As the shutter will be open for a long time, a decent tripod is essential to keep your camera still. Remember, at least some of the scene needs to be sharp or it'll just look like a blurred mess. With your camera secured, frame up your shot. Note that if you're wedging tripod legs into wet sand at the beach they may slip. Also, in windy conditions, you can use your camera bag as tripod ballast.

2 REDUCE YOUR ISO Once you've got your shot lined up in the viewfinder, you need to get your shutter speed down as low as possible in the available light. To start off, dial-down the ISO setting on your camera to its lowest sensitivity – on most DSLRs this will be ISO 100 or 200. Now set your DSLR's shooting mode to aperture-priority on the main mode dial.

3 SET YOUR APERTURE As a starting point, set an aperture of f/11 and then take a meter reading of your scene, noting the shutter speed. You ideally want a shutter speed of 1 second or longer to achieve sufficient blur, so if it's still too high, try stopping down the aperture to f/16 or even f/22, and then take another meter reading.

4 USE A FILTER If you still can't achieve the slow shutter speeds you require, wait until the light drops, or use an ND filter. When buying one, go for a 2- or a 3-stop (0.6 or 0.9 filter). Before you attach it, switch to manual focus, as your lens autofocus may hunt. Now place the filter on the front, and the shutter speed will drop dramatically.

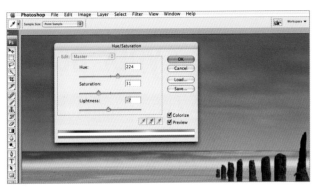

5 CREATE AN ADJUSTMENT LAYER At home, open the image on your computer and bring up your Layers palette by going to Window>Layers. We want a cool tone for our image; click on the Create New Fill or Adjustment Layer icon at the bottom of the palette and from the drop-down menu, select Hue/Saturation. When the pop-up box appears, tick Colorize in the bottom right-hand corner.

6 TONE IMAGE Drag the Hue slider to the right until it reads 224 then increase the Saturation slider to 31. Reduce Lightness to -7 and then click OK. At the moment, our result here looks quite harsh, but we can change this by using a Blending Mode. With the Hue/Saturation Layer still selected, click on Normal and from the drop-down, select Soft Light.

7 SELECT THE SEA Click back on the Background Layer then select the Rectangular Marquee tool from the toolbox. Drag it out across the bottom half of the image. Now feather the Selection by pressing Refine Edge in the Options bar, and in the pop-up box, enter a Feather value of 130px. Click OK. On earlier versions of Photoshop or Elements, go to Select>Feather and enter the same pixel value.

8 BOOST CONTRAST Click on the Create New Fill or Adjustment Layer icon and select Levels. Drag the left and right arrows in to meet the histogram, and click OK. Click on the Background Layer, add another Adjustment Layer and choose Curves. Drag out a subtle "S" curve to boost contrast and click OK. In Elements, go Enhance>Adjust Color>Adjust Color Curves. Under Select a Style, choose Increase Contrast.

FINISH

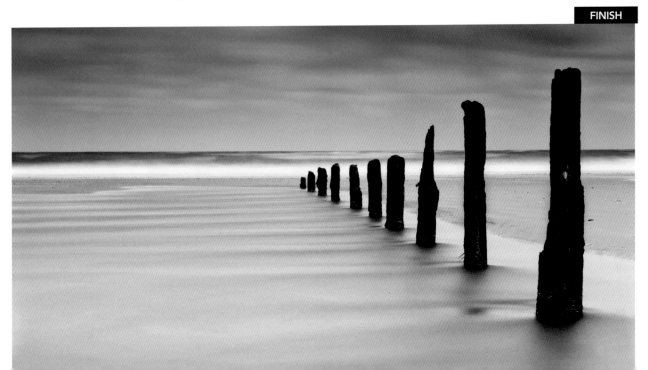

Get creative with your pop-up flash

Master slow synch flash portraits at night

WHAT YOU NEED
DSLR WITH POP-UP
FLASH; PHOTOSHOP
OR ELEMENTS
WHAT YOU'LL LEARN
HOW TO USE
SLOW SYNC FLASH

PEOPLE PICTURES OUTDOORS AT NIGHT present something of a challenge… especially when you want to keep some of the ambient light and atmosphere of the surroundings in the shot. Normally if you just fire away with the camera on automatic you get a harsh, flash-lit portrait that sharply fades out to pitch black in the background. Get to know your DSLR a little better and you'll realize that the restrictions of low-light photography actually offer a huge creative opportunity – night-time is a great time to experiment with portraits.

Here, we'll be using a slow sync flash technique to keep our subject's features sharp and create an exciting background that's full of colour and movement. The technique requires combining your camera's burst of flash with a long exposure.

On your DSLR you can set the flash to fire at the start (Front Curtain) or end (Rear/Second Curtain) of your long exposure. By deliberately moving the camera while the shutter is open you can create some really exciting visual effects.

Twilight and night-time are the best time of day to try out slow sync techniques because the dim conditions force you to use a slow shutter speed. Plus, the combination of natural dusk conditions and street lighting will ensure you get some attractive lighting effects in the background.

This step-by-step project shows how it's done and then it's just a matter of getting out there, giving it a go, and seeing what you can come up with. There's a bit of trial-and-error involved but every shot will be unique.

1 SET THE FLASH Engage the pop-up flash unit and then make sure your camera's flash mode is set to Rear Curtain or Second Curtain sync. This is usually done via the main menu, or, as shown here, by holding down the flash button on the camera body and using the scroll wheel to choose between the various flash sync modes.

2 SET EXPOSURE Set your metering mode to multi-zone (Evaluative, Matrix) and picture quality to RAW. Next, put your camera in aperture-priority mode (A or Av on the main mode setting) using f/16. Now frame up your model and background and check the resulting shutter speed. Ideally it'll be about two seconds, but if it's faster, use a higher f/number or a lower ISO.

EXPERT ADVICE

EXPERIMENT WITH SLOW SYNCH

AS EACH SLOW SYNC PORTRAIT IS UNIQUE, getting a good one comes down to trial-and-error, so once you've got your exposure set up, experiment with a few different camera movements to see what interesting effects you can achieve. On the right you'll see how the camera responds to different movements – try them all out during your shoot and make sure you review the shots on your LCD screen to see which techniques yield the best results.

HORIZONTAL **VERTICAL**

CIRCULAR MOTION

ZOOM-OUT MOTION

LATERAL MOTION

Spinning, zooming, shaking, even a simple quarter-turn of the camera, will all result in vastly different visual effects, so make sure you try them all when experimenting with slow sync flash. However, if your flash is firing at the end of the exposure [Rear/Second Curtain sync], concentrate on

3 TAKE A SHOT Focus on your model. On pressing the shutter release button, try out a range of camera movements during the exposure, such as rotating it or zooming the lens. Move quickly, because by the end of the exposure you need the camera to be quite still – this way, when the flash fires (using Second Curtain sync) your subject will be sharp.

4 CONVERT RAW FILE We converted our RAW image file with Adobe Lightroom, but the sliders are the same as in Photoshop. Adjust the Blacks to +40, crank up Recovery to +100, and increase Saturation to +10. If you're in Adobe Camera RAW, hit Open Image to edit the picture in Elements or Photoshop, or if you're in Lightroom, use Export.

FINISH

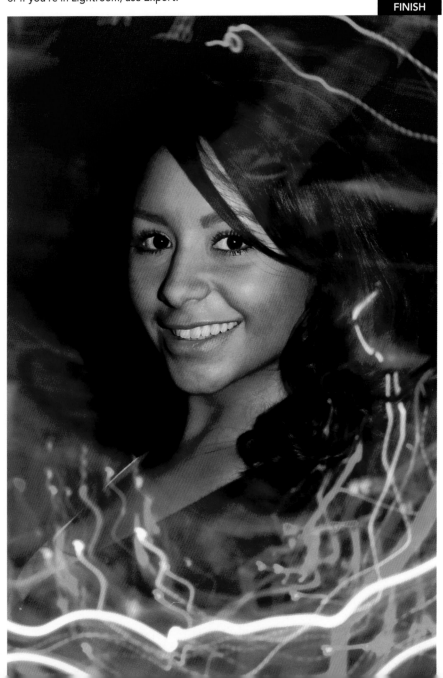

5 REDUCE FLASH GLARE To take the edge off the flash glare, select the eyedropper tool and sample a skin tone next to it. Now select the Paint Brush tool, change the Mode to Darken, reduce Opacity to 40% and paint over the glare using just a couple of clicks. Repeat this process, working around the subject's face to reduce all the shiny spots.

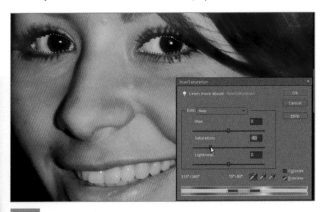

6 ENHANCE THE EYES Select the Polygonal Lasso tool, click Add to Selection in the Options bar and make a Selection of both eyes. Now go to Select>Feather, enter a Radius of 5px and press OK. Hit Ctrl+L, drag the White Point slider to 220 then hit OK. Finally, press Ctrl+U, select Reds from the Edit menu and set Saturation to -50.

Paint with flash

Use flash off-camera

START IMAGES

WHAT YOU NEED
DSLR AND FLASHGUN;
PHOTOSHOP OR
ELEMENTS
WHAT YOU'LL LEARN
HOW TO PAINT
WITH LIGHT

THIS TECHNIQUE IS LOADS OF FUN. The basic idea is to set up the camera for a long exposure so you can record the fading light in the sky. This gives you (or an assistant) sufficient time to light a foreground subject with some well-placed bursts from your flashgun. Thanks to the fact you're making a *very* long exposure, the person "painting" the scene with flash (moving around) will disappear into a blur.

For best results use Manual exposure mode to control the shutter speed and aperture independently from each other. This means you can tweak the settings at will, controlling the way light enters the lens and for how long. If this sounds a bit daunting, don't worry – there's a great safety net in the form of your DSLR's viewing screen, so you can take a few exposures, check the results and vary the settings based on what you see.

Shots of this kind really benefit from a bit of pre-planning. It's best to have a location in mind before you set out so you can get there and set up the camera in daylight. All you need is a camera, tripod and a cheap flashgun; you're only using the flashgun to paint the scene with light, so it doesn't matter if camera and flash are not 100% compatible.

Once the camera is positioned, focus on the foreground using AF, then switch to manual focus to stop the camera hunting as the light fails. Next, select the self-timer, giving you time to fire the shutter and get into flash-painting position.

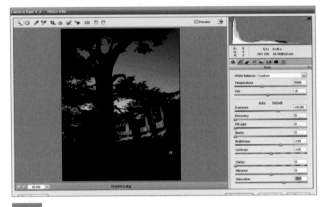

1 SELECT AND OPEN Review the shots from your painting-with-flash shoot and pick out those ones you want to use in your composition. For our final shot opposite we used three images (see Start Images, above) plus another photograph showing just the sunset sky. Start by opening the first of your flash-lit night pictures into the Photoshop or Elements RAW converter.

2 CONVERT THE RAW FILES Use the following settings for your conversion: Temperature: 5700; Tint: -8; Exposure: +0.80; Recovery: 0; Fill Light: 0; Blacks (Shadows): 0; Brightness: +40; Contrast: +25; Clarity: 0; Vibrance: 0; Saturation: +35. Use the same settings for each RAW, then once they're converted, open them all into your Photoshop or Elements software.

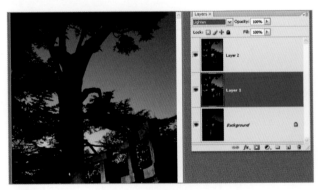

3 COMBINE THE PICS With the Move tool, click in the first flash image and while holding Shift, drag it into the second flash image. Because you used a tripod, they should align. Release the mouse. Now close the first image and repeat the process with the third image, dragging it into the composite. Go Window>Layers – all three Layers are combined.

4 BLEND THE SHOTS TOGETHER In the Layers palette, click where it says Normal, choose the Blending Mode called Lighten and the lighter parts of Layer 1 will appear through Layer 2. Next click on Layer 1 and do the same. Once you've done that, the flashed parts of all three images will be visible in your picture. Now go to Layer>Flatten Image.

5 STRAIGHTEN AND TRANSFORM If your image looks a bit wonky like ours did, go to Select>All, then Edit>Free Transform. Now position the cursor outside a corner "handle" and click and drag to rotate the image. Next, click on one of the corner "handles", hold Shift and drag it out to enlarge the shot and make the white canvas disappear. Click and drag on the image to recompose, then click the tick or hit Enter.

6 CLONE OUT ANY LENS FLARE Go to Select>Deselect, then pick the Clone Stamp tool. Set Brush size to 50px, Mode to Normal and Opacity to 100%. Now press and hold the Alt key on the keyboard and click on a "clean" area of the image to clone. Release the Alt key and paint over the lens flare to remove it from the picture.

7 ADD A NEW SKY Open your sunset sky image and copy it into the main image using the Move tool, as in step 3. Now change its Blending Mode to Soft Light. Next press Ctrl+L to open the Levels palette and drag the Black and White point sliders in to meet the ends of the histogram as shown. Press OK, then go to Edit>Free Transform.

8 TRANSFORM AND ERASE Rotate and enlarge the sky as in step 5, then pick the Eraser tool. Set its Size to 300px, its Hardness to 0% and its Opacity to 100%. Now paint over any hard edges or poor blending that's visible. Finally, go to Layer>Flatten Image and save the image.

FINISH

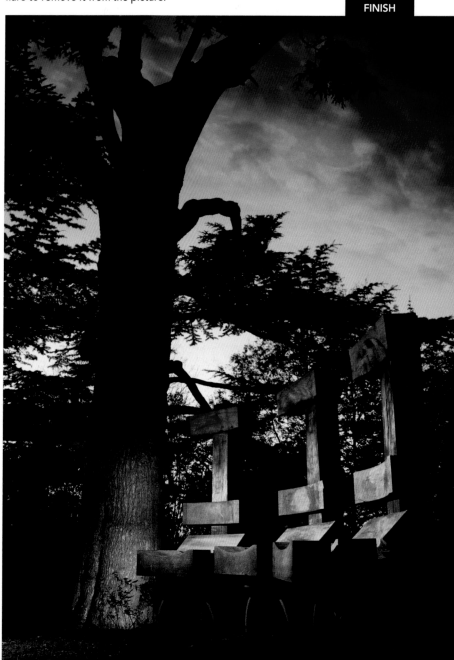

Use studio flash

Set up a simple home studio portrait

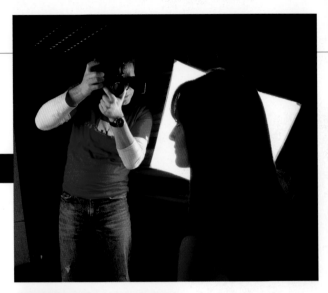

WHAT YOU NEED
DSLR AND STUDIO
FLASH KIT
WHAT YOU'LL LEARN
HOW TO LIGHT A
PORTRAIT WITH
STUDIO FLASH

THE WORDS "STUDIO FLASH" can strike fear into the heart of even the bravest enthusiast, but give it a try and you'll soon discover how simple it really is. There are lots of easy-to-use home studio flash kits on the market, all with good instructions on how to use them. They're the perfect way to start taking professional-looking pictures.

There are two reasons why studio flash is great for portraits: first, it produces an enormous amount of consistent light; second, it's endlessly versatile and not tethered to the camera. Many kits are also very portable, too, so they're easy to set up and small enough to be used at home.

SETTING IT UP

For our shot overleaf we wanted to produce a clean and simple cover-style image, using one softbox with a gold reflector to bounce the light back onto the shaded side of the subject's face. A plain background helps isolate the model – a plain wall or sheet will do. If you want a bright, evenly lit background you'll need to direct another light or two onto it. Once the lights and reflector are in place, the tungsten modelling lamps give an idea how the contrast will look.

Once you're happy with the set-up, turn off the room lights and try to block any natural light from windows and doors, so you're in total control of the light conditions.

With a DSLR you don't need to use a flash meter to measure the light – just take a test shot and check it on your camera's viewing screen. However, instead of using the histogram to assess exposure, try setting the Highlight/Shadow warning where pixels will flash showing burnt out or underexposed areas. For portraits, this is useful as it's quite acceptable to have a pure white or black background, so long

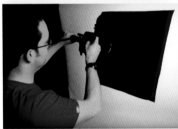

STUDIO FLASH KITS
Cheap, portable and easy-to-use, home studio kits can have a huge impact on the quality of you portraits. The flash heads can be positioned at any height or angle, so there are loads of creative options to explore.

as the skin tones are correct. Most cameras offer this option, so just scroll through the viewing modes until you find it.

As usual, it's best to shoot in RAW because you'll be able to tweak the exposure and White Balance settings more easily later, than with a JPEG. And you should also use the lowest ISO setting your camera has – the burst of flash provides enough light to allow a fast shutter speed and avoid camera shake, so there's no need to incur unnecessary digital noise.

Check the flash sync speed of your camera and set it no higher – most cameras have a sync speed of 1/250sec; any faster will result in a black line shearing across the frame.

Use a mid-range aperture of f/8 or f/11, because it'll hold most of the subject in focus, allowing you to work faster. If you try out lower f/numbers, remember to reduce the flash units' output and try a few test shots first.

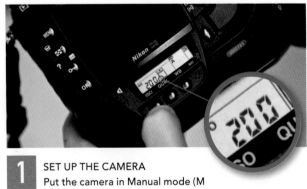

1 SET UP THE CAMERA
Put the camera in Manual mode (M on the exposure dial), then set it to f/11 at 1/250sec (or whatever sync speed your camera recommends). Change the ISO to its lowest possible sensitivity (usually 100) and use "Flash" White Balance setting. Move the studio lights into position and connect your camera to the flash sync lead or infrared trigger as per the manufacturer's instructions.

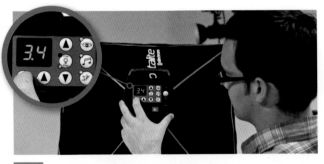

2 TAKE A TEST SHOT Dial in a test exposure of f/8 at 1/250sec (flash sync speed) and take a shot, ensuring that the lights fire. Check your camera's viewing screen to see how the image is looking. If it's too washed-out and over-exposed, stop the camera's aperture down to f/11 or decrease the output of your lights. If the image is too grey and under-exposed, open up the aperture to f/5.6 or turn up the power of your lights.

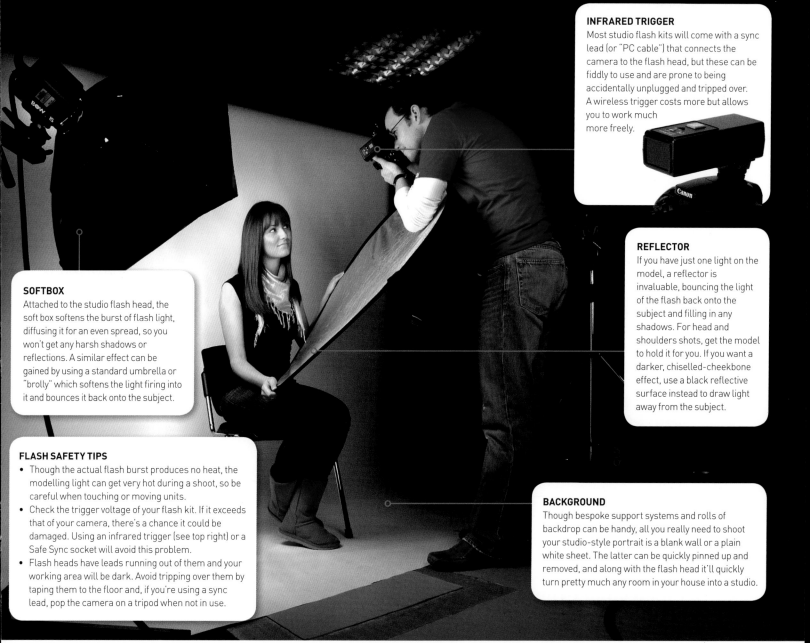

INFRARED TRIGGER
Most studio flash kits will come with a sync lead (or "PC cable") that connects the camera to the flash head, but these can be fiddly to use and are prone to being accidentally unplugged and tripped over. A wireless trigger costs more but allows you to work much more freely.

SOFTBOX
Attached to the studio flash head, the soft box softens the burst of flash light, diffusing it for an even spread, so you won't get any harsh shadows or reflections. A similar effect can be gained by using a standard umbrella or "brolly" which softens the light firing into it and bounces it back onto the subject.

REFLECTOR
If you have just one light on the model, a reflector is invaluable, bouncing the light of the flash back onto the subject and filling in any shadows. For head and shoulders shots, get the model to hold it for you. If you want a darker, chiselled-cheekbone effect, use a black reflective surface instead to draw light away from the subject.

FLASH SAFETY TIPS
- Though the actual flash burst produces no heat, the modelling light can get very hot during a shoot, so be careful when touching or moving units.
- Check the trigger voltage of your flash kit. If it exceeds that of your camera, there's a chance it could be damaged. Using an infrared trigger (see top right) or a Safe Sync socket will avoid this problem.
- Flash heads have leads running out of them and your working area will be dark. Avoid tripping over them by taping them to the floor and, if you're using a sync lead, pop the camera on a tripod when not in use.

BACKGROUND
Though bespoke support systems and rolls of backdrop can be handy, all you really need to shoot your studio-style portrait is a blank wall or a plain white sheet. The latter can be quickly pinned up and removed, and along with the flash head it'll quickly turn pretty much any room in your house into a studio.

3 ADJUST OUTPUT Most flash units are easy to adjust using the dials or knobs on the back of the flash head itself. Many of them show output in terms of the f/number in use or as a fraction of overall output. It's a good idea to get to know how powerful your units are at given distances in your home studio. The closer you move the flash unit to your subject, the brighter the light on their face and vice versa; as you move the units further back, the light effect will reduce.

4 ASSESS THE IMAGES Keep referring to the viewing screen on the back of the camera until you're happy with the exposures. Look out for things such as burnt-out skin tones: this is a sign you need to use a smaller aperture, such as f/16, or power down the lights. Direct the model to vary their pose for you from frame to frame so you get a good variety of pictures. Each time the model changes their orientation to the lights, take another test shot to confirm exposure is still correct.

EXPERIMENT WITH YOUR LIGHTING SET-UP

Unlike using on-camera flash, studio flash allows you to take the flash right away from the camera, providing ample opportunity for a much wider variety of lighting effects. Even using just one flash unit and a reflector can offer numerous creative alternatives. Just change the position of the flash head around the subject – above, below or even behind – and you'll see what it's possible to achieve. With a simple, one-light set-up you can get pretty much anything from an evenly lit portrait to something that's shadowy, brooding and dramatic. Take a look at the example pictures here and you'll see what we mean.

Side lighting with white reflector.

Side lighting with gold reflector.

Lighting from softbox below subject.

Lighting from 45° right of model.

Lighting from direct above without reflector.

Lighting from above with gold reflector beneath.

EXPERT ADVICE

GET TO KNOW YOUR STUDIO KIT

UMBRELLA
Slots into the flash head to bounce or diffuse your flash output. Some kits offer softbox attachments too.

SPILL KILL REFLECTOR
These fit round the front of the flash head and, as the name suggests, prevent stray light spilling out of the side.

STANDS
These are the supports for your lights, offering height adjustment.

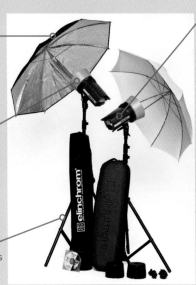

FLASH HEAD
This is your light source, with power output manually controlled.

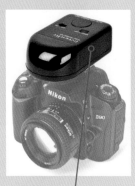

IR TRIGGER
Fire your flash heads wirelessly with an infrared trigger.

SYNC LEAD
Most budget kits come with a flash sync lead to fire the heads, but not every DSLR has a socket.

REFLECTOR
Really useful and inexpensive, it allows you to bounce light back onto your subject.

PORTRAIT PITFALLS – MISTAKES TO AVOID

EVEN TOP professional photographers get the odd duff exposure during a shoot. Here are some of the typical pitfalls to avoid:

1 BAD ANGLES
Shooting from too low an angle can be unflattering, so try shooting from their eyeline or slightly above.

2 BLINKIES
In any portrait shoot you'll get a few blink shots for the bin. Just get plenty of pics from each angle to compensate.

3 BURNT-OUT SKIN
Over-exposing the subject's face is a real no-no because you'll lose detail in important highlight areas that can't be rescued in Photoshop.

1

2

3

RELAXED MODEL = GREAT PICTURES
For good results like these, communicate fully with your model, talk them through poses or have them brief you on what they want from the shoot. Show them the pics you're getting so they're engaged in the process. If you have a TV with a yellow video-in phono socket, you'll be able to connect your camera to that for a really big display. Make sure they're comfy, warm and taking frequent breaks – also, try putting on some music they like.

Turn a landscape black and white

Transform flat colour images to stunning black and white ones

START

WHAT YOU NEED
PHOTOSHOP OR ELEMENTS

WHAT YOU'LL LEARN
HOW TO TRANSFORM COLOUR IMAGES

OVERCAST DAYS BRING FLAT, shadowless lighting and bland, featureless skies. Not exactly perfect conditions for scenic shots! But if you start thinking in black and white, everything changes. Close one eye and squint the other at a flat, low contrast scene and you'll find that contrast is still present – it just needs a bit of help to bring it to the fore.

One of the great things about working in mono is that you can push contrast much harder than you can with colour. That means you can take a drab, dull scene and turn it into a punchy tonal image, simply by getting rid of the colour and working it hard in Photoshop or Elements.

Even if your camera has a black and white mode, you should always shoot in colour in the first place, because this gives you maximum detail to work with. If possible, shoot in RAW format too, because this gives you extra flexibility in adjusting the

contrast and exposure – exactly what you need to create a good mono pic.

To extract maximum detail from our original RAW file here, we're going to convert it not once, but twice. This will allow us to create a great-looking sky first, then after we've saved the results, we can make a second conversion for the foreground. And because both the conversions come from the same RAW file, we know every pixel in the scene will align exactly. Working this way may appear a bit long-winded, but it allows you to take complete control over the contrast in different parts of the scene.

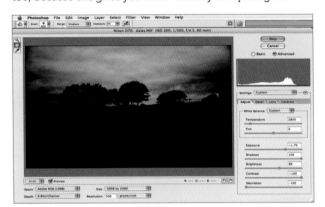

1 CONVERT FOR THE SKY Open a flat-looking colour RAW file landscape into Photoshop or Elements and it'll launch the RAW converter. We need to get some detail into the sky first, so concentrating on that part of the pic, move the sliders to see detail emerge. Here, we chose Temperature: 2850, Tint: 0, Exposure: +1.70, Shadows: 100, Brightness: 89, Contrast: +100, Saturation: –100. Save this as Landscape A.jpg.

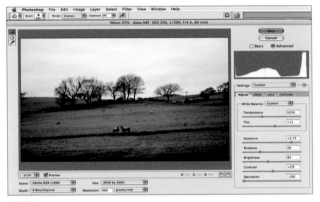

2 CONVERT FOR THE LAND We now need to make a second conversion that restores detail to the foreground, so re-open the same RAW file and this time, ignore the sky and just consider the land. We went for settings of Temperature: 5250, Tint: +11, Exposure: +2.75, Shadows: 29, Brightness: 64, Contrast: +27, Saturation: –100. Save this as Landscape B.jpg.

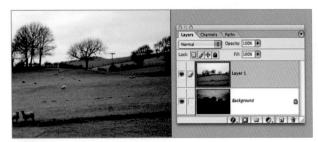

3 COMBINE THE PICS With your A and B files open in Photoshop, make sure you can see both on screen and then select the Move tool. While holding Shift, drag B into A so the bleached-out white sky is dragged into the dark one. Holding Shift ensures that it goes straight in the middle of the pic so every pixel will line up and be in register. Go to Window>Layers, and you'll see the two Layers in the stack.

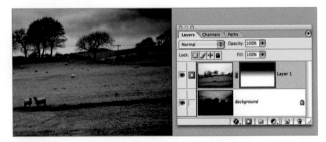

4a BLEND THE PICS (PHOTOSHOP USERS). Hit D to set the colours to black and white. In the Layers palette, click on the Layer Mask icon, and select the Gradient tool. Hit X to swap the colours over, and in the Options bar, make sure Foreground to Background is selected. Drag a line from just above the horizon in the sky to a little way into the land. The two shots will be blended together.

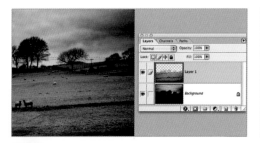

4b BLEND PICS (ELEMENTS USERS) Make sure Layer 1 is active and select the Rectangular Marquee tool. Select the entire sky area and feather by 250px. In Elements 6, use the Feather slider in the Select>Refine Edge command for this; in all other versions, go Select>Feather. Hit Backspace, and the pics will be blended. Hit Ctrl+D to lose the "marching ants".

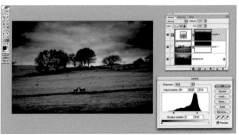

5 DARKEN THE SKY With the Lasso tool, make a rough Selection around the top of the sky, and then Feather by 200px (Select>Feather or Select>Refine Edge in CS3/Elements 6). Now create a Levels Adjustment Layer (click the half black, half white circle in the Layers palette and choose Levels), and move the Black and Mid-point sliders to the right. Click OK.

6 MERGE VISIBLE In the Layers palette, click the Create a New Layer icon, then hold Alt and go to Layer>Merge Visible. Only release Alt after you have clicked on Merge Visible, and all the work you've done will be crunched into a single Layer. The good news is, your Layers aren't lost, so this trick gives you a little flexibility if you decide to change anything later.

7 DODGE THE HIGHLIGHTS Pick the Dodge tool and in the Options bar, set Range to Highlights and Exposure to 4%. With a large soft-edged brush (try around 600px) play the Dodge tool over the image to lift the lighter tones in the foreground. Work on the central area to give a subtle "pool of light" effect. Take care not to overdo it, though.

8 BURN THE SHADOWS Copy the dodged Layer (hit Ctrl+J) and then select the Burn tool (you'll find it under the Dodge tool). This time set Range to Shadows and Exposure to 3 or 4%. Again with a large soft-edged brush, work into the darker areas of the sky and foreground, to boost the contrast and introduce a little more "bite" into the image.

9 ADD GRAIN For a gritty, filmic effect, create a new Layer and then go to Edit>Fill. Select 50% Gray in the Use box, and click OK. Now in the Layers palette, click where it says Normal and choose the Linear Light Blending Mode. Go to Filter> Noise>Add Noise, and enter an amount of around 6%. Tick the Gaussian and Monochromatic boxes, and click OK.

10 ADJUST THE GRAIN You can adjust the grain's intensity by changing the Opacity in the Layers palette. We went for a setting of 50% in this example. To change the grain's size and character, hit Ctrl+T, and pull the corner handles on the Transform bounding box outwards. Hit Enter when you're happy, and go to Layer>Flatten image to complete the pic.

FINISH

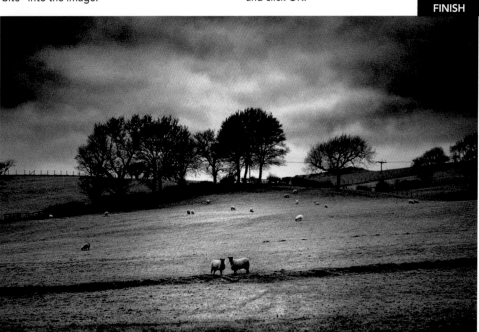

Control and boost contrast

Add extra punch to monochrome images

WHAT YOU NEED
PHOTOSHOP OR
ELEMENTS

WHAT YOU'LL LEARN
HOW TO BOOST
CONTRAST

THE BEST BLACK AND WHITE PHOTOGRAPHS display a wide range of tones with plenty of contrast between the darkest shadows and brightest highlights. But you might have found that after converting your colour images into mono, the initial results can be a little flat, with lots of dull, grey tones that require extra attention to give them some more "bite".

There are two main ways to boost black and white contrast in Photoshop – using the Dodge and Burn tools or making a Selection before applying Levels or Curves adjustments. We'll take a look at the Dodge and Burn tools first (also see the step-by-step project on the following pages).

DODGE AND BURN

The term "dodge & burn" was first coined in the chemical darkroom, and refers to the technique of selectively darkening and lightening parts of an image to increase contrast. Using a traditional enlarger to expose a negative, "dodging" involved using your hand or a piece of card to restrict the length of exposure in certain areas to lighten them.

Conversely, "burning" involved increasing the length of the exposure in selected areas, making it possible to bring detail back into the brightest parts, such as the sky. Working in the dark, and not being able to assess the results of your dodging and burning until the print had been developed, meant getting good results could be hit and miss. In the digital darkroom however, the process is much easier thanks to the Dodge and Burn tools that allow you to paint in these adjustments and evaluate them as you go.

START

THE BUILDING
Dodging the highlights and burning the shadows has given the building's features some extra definition.

THE SKY
A Levels adjustment has darkened the sky and lightened the clouds to give them more impact.

SKY HIGHLIGHTS
A quick sweep of the Burn tool has brought detail back in the brightest areas of the sky.

THE BUSHES
Some heavy highlight-dodging was required to break up this dull grey band of bushes.

FOREGROUND DETAIL
Increase contrast and add some punch to the foreground with a second Levels adjustment.

MORE DODGING
Some extra Dodging in the darkest parts of the bench is required to ensure we don't lose any detail.

USING SELECTIONS

While the Dodge and Burn tools are great for applying small incremental changes to the tonal register, you'll sometimes need to make more dramatic changes to get the best from your mono pics. Levels or Curves offer a great way to achieve this, but one of the problems of applying these adjustments across the whole image is you're limited to how much you can boost contrast before you begin to lose detail in the darkest and brightest pixels. This is where Selections play a vital role.

By isolating certain sections of an image you can push the exposure much harder, and punch up the contrast selectively in some areas, without losing detail in others. This allows you to keep darkest shadows and lightest highlights intact.

Take the sky in our bench shot opposite, for instance. To darken the top of the sky and boost the contrast between the clouds, a heavy Levels adjustment was required. If we'd applied such an adjustment across the entire image, it would render much of the detail in the foreground and middle ground completely black. But, by isolating the sky using a Selection, we can control the contrast of this area alone.

Both the Dodge and Burn and Selections techniques are compatible with the full version of Photoshop as well as its streamlined sibling Photoshop Elements. That means there's really no excuse for flat or dull mono pics, so why not give your black and white landscapes a helping hand?

EXPERT ADVICE

CONTROL CONTRAST WITH CURVES

IF YOU'RE USING the full version of Photoshop you'll have access to the Curves palette for greater contrast control. The Curves palette allows you to very precisely adjust contrast across the whole tonal register by setting up to 14 different adjustment points along the Curve line.

All the tones in an image are mapped against the Curve line, with the darkest tones placed in the bottom left, midtones in the middle and highlights in the top right. So by clicking on, and manipulating, the Curve line you can darken or lighten any of these tonal regions.

Curves adjustments are always image-dependant, but our basic Curve recipes below will get you started with some simple adjustments you can make to alter contrast. Even though Curves offer more control over contrast than Levels, you'll still want to combine Curve adjustments with Selections, otherwise you risk inverting your tonal register if you pull the Curve line around too much.

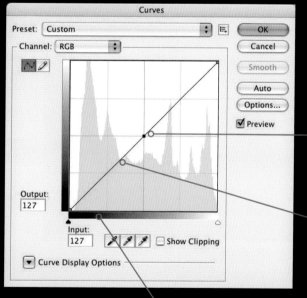

ADJUSTMENT POINTS
Click on the Curve line to set an adjustment point and manipulate the Curve line to darken or lighten tones in the image.

CURVE LINE
The Curve line represents the tonal range of the image, with the default Curve being a straight diagonal line running from bottom left through to top right.

TONAL REGISTER
All tones are mapped against the Curve line with the darkest tones placed on the left and brightest tones on the right.

SIMPLE CURVE RECIPES

DARKEN

Set an Adjustment point in the centre and then drag the Curve line down to darken the image.

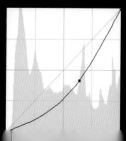

LIGHTEN

Set an Adjustment point in the centre and then push the Curve line up to lighten the image.

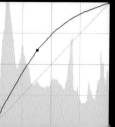

BOOST CONTRAST

A subtle "S" Curve is a common adjustment that will lighten the highlights and darken the shadows.

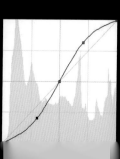

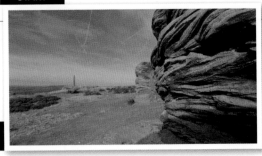

START

Dodge and burn with Layers

Use Layers to boost contrast selectively

WHAT YOU NEED
PHOTOSHOP OR ELEMENTS

WHAT YOU'LL LEARN
HOW TO DODGE AND BURN

THE TERMS DODGING AND BURNING refer to techniques that originated in the chemical darkroom. They allow you to control the lightness and darkness of specific areas of a print during enlargement. They're techniques which add that extra "oomph" to an image.

When making a print in the chemical darkroom you'd use an enlarger to expose a negative onto light-sensitive paper before plunging the paper into a tray of developer. Though some prints looked fine straight off, they could look so much better with a bit of dodging and burning to accentuate certain areas and add more "bite". The skill lay then, as today, in knowing which areas to lighten and which to darken.

With digital manipulations, as with darkroom ones, you lighten an area by dodging it. In the traditional darkroom this meant hovering your hand (or a piece of card on a stick) over the area you wanted lightened during the enlargement. This would reduce the amount of light getting to that area of the print, so once it was developed, it would appear lighter.

Burning involves using the exact opposite technique – allowing more exposure to reach those areas of the image you want to appear darker. In the chemical darkroom you exposed the print as normal, then covered the areas you wanted to keep unaffected before "burning in" – adding extra exposure to those areas you wanted darker on the print. There was a fair amount of trial-and-error in the process – especially if a print required both dodging and burning. Happily, though, Photoshop makes the digital photographer's life much, much easier.

You've probably used the Dodge and Burn tools found in Photoshop's toolbox to carry out your own adjustments and they do the job well. But as all adjustments are made on one Layer, any mistakes are hard to rectify – you have to step back in the History palette, which can quickly clog up with dodge or burn status changes, so that's not always an option either.

Using the technique below allows you to dodge and burn non-destructively – it offers bags of control and uses separate Layers, too.

1 CREATE A NEW LAYER Open up an image from your JPEG files – for this technqiue we need one that's already been converted from a RAW colour file as a black and white image. Ideally we need one that's looking a bit flat like our rock picture above.
Here the sky needs to be darker and some of the shadows need lightening. First, we'll make a new Layer – go to Layer>New Layer and in the pop-up box, name the new Layer "Burn" and hit OK.

2 OVERLAY IMAGE If you haven't already done so, make sure your Layers palette is visible by hitting F7. Check that the new Burn Layer is selected and then go to Edit>Fill. Another pop-up box will appear; this time set the Contents to 50% Gray and leave the Blending Mode at Normal. Once done, hit OK, then go to the Layers palette and change the Blending Mode to Overlay.

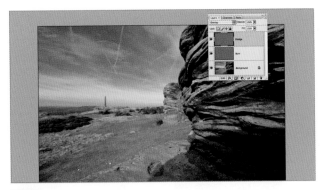

3 SECOND LAYER Now we're going to create another new Layer, but this time we're going to call it "Dodge" and again fill it with 50% Gray. Finish off by changing the Blending Mode to Overlay as before. Now we can start dodging and burning into the image non-destructively. Hit D to select Black as your foreground colour and White as the background, and pick up the Brush tool.

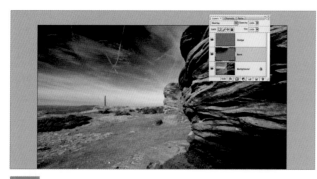

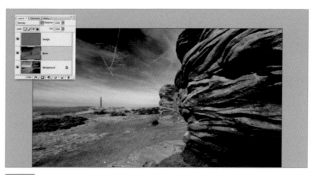

4 DARKEN THE SKY Select a brush size of 700px and set Opacity to 35%. We're going to darken the sky first, so select the Burn Layer and begin gently brushing into the sky. If you think you've done too much, either click back in the History or select 50% Gray from the Swatches palette and brush over the area you want to pull back.

5 BURN IN OTHER AREAS Here we reduced Opacity to 15%, set the Brush to 500px and brushed over the grass on the left and the rock in the distance. Moving over to the rock on the right-hand side we reduced the Brush size to 200px, and burned in the light areas. With the burning in completed, we can now focus on dodging areas on the second Layer.

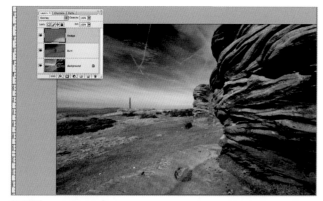

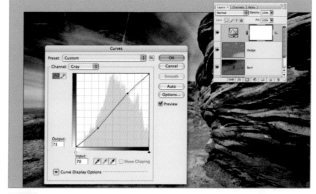

6 DODGE THE SHADOWS Hit X on your keyboard to swap to White as your foreground colour and select the Dodge Layer from the Layers palette. Set the Brush to 600px and the Opacity to 25%, then brush into the shadow areas. We dodged the rock in the bottom right. Now reduce the Brush to 125px and gently run over areas of shadow, bringing back detail.

7 BOOST CONTRAST The clouds are looking a little flat, so reduce the Opacity to 10% and set the Brush to 100px. Lightly run over the clouds to bring a bit of white back into them so they're more prominent in the image. Click back on the Background Layer, select Curves from the Create New Fill or Adjustment Layer icon, and apply a subtle "S" curve, then hit OK.

FINISH

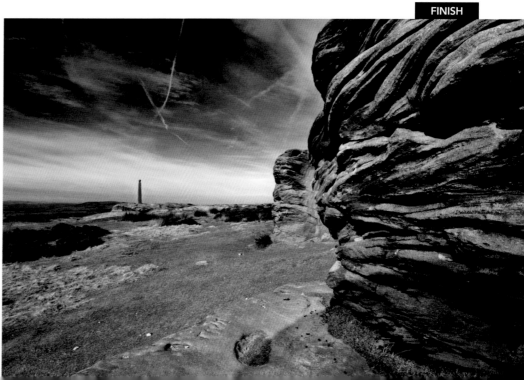

8 FINISHING TOUCHES To boost midtone areas, click on the Background Layer and make a Selection using the Polygonal lasso tool. To lighten this area of rock we feathered the Selection by 1.5px and, with the Dodge tool set to Midtones (Size 150px; Opacity 10%), ran over the rock, lightening it slightly to make it look more defined. Once done, hit Ctrl+D to deselect the Selection and get rid of the "marching ants".

START

Generate the lith film look

Create special lith effects in black and white

WHAT YOU NEED
PHOTOSHOP OR
ELEMENTS

WHAT YOU'LL LEARN
HOW TO CREATE
LITH EFFECTS

LITH FILM IS A DARKROOM MATERIAL that offers extremely high contrast images – just blacks and whites with no greys in between. Prints made using lith film often have an attractive pinkish brown tone in the highlights, and a film-like grain to the shadows giving a gritty, split-tone look.

Recreating a convincing lith printing effect is all about softening and toning the highlights, while adding a harsh grittiness to the shadows, and in Photoshop there are a couple of tools that are perfect for the job.

Curves are a great way of making adjustments to a small section of the tonal register, and because the Curves palette gives you control over the three colour channels, it's ideal for

adding some toning just into the highlights.

The specialist lith chemicals used in the "wet" darkroom are what gave the shadow areas that lovely grainy quality, and by adding some noise to our image on its own Layer, we can use Blending Modes to restrict the noise to the shadow areas.

Finally, the Diffuse Glow filter can help us add some shimmer to the highlights and complete the lith film look.

Those with the full version of Photoshop will find the step-by-step below provides a comprehensive guide to how to create lith printing effects. Elements users don't have access to Curves, so we've included a short work around in the panel at the bottom of this page.

1 ADJUST RED CHANNEL Starting with a mono shot, go to Image>Adjustments>Curves, click next to Channel and select Red from the drop-down menu. Click on the Curve three-quarters of the way along the line and push it up to an Output of 221. Next, click on the centre point of the Curve and drag the line down to Output 128 and Input 128 to restrict the red toning in the shadows.

2 ADJUST GREEN CHANNEL Next, click again in the Channel box and select Green from the drop-down menu. Click on the Curve three-quarters of the way along the line and push it up to an Output of 197 to reduce the red, and make the highlight toning more of a pinkish-brown. Now click on the centre point of the Curve and drag the line down to an Output of 128 and Input 128 and click OK.

EXPERT ADVICE

CREATE LITH EFFECTS IN ELEMENTS

WHILE CURVES ARE AN IDEAL TOOL for toning colour selectively in small parts of an image's tonal register, if you're an Elements user you don't have access to control the Curve. Don't panic though! It's still possible to recreate a lith printing effect in Photoshop's streamlined sibling and we'll show you how.

In Elements, open your start image then go to Windows>Layers to open the Layers palette. Next go to Layer>Duplicate Layer and click OK. Hit Ctrl+U to open the Hue/Saturation palette, make sure the Colorize box is ticked and enter Hue +20, Saturation +50, then click OK.

In the Layers palette change the Blending Mode of the Background Copy Layer to Soft Light. Now hit D and then go to Filter>Distort>Diffuse Glow and enter Graininess 0, Glow Amount 3, Clear Amount 10 and click OK. Finally, click back on the Background Layer and go to Enhance>Unsharp Mask and enter Amount 100%, Radius 2, Threshold 1 and then click OK.

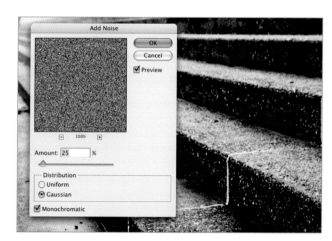

3 ADD SOME NOISE Hit Shift+Ctrl+N to create a new Layer and in the New Layer dialog box change the Mode to Overlay and click OK. Now tap Shift+F5 and under the Use menu select 50% Gray and click OK. Next go to Filter>Noise >Add Noise, enter an Amount of 25% and ensure the Gaussian and Monochromatic boxes are ticked and click OK.

4 RESTRICT THE NOISE Double-click on Layer 1 and, holding down the Alt key, click and drag on the white triangle icon under the Underlying Layer gradient bar. Move one half of the triangle to 10, then drag the other half to 140. On the Background Layer go Filter>Distort>Diffuse Glow, enter Graininess 0, Glow 2 and Clear 8. Hit OK then save.

FINISH

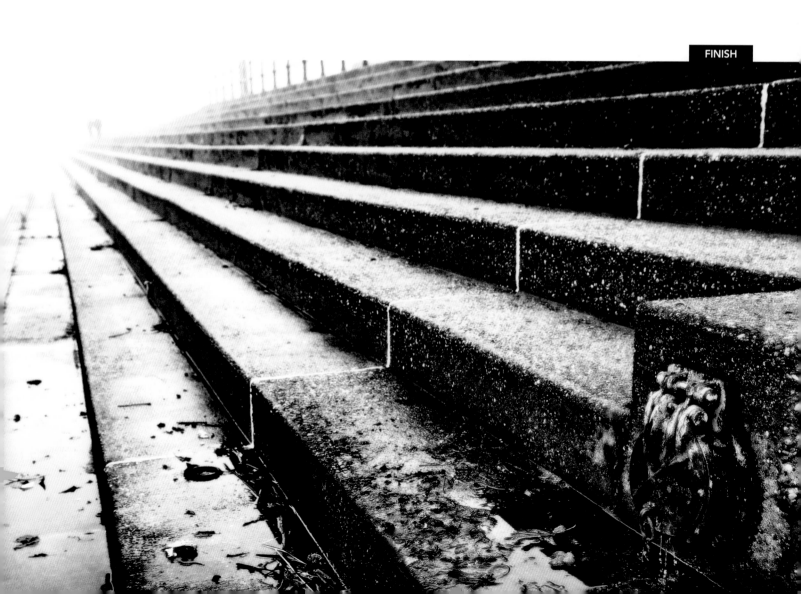

Apply a solarization effect

Create an artistic solarization look by inverting tonal range with Curves

SOLARIZATION IS ANOTHER old darkroom technique that's enjoying renewed interest in the digital age. It involved enlarging an image onto a piece of photographic paper in the conventional way, but before the print was developed it was first exposed to an additional flash of light. The result was a black and white picture that had a partially inverted tonal range, and looked like a cross between a positive and negative image. It's great for occasions when you've got an image with strong form and clearly defined edges and you want to create an unusual, retro finish.

SOLARIZATION WITH A JPEG (PHOTOSHOP)

Start with a JPEG image you've already converted to mono and go to Image>Adjustments>Curves. There's no single recipe that works with every image but for a good starting point there are a couple of Curves manipulations that are worth trying out.

Click in the centre of the Curve Line and push it up to Output 190. Now drag the Adjustment Point in the top right-hand corner down to an Output of 0 to form the shape of a hill. If this doesn't achieve the desired effect then add two new Adjustment Points, one a quarter, and one three-quarters of the way along the line, and drag the Curve into the shape of an upside down "V", or an "M" or "W". If none of these Curve Line shapes invert the tones in your image in a pleasing way, then it's a process of trial-and-error manually adjusting the Curve until you recreate that solarized look – you can see from the images below the Curve we used in our image.

Once you're happy with the basic solarization effect, add some blur to the edges to make it look more authentic. Press Ctrl+J to duplicate the Background Layer and then go to Filter>Blur>Smart Blur. Under Mode, select Edges Only, under Quality select High and then use the Radius and Threshold sliders to isolate the tonal edges (a Radius of 2 with a Threshold of 25 works well).

Finally, click OK and in Filter>Blur>Gaussian Blur, increase the Radius to 3 pixels and hit OK. Now change the Blending Mode of the Background Copy Layer to Screen. Now Save.

SOLARIZATION ON A RAW IMAGE

It might surprise you that it's also possible to recreate a traditional black and white solarized effect using Camera RAW, too. Applied to the right kind of shot it creates a pretty striking result with plenty of the "wow" factor.

In the "wet" darkroom getting the right result was very hit and miss, but digitally it's much easier. As we've just seen, it's possible to manipulate the tonal register as much as we like using Curves in the full version of Photoshop. You may be familiar with this Parametric Curve tab, which is ideal for making subtle changes to the tonal register and increasing contrast, but for a dramatic solarized effect, much more dramatic adjustments are need and for that you ideally need to dive into the Point tab, which allows you full control to bend and distort the tone curve however you wish.

The following step-by-step can be done when converting a RAW file in Adobe Camera RAW.

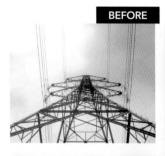
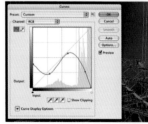

If "V", "M" or "W" Curve shapes don't quite work on your image, it's a process of trial-and-error, adjusting the Curve Line manually.

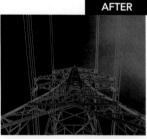
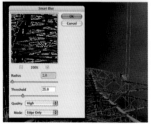

Reducing the Radius and increasing the Threshold sliders in the Smart Blur filter dialog box will isolate the tonal edges in your image.

Always shoot colour in camera and then convert to mono in Photoshop for greater creative control.

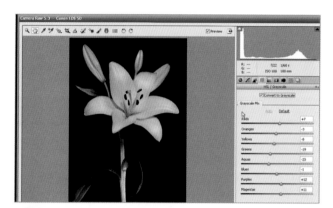

1 CROP AND GRAYSCALE Open your RAW image and in the toolbar click and hold on the Crop icon and select 2 to 3 from the menu. Now draw a crop box over the subject, cropping out any dead space in the composition. Next click on the HSL/Grayscale tab – the fourth tab along in the Camera RAW interface, and tick the Convert to Grayscale box.

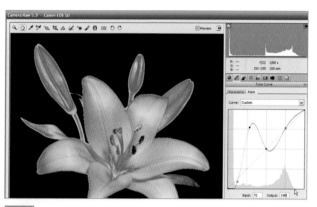

2 ADJUST THE SHADOWS Next we're going to manipulate the tone into an "M" shape. Click on the Tone Curve tab followed by the Point tab. Follow the Tone Curve (the black line running from bottom-left to top-right) up from the bottom-left and click on the second Control Point (black circle) and push it up to the top horizontal grid line (Input 72, Output 198).

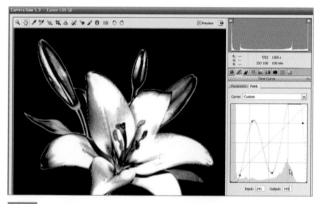

3 MIDTONES AND HIGHLIGHTS Now click on the central Control Point and drag it down halfway below the bottom horizontal grid line (Input 139, Output 30). Move the top right Control Point and drag it to the bottom (Input 255, Output 0) then click on the fourth Control Point along and drag it right about three-quarters of the way along the top horizontal line (Input 241, Output 193).

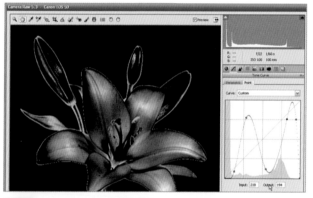

4 COMPLETE THE CURVE Next, we're going to add a new Control Point simply by clicking on the Tone Curve in the middle of the curve where it "flatlines" at the top of the grid. Now using that new Control Point, drag the Tone Curve down and right to about a quarter of the way past the third vertical line (Input 210, Output 194) and that's the solarization effect complete.

THE FINISHED SOLARIZED SHOT
The Solarization technique, also known as the Sabattier effect, is an intriguing black and white special effect that creates a finish which is somewhere between a positive and negative image.

FINISH

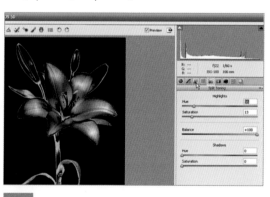

5 TONE THE HIGHLIGHTS Now select the Spilt Toning tab and drag the Balance slider right to +100. Next, under the Highlights menu drag the Hue slider right to 56 and then drag the Saturation slider right to 13. This adds just a hint of yellow to the highlights but feel free to experiment with the Hue and Saturation sliders to create your own toning effect.

6 SHARPEN Zoom in 100% then use the Hand tool to scroll around the image to find a large exapanse of uniform pixels. Click on the Detail tab and under the Sharpening menu click and drag the Detail slider to 80. Simply click Done to save your RAW conversion or Open to launch the pic in Photoshop and save as a JPEG.

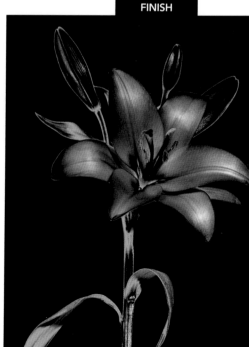

Create liquid emulsion borders

Make DIY painted borders for the "liquid emulsion" look

THE TRADITIONAL CHEMICAL DARKROOM offered photographers a bit of creative fun by printing their images onto a substance known as "liquid emulison" or "liquid light". This was a light sensitive paint (made from silver nitrate, gelatin and citric acid) which you could paint direct onto a wide range of different objects and surfaces such as canvas, glass or metal.

Applying the emulsion evenly and neatly in the dark could be pretty tricky, and often resulted in an imperfect finish with rough, ragged borders.

The length of light exposure required also varied each time, depending on the thickness of emulsion applied, and this made printing a real process of trial-and-error. This could be both exciting as well as sometimes a little frustrating, but often yielded some unexpected and interesting effects. What's more, once the liquid emulsion was exposed,

developed and dried, the surface would often split and crack, really adding to the coarse and tactile finish.

Working in the digital darkroom, it's much easier (and cleaner) to recreate this liquid emulsion effect. If you like the sound of getting hands-on with some paint and a brush, this technique lets you do that, too.

To achieve the "brush stroke" effect you just need to paint black poster paint onto white A4 paper. Poster paint isn't light sensitive thankfully, so you can leave the lights on.

As you paint, apply less pressure towards the edges, and you'll get the effect you need. Make sure you leave plenty of space around the edges so your arty border will stand out when the image is added.

Once you're done you'll need to scan in your handiwork and save it as a JPEG file, and then it's just a matter of blending it with an arty mono pic in Photoshop.

Take any pic and add it to your own hand-painted borders to create a striking "liquid emulsion" style image in minutes.

START IMAGES

1 PAINT A BORDER Get some black poster paint and a large paintbrush. A tatty old brush works best because the stiff, worn bristles give a better brush effect. Now take a few sheets of thick white A4 paper and paint a large black rectangle in the centre, remembering to leave a decent white border with some messy brush strokes towards the edges.

2 SCAN THE BORDER Once the border has dried, scan it in using a flatbed scanner to get an electronic copy. Set Target Size to A4 (Width 210mm and Height 297mm) and set Resolution to 300ppi. With the scan properties set up correctly, just hit the Scan button to start scanning. Save the image as a JPEG on your desktop.

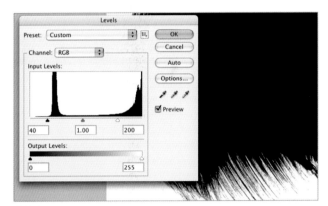

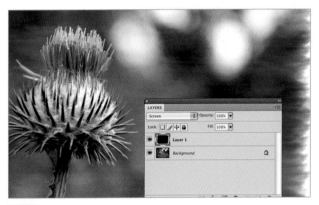

3 ADJUST THE LEVELS Open your new scan into Photoshop or Elements. Now we need to boost the contrast to create a clean white border and jet black image area. To do this, open Levels (Ctrl+L) and drag the White Point slider left, to an Input Level of 200 or so, and the Black Point slider right, to an Input Level of around 40, and click OK.

4 CHANGE THE BLENDING MODE Hit Ctrl+A and then Ctrl+C to copy the border. Now open your image and hit Ctrl+V to paste the border on top of the image. Hit Ctrl+T and pull on the handles to resize it if needed. Finally, open Layers (Window>Layers) and with Layer 1 highlighted, click where it says Normal and pick Screen from the list. Flatten and Save.

FINISH

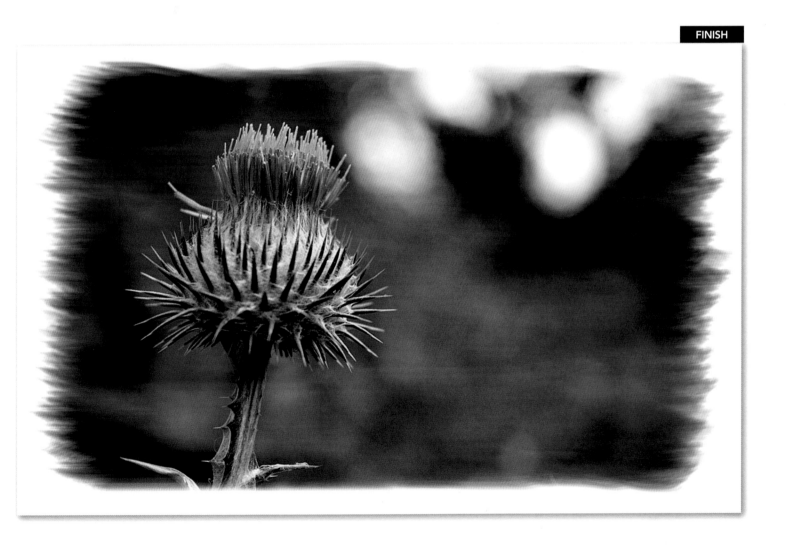

Shoot infrared in colour and black and white

Have an old camera converted for infrared, or use Photoshop's Channel Mixer

WHAT YOU NEED
INFRARED DSLR;
PHOTOSHOP OR
ELEMENTS
WHAT YOU'LL LEARN
HOW TO SHOOT
INFRARED EFFECTS

EVERY NOW AND THEN our photography needs a creative prod, and infrared (IR) photography will certainly do just that. Infrared is electromagnetic radiation whose wavelength is longer than visible light – which is why we can't see it but, fortunately, our cameras can.

Although it is possible to shoot IR using a normal DSLR and a heavy opaque filter to block out all visible light, it is incredibly fiddly (requiring very long exposures that remain hit and miss). Instead, the route into IR that we've chosen here gives an old digital camera a new lease of life: we rescued an old DSLR from redundancy and had it converted to shoot infrared-only. The process involves sending the camera off for conversion by specialists who remove its low pass filter – the mechanism that stops IR light from hitting the sensor when taking pictures normally. They replace the filter with a 720nm (nanometers) IR filter that allows the maximum amount of IR light through and also adjusts it to the infrared wavelength, so you can use all of your lenses at their normal focal lengths.

Adapting a DSLR for infrared photography is a pretty skilled job and we'd certainly recommend using a specialist

company unless you have total faith in your abilities.

Once done, it's incredibly simple to work with: you can use all your lenses as normal, metering and shooting as you would for any digital image. The downside is your camera will now only take IR images, unless you go to the trouble (and expense) of having the process reversed.

CONVERT COLOUR IMAGES TO MONO IR

If you don't want the expense of converting an old camera, it's also possible to generate a bold black and white infrared effect to colour images using Photoshop's Channel Mixer.

Start with a colour image go to Image>Adjustment>Channel Mixer. Tick the Monochrome box and adjust the Green and Blue sliders. Set Blue to around -200 or -100 and Green to +150 or +200. Adjust each slider until contrast and balance looks about right. A similar look can be achieved in Elements going Enhance>Convert to Black and White.

To make the foliage shimmer and get a heavy film-grain effect, hit D on the keyboard to set Foreground to Black, then go Flter>Distort>Diffuse Glow and set Graininess to 8, Glow Amount to 2, Clear Amount to 12. Click OK.

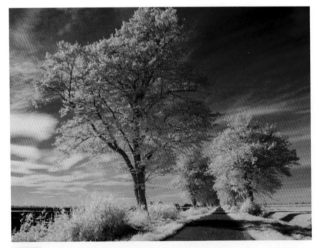

1 DOWNLOAD YOUR IMAGE FILES With your old DSLR camera converted for infrared photography, it's advisable to shoot in RAW mode as this provides a much better conversion to black and white when you process the shots. Your resultant images will have this surreal Martian-red look. You can convert the image to mono from this point, or remove the colour cast as we did for our main colour image.

2 REMOVE THE COLOUR CAST Open your converted RAW (or custom white-balanced JPEG) in Photoshop or Elements. To get rid of the pinky cast go to Image>Auto Color or Image>Adjustments>Auto Color in Photoshop. Go to Enhance>Auto Color Correction in Elements. This does a great job, but experienced users might like to use the grey point eyedropper in Levels (Ctrl+L) to neutralize the foliage further.

3 SWAP THE COLOURS If you're working on a portrait subject then you'll probably be happy with the result as it is – skip this step if you like. However, landscapes will have a surreal red sky that needs sorting by inverting the colours. To do this hit Ctrl+U and drag the Saturation slider to +180. Click OK. This result looks fine, but if you own Photoshop, go to Edit>Undo and try the following technique instead.

4 CHANNEL SWAP (PHOTOSHOP ONLY) Now we're going to swap the Red and Blue channels over. Go to Image>Adjustments>Channel Mixer. With the Red Output Channel selected from the top of the palette, enter 0 next to the Red slider and +100 for Blue. Now select the Blue Output Channel and enter +100 next to the Red slider and set the Blue slider to 0. Click OK.

FINISH

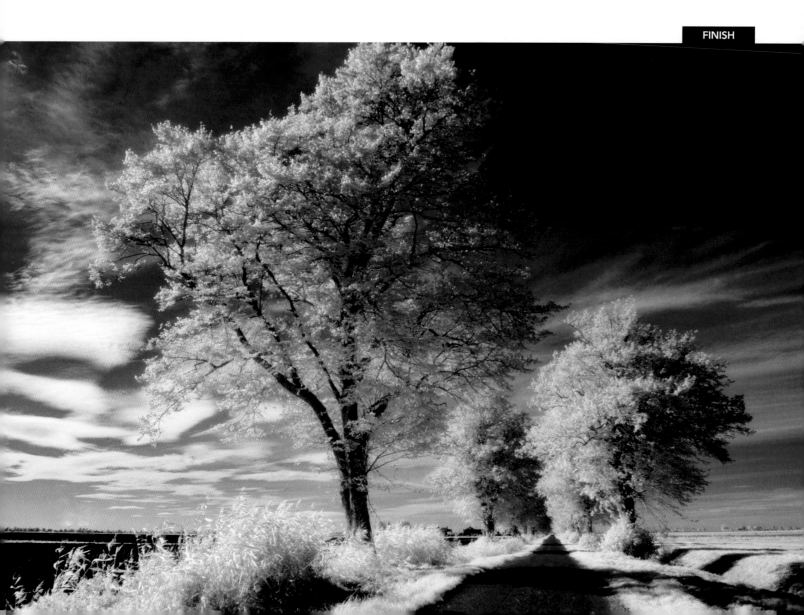

Try diffusion effects in black and white

Compare different soft focus effects

SOFT FOCUS HAS ALWAYS BEEN a popular finish for wedding and portrait photographers because of the way it smooths out blemishes and imperfections, to produce a romantic and stylized finish. It will also create a timeless and nostalgic feel that really lends itself to black and white photography, so it's an important technique to learn.

There are three great Photoshop techniques to introduce soft focus effects into your images: Gaussian Blur, Diffuse Glow and the Lens Blur filter.

GAUSSIAN BLUR (PHOTOSHOP AND ELEMENTS)

By applying Gaussian Blur onto a separate Layer, you can erase through the blurred Layer to reveal sharper detail beneath. Open your start image then go Window>Layers then Layer>Duplicate Layer and name the Layer "Blur". Click OK. Next go Filter>Blur>Gaussian Blur and enter a radius of 15 and click OK. By reducing the Opacity of this Layer you can alter the softness. In the Layers palette click on the drop-down arrow in the Opacity box and drag the Opacty slider to 75%. Next select the Eraser tool and choose a soft-edged 50px brush, 50% Opacity. Ensuring the Blur Layer is selected, brush over any item you want to keep sharper.

DIFFUSE GLOW (PHOTOSHOP)

Photoshop's Diffuse Glow filter has the effect of bleeding highlights into shadows. It works best on landscapes that include smooth water and dark gritty details, or on backlit scenes (see right) for a cinematic and dream-like finish.

To use it, open up your start image and press D on the keyboard to set your background colour to White. Create a copy of the Background Layer (Layer>Duplicate Layer) then go Filter>Distort>Diffuse Glow and enter Graininess 5, Glow Amount 17, Clear 10 and click OK. Reduce the effect using the Opacity slider in the Layers palette (Window>Layers).

For a darker effect (below right), you can apply the filter to a mono image with an inverted tonal range, making the shadows bleed into the highlights instead. Open your start image and create another copy. This time hold down the Ctrl key and press I on the keyboard to invert the tones (so the image looks like a negative). Go to Filter>Distort>Diffuse Glow and enter the same settings as before. To make the image positive again, hold down the Ctrl key and press I on the keyboard. With the Background Copy Layer still selected, reduce Opacity to 75% to bring back some detail.

LENS BLUR (PHOTOSHOP)

This technique offers more adjustment sliders than the Gaussian Blur technique detailed above. To use the filter, open the Layers palette (Window>Layers) and click on Duplicate Layer. Rename it "Blur" and click OK. Go Filter>Blur>Lens Blur and under the Iris menu set shape to Octagon, Radius to 50 and leave all the other sliders to 0 before clicking OK.

Next click on Add Layer Mask and click on the downward arrow in the Opacity box, reducing the Opacity to 50%. Press D on the keyboard to set the foreground colour to Black. Pick the Brush tool and in the Options bar select a soft-edged brush 40px with 100% Opacity. Zoom in and paint over any details you want to retain sharp. Finally you can set the strength of the Lens Blur using the Opacity slider on the Background Copy Layer.

DIFFUSE GLOW: Bleed the highlights into the shadows to create a dream-like effect on backlit mono landscapes...

START
After a straight mono conversion, any little skin blemishes will still be visible.

GAUSSIAN BLUR
The Gaussian Blur filter is the simplest way to recreate a soft-focus effect for Elements users.

DIFFUSE GLOW
The Diffuse Glow filter will smooth out skin and bleed the highlights into the shadows.

LENS BLUR
The Diffuse Glow filter will smooth out skin and bleed the highlights into the shadows.

FINISH

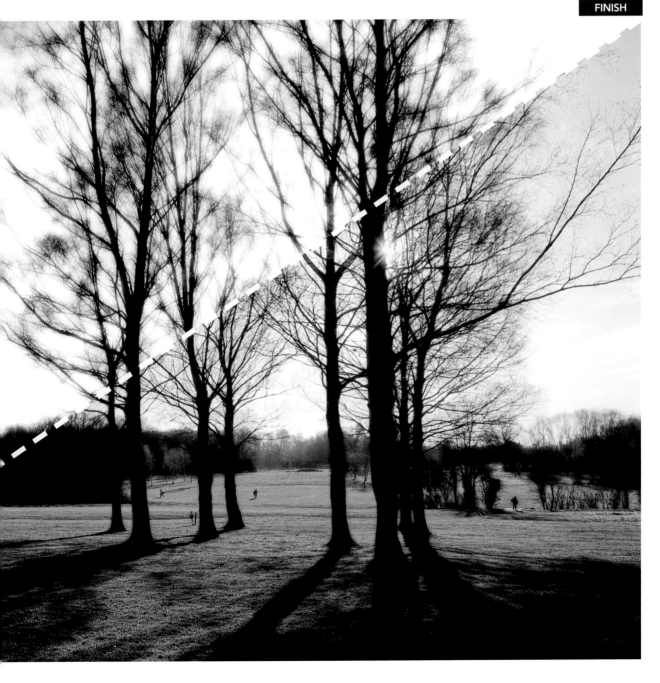

...or invert the tones and bleed the shadows into the highlights for a much moodier finish.

Traffic trails

SHOT 1	SHOT 2	SHOT 3	SHOT 4

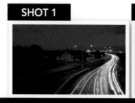 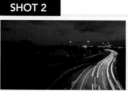 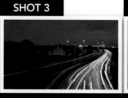 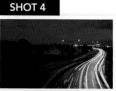

Capture the rush hour at dusk in a dynamic time exposure

WHAT YOU NEED
DSLR AND TRIPOD;
PHOTOSHOP OR
ELEMENTS
WHAT YOU'LL LEARN
HOW TO SHOOT
TRAFFIC TRAILS

LIGHT TRAILS FROM MOVING TRAFFIC LOOK AMAZING, but are so simple to create using your DSLR and Photoshop. You just need to lock your camera on a sturdy tripod so it won't move, get a good vantage point of a busy road and point your camera in the direction of the oncoming traffic. This, combined with a slow shutter speed, turns a mundane rush hour into a brilliant picture of moving headlights.

Dusk is a great time to shoot traffic trails thanks to the dim mix of artificial and natural light which means you can get a slow shutter speed just by selecting a low ISO sensitivity (100–200) and a small aperture (f/11–22). A shutter speed of around three to eight seconds is perfect – blurring the moving lights, while your tripod keeps everything else crisply sharp.

Getting it right with one single shot can be tricky however;

you can't always get enough traffic moving through your shot, and that's where Photoshop comes in – rather than staying out all night just to get one perfect shot, it's possible to blend a series of start images together, producing the perfect traffic trail composite image.

Perhaps the most important part of this technique is to use a tripod – blending the images you've shot is easy, but unless they're all taken from the same identical position, all you'll end up with is a mess of lights.

In this step-by-step project we'll take you all the way from getting the right starting images using long exposures to the post-production work back at home. Using Photoshop (or Elements) we can easily refine the blending process to create an impressive finished image.

1 SET UP THE CAMERA Find a suitable location to shoot your traffic trails – bridges and buildings offer a great elevated vantage point – and try to get there just before dusk so you have time to set up your camera and tripod. Frame up, set the ISO to 100, image quality to RAW and put the camera in aperture-priority mode, with an aperture of f/11. At dusk exposures should last about 1 second or longer.

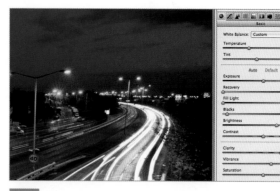

2 CONVERT RAWS Open your RAW files on the computer. Photoshop's RAW Converter will launch automatically. Our image was looking a bit too cool, so we increased Temperature from 3150 to 5200 and bumped-up Exposure to +0.35 to lighten the shot. If you're using CS3/Elements 6 or above, also increase the Clarity slider +45 and Vibrance to +20. We also increased Saturation +10.

3 MERGE THE IMAGES Once the RAW files are all converted, open all the images in Photoshop or Elements. Select your second traffic trail shot. Press Ctrl+A to select the whole canvas and then Ctrl+C. Now click back on the first traffic trail image and hit Ctrl+V to paste in the new copied Layer. Next go to Window>Layers to open the Layers palette.

4 REPEAT THE PROCESS In the Layers palette, click on Layer 1 and then click where it says Normal. From the list of Blending Modes choose Lighten, then repeat this same process of copying and pasting in the remaining files, changing the Blending Modes to Lighten. Now click back on the Background Layer.

5 MAKE SELECTION From the toolbox, select the Lasso tool and make a Selection around the darker left-hand side of the road. Feather this by 80px (Select>Feather in CS2 or earlier, Select>Refine Edge and then the Feather slider in CS3/4). With the Background Layer still selected, click on the Create New Fill or Adjustment Layer icon, and from the drop-down menu select Levels from the list.

6 ADD A GRADIENT Drag the right-hand arrow towards the middle – this will boost the intensity of the traffic trails on the left. In our image the sky looks a bit too light, so we'll now darken it down. Click on Layer 3 then go to Layer>New Layer. Next, in the toolbox, select the Gradient tool (sometimes hidden underneath the Paint Bucket tool).

7 CHANGE BLENDING MODE Click on the foreground colour swatch and choose a dark grey from the Color Picker. Then, in the Options bar, select Foreground to Transparent and Linear Gradient. Click on the top of the image, drag down to the horizon and release. Now change Layer 4's Blending Mode to Multiply and if it looks too strong, reduce the Opacity to 80% in the Layers palette.

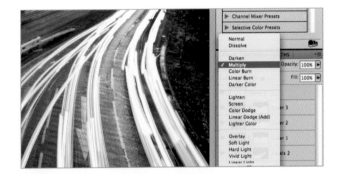

FINISH

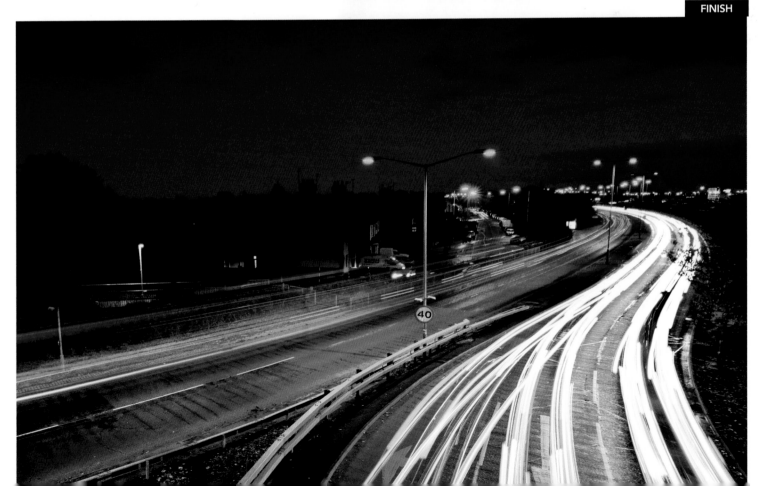

Shoot fireworks

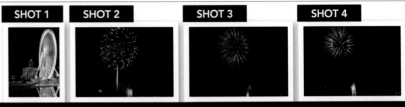

| SHOT 1 | SHOT 2 | SHOT 3 | SHOT 4 |

Fill the night sky with explosions of colour and light

A GOOD FIREWORKS SHOT is a must for any portfolio, but if you've ever been to a fireworks event and tried to shoot them during a display you'll know it's not as easy as it seems. For a top-class image, not only do you need to capture the explosions as they happen in pin-sharp detail, you also need to make sure they're part of a pleasing overall composition too.

For best results you'll want a dark-blue sky instead of an inky black one, so choose an event where the fireworks start at dusk and on an evening without too much cloud. For maximum effect you'll want several explosions all neatly framed up in the same shot, too. It's a tall order!

The traditional way of shooting fireworks is to set your camera on a tripod and use a very long exposure (around, say,

5 to 10 seconds, depending on the available light) or with the camera's shutter held open on its B (Bulb) setting. Then you have to try to capture several explosions all in the same frame, holding a black card over the lens to ward off over-exposure in-between the explosions.

This is a fun technique to try on bonfire night, but the digital route is a whole lot simpler and, thanks to Photoshop and Elements, you can have a lot more control over the composition, too.

By shooting the fireworks singly and adding them to a striking low-light image using Layers and Blending Modes, you can take all the guesswork out of creating an amazing fireworks shot. Just follow the step-by-step guide below.

1 LIGHTEN THE SKY Start off by opening up one of your best night-time exposures with plenty of rich blue sky. Call it "Night scene". Make sure the Layers palette is open on screen (Windows>Layers) and then go to Layer>New Adjustment Layer> Levels and hit OK. Now click and hold on the Gamma (middle) slider. Drag it left to an Input Level of 1.30 and click OK.

2 ENHANCE THE BLUES Now we're going to add some saturation to the blues in the sky. Go to Layer>New Adjustment Layer>Hue/Saturation and click on the drop-down arrow in the box where it says Master, selecting Blues from the menu. Now increase the Saturation slider to +20, reduce the Lightness slider to -5 and click OK.

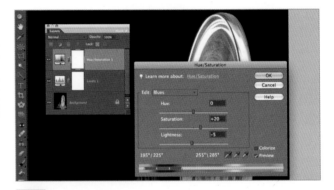

3 ADD THE FIRST FIREWORK Open your first firework and select the Lasso tool from the toolbox. Make a rough Selection of the firework explosion then hit Ctrl+C to copy it. Go back to your night-time exposure and hit Ctrl+V to paste in the first firework. In the Layers palette, click on the drop-down arrow where it says Normal and select Screen from the list.

4 POSITION AND DARKEN Select the Move tool and, making sure Layer 1 is selected, click on the firework and reposition it to a suitable place within the composition. Go to Layer>New Adjustment Layer>Levels and in the New Layer dialog box tick Group With Previous Layer, then click OK. Set the Black Point Input Level to 30, Gamma to 1.80 and click OK to confirm.

5 ERASE UNWANTED FLARES Click back on Layer 1, pick the Eraser tool from the toolbox and in the Options Bar select a 100px soft-edge brush with 100% Opacity. Now zoom in to 100% and erase any flashes that fall in front of the subject in your night scene (such as the buildings here). When you've finished erasing, go into the Layers palette, and click on the Levels 2 Layer to select it.

6 ADD SECOND FIREWORK Open your second firework image and make another Selection with the Lasso tool and copy and paste it into the night scene. In the Layers palette click on Layer 2 and select the Move tool from the toolbox. Now click on the second firework and reposition it in the top-left hand corner of the image. Now, in the Layers palette, click on Normal once more and select Screen from the list.

FINISH

7 DARKEN THE FLARES Now go to Layer>New Adjustment Layer>Levels and in the New Layer dialogue box tick Group With Previous Layer and click OK. Set the Black Point Input Level to 40, Gamma to 1.60 and click OK. Next open your third firework, make a Selection of the flares and copy and paste into your Night scene JPEG then use the Move tool to reposition the third firework into a suitable place in the night sky.

8 ERASE AND SAVE In the Layers palette change the Blending Mode to Screen, go to Layer>New Adjustment Layer>Levels and in the New Layer dialogue box tick Group With Previous Layer, click OK and set the Black point Input to 50 and Gamma to 0.60. Click on Layer 3, hit E on the keyboard to select the Eraser tool and erase away any extraneous firework flares. When you've finished tidying the image go to Layer>Flatten Image and Save.

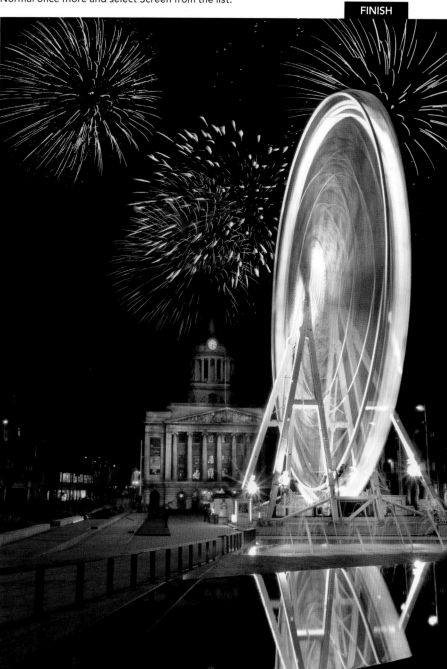

Paint with light

Use a torch to light a creative still life

WHAT YOU NEED
DSLR, TRIPOD
AND TORCH

WHAT YOU'LL LEARN
HOW TO PAINT
WITH LIGHT

WITH A DSLR, YOU CAN KEEP CREATING GREAT images long after the sun has set, so don't let lack of daylight stop you. Photography actually means "drawing with light" and this technique allows you to take this meaning very literally to create, control and conjure up every element of your image using nothing more than a humble torch as your artist's "brush".

To light a small still life scene like this you can either paint in a traditional fashion, illuminating the subject while holding the torch beam out of shot, or you can feature the torch's bulb in the shot and create continuous streaks of lights by tracing round the subject as we have done here. Of course, you can do both in the same image too, if you prefer.

As with so many creative techniques, a tripod is essential, as your camera mustn't move during, or between, exposures.

Afterwards, blending all the best frames together is really easy in Photoshop or Elements provided you capture the shots from a tripod so they all align correctly. Combining lots of exposures together into one montage image gives you unparalleled control to pick and choose which painting effect you use for each part of the image.

To combine our best pictures here, we loaded them all into Photoshop and, using the Move tool, held down Shift to drag one onto the next so they aligned correctly. Go Window>Layers to see your images on top of each other in the Layers palette. Click where it says Normal and change Blending Mode to Lighten. Highlight the next Layer down and Lighten again. Once you're happy with the result, go Layer>Flatten image and File>Save As.

1 SET UP YOUR CAMERA Switch the main mode wheel to Manual (M). Dial in an aperture of f/11 and a shutter speed of 4 seconds. Set the ISO speed to its lowest value (normally 100) and compose your shot. Because you're in full Manual mode, you've bypassed all the camera's automated functions and are making all the exposure decisions yourself.

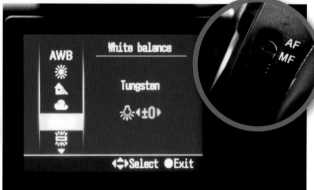

2 FOCUS ON YOUR SUBJECT With the room lights on, switch to Manual focus mode and focus on the nearest part of your subject. Your focus point is now fixed – don't touch your lens after this point, as you don't want the zoom position or the focus to drift away from where you set it. Set White Balance to "Indoor" so your torchlight looks natural.

HOW WE SET UP THE SHOT

We secured the cards with Blu Tack, placed at the back to keep it out of shot. You can try this technique using beer mats too.

We locked off the camera on a tripod and positioned the playing cards on a table using blobs of Blu Tack. The cards were placed while looking through the viewfinder, and once we'd achieved a good composition, we used larger lumps of Blu Tack to reinforce the positioning so the cards couldn't move during the multiple exposures. This was critical, as any subject movement would have ruined the shot. We kept the Blu Tack behind the cards and out of sight so we wouldn't have to clone it out of the final image.

3 SELECT THE SELF-TIMER Set the camera to self-timer mode so you won't have to release the shutter button. Switch off the room lights so you're in complete darkness. With your torch, rehearse your movements. If you're tracing around the subject, count to four while doing so, so your torch movements are smooth and positive.

4 TAKE THE FIRST SHOT When you're all set, press the shutter and get into position with your torch switched on while the timer counts down. As soon as the shutter fires, run through the painting-with-light movement that you've rehearsed, and keep the torch gently moving until you hear the mirror slap that signifies the end of the exposure.

FINISH

5 CHECK THE SHOT Take a look at the screen and assess your shot. If the torchlight is too bright on the subject, change the aperture to f/16, and try again. If it's too dark, go for f/8. Once you've established the optimum exposure settings for the torch you're using, repeat step 4, and keep shooting, building up the effect around the subject over as many shots as it takes.

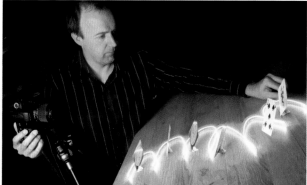

6 KEEP SHOOTING Take care not to move the camera or the subject, and if an attempt goes wrong, just repeat the shot. You'll end up with somewhere between 10 and 20 shots with a typical subject, and when you're content that all your results are as good as possible, it's time to blend your best exposures together using the technique detailed above.

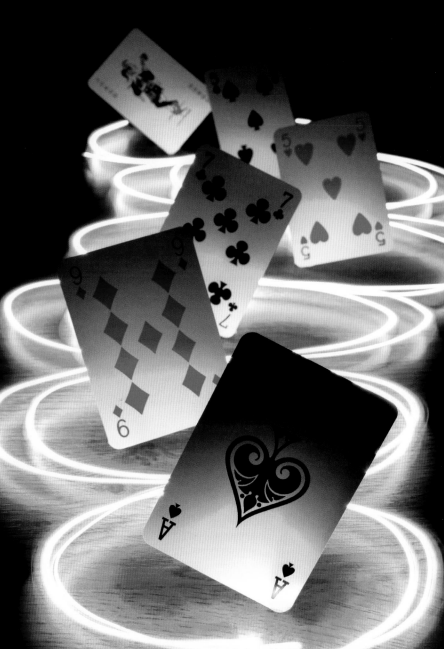

Take natural close-up shots

Explore the world of macro photography

Simple, window-lit set-ups work really well. Just lock off your camera on a sturdy tripod as exposures can be long.

WHAT YOU NEED
DSLR, LENS AND TRIPOD

WHAT YOU'LL LEARN
HOW TO SHOOT MACRO SUBJECTS

NATURE IS A GREAT PROVIDER, not least when it comes to providing richly detailed subjects for macro photography. Many of the everyday items we take for granted are intricately structured and hold amazing detail, making them truly spellbinding under the revealing gaze of a macro lens. All you have to do is look for them.

Your local supermarket is an ideal place to start the search, and you'll find stacks of inspiration in the fruit and veg section. Look for the loose-packed produce so you can chose perfect quality, photogenic examples that aren't damaged. Keep your subjects in the fridge when you get home, and choose a simple backdrop such as the wooden chopping board here.

You won't need a specialist macro lens for this shot. Any standard zoom lens with a close-focus setting will do.

To light your macro still life, you can't beat the soft directional illumination offered by natural light, and all you need for this is a north-facing window – or any window you like on a cloudy day. Paradoxically, if the sunlight is too bright it will cast deep shadows that are too hard and harsh, robbing your macro subject of detail.

1 SET UP THE SUBJECT Place the mushroom on a board or plate and then position it on a table top. Ideally, this should be next to a large window so you can use natural light to add form and contrast to the shot. Set up your gear, placing your camera on a sturdy tripod. Position it close to your subject so you can fill the frame with the mushroom's intricate gill detail.

2 CHECK FOCUS Switch to manual focus for precision and also to avoid having to recompose after locking focus with the AF system. Frame-up and then focus with a bias towards the front of the frame – you want the nearest point to be really sharp. Set the camera to its lowest ISO (100 or 200) and then select aperture-priority mode (A or Av) with a small aperture value of f/16 or so.

3 CHECK DEPTH OF FIELD Use your DSLR's depth of field preview button to check depth of field in the viewfinder. If it's sufficient to keep the subject in focus, either set the camera to self-timer or attach a remote trigger to avoid any camera shake – in this case, we used a remote control to fire the shutter away from the camera. This keeps your hands away from the camera at the critical point of making the exposure.

4 ADD A REFLECTOR Review your shot on the LCD screen, and if there's too much shadow in the gills of the mushroom, use a reflector to counteract it. You can use a purpose-built reflector if you have one, but a sheet of white card angled back at the mushroom, arranged opposite the window, will reduce the shadows just enough to bring back a little more detail.

FINISH

HOW CLOSE CAN YOU GO?

Most standard zooms offer some form of close focus facility, down to less than 30cm (12in) from the subject in some cases. But for true macro photography you need a specialist lens which allows you to focus even closer still, to allow for at least 1:1 ratio reproductions – that is, life-size or larger. This is all very well for static subjects such as this mushroom, but with live subjects such as flying insects you have to catch them at the right time of day to get close enough, watching your shadow and holding your breath, focusing manually by rocking to and fro gently until the subject comes into sharp focus.

EXPERT ADVICE

MACRO PHOTOGRAPHY

WHAT GEAR FOR MACRO?

All "normal" lenses have a minimum focusing distance and this will be marked on the barrel or visible in the distance window. This is true whether they are fast or slow, zooms or primes.

The trouble is, a normal lens won't be able to focus close enough for true life-size macro work because if it did, it wouldn't be able to focus on infinity, too. This means you have to modify a lens in some way to force it to focus closer than its normal limit.

There are basically two ways to force a lens to focus closer: you can put a magnifying lens in front of it (try a magnifying glass or a spectacle lens and you'll see how this works) or you can move the lens unit further away from the sensor.

This will make it focus closer than before, but you need a light-tight tube to mount the lens on and hold it in place (see section on Extension Tubes below).

CLOSE-UP FILTERS

Also known as dioptre lenses, supplementary close-up lenses are basically magnifying glasses that attach to your existing lenses. They screw or clip on to the front of a normal lens and magnify its view.

Close-up filters come in different strengths (+1D, +2D, +3D, etc) with higher numbers offering greater magnification. You can get round screw-in dioptres that attach directly to the lens filter thread, or buy slightly more versatile square dioptre lenses that are placed in a filter holder. The advantage of the latter is that they can be used with any lens once you have the correct filter holder adaptor. Close-up filters are a cost-effective starting point for those just getting into macro photography.

REVERSING RINGS

A reversing ring allows you to mount a lens backwards and turn it into a close-up device. Stick any standard or wide angle prime lens on the wrong way round, and you have a great quality close-up lens. This is really easy to try – you can just hold the lens in place and look through the viewfinder – but take great care not to scratch the lens. Some people have taken shots by simply holding the lens against the camera body in this way, but life is much easier if you buy a reversing ring and screw the lens in place properly.

You can use any lens by any manufacturer – all you need is one with a physical aperture ring. Modern lenses without aperture rings will only work at minimum aperture, making the

EXTENSION TUBES

Extension tubes are a mid-priced option and the best ones offer all the linkages and stack together so you have a variety of different lengths to choose from. On the science side, if you extend a lens by its focal length, you'll get 1x magnification or life-size reproduction, and if you use double (eg: put 56mm of extension on a 28mm lens), you'll get 2x magnification. Extension tubes are well worth having as they'll make any lens focus closer, and the most versatile ones come in sets of three so you can mix and match the amount of extension you want.

Optically they're as good as the lens in use, so there's no loss of quality. You'll need loads of light or long exposures to use them at smaller apertures. Also they're a bit fiddly, as you have to stack

MACRO LENSES

The perfect solution in terms of optical quality and ease of use, macro lenses are also the most expensive option, with prices starting at around £240 for a 50mm f/2.8 macro lens. A macro lens is different from a normal lens in that the front racks right out to allow close focusing – right down to life-size. Macro lenses still rob you of light (the closer you focus, the more light you lose) but you get great optical quality, and what's more they double up as good portrait lenses, too. Optical quality, speed and convenience are great and they can be used with extension tubes or dioptres for even greater magnification. It's safe to say that all close-up enthusiasts eventually acquire a macro lens, as your photographic life won't be complete

Shoot a still life by torchlight

Creative lighting for your still life subjects

WHAT YOU NEED
DSLR, TRIPOD AND
TORCH; PHOTOSHOP
OR ELEMENTS
WHAT YOU'LL LEARN
HOW TO SHOOT STILL
LIFE WITH A TORCH

SHOOTING STILL LIFE SCENES IS ALL ABOUT EXPERIMENTATION – not just with your camera, but with your subjects and lighting, too. Fortunately digital cameras and software make this easy, because not only can you check the fruits of your labour on screen, you can also use Photoshop to refine the results afterwards.

In this project we've taken a still life scene and dramatically improved the lighting, using nothing but a small torch. This, combined with a series of long, 6-second exposures allowed us to light the scene subject by subject, choosing exactly how each subject should be lit. All that's left to do then is blend the pictures in Photoshop or Elements.

Compare the flat and dull picture above, lit from a single ceiling lamp, to our finished version below right, and you'll see what a difference you can make using this creative approach. So, grab your tripod, a torch and a few trinkets from around the house and give it a go.

Shot with a single overhead lightbulb, this still life scene is flat, dull and lacking in impact. But light the subjects independently, then use software to blend them and the result is full of impact.

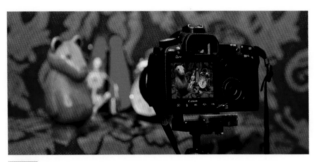

1 SET UP AND COMPOSE With your camera on a tripod, use the viewfinder to arrange your still life against a suitable backdrop. Your viewfinder may not give 100% coverage, so shoot a few test pics to see what's included in frame at the edges. Once you've finished arranging, focus the lens manually and select the self-timer mode, taking care not to jog the camera.

2 SET APERTURE AND SHUTTER SPEED Using Manual mode, set the shutter speed and the aperture. Here we've gone for 6 seconds at f/14 – enough time to move the torch beam while the shutter is open. Make sure your ISO sensitivity is at 100 or 200 and change your White Balance to "Tungsten" to match your torch's bulb. Shoot high quality JPEGs to save you time editing later.

3 LIGHT THE SUBJECT Now turn out the room lights, plunging the room into total darkness. Release the shutter to take a shot. As soon as it opens, wave the lit torch over one part of the scene, creating the lighting effect you require. Looking on screen, if it's too bright, use a faster shutter speed; if it's too dark, select a slower one. When you're satisfied with your result, move on to another subject within the composition, but make sure you don't move the camera.

4 KEEP SHOOTING Now move on to the other parts of your scene in turn and light them individually, too, recording each part of the scene in a separate exposure. Keep the beam pointed away from the lens and try not to let it shine directly at the lens or you'll get light trails (as shown here). Ideally you'll end up with 5 to 10 different exposures that you can then blend together in Photoshop. Once you've finished, download the images to your computer.

5 LOAD YOUR IMAGES INTO PHOTOSHOP Open your pick of still life shots into Photoshop or Elements (in our example we're using six different exposures – see below left). Now go to Window>Arrange>Cascade to make sure you can see them all at once then, using the Move tool, click in your second shot, hold down the Shift key and drag it into the first shot. Repeat this process with all the other pics.

6 BLEND LAYERS Now go to Window>Layers and you'll see all the separate images as a Background Layer and as in the Layers palette. To blend them together, highlight one of the Layers by clicking on it, then click where it says Normal and choose Lighten from the list. Each time you do this more of the picture will appear, so make sure you repeat the procedure on all the Layers.

7 CLEAN UP THE IMAGE Though the lighting is already selective, we can refine it further with the Eraser tool or Layer Masks. As an example, we clicked on Layer 5 (the violin) then clicked on the Add Layer Mask icon in the Layers palette. We pressed D then X on the keyboard and, using the Brush tool, painted over the lit areas we wanted to remove. Elements users can use the Eraser tool instead.

8 FLATTEN AND FIX DISTORTION Once you've cleaned up the lighting, just go to Layer>Flatten Image. To sort the wide angle distortion here, we went Select>All and then Ctrl+T on the keyboard. We clicked on the top-left corner handle and, holding the Ctrl and Shift keys on the keyboard, dragged the handle to the right. We did the same with the top-right to correct the perspective, then hit Return and Select>Deselect.

FINISH

All six individual shots were blended in Photoshop to produce the image shown right.

Capture backlit leaves

Create an autumnal still life, shooting into the light

COLOURFUL LEAVES ARE PROBABLY THE MOST ICONIC symbol of autumn (fall). They're a beautiful, natural phenomenon that marks the passage of the seasons, but so commonplace in autumn that their individual details can often get lost in the sea of red and gold.

To really explore their myriad shades, texture and structure you need to isolate one particular leaf on its own. In this creative still life project we'll show you how.

To start off we're going to light an acer leaf from behind so its veins and ribs are really well-defined against the leaf outline. Just pluck a few nicely reddened leaves from a nearby tree in the garden or collect them off the ground on your next

woodland walk and, making sure they're not muddy or damaged, flatten them by placing them between the pages of a large, heavy book. This will make them easier to shoot using our improvised light box for the project – a window.

An alternative to using a window pane is to physically scan the leaf in using a flatbed scanner set to transmissive mode, as though the leaf were a sheet of slide film. But then, using a scanner instead of a camera, you'll miss out on the challenge of photographing the leaf and getting the back-lit exposure bang-on.

For best results follow the steps below to get a bold composition in Photoshop or Elements.

1 TAPE THE LEAF TO THE WINDOW Find a large window facing a bright area of sky and use some clear sticky tape to attach the leaf to the glass, so it's backlit. Try not to shoot directly into the sun or you may find the effect too extreme. Now, to ensure your leaf picture is as sharp as possible, set your camera on a tripod and compose the shot so the leaf is completely surrounded by the sky (with no obstructions). Make sure it fills the frame as much as possible and is flat-on to the camera. Now you're ready to shoot.

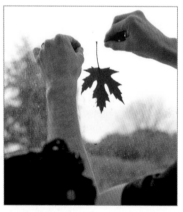

2 SET UP THE CAMERA Set your camera to aperture-priority (A or Av) and dial in the widest f/stop available (usually f/2.8 or f/3.5). Change the ISO to its lowest sensitivity and focus on the leaf. Before you shoot, press the Exposure Compensation button (+/-) and dial in a positive value of around +3. Now, using the self-timer, shoot and check the picture on screen. The leaf's background should be completely white, but if not, just increase Exposure Compensation until it is, making sure you don't over-expose the leaf.

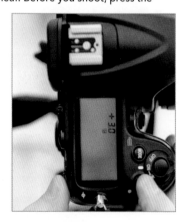

3 BOOST CONTRAST No matter how well you exposed and focused your leaf photo, it's worth checking the Levels in Photoshop to ensure all the details are clear and that there's plenty of contrast in the subject. Open your leaf image and then bring up the Layers palette on screen by going to Window>Layers. Click on the Create New Adjustment Layer icon and pick Levels from the list. Now press and hold the Alt key on the keyboard and drag the Black point slider to the right. You'll see nothing at first but eventually clipping warnings will appear on the screen. When you see black appearing leave the slider there (at about 120). Now Alt-drag the White point slider left in the same way, ensuring the background is perfectly white – about 228 was fine for our example shot.

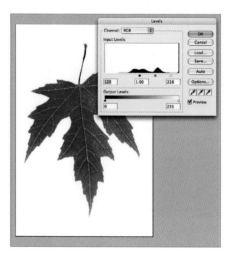

4 SHARPEN THE SHOT To improve the rendition of detail, click back on the Background Layer and go to Filter>Sharpen>Unsharp Mask (Enhance>Unsharp Mask… in later versions of Elements). For our image we used settings of Amount 150%, Radius 1.0px, Threshold 2 Levels. Click OK and then go to Layer>Flatten Image to finish.

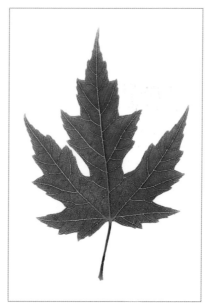

FINISH

5 WORK ON COMPOSITION To clean up the image for printing, first press Ctrl+J to copy the leaf pic to a new Layer, then press these keys again to make another copy. In the Layers palette you'll now have the Background Layer plus Layer 1 and Layer 1 copy. Press Ctrl+D to set the default colours and then click on the Background Layer in the Layers palette and press Ctrl+Alt+Backspace to fill it with White.

6 COPY AND ROTATE Hide the Layer 1 copy by clicking on the eye icon next to its thumbnail. Now click back on Layer 1, and while holding down the Ctrl and Shift keys, click and drag it to the left. Click the eye icon back on the Layer 1 copy to make it visible and also click on the Layer 1 copy to make it active. Now click where it says Normal and choose Darken as the Blending Mode. Go to Edit>Transform> Rotate 180° (Image> Rotate>180° in Elements), and then press Ctrl+Shift once more before dragging the leaf right so it nicely complements the one on the other side.
Once you're happy with the composition, go to Layer>Flatten Image and Save.

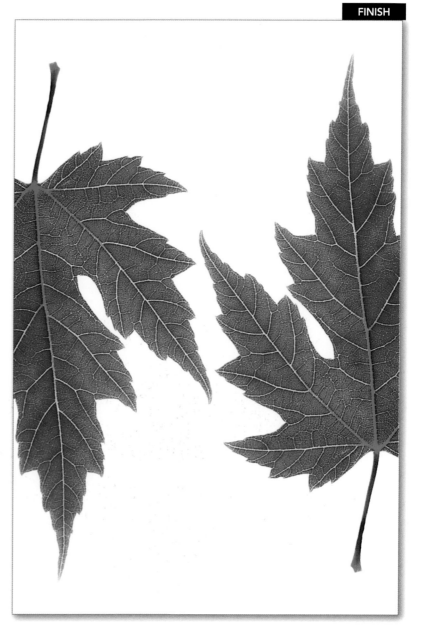

THE SET-UP

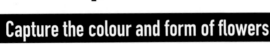

Shoot flower portraits

Capture the colour and form of flowers

WHAT YOU NEED
DSLR AND TRIPOD

WHAT YOU'LL LEARN
HOW TO SHOOT
FLOWER PORTRAITS

IF YOU'VE NEVER SHOT FLOWERS before, you're missing out. They're an excellent source of colour, texture and form for still life images, plus they don't move so you can take your time. You can keep them fresh in a vase of water throughout your shoot and they make excellent subjects for wall art.

This technique will quickly get you into the swing of shooting them. Success hinges on choosing the best flower specimen for the job: not every flower makes a good photo, no matter how pretty it might look to the eye. Choose simple, single-stalk cut-flower varieties such as this pink gerbera. Roses, daffodils and tulips are all great too. Avoid sprays and species with a tangle of stalks, petals, buds and leaves as they're more difficult to turn into a nice bold portrait.

With your single, tall-stem flower in a vase, it's time to look at it through the camera's viewfinder to find a composition that works. Start with one of the classic compositions shown here: shooting oblique across the petals (below left), from behind (below right) or straight on (bottom). These are tried and tested ideas and don't require a dedicated macro lens to achieve – all you need is a standard zoom lens.

Work slowly and methodically. Tiny adjustments to the camera position can make or break a shot, so expect to spend at least 10 minutes just tweaking the framing and position of the flower to catch the right light.

Also remember that the stem is just as important as the flower head, and needs to be positioned carefully in frame.

Set the camera on a tripod to hold it steady and, last but not least, select a coloured sheet of background card that suits the subject: we've outlined a few options below. Try to position it so it's far enough away to lie beyond depth of field.

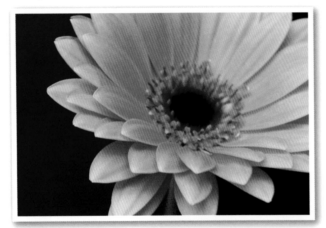

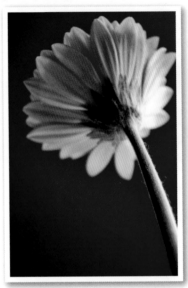

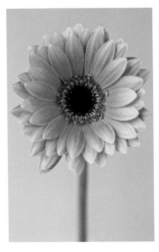

CHOOSE YOUR BACKGROUND
For a fresh and clutter-free image you'll need a simple backdrop. Our preferred option is coloured A4 card or mountboard as it's cheap and can be tailored to match your décor. Visit your local art shop and buy a selection of vibrant and contemporary colours. Simply hold these behind your flower to quickly ascertain which work and which don't. Try colours and tones that create an attractive contrast for a range of different effects.

1 SET YOUR CAMERA on a tripod and zoom all the way in with your standard zoom lens – this will usually be between 50mm and 70mm. Carefully frame up your shot.

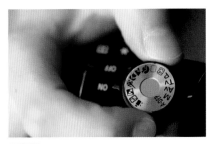

2 SELECT APERTURE-PRIORITY (A or Av). This allows you to control the sharpness of the stem and background. For now, choose a fairly wide setting of f/5.6.

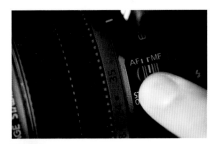

3 SWITCH TO MANUAL FOCUS Focus manually on the nearest petal or on the centre of the flower. If you have Live View, use it to check your focus.

4 SET YOUR SELF TIMER Choose a 2-second delay on your self-timer so you can take a shot without touching the camera. If you have a remote control handset to trigger the shutter, use this instead.

5 HOLD THE CARD IN PLACE Use a clamp or pegs to hold your coloured card backdrop behind your subject. Position it a good distance behind but make sure it fills the entire viewfinder so you can't see its edges.

6 SET THE WHITE BALANCE If using cool window light, choose Cloudy to warm it up it a little. Choose the lowest ISO setting possible – ISO 100 or 200 will be perfect for low noise and fine image detail.

PICK A PERFECT BLOOM
Gerberas look fabulous from every angle and are available in loads of vibrant colours. When you're shopping at your local florist or supermarket, make sure you pick out the best bloom.

FINISH

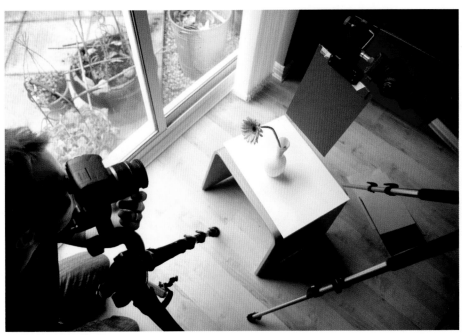

A vase with a little water in will keep your flower in place and stop it wilting during the shoot. Also, try to angle it towards the window light, to avoid strong shadows and ensure a bright backdrop.

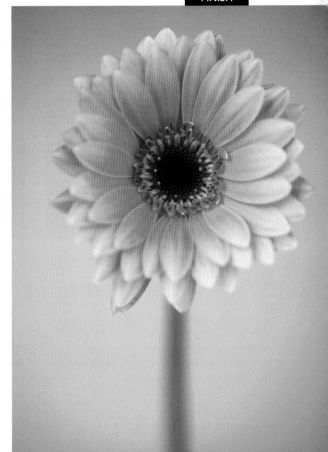

Shoot smoke patterns

Create smoke patterns for stunning abstracts

SHOOTING STILL LIFES OFFERS a great chance to indulge your creative side. They don't need to be complicated, though: all you need for this project is a humble incense stick, a glass to put it in and an angle-poise lamp or torch to light it.

Plumes of smoke might not sound like the most exciting subjects, but use an angle-poise lamp to light its ethereal trails, experiment with some manual camera settings and different colour effects in Photoshop, and you'll end up with some very arty, abstract images. No two images will look the same – making this one of the most unique and easy subjects you can tackle with your camera.

You don't need lots of complex camera gear for the project either: assemble the items in our set-up picture below and you'll be ready to shoot in minutes.

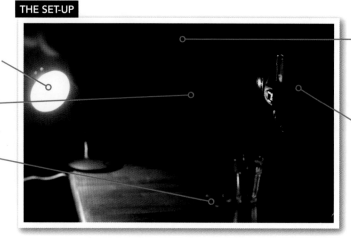

THE SET-UP

DESK LAMP
To backlight the smoke effectively, the lighting needs to be directional.

SMOKE
Set a match to the joss stick tip and the smoke will gently rise upwards.

GLASS & MAT
Rest the joss stick in a glass and place a non-flammable mat or ashtray underneath to collect the ash.

BACKGROUND
Choose a dark background – black cloth or card will do the trick.

CAMERA & TRIPOD
Set your camera to Manual exposure mode and manual focus, then place on a sturdy tripod.

1 PLACE YOUR INCENSE STICK in a glass or jar so it rests at an angle. Sit the glass in front of a black backdrop – a cloth or card will be fine – then light the joss stick. Now set up an angle-poise desk lamp to one side so it picks out and highlights the smoke. Be careful not to let the light flood onto the backdrop otherwise this will ruin the effect. Focus the lens manually on the smoke to prevent the AF hunting for it in the low-light conditions.

2 SHOOT RAW AND SET EXPOSURE
We're shooting RAW files for this project. With the exposure dial set to Manual, we used 1/40sec at f/3.2 with an ISO of 400, but this will vary depending on your lighting. Experiment with your exposure, checking results on the LCD screen, but don't let your shutter speed drop too slow or the smoke will have no crisp edges. As the incense stick burns, fire off lots of different compositions to get a good selection.

3 OPEN THE FIRST IMAGE Open up your RAW file (call it "Smoke 1"). We're using Adobe Camera RAW 4.3, where you click on the Basic tab (or Adjust) to make adjustments. Our file is looking quite flat, so set the Exposure slider to +1.50 and increase the Blacks (or Shadow) slider to 12. Leave Brightness but boost Contrast to +45. If you have Clarity and Vibrance (CS3 only), increase both to 30. Finally, increase Saturation to +23. Now Open Image (Open>OK).

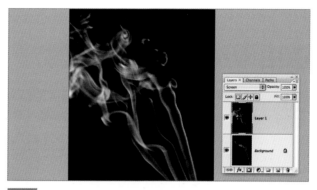

4 BOOST LEVELS Go to Image>Adjust>Levels and in the Levels palette, drag the right-hand slider left until it drops from 255 to 200, then hit OK. Now open the second RAW image (call it "Smoke 2") and input the same settings as in Step 3. This time, adjust the Temperature to read 2750 and the Tint to +7, then open the image as before.

5 BLEND LAYERS TOGETHER Bring up the Levels palette (Image>Adjust>Levels) to adjust the sliders and hit OK. Now press Ctrl+A to select all, Ctrl+C to copy and then click back on "Smoke 1". Hit Ctrl+V to paste in "Smoke 2" and then hit F7 to bring up your Layers palette. Finally, change the Blending Mode of Layer 1 from Normal to Screen.

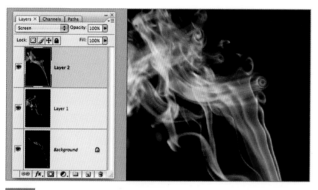

6 ADD A LAYER MASK Now open your "Smoke 3" RAW file and apply the same adjustments as before, except Temperature and Tint – change these to 7500 and -7, then hit Open Image. Apply the Levels as before, then copy and paste as we did with "Smoke 2", and change the Blending Mode to Screen. With Layer 2 selected, click on the Add Layer Mask icon.

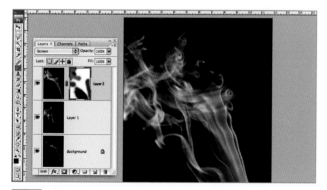

7 MASK AREA. Hit D to select Black as your foreground colour and choose a Brush size of 500px, with an Opacity of 75%. Now brush into the top-left. As the new Layer is quite dominant at the moment, this will help to ease it back. Next, brush in the bottom-right to darken that area, too. If you want to rotate your image, go to Image>Rotate Canvas>90 CW and then Layer>Flatten Image. Now Save.

FINISH

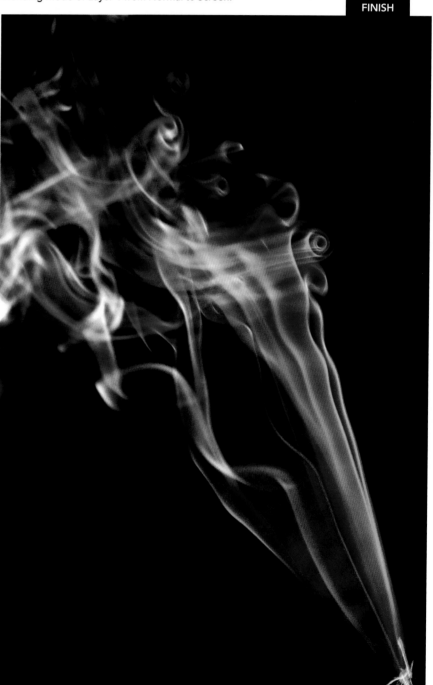

START

Add drama to static shots

Create dirt, dust and drama in Photoshop

WHAT YOU NEED
PHOTOSHOP OR
ELEMENTS

WHAT YOU'LL LEARN
HOW TO ADD
MOVEMENT BLUR

IN THIS ADVANCED PHOTOSHOP TUTORIAL, we're going to show you how to add a sense of movement and drama to an otherwise static shot.

Though our image, above right, is nicely lit and well composed with a dynamic angle, it's still lacking in energy. We can improve this by making the subject look as though it's travelling at speed, using a few simple tricks in Photoshop.

First we're going to blur the background and make the wheels look as though they're spinning. To finish off, we'll make it look as though the car is kicking out a lot of dust on the dirt track, too.

To get started, we've made a precise Selection of our vehicle which may take some time and patience. After that you can just get stuck in adding the creative effects.

1 MAKE SELECTION Open up your vehicle image and bring up the Layers palette (hit F7 as a shortcut). Make a neat and precise Selection of the vehicle using the Polygonal Lasso tool from the toolbox, entering a Feather Radius of 1px and hit OK. You should now have "marching ants" running round the car. Hit Ctrl+C to copy the Selection to the clipboard and then Ctrl+D to deselect.

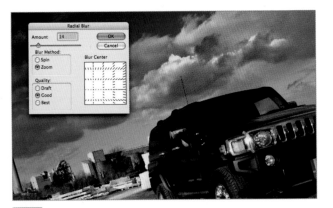

2 ZOOM BLUR Go to Filter>Blur>Radial Blur and in the pop-up box set Amount to 14, Blur Method to Zoom. Position the Blur Center left and down from the centre, then hit OK. With the blur complete, hit Ctrl+V to paste in the vehicle Selection. Use the Move tool to position it. Hit Ctrl+T and, while holding down Shift, pull the top right-hand corner outwards until it covers the blur of the car underneath. Hit return.

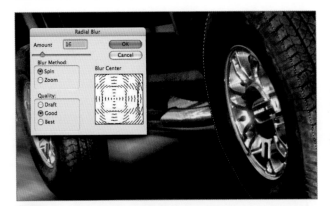

3 ADD MOTION TO WHEELS Select the Polygonal Lasso tool and click around the front wheel's rim. Feather by 5px. Go to Filter>Blur>Radial Blur. In the pop-up box, set Amount to 16 and Blur Method to Spin. Set the Blur Center off to the left and hit OK. Hit Ctrl+D to deselect the "marching ants" and repeat the process on the other two wheels. Now return to the first wheel to make a Selection of the tread.

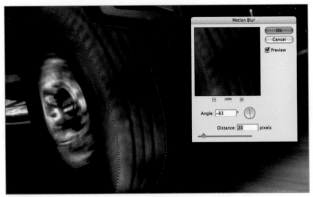

4 ADD TWO TYPES OF BLUR Use the Polygonal Lasso tool and Feather your Selection with a value of 5px as we did before and go to Filter>Blur>Gaussian Blur. Enter a value of 3.5px, then hit OK and go to Filter>Blur >Motion Blur. Set an Angle of -83° with a Distance of 20px and click on OK. Press Ctrl+D to remove the "marching ants" and repeat the blurring process on the other two visible wheels.

5 CREATE DUST Select the eyedropper to sample the dirt track. Go File>New>Create a new document (Width 2500px, Height 1750px). Set Resolution to 240, Background Contents White. Enter Quick Mask mode (Q) then go Filter>Render>Difference Clouds. Hit Q again to exit. Go Layer>New Layer, hit OK, select the Paint Bucket and fill the document. Drag the dust Layer onto the vehicle image.

6 POSITION LAYER Hit Ctrl+T to transform and rotate the Layer anti-clockwise, increasing it in size. Once in position, hit Enter and, at the bottom of the Layers palette, select the Add Layer Mask icon. With Black selected as the Foreground colour, select a 400px Brush with the Opacity set to 65%. Now brush into the Layer, removing the harsh transition at the edges.

7 BUILD UP DUST In the Layers palette, reduce the Opacity of the new Layer to 70%. We'll build up the dust, so bring in another dust Layer as before, rotate and stretch outwards. Like you did with the first dust Layer, add a Layer Mask and brush away the edges, reducing the Opacity of the Layer to 90%. Finally, drag another dust Layer across onto the image to add the finishing touches.

8 TOP LAYER OF DUST Make sure the new dust Layer sits at the top of the Layers stack. Transform, rotate again and scale so it covers the vehicle. Add a Layer Mask and increase Brush Opacity to 85%. Now brush over the top half of the vehicle as well as the edges of the Layer, leaving the bottom half and areas round the wheels unaffected.

FINISH

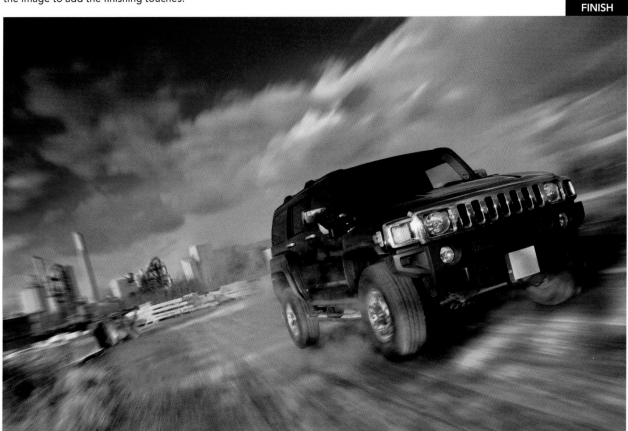

Present an image as a joiner

Joiners present an artistic way to show your work

WHAT YOU NEED
PHOTOSHOP OR
ELEMENTS

WHAT YOU'LL LEARN
HOW TO MAKE A
JOINER PICTURE

IT WAS PROBABLY DAVID HOCKNEY who first brought joiners into the public consciousness. His style of photographing a scene then splintering it into its constituent parts, some large, some small, some sharp, some less so, really caught the imagination by "breaking the rules".

The technique here is a sort of homage to Hockney's approach. Basically, you shoot a selection of photos showing just parts of the subject, often from slightly different angles, then combine them in presentation to make a single image.

This creates a unique and slightly skewed version of reality, disguising and distorting the subject's shape, a bit like an avant-garde cubist painting.

Making a joiner presents an intriguing view of the world, which should be more engaging to the viewer than a straight shot of the same subject.

Here we've used a bit of colour work in Photoshop to complete the look, so have a go with your own images and you'll be surprised by your results.

START IMAGES
By shooting your subject from slightly different angles
you'll have all you need to make a photo joiner.

1 SET UP THE BACKGROUND Before assembling your joiner images, you need to shoot or scan in a "Background" image on which to assemble them. We used a sheet of graph paper here, saved as a JPEG file. Open it, then open your first joiner image (call it "Joiner 1") and go to Select>All, then Edit>Copy. Close Joiner 1 down and, back on the Background JPEG, go to Edit>Paste.

2 RESIZE THE PHOTO Pick the Move tool, making sure Show Bounding Box is ticked in the Options bar. Click on one of the corners and drag inwards to shrink the photo. Make sure Constrain Proportions is ticked and reduce the image to 30%. Click the tick box once you've resized the photo, then click and drag the image to the top of the page. Go to Window>Layers and you'll see it sitting above the Background.

3 ADD MORE PHOTOS Now repeat steps 1 and 2 with the remaining joiner photos, but resize them to about 40%, before clicking and dragging on each to roughly arrange them on the page. Try to line up the central part of the scene, but don't worry too much about the smaller details. To help spread the photos around, see that Auto Select Layer is ticked in the Options bar.

4 SORT THE LAYERS Now we need to rearrange the order of the joiner photos. In the Layers palette, click and drag each image thumbnail up or down to change the order – those that are nearer the top of the stack will be more visible and cover up the others. Arrange the joiner photos so that the centre parts of the image are nearer the top of the Layers palette, while the outer parts are at the bottom.

5 BLUR THE OUTER IMAGES In the Layers palette, click on one of the outer photos' thumbnails (the bounding box will appear around it on the image), then hold Ctrl and click on its thumbnail again, so that "marching ants" appear all the way around its edge. Next go to Filter>Blur>Gaussian blur. Use a Radius of 6–10px and hit OK. Repeat this with all the other pics except those in the centre of the joiner.

6 ROTATE THE OUTER IMAGES Once you've blurred the last of the outer photos, go to Select>Deselect. Now, on the image itself, click on one of the outer photos to bring up the bounding box once more. Position your cursor just outside one of the corner handles and click and drag to rotate the photo slightly. A few degrees is fine and once it looks good, click the tick. Repeat this with a few of the other photos.

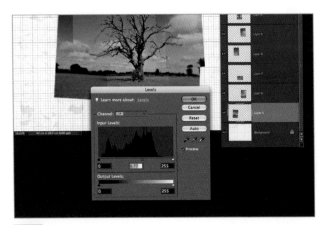

7 ALTER LIGHTING To draw even more attention to the centre, use the Move tool to click on one of the outer photos then press Ctrl+L. In the Levels palette, drag the Middle (Midtone or Gamma) slider right, then press OK to darken that part. Repeat this on the other outer images to create a vignette effect. Next, click the centre pics and press Ctrl+L, dragging the White Point sliders in a little, then press OK.

8 MERGE AND DUPLICATE. Once you're happy with the positioning of all the photos, click on the eye icon next to the Background Layer to make it invisible. Next go to Layer>Merge visible, then make the Background visible once more by clicking where the eye was. Using the Move tool once more, click and drag the corner handles of the merged Layer to resize it, making it a little larger in the frame.

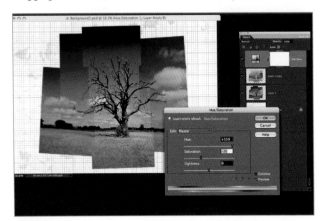

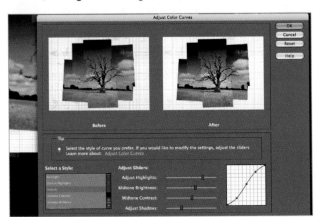

9 ADD A COLOUR TREATMENT Now go to Layer>New >Layer via Copy. Press Ctrl+I to invert the colours, and at the top of the Layers palette click where it says Normal and change the Blending Mode to Hue. Again in the Layers palette, click the Create Adjustment Layer icon and pick Hue/Saturation. Move the Hue slider to about +160 and Saturation to -30. Click OK.

10 ADD CONTRAST Go to Layer>Flatten Image, then Enhance>Adjust Color>Adjust Color Curves (Image> Adjustments>Curves in Photoshop). Push the Adjust Highlights slider to the right and the Adjust Shadows slider to the left, making an "S" curve. In Photoshop, just click and drag the Curve instead of using the sliders. Press OK, then go to Layer >Flatten Image. Now Save.

Make a triptych

Combine three images for bolder presentation

WHAT YOU NEED
PHOTOSHOP OR
ELEMENTS

WHAT YOU'LL LEARN
HOW TO COMPILE
A TRIPTYCH

CREATING A TRIPTYCH IMAGE is a great way to draw attention to the similarities between the subjects in your photographs. This three-picture framing device allows you to tell a story about a subject, perhaps showing it off from different angles.

You can make a set of triptych images from any subject – not just macro shots as we've done here. You can also use it retrospectively to group three pictures from a holiday, for instance, or three pictures showing different subjects linked by

the same theme, colour or shape. When shooting, you'll need to capture your subject from a variety of angles, but make sure there's at least some consistency between the shots – too much variation will make the images jostle for your attention and won't create a balanced, harmonious presentation.

In this technique we'll show you how to make your own A3 triptych template for printing out on an A3 photo printer, but you can easily make it A4. The three apertures can be easily modified to suit any size of photograph in your collection.

1 SHOOT YOUR IMAGES For a really cohesive set of images, shoot all three for the project at the same time. Because we were shooting a macro triptych, we locked off the camera on a tripod to hold it nice and steady, sliding the fob watch around to get lots of different angles. For an attractive warm-tone effect, either use an angle-poise desk lamp and set White Balance to "Daylight" or – for more control – use the Hue/Saturation sliders in Photoshop.

2 MAKE THE TEMPLATE Create a new blank A3 Photoshop document (File>New). Call it "Triptych" and select A3 file dimensions. To rotate it, go Image>Image Rotation 90°CW. Next, go to View>Show>Grid then pick the Rectangular Marquee tool to draw out three evenly spaced apertures as shown. Go Edit>Fill and click OK to fill each hole with your foreground colour (Hit D to get Black). Click Ctrl+D to deselect them. To hide the grid, go View>Show and untick Grid.

3 PASTE THE IMAGES INTO TEMPLATE Pick the Magic Wand tool and in the Options bar set Tolerance to 32, making sure New Selection, Contiguous and Anti-alias are selected. Click in the central black area to select it. Go Select Modify>Expand and use 1px. Now select and paste your first image (Select>All, Edit>Copy, Edit>Paste into). Tap Ctrl+T and use the corner handles to resize and rotate it. Click the tick.

4 ADD MORE PICTURES Elements users will need to press Ctrl+D to Deselect, but remember, you won't be able to change the position after Deselecting. In Photoshop, go to Window>Layers, click on the Layer you want to change and use the Move tool to alter it. To add more pictures, click on the Background Layer and use the Magic Wand as in step 2 to add your next two images. Go File>Save to save the triptych.

7 RAW IMAGING ADVICE

IF YOU'VE BEEN HAPPILY CAPTURING images in the universal JPEG file format, you may be wondering what's the point in switching to RAW. JPEGs allow you to view, edit and share your images easily, so why bother changing? The answer is simple – quality and control.

Although the term RAW looks like a clever acronym, it's not; it's exactly what the name suggests – raw picture information recorded by your camera's sensor at the time of capture. When shooting RAW images, the picture information is written to a memory card without any adjustments being applied by your camera's image processor. When JPEG files are written to a memory card, a whole series of automatic adjustments are applied in a split second, such as changing the exposure, altering the saturation or adding some sharpening. The camera then discards the information it considers no longer required. With JPEGs, therefore, you end up with a smaller, compressed image file that doesn't contain the same amount of depth or detail as a RAW file.

Through the RAW conversion process you have control over an array of variables, such as the exposure, white balance and saturation, to name just a few, allowing you to develop your images in the way you choose, rather than leaving it up to your camera's circuit boards.

All RAW editing is non-destructive, too, so any adjustments you make won't adversely affect the integrity of the pixels. Instead, adjustments simply determine how the data contained within them is interpreted and ultimately displayed. So, if you're not happy with the changes, simply hit Reset and you'll revert to the original image as recorded on the sensor.

RAW files take up more space on your memory card but this doesn't mean they have a higher resolution (more pixels) than a high quality JPEG. RAW files are larger because the picture data is unprocessed and uncompressed, and it's this that gives them the edge, allowing you to coax out the best result from every shot you take without ever having to compromise quality.

What is RAW?

Understand how shooting RAW can help you improve

WHAT YOU NEED
PHOTOSHOP OR
ELEMENTS

WHAT YOU'LL LEARN
THE ADVANTAGES
OF RAW CAPTURE

IF YOU'VE NO IDEA WHAT RAW IS, or what it means for your photography, then this section is just for you. RAW is not some sort of clever acronym – it's just a generic term for a file that contains the raw data from a camera's sensor. Every camera shoots RAWs, but most of them then convert, process, compress and package the information recorded into a standard JPEG file.

All digital SLRs and many high-end compacts now have the option to record and output the RAW file itself, and that means all the processing formerly performed inside the camera can now be done by you on the computer. At first glance, this sounds like a chore that's simply creating extra work for photographers, but when you take a look at all the decisions that are made in the processing of a RAW file, you'll definitely want to be involved! If we mention things like colour temperature, contrast, shadow depth, highlight brightness, saturation, sharpening, and even the exposure itself, then you may well recognise that it'd be handy to be able to control and fine-tune these fundamental building blocks of a picture.

TAKE CONTROL
All the settings above, and plenty more besides, aren't "fixed" in a RAW file, like they are in a JPEG. They're actually "floating" values in a RAW and can be altered, adjusted and tweaked to allow you to get the very best out of the shot you've taken.

It takes a while to get your head around the concept, but a RAW file is a bit like a digital version of an old negative – it's not the picture itself, but it contains all the information you need to make the picture.

All you have to do is extract that information and adjust it to create the kind of picture you wanted when you pressed the shutter. These adjustments take place in special RAW conversion software, and this is where you turn your RAW file into a normal image file format like a JPEG or a TIFF. Photoshop (CS and higher) and Elements (3 and higher) feature the Adobe Camera RAW plug-in, which we'll refer to in this guide.

RAW V JPEG
Shooting in JPEG may seem like the easiest and quickest route to great pictures, but shooting in RAW can be incredibly powerful and produces the ultimate in quality.

If you've been used to a digital compact camera in the past, then all your pictures have more than likely been shot in JPEG as it's the default (and in many cases, the only) file format available to some cameras. And it's probably never been an issue as pictures can be loaded onto your PC without any hassle, and then easily viewed and shared between friends and family. So why change that when you upgrade to a DSLR?

When you shoot in JPEG, a series of adjustments are applied to the image in an instant via the camera's built-in image processor at the time of capture. These adjustments include a range of variables, such as Exposure, White Balance, Saturation and Sharpness, and the end result is a decent enough compromise giving an acceptable shot.

But as well as the option of shooting in JPEG, every DSLR can record your pictures in what's known as a RAW file format. A RAW file is exactly what its name suggests – it's an image in its purest state before any image processing has been applied. It's exactly how the camera's sensor recorded the raw data of the scene at the time of image capture.

EXPERT ADVICE

SET UP AND SHOOT FOR RAW

To capture an image in RAW the first thing you need to do is make sure the Image Quality option on your camera is set correctly. On most cameras this can be done via an image quality button on the body, or on some models you'll need to access it via the main shooting menu.

A good tip for shooting RAW, which makes the conversion process easier, is to activate your camera's highlight clipping warning. Then, after each shot, quickly check your LCD screen and make sure you haven't blown too many highlights. With the

warning activated, blown highlights will flash black and white to show pixels that have been recorded in pure white and have no detail.

If large sections are flashing then you may not be able to recover the highlight detail during the RAW conversion process, so when shooting, it's better to slightly under-expose if necessary, and make sure you keep detail in those highlights.

Blocked out shadow detail will often be the result, but this is relatively easy to bring back once you're in front of your computer.

Activate the highlight clipping warning on your LCD screen and make sure your exposures don't blow out the highlight detail.

Set up your camera to shoot RAW in the Image Quality menu.

REASONS TO USE RAW

So why would you want to shoot in RAW when a JPEG file has been automatically adjusted for you and appears spot-on, straight out of the camera? The answer is simple – control.

Whereas your camera's image processor has made a series of decisions in a split second to adjust the image, a RAW file allows you to take charge of the image, have complete control over the look of the shot and make a broad range of adjustments in a much more considered manner via your computer. In a sense, a JPEG is like a standard machine print – it's the final so-so outcome, while a RAW file is like a negative – it's the starting point of the creative process, and allows you to achieve much more using your skill and judgement.

When you find out what you can control in a RAW file, you'll never want to shoot JPEGs again. With a RAW file, you have control over a host of variables. We've already mentioned Exposure, White Balance, Saturation and Sharpness, but there's also Contrast, Highlight detail and Shadow depth, and in some instances, you can even control noise, Chromatic Aberration (fringeing) and vignetting. And because the latitude of a RAW file is a lot better than a JPEG file, it can be pushed more, allowing you to darken or lighten areas quite dramatically and still maintain detail. Though there's a bit more effort required when converting RAWs, the rewards will justify that extra dedication.

SHOOTING IN RAW

To take a shot in RAW, the first thing to do is change the Quality setting on your DSLR from JPEG to RAW. This is easily done in your camera's menu, and then you take shots as normal! Once you're back in the warm, fire up your computer and you can begin to convert your RAW files.

If you've got a copy of Elements (Version 4 or above) or Photoshop (CS and above), they both feature a RAW converter called Adobe Camera RAW (ACR), and this will automatically launch when you open a RAW file. There are other specific RAW converter programs available, and some DSLRs are also supplied with their own software, but ACR has the broadest appeal and is one of the easiest to use.

INTERFACE TABS

So how do you start converting your RAW files? Once you've transferred your files from card to computer, you can get started straightaway. Double-click on your RAW file and Elements/Photoshop will automatically launch the ACR interface, from which you can make a wide range of adjustments.

If you're using Photoshop, there can be up to eight different Tabs depending on which version you've got, while Elements will have between two or three tabs available, again depending on the version.

Though the full version of Photoshop offers a greater breadth of adjustments with its additional Tabs, it's the core Basic tab (known as Adjust in earlier versions) that it shares with Elements. And this Basic Tab is the one we're really interested in, as it's where we can make the most dramatic changes to an image.

ADVANTAGES OF RAW OVER JPEG

These two identical images show the power of shooting in RAW. The image below is a JPEG straight out of the camera. As you can see, though it's perfectly adequate, it looks fairly flat and cold, lacking impact. With the RAW file (bottom), we can make a series of adjustments and improvements to dramatically improve the file and give a more satisfying result.

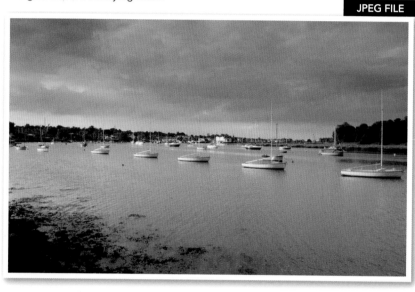

JPEG FILE

WHITE BALANCE
Colour temperature has been increased to warm up the shot.

DARKEN SKY
RAW files can be pushed more than JPEG files, allowing you to darken the sky and enhance the mood of the shot.

EXPOSURE
Overall exposure has been tweaked to give the look and feel of the scene we observed rather than the one the camera took.

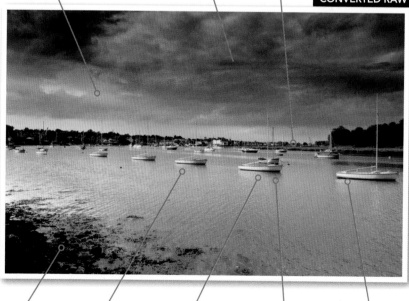

CONVERTED RAW

SHADOWS
Blocked out shadow detail has been restored in the RAW.

SATURATION
The colour in the image has been given a boost, with more vibrancy.

CONTRAST
We've been able to boost the contrast to give the shot a bit more "bite", without sacrificing quality.

HIGHLIGHTS
The in-camera JPEG had blown highlight detail, we've brought it back with the RAW file.

SHARPENING
We've been able to control the amount of sharpness that's been applied to the image.

Using Adobe Camera RAW

Get to know the Adobe Camera RAW interface

ALTHOUGH INITIALLY THE CAMERA RAW interface may seem daunting, once you're familiar with it you'll find it as easy-to-use as any other palette in Photoshop.

With a vast array of sliders, icons, buttons and features on show when you first open the Adobe Camera RAW (ACR) interface it can seem like a whole new world of image-editing. Depending which version of Photoshop and Camera Raw you're using, there can be up to nine tabs to access the adjustment sliders and controls, in addition to the tools available in the toolbar, the Image Histogram, Metadata information, as well as the ability to configure your preferences and workflow options. If you've just started to grapple with the intricacies of RAW conversion all this functionality can seem a little daunting and scary. Don't panic though, the ACR interface has a logical and intuitive layout and really is just as easy-to-use as any other palette in Photoshop, and once you've spent a bit of time with it you'll find it as familiar as an old friend!

To get you up and running, here's a guided tour of the controls and sliders under the Basic tab.

IMAGE ADJUSTMENT TABS
For ease of navigation the Adobe Camera RAW adjustment sliders are grouped into different tabs with the most dramatic and regularly used controls located under the Basic tab.

RGB VALUES
Hover the cursor over your Image Preview and the RGB (Red, Green and Blue) colour numbers that make up each pixel will be displayed – handy for checking you've maintained detail in very precise areas.

TOOLBAR
Provides access to a range of adjustments such as the White Balance and Crop tools as well as icons for navigating or rotating the image preview and setting up the Camera RAW preferences.

IMAGE PREVIEW
Changes as you adjust the sliders and displays how the image will look once opened into Photoshop.

FILMSTRIP
Open multiple RAW files and their thumbnails will appear here for easy access.

SAVE IMAGE
Save another version of the image in formats such as .PSD or .JPEG without having to open the shot. Elements users note: this option will only allow you to save in Adobe's Digital Negative format .DNG.

VIEW CONTROLS
Quickly and easily zoom in and out of the Image Preview without having to select the Zoom tool.

WORKFLOW OPTIONS
Configure preferences such as Colour Space, Bit-Depth and Resolution as well as enable Smart Objects.

PREVIEW BOX
Make sure the Preview box is ticked so the Image Preview changes when you move the adjustment sliders.

HISTOGRAM
Displays graphically how each of the pixels within the RAW file are distributed across the tonal range with the darker tones mapped on the left, midtones in the middle and lighter shades on the right.

CLIPPING WARNINGS
Click the upward arrows in the histogram box to display warnings on the Image Preview where data is lost, or "clipped". Blocks of blue are displayed where the shadows have been clipped, and blocks of pure red indicate where the highlights have been "blown".

METADATA
Some of the most basic camera settings such as aperture, shutter speed, lens and focal length are displayed here.

TEMPERATURE AND WHITE BALANCE
White Balance can be adjusted by selecting one of the Presets under the drop-down menu, or by adjusting the Temperature slider to warm up or cool down the shot. Use the Tint slider to compensate for any magenta or green colour casts.

AUTO/DEFAULT
For quick and easy conversions simply hit Auto for ACR's best guess at a conversion and, if you don't like what it comes up with, hit Default to revert to the settings you started out with.

EXPOSURE
With an exposure latitude of 8 stops (-4 to +4) RAW files provide a lot of scope for fine-tuning how bright or dark you want your shot to be.

RECOVERY
If you've got burnt-out highlights, the Recovery slider will help restore some of that must-have detail in the lighter tones.

FILL LIGHT
If the shadow areas are becoming blocked out, the Fill Light slider will boost the luminance in the darker tonal regions.

BLACKS
Also called Shadows in earlier versions of Adobe Camera RAW, increasing this slider will darken the pixels at the shadow end of the tonal register.

BRIGHTNESS
Increase the overall luminance of an image using the Brightness slider.

VIBRANCE
Boosts the colour saturation of non-saturated image colours.

SATURATION
Boosts colour saturation globally, but use with caution to avoid an unnatural-looking finish.

OPEN IMAGE
Once you're happy with adjustments hit the Open Image button to open the file in Photoshop.

CLARITY
This slider will add more depth to the midtone range to boost the clarity and definition of an image.

CONTRAST
To boost the contrast, this slider darkens the shadows and lightens the highlights for a punchier image.

Interface labels visible in the screenshot:

EOS 5D Mark II
Preview
R: ---
G: ---
B: ---
f/22 1/15 s
ISO 100 17-40@40 mm
Basic
White Balance: Custom
Temperature 6150
Tint +17
Auto Default
Exposure +0.50
Recovery 20
Fill Light 10
Blacks 10
Brightness +50
Contrast +25
Clarity 0
Vibrance +5
Saturation +5
(21.0MP); 240 ppi
Image 1/2
Open Image Cancel Done

Basic RAW conversion

Learn how to bring a basic RAW file to life

WHAT YOU NEED
PHOTOSHOP OR
ELEMENTS

WHAT YOU'LL LEARN
HOW TO MAKE A BASIC
RAW CONVERSION

SOME OF THE MOST DRAMATIC CHANGES that can be applied to the unprocessed image data contained in a RAW file are made within the Basic tab of Adobe's Camera RAW plug-in. Using the Adjustment sliders you have the ability to manipulate colour, exposure, contrast and saturation with editing that's completely non-destructive. If you're unhappy with your adjustments, you can easily revert to the original "as shot" image whenever you like. Below we're concentrating on the Adjustment sliders within the Basic tab, as well as some of the tools in the toolbar, to demonstrate how relatively minor alterations can have a dramatic impact on the final image. First, using the Crop and Straighten tools we'll recompose the shot. This may seem an odd place to start, but there's no point making adjustments to areas we don't want: by cropping them out first we ensure those unwanted pixels don't influence the other adjustments we make. Next we'll look at changing the Colour Temperature using the White Balance controls to warm up the image, a process which generally makes images more appealing. Then the main conversion adjustments revolve around fine-tuning the exposure. While keeping a close eye on the image histogram, and activating the clipping warnings, we'll use the Exposure, Recovery, Fill Light, Blacks and Contrast sliders to alter exposure, boost contrast and create a much punchier-looking image. To finish off, we'll boost the colour saturation and increase midtone contrast with the Clarity, Vibrancy and Saturation sliders.

1 OPEN A RAW FILE Open a suitable RAW file into either Elements or the full version of Photoshop. Our example image has a flat horizon and quite a cool range of colours to adjust. Now click and hold down your mouse button on the Crop tool icon, which is located within the toolbar at the top left-hand corner of the Camera RAW screen, and then select 2 to 3 from the fly-out menu.

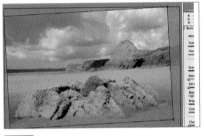

2 STRAIGHTEN AND CROP Next click on the Straighten tool in the toolbar, or just press A on the keyboard. By clicking and holding down your left mouse button, drag a line along the horizon (here, extending that straight line along the base of the cliffs) then release the mouse. Now click and hold in the Crop box and move it left until the edge of the Crop box meets the edge of the frame.

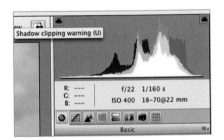

3 ACTIVATE CLIPPING WARNING Before making tonal or colour adjustments, activate the histogram clipping warnings to flag up areas where you're losing detail. To do this, simply click on the upward facing arrows in the top-right and top-left corner of the histogram display. You'll know the clipping warnings are active when a thin white border appears around each of the arrow boxes.

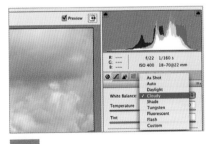

4 ADJUST WHITE BALANCE Now the image is cropped and warnings activated, turn your attention to the main tonal and colour adjustments. To warm up the image, make sure the Basic tab is selected on the right-hand side of the dialogue box. Under the White Balance menu click in the box where it currently reads "As Shot" and select "Cloudy" from the drop-down menu.

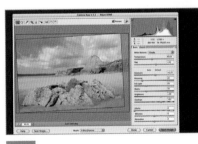

5 ADJUST TONAL RANGE Use the Adjustment sliders under the second section of the Basic tab to adjust the tones within the image. Click and drag the Adjustment sliders to increase Exposure to +0.25, Recovery to 20, Fill Light to 30 and Blacks to 30. Leave the Brightness slider set to its default value of +50 but boost the Contrast to +50.

6 ADJUST COLOUR SATURATION Now use the three sliders at the bottom of the Basic tab to boost the colour and midtone contrast by increasing Clarity to +50, Vibrancy to +10 and Saturation to +10. Finally, once you're happy with all your adjustments, just hit Open Image to launch the converted RAW file into Photoshop's main image-editing area.

BRING IMAGES TO LIFE
Here our "before" image looks flat, cold and wonky. A few basic adjustments using the RAW conversion software in Photoshop have redeemed the exposure and colour, as well as straightening the horizon.

BATCH PROCESSING

Lovingly converting each of your RAW files is a rewarding process as you watch your initial image take on a new lease of life. However, if you've got tens, or even hundreds, of RAW files to convert, it can also be time-consuming. Fortunately a handy little feature exists to speed up the process and banish any dull repetition of the same task: it's known as "batch processing".

If you've got several images from a shoot that need the same RAW settings applied, it's possible to make one single conversion and then apply those same settings to as many RAW files as you like. This can be done in either Elements or the full version of Photoshop.

Check out our RAW batch processing step-by-step project below, which demonstrates how to quickly adjust the exposure and saturation on a series of images shot in the same light, and then you'll be able to make a speedy job with multiple files in the future.

1 CONVERT ONE IMAGE Open a RAW file (File>Open) in Elements or the full version of Photoshop to launch Camera Raw. Convert the RAW file in the most appropriate way, in our conversion we've increased the Exposure to +1.00, Recovery to 50 and Fill Light to 25, and then hit Done to save your conversion settings.

2 BATCH CONVERT IN PHOTOSHOP If you're using the full version of Photoshop it's easy to apply the conversion in Bridge. Go to File>Browse in Bridge and navigate to the files you want to apply the conversion to. Now simply highlight the RAW files to be converted (Ctrl+click) and then go to Edit>Develop Settings>Previous Conversion.

3 BATCH CONVERT IN ELEMENTS In Elements, open all the RAW files you want to convert and hit the Select All button in the Filmstrip. Click on the down arrow in the right-hand corner of the Basic tab and from the fly-out menu select Previous Conversion. Now all you need to do is hit Done for the settings to be applied to all the shots.

Convert to mono with RAW

Use the HSL/Grayscale tab for RAW to mono

WHAT YOU NEED
PHOTOSHOP OR
ELEMENTS

WHAT YOU'LL LEARN
HOW TO CONVERT
RAWS TO MONO

IF YOU'VE GOT AN IMAGE that you think will work better in black and white, it's worth taking a look at the stunning results you can achieve direct from RAW.

While boosting colours on bright and vivid images looks great on some shots, you'll no doubt have other files in your collection that'll work better in black and white. If so, the Adobe Camera RAW HSL/Grayscale tab is an excellent tool for making mono conversions, because it provides lots of control to determine at which end of the tonal register the different colours are placed.

1 OPEN AND CROP Open a suitable RAW file, click and hold on the Crop tool in the toolbar and select 2 to 3 from the fly-out menu. In our image we wanted to include the fluffy white cloud at the top centre of the frame, so we clicked and dragged the crop out towards the top-left of the frame, also ensuring the crop included the large rocks at the bottom in the foreground.

2 ADJUST THE EXPOSURE Improve the contrast of the image globally by increasing Exposure to +0.25 and Blacks to 12. A good tip to ensure you don't lose shadow or highlight detail is to hold down the Alt key while adjusting the sliders, then any tones that become clipped will be highlighted in the image preview. Now move the Clarity slider to +50 and improve the definition in the midtone region.

3 CONVERT TO MONO Next click on the HSL/Grayscale tab and tick the Convert to Grayscale box at the top of the tab. This will convert the image to mono, giving a similar finish to removing all the colour using the Saturation slider. Here we moved the Oranges slider to -88 to darken some of the pebbles and increased the Yellows slider to +100 to lighten the tones in the sand.

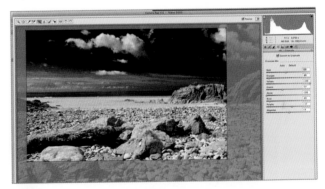

4 CONVERT THE SKY Now set the Blues slider to -85 to really darken the sky, making any white, fluffy clouds stand out. We also set the Aquas slider to -100 which darkened the sky just above the horizon. We left the Reds, Greens, Purples and Magentas sliders to the default values as these have little impact on the conversion. Finally hit Done to save your adjustments.

GRAYSCALE MIX SLIDERS

Once you've converted to mono, by simply ticking the Convert to Mono box at the top of the HSL/Grayscale tab, you can use the Grayscale Mix sliders to lighten or darken areas of the image based on colour. So, for example, by shifting the Blues and Aquas sliders in our beach shot to the left (and into negative values) the blues of the sky start to turn black because we're moving the blue tones to the darker end of the tonal register in our mono conversion.

Conversely, by shifting the Yellows Grayscale Mix slider to the right, we move the yellow tones of the sand to the lighter tonal region which makes them appear whiter. This has the effect of really boosting the contrast in mono conversions and means we can produce much punchier-looking pics without having to make any selective Levels or Curves adjustments later in Photoshop.

There's no exact science to using the Grayscale Mix sliders – each conversion will differ depending on the colours in the RAW file. You'll soon get the hang of how darkening and lightening tones can boost contrast for a better mono result.

If you're using Elements to convert your RAW files you won't have access to the HSL/Grayscale tab. The only mono conversion option you have is to desaturate the file by moving the Basic tab's Saturation slider all the way over to the left.

This will convert the image to black and white, but you'll need to increase contrast selectively across the image using Selections and Levels once the converted file is opened into the main editing area, or you'll end up with a pretty flat mono shot – and no one wants that!

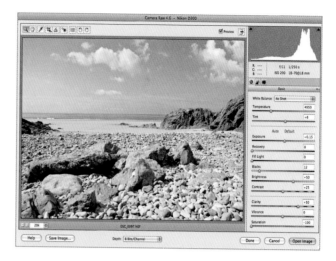

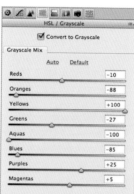

HOW THE CAMERA RAW PACKAGES DIFFER

If you're using Photoshop Elements (shown above) you can make a basic mono conversion by setting the Saturation slider under the Basic tab to -100. In the full version of Photoshop (shown left) use the Grayscale Mix sliders under the HSL/Grayscale tab to make more advanced mono conversions.

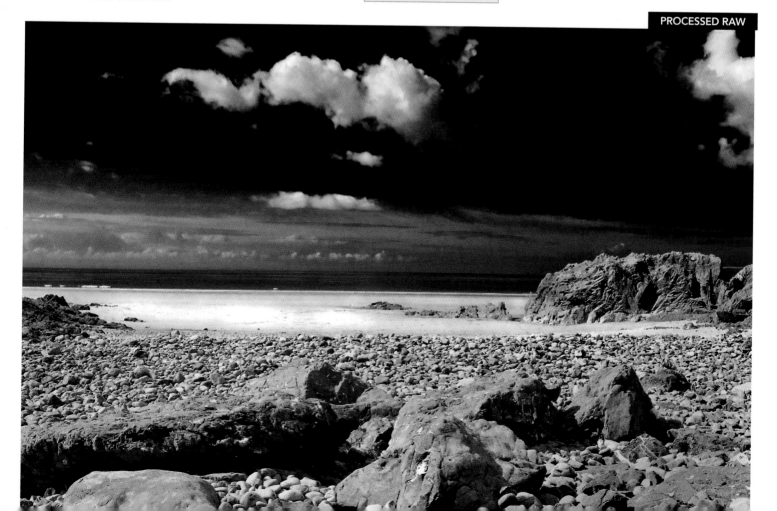

PROCESSED RAW

Split RAW conversions – the basics

Balance exposure by making two conversions, then merging them again

WE'VE ALREADY SHOWN HOW CONVERTING the unprocessed data in a RAW file means you can push adjustments much harder without compromising quality. We also revealed that the Adobe Camera RAW interface is as intuitive to use as any other palette in Photoshop.

Hopefully, by now you've caught the RAW bug, made sure that your camera's Image Quality is always set to RAW, and have started to capture pictures in the file format that affords you the best quality and gives the greatest amount of control.

We're now going to get you up and running with some great projects and techniques to show how RAW has revolutionized the way we tackle problems of exposure. This is really significant because it changes the way you shoot as well as making your photographic life much easier.

EXPOSURE DILEMMA

Picture the scene: a stunning vista with an interesting foreground and an atmospheric sky – sounds perfect for a landscape shot – but there's a problem. When you take a meter reading, the sky is several stops brighter than the land, and to retain that must-have detail in both the brightest highlights and darkest shadows is a real challenge.

The human eye can quickly adjust to these extremes of brightness, but your camera can't and needs to be set up specifically to capture detail in each area.

This is nothing new and has long been a photographic exposure dilemma that, until now, has been solved using graduated Neutral Density (ND) filters to balance the exposure between the darkest and brightest areas. Filters can be fiddly and expensive, not to mention being an additional load of kit to cart around, but thankfully a much easier solution has come to the rescue in the form of RAW.

When shooting in RAW none of the original picture information is discarded, and that means each file has greater exposure latitude making it possible to make two different conversions – one that retains detail in the highlights and another that retains detail in the shadows.

COMBINE THE SHOTS

With these separate conversions open in the main image-editing area of Photoshop all you need to do is combine them to create a single cracking shot. This may sound like a tall order, but it's really very simple to do.

All you need to do is stack the two conversions in Photoshop's Layers palette and then erase away pixels from the top Layer to bring through detail from the Layer beneath.

This technique will work in either Elements or the full version of Photoshop, although a more advanced, non-destructive, method for those with the full version of Photoshop would be to use a Layer Mask to hide sections of the top Layer to reveal the detail beneath – instead of erasing them forever.

The erasing method works just as well, though, so follow our split RAW step-by-step project below to get you started. You'll soon be defying the traditional problems of exposure control by making stunning split RAW conversions.

GOODBYE GRADS
Combining RAW conversions does away with the need for fiddly filters when you want to balance the exposure across a bright sky and a dark foreground.

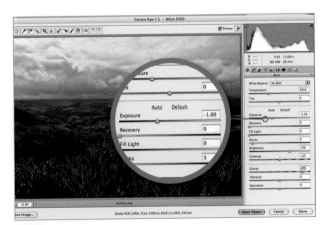

1 CONVERT THE SKY Open a suitable RAW file into Photoshop or Elements. You just need an image where either the sky has blown out or the landscape detail blocked in. First convert the sky by reducing the Exposure slider to –1.00 and increasing the Clarity slider to +75. Hit Open Image to launch the file into Photoshop or Elements and then go to File >Save As... and save this conversion as "sky.psd".

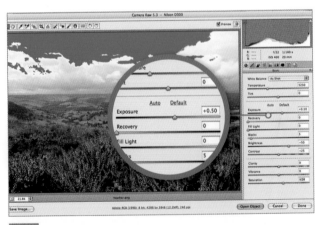

2 CONVERT THE LAND Open the same RAW file again into Photoshop or Elements. Revert back to the default settings by clicking on the downward facing arrow in the corner of the Basic tab and select Camera RAW Defaults from the fly-out menu. Now make a second conversion, this time for the land by increasing Exposure to +0.50 and Saturation to +15 and hit Open Image.

FIRST RAW CONVERSION

SECOND RAW CONVERSION

FINISH

IMPROVE DYNAMIC RANGE
By making a split RAW conversion we can increase the dynamic exposure range of any image. It just involves using Photoshop's Layers palette and Eraser tool to seamlessly merge together two different RAW conversions.

3 STACK IN PHOTOSHOP With the conversion for the land visible on screen, press Ctrl+A on the keyboard to select all the pixels, followed by Ctrl+C to copy them to your computer's memory. Now go to Window and click on sky.psd, and with the conversion for the sky on screen hit Ctrl+V to paste the land conversion over the top of the sky conversion.

4 MERGE IN PHOTOSHOP Go to Window>Layers to open the Layers palette and make sure Layer 1 is selected. Next select the Eraser tool from the toolbox. In the Options bar select a 700px soft-edged brush and sweep the Eraser over the sky. Once the sky detail has been restored, simply flatten the Layers (Layer>Flatten Image) and save the image to your computer as a JPEG file.

START

Split conversions – three Layers

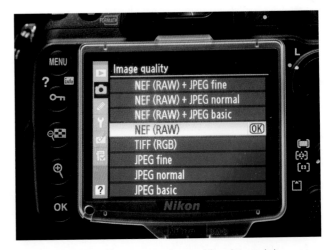

Convert RAWs into three Layers or more

FOR LANDSCAPE PHOTOGRAPHERS, perfect lighting is an elusive thing. The chances of everything falling into place at the right time, when you're actually there with your camera and tripod, are quite slim. Often your best bet is to work out how to make the most of those elements which *are* there.

Shooting in RAW mode gives you the flexibility to do just that because a RAW file contains much more picture information than a JPEG or TIFF. And the beauty is, you can manipulate this RAW data, and extract all the bits you want in the way that best suits your image.

In this step-by-step project we're starting from a single RAW file, captured in a single moment spanning a mere 1/40sec. We're going to use it to create three different images, and blend the best parts of them all together to construct the scene we experienced, rather than the one the camera recorded in that brief fraction of a second.

We're not going to add or remove anything from the scene, but by making multiple RAW conversions, and blending them with each other in the right way, we can transform the image and turn it into something worthwhile.

That's why this technique is so important – it uses the power of RAW to rescue and release great images that would otherwise be heading for the recycling bin.

Shooting a RAW file with your camera is easy. All you have to do is set Image Quality to RAW, and the job is done. On DSLRs, this is usually achieved via a Quality button or through the Image Quality screen in the menus.

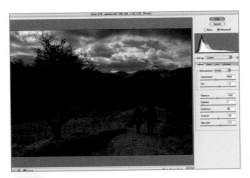

1 CONVERT THE SKY Open a suitable RAW file and convert it to get a good exposure of the sky. Don't worry about the rest of the image – just focus solely on the sky. For our image here we used settings of Temperature: 6500; Tint: +10; Exposure: -0.20; Shadows: 5; Brightness: 50; Contrast: +25; Saturation: +13. Click Open when you're done and save this file as "Image-sky.jpg".

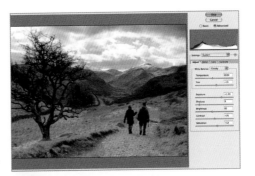

2 CONVERT THE MIDGROUND Open the RAW file into Adobe Camera RAW again and this time convert for the pale area in the middle distance. Here we moved the Exposure and Shadows sliders to gain some detail, choosing settings of Temperature 6500; Tint +10; Exposure +1.50; Shadows 9; Brightness 65; Contrast +25; Saturation +13. Save this file as "Image-midground.jpg".

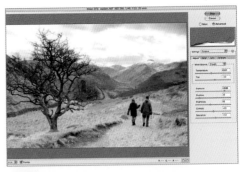

3 CONVERT THE FOREGROUND Open the same RAW file a third time. This time we're going to convert the RAW so it gives a good exposure of the foreground. The settings you use will vary from image to image, but in this example, we've increased Exposure to +2.65 and Shadows to 12. Everything else we've left the same as the last conversion. Save this as "Image-foreground.jpg".

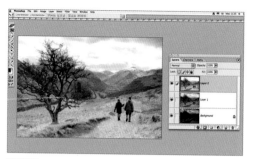

4 STACK THE IMAGES With the Move tool, click on the mid image to select it, and then hold down Shift and drag it into the sky image. Now do the same with the foreground image – hold Shift and drag it into the sky pic. Now close down the mid and foreground pics. Open the Layers palette (Window>Layers) and you'll see the three Layers in the stack.

5 BLEND THE SECOND LAYER Now we have all three JPEG conversions, it's time to blend together the best bits. In Photoshop, switch off the top Layer with the "eye" icon, and click on the second Layer to highlight it. Now click the Layer Mask icon. Hit D then X to set Black as the foreground colour, and paint into the sky area with a large soft-edged brush.

6 BLEND THE TOP LAYER Once you have an imperceptible join, click on the top Layer and create another Layer Mask. Now paint black into the sky and the midground to reveal these areas from the Layers beneath, and gently blend in the edges for a seamless join. You may need to reduce the Opacity of the Black brush in the Options bar for a really good blend.

7 BOOST CONTRAST SELECTIVELY With the Lasso tool, select the strip of midground and Feather by 120 pixels (Select>Feather, or Select>Refine Edge and move the Feather slider in Elements 6/CS3). Click on the Adjustment Layer icon and select Curves from the list. In the palette, drag the curve into a gentle "S" curve to increase contrast, and click OK.

8 DARKEN THE FOREGROUND Make a rough Selection of the foreground area. Feather this by 120 pixels as you did in step 7, and add another Curves Adjustment Layer. Pull the curve down a touch to darken the area and increase saturation. This will beef up the foreground to echo the dark sky and hem in the image. Click OK when you're happy.

9 BURN-IN THE SHADOWS In the Layers palette, click on the Create a New Layer icon to make a new blank Layer at the top of the stack. Hold down Alt and select Merge Visible from the Layer menu, and then release Alt. This will crunch all your work into a new Layer. Now select the Burn tool and in the Options bar, set Range to Shadows and Exposure to 4%. Play a large, soft-edged brush over the image to darken the shadows.

10 DODGE THE HIGHLIGHTS Drag the Burn Layer over the Create a New Layer icon to copy it, and then select the Dodge tool. In the Options bar, set Range to Highlights and Exposure to 3% and again, use a large, soft-edged brush to bring out the detail in the foreground and midground areas. Don't worry about dodging the sky, as that's bright enough already. When you're happy, Flatten and save the image.

FINISH

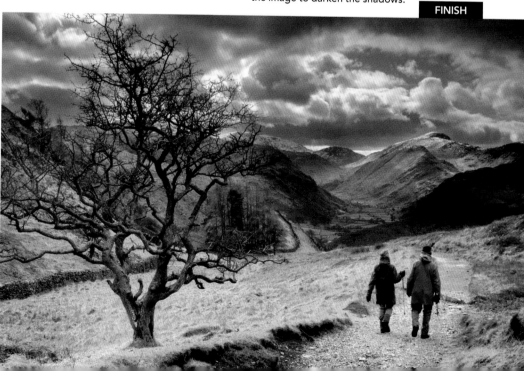

Split RAW conversions – black and white

Make superb mono with Dual Raw conversions

WHAT YOU NEED
PHOTOSHOP OR ELEMENTS

WHAT YOU'LL LEARN
HOW TO MAKE SPLIT MONO CONVERSIONS

WE'VE SEEN HOW RAW FILES ARE INCREDIBLY VERSATILE, and are perfect for creating high-contrast scenes with extreme lighting. The beauty of making a split RAW conversion with mono is that you can really work on areas of the image and push them to their limits, enhancing both the mood and intensity of the shot.

Black and white landscapes are a perfect example – skies can be worked on until they're dark and menacing, completely changing the atmosphere of the image. The most impressive shots generally show high-contrast scenes, taken in contrasty lighting that produces areas of extreme light and dark, but even the best cameras will struggle to balance lighting like this, either under- or over-exposing the shot.

If you shoot in JPEG and try to rescue the image in Photoshop then it's going to be an uphill struggle from the start. Though a certain amount of adjustment can be achieved, you can often be trying to bring back detail that simply isn't there in the first place. A RAW file is a lot more flexible as it can be pushed much further and still deliver great results as you're dealing with raw data, and not information that's already been processed.

We've seen how it's possible achieve a perfectly balanced colour shot by doing not one, but two or three, RAW conversions of the same image. Here we'll see how the process works in black and white, applying a different set of adjustments, before blending the files together in Photoshop.

START IMAGE

FIRST RAW CONVERSION

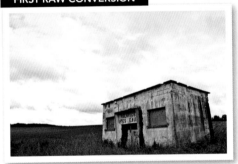

SECOND RAW CONVERSION

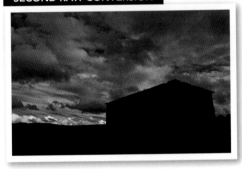

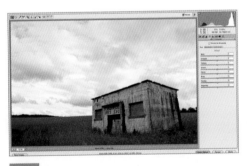

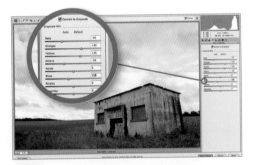

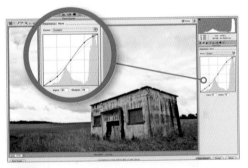

1 OPEN RAW Open up a suitable RAW start image and it will launch Photoshop's RAW converter. For this conversion, we're going to concentrate on the foreground, adjusting the Exposure to +0.80 on the Basic tab to lighten it. Before you make any more adjustments using this tab you need to convert the image to mono, so click on the HSL/Grayscale tab.

2 MONO CONVERSION Now click on Convert to Grayscale and once you've done that, click on Default to set the sliders to zero. Here we set the Reds slider to -40, Oranges to +30, Yellows to +25, Greens to -33 and finally Blues to -18. We left the other three sliders alone as these didn't have an effect on our foreground. Click back to the Basic tab.

3 FINE-TUNE Increase the Tint slider to +40, Fill Light slider to 7 and then the Clarity to +75, before selecting the Tone Curve tab. Select the Point tab and increase the severity of the "S" curve, then tap Open Image. Now save the image as "Foreground" – either a TIFF or .PSD file (somewhere easily accessible such as your Desktop) and then open your original RAW file again.

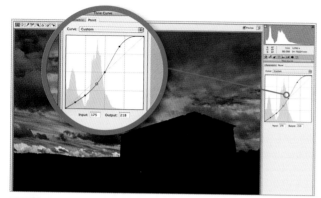

4 CONVERT SKY With the Basic tab selected, reduce the Exposure slider to -1.95. Now increase the Recovery slider to 20 and Blacks to 22. Now click on the HSL/Grayscale tab and adjust the Blues slider to -56, Purples to +34 and Magentas to +38. Now click on the Tone Curve tab and then the Point tab, increasing the severity of the top of the curve, hitting Open Image once done.

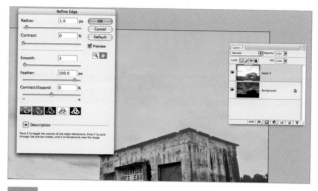

5 MERGE THE PICS Open up your first conversion ("Foreground.TIFF") and hit Ctrl+A and Ctrl+C to copy it, then Ctrl+W to close it. Now select the RAW file again and hit Ctrl+V to paste in the image. Bring up your Layers palette by hitting F7 and then go to the toolbox and select the Lasso tool. Now make a rough selection of the foreground and then go to Refine Edge, entering a Feather value of 100px.

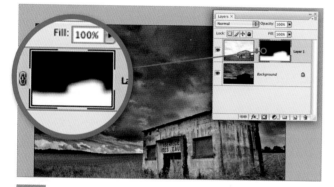

6 ADD A MASK At the bottom of the Layers palette, click on the Add Layer Mask icon and the correct sky will be revealed. You can fine-tune the transition between the two Layers if you wish. Click on the Layer Mask's thumbnail, select Black as the foreground colour, and with a brush of around 200px with an Opacity of 40%, brush over the sky around the horizon.

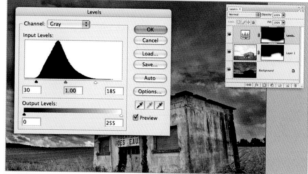

7 ADD CONTRAST Click back on the Layer 1 thumbnail and then with the Lasso tool, make a rough Selection of the foreground. Feather by 100px and from the bottom of the Layers palette, hit the Create New Fill or Adjustment Layer icon. Select Levels and in the pop-up dialogue box, drag the left and right-hand arrows inwards so they both meet the edge of the histogram.

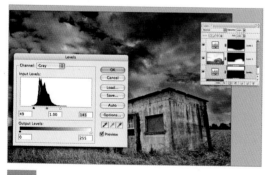

8 DARKEN SKY Select the Background Layer and choose the Rectangular Marquee tool from the toolbox. Drag out a Selection across the top third of the image and then feather it by 130px. Now select the Create New Fill or Adjustment Layer icon and select Levels. In the dialogue box, drag the left- and right-hand arrows inwards again, so they both meet the edges of the histogram.

FINISH

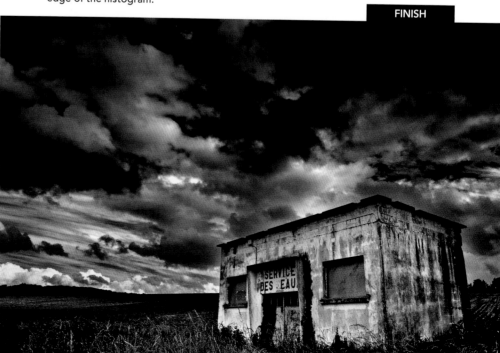

Control colour with RAW

Change White Balance and Saturation for cleaner colours

CHANGING THE COLOUR TEMPERATURE of your images can have a dramatic effect, either warming up or cooling down a scene. Colour temperature is controlled using the White Balance setting, which determines how the light reflected by a subject is recorded.

Different types of light have different colour temperatures – for example, direct midday sunlight is much "cooler" in temperature than artificial light from a tungsten bulb. Matching your camera's White Balance setting to the lighting you're shooting in means you'll record the subject colours accurately (so a white wall looks white, not orangey-yellow).

Although it's good practice to set White Balance specifically for each shot, it's quicker to shoot in Auto White Balance (AWB) – particularly if the light keeps changing. One of the problems with this is that AWB can easily mistake large expanses of subject colour for a wash of lighting colour, then try to "correct" them automatically.

If you shoot JPEG there's no direct control over White Balance in post-processing, so to remove a colour cast you'll have to adjust the colour sliders in Photoshop (which can be tricky to get right). If you shoot in RAW, however, it's really easy to change the White Balance.

CONTROL WITH RAW

Adobe Camera RAW provides three controls under the Basic tab for fine-tuning White Balance, as well as a specific tool for ultra-precise control. The White Balance tool is the most accurate way of setting colour temperature: using an eyedropper you simply click on the image preview to identify tones in the file that should be neutral – for example either white or average grey. Once selected, the temperature is

adjusted to make those tones look neutral, adjusting the rest of the colours along the way.

Another way to change the colour temperature is to use one of the default settings under the White Balance drop-down box. These settings mirror many of the White Balance options you have on your camera, such as "Daylight", "Cloudy" or "Flash". Each of these settings uses a pre-set colour temperature and tint to accurately reproduce colours shot under those different lighting conditions.

While presets are a quick and easy way to set your White Balance – particularly if you make a mistake and leave it on the wrong setting at the time of capture – Adobe Camera RAW's Temperature slider is great for achieving a specific look. If you wanted to apply a cool tone effect to a winter portrait, for example, just shift the slider to the left.

Conversely, to warm up a landscape and recreate the feel and colour temperature of shooting during the golden hour (the first hour after sunrise and the last hour before sunset), just move the Temperature slider to the right.

Like all adjustments to RAW files, changing the White Balance is non-destructive so there's no reason why you shouldn't experiment with it to see what creative effects you can achieve.

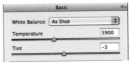

The White Balance tool sits in the Camera RAW toolbar alongside the other colour controls, providing ultra-precise adjustment to colour temperature. The main White Balance tools are located under the Basic tab instead

AS SHOT WHITE BALANCE
Sticking with the Auto White Balance temperature set by the camera, our groyne shot looks cold.

ACCURATE WHITE BALANCE
Using the White Balance tool you can sample a white or neutral tone for more accurate colours...

WARM WHITE BALANCE
...or you can warm up the image manually with the Temperature slider for a more pleasing effect.

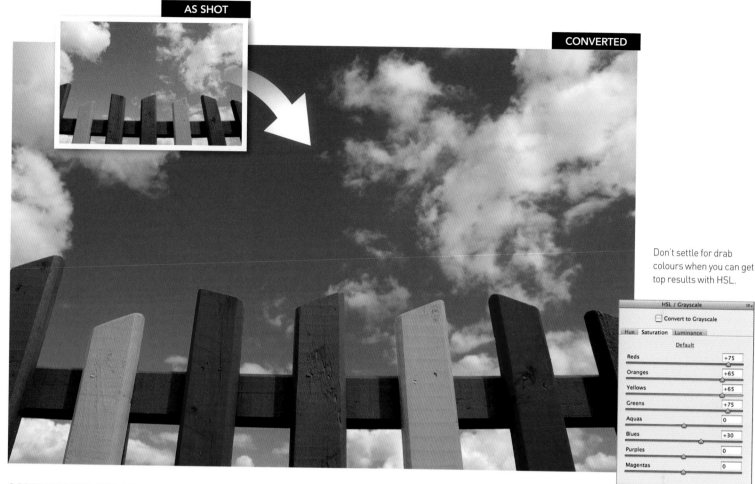

AS SHOT

CONVERTED

Don't settle for drab colours when you can get top results with HSL.

HSL / Grayscale	
☐ Convert to Grayscale	

Hue Saturation Luminance

Default

Reds	+75
Oranges	+65
Yellows	+65
Greens	+75
Aquas	0
Blues	+30
Purples	0
Magentas	0

CONTROLLING COLOUR

Having strong, bold colours in your images like this really gives them the "wow factor". While Adobe Camera RAW's Vibrance and Saturation sliders are great for global colour adjustments, they aren't much use for adjusting specific colour tones, such as making a blue sky look bluer.

The HSL/Grayscale tab, however, lets you do just that with sliders to adjust each colour independently (HSL stands for Hue, Saturation and Luminance).

- Hue allows you to change the colour itself
- Saturation lets you increase or decrease colour strength
- Luminance is for lightening or darkening individual tones.

Our fence shot above had great potential, but the colours

in our initial RAW file (inset) looked washed-out. To sort this out, we opened the file into Camera Raw, clicked on the HSL/Grayscale tab and then selected Saturation. By increasing Reds to +75, Oranges to +65, Yellows to +65 and Greens to +75, we achieved the saturation we wanted, judging the image in the preview. However, pushing the saturation of the sky this hard would have looked unnatural, so we chose a more subtle +30 for the Blues, which looked better.

The sky still lacked impact, so by using the Blues slider under the Luminance tab, we darkened it down. For this manoeuvre, click on the Luminance tab and drag the Blues left to a value of -30. To finish off, you can either hit Done to save the changes or Open to launch the image in Photoshop.

EXPERT ADVICE

ADJUST COLOUR WITH HUE

WHILE THE LUMINANCE AND SATURATION SLIDERS are great for enhancing colour, using the Hue slider makes it possible to completely change colours in a RAW image file. Take our shot of grape hyacinths (muscari), right. By adjusting the Blues Hue slider we can completely change their colour without affecting hues in the rest of the image.

This procedure won't work with all images, however. That's because adjusting the Hue sliders affects all the same-colour pixels in an image, so it's not always possible to adjust one area independently. For example, if you tried to change the colour of a model's hair using the Reds or Yellows Hue sliders, the adjustments would affect the model's skin tones too.

AS SHOT

CONVERTED

Fix camera and lens problems

Sort noise and lens faults using the Detail tab in Adobe Camera RAW

SO FAR WE'VE LOOKED AT USING RAW to correct the exposure of your photos, enhance contrast, improve colour or remove it to make a mono conversion. But that's certainly not the end of its usefulness. If you've ever been annoyed by fringeing, unsightly digital noise, and photos that aren't quite sharp, you'll be pleased to discover that by shooting in RAW, you can help alleviate these technical problems, too.

These issues are often more pronounced when using cameras and lenses bought at the cheaper end of the scale. For instance, at extreme focal lengths and aperture settings, cheap lenses can produce defects such as:

- chromatic aberration – where gaudy fringes of colour appear around the edges of your subject
- vignetting – where the edges of the frame are darker than the middle
- loss of sharpness – a reduction in the lens's ability to resolve sharp detail.

That's not to say that expensive lenses don't have their problems – the wider maximum apertures on many "fast" lenses can produce vignetting and fringeing too.

It's the same story when it comes to digital noise. Expensive professional-spec full-frame DSLRs tend to deal with noise significantly better than compact cameras and DSLRs with smaller sensors, so shots taken at high ISO will often look a lot more grainy and pixellated than you'd like.

REDUCE DIGITAL NOISE

Shooting at high ISO sensitivities causes digital noise in your shots. This is because, as you increase the sensitivity of the sensor, it also picks up interference, making the signal less clear. This is a lot like amplifying a weak signal on a radio – the higher you push it, the louder it will get, but so will the hiss or static that's also there. In digital photography, by increasing the ISO, you're amplifying the light and the interference takes the form of a grainy texture on your photo. This effect becomes more and more pronounced as the sensitivity is raised or the "signal" turned up.

To remove it, use the Noise Reduction tool in Adobe Camera RAW. Click on the Detail tab and under the Noise Reduction heading you'll find options to control the luminance and colour of any noise. Zoom in to 100% so you can see the effect of moving the sliders.

THE NOISE REDUCTION SLIDERS
Just a few nudges of these can make a big difference to image noise – as you can see in the example below.

ORIGINAL RAW WITH NOISE　　　**RAW FILE WITH NOISE REMOVED**

ORIGINAL SHOT
This shot was taken at ISO 3200. Close examination at 200% shows obvious noise – but it can be removed using Camera RAW software (see right).

DEALING WITH NOISE

Digital noise appears on photos in two distinct variations Chrominance (or Chroma) and Luminance (or Luma).

Before　　　**After**

CHROMINANCE (CHROMA) disrupts colour, leading to unsightly red, green and blue speckling. This ugly, coloured mosaicing can be desaturated with the Color slider – we've pushed it to 80 here.

Before　　　**After**

LUMINANCE (LUMA) is less unsightly than Chroma, looking more like a fine texture. It can be reduced with the Luminance slider. We've set it to 50; any more can cause unwanted image softness.

SHARPEN IMAGES

Regardless of whether you're using a state-of-the-art camera or a bargain-basement DSLR, if you shoot in RAW, your images will always require additional sharpening. They'll look slightly soft compared to a standard JPEG: this is because JPEGs enjoy a small amount of automatic sharpening as they're processed by the camera's image processing chip, on the way from your camera's sensor to its memory card.

By comparison, a RAW file remains untouched by any post-processing filters or adjustments made by the camera. Not to worry: sharpening RAW files is easy using the Detail tab and the four sliders found inside Adobe Camera RAW.

Many photographers prefer to sharpen their RAW files after RAW conversion using either the High Pass or Unsharp Mask filters in Photoshop. While this is fine (we'd always advise leaving any sharpening to the end of the editing process anyway), it does add another stage to your workflow – a stage that can also be completed during the initial conversion process in the Adobe Camera Raw interface.

Adding sharpness in RAW works very much like the Unsharp Mask filter in Photoshop, by adjusting local contrast along the edges of subjects within the image to give an impression of overall sharpness. Just as when controlling noise in the Camera RAW interface, you'll need to zoom in to 100% to see any effect from the sliders. Once you've positioned the sliders, click the Preview button on and off to see what effect the sharpness is having.

Use the following sliders:

- Amount adjusts the level of definition applied to an "edge" in your picture – how much those pixels are lightened or darkened to create the impression of clarity
- Detail works like the Threshold control in Unsharp Mask and adjusts how much "high-frequency" information is sharpened in the image – lower values will sharpen everything, including any noise, while higher settings sharpen only very distinct details
- Radius sets the thickness of the "edge" being adjusted, in pixels. Too large a Radius will cause fringeing
- Masking constrains the area of sharpening. A setting of 0 will allow everything in the image to be sharpened, while 100 restricts sharpening to the strongest edges.

UNSHARPENED RAW **SHARPENED RAW**

Opening a RAW file into Photoshop loads the Camera RAW interface. Initially greeted by the Basic tab, you need to change this to the Detail tab to carry out sharpening using the four sliders. The Detail tab is the second or third tab from the left, depending on which version of Photoshop or Elements you're using.

CONTROL LENS VIGNETTING

Vignetting is an effect where the edges of an image – and particularly the corners – appear darker than the centre. Although this can sometimes be used to frame shots creatively, it's usually considered an undesirable lens defect and is best removed.

Vignetting occurs because the intensity of light tends to "fall off" towards the edges of a lens's image circle – the focused light that falls on and around your camera's sensor. Most of the darkened areas are cropped out because they're outside of the sensor's position, but those that aren't will cast a shadow over the corners and edges of your picture.

Adobe Camera RAW (in the full version of Photoshop) has a Lens Corrections tab with two sliders, Amount and Midpoint, that help to combat the effect. To see how they work, open any RAW image that suffers from vignetting in Photoshop and click on the Lens Corrections tab. The Lens Vignetting sliders are at the bottom, so just click and drag to push the Amount slider into a positive value to lighten the corners of the frame (or, if you want to exaggerate the effect, use a negative value to darken them).

The amount of corner lightening required varies from image to image, but for our image below we went for a value of +80. The Midpoint slider becomes active as soon as the Amount slider is adjusted, and by decreasing the value, corner lightening is applied to a larger area (smaller area if the value is increased). When active, the Midpoint's default value is 50 and that seems to work fine on our example image.

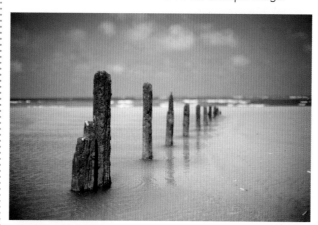

WITH VIGNETTING

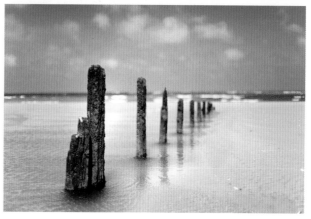

VIGNETTING CORRECTED

Further down the Lens Corrections tab you'll find the Post Crop Vignette sliders which work in tandem with Camera RAW's Crop tool. Drag out a Crop Marquee and use the Amount slider and you'll see the vignetting effect is limited to the crop you're making. This is of most use when adding creative vignetting effects, and in addition to the Midpoint, you can also change the Roundness from circular to oval and the amount of Feathering – the softness of the edges.

Very harsh vignetting may also occur when using super wide angle and fish-eye lenses, or if your lens hood is badly fitted, causing a physical obstruction to the light. The only option to remove this by cropping into your image, or by cloning out the affected areas in Photoshop proper, once the RAW file has been converted.

CHROMATIC ABERRATION

Chromatic aberration, or fringeing as it's often called, is another lens defect, but unlike vignetting it has very little artistic benefit. Fringeing is most commonly found along high-contrast edges, such as branches set against a bright sky, and is characterized by an unsightly bright colour, such as purple, blue, green or red.

Fringeing happens when your lens fails to focus light correctly, splitting it into its constituent parts – red, green, and blue – and sending them onto different parts of the sensor instead of a single point. This prevents the colour channels of a digital image from lining up correctly. Anywhere this happens, you'll see a colourful fringe.

Lens manufacturers work hard to minimize fringeing by using corrective glass elements, but on zoom lenses that offer a great range of different focal lengths or a very wide angle of view, it's difficult to prevent fringeing at all focal lengths, while trying to keep both the cost and the weight of the lens down. As with vignetting, using smaller apertures and focal lengths that aren't at the extreme ends of a lens's focal range can minimize the problem.

Fortunately, when fringeing does rear its ugly head it's possible to remove or minimize it using the Lens Correction tabs – provided you've shot in RAW.

Under the Lens Corrections tab in the full version of Photoshop's Camera RAW interface there are two sliders to remove fringeing. The Fix Red/Cyan Fringe and Fix Blue/Yellow fringe sliders work by rescaling the colour channels in the image, and lining them up so the fringe disappears. Depending on how pronounced the fringeing is, you might need to use both to correct the defect.

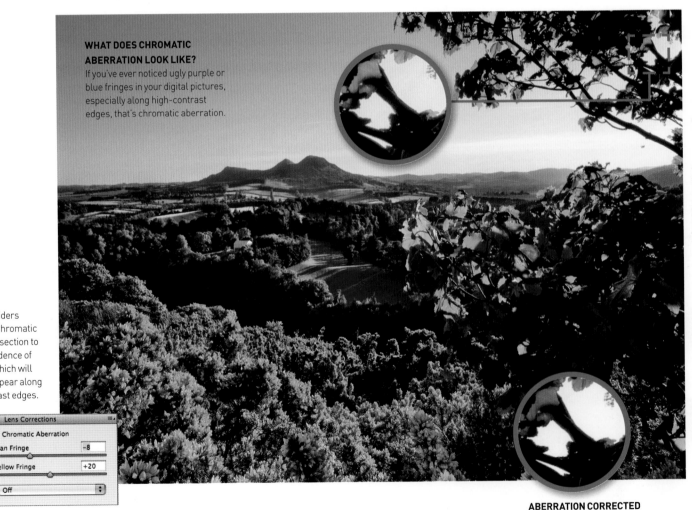

WHAT DOES CHROMATIC ABERRATION LOOK LIKE?
If you've ever noticed ugly purple or blue fringes in your digital pictures, especially along high-contrast edges, that's chromatic aberration.

FIXING IT
Use both sliders under the Chromatic Aberration section to remove evidence of fringeing which will typically appear along high-contrast edges.

ABERRATION CORRECTED

To remove the colour fringeing in our example, below left, we had to open the file and zoom in 100% on the trees in the top right-hand corner. We moved the Fix Blue/Yellow Fringe slider to +20 to banish most of the blue fringeing, then dragged the Fix Red/Cyan Fringe slider to -8 to get rid of the rest of it. The options in the Defringe drop-down menu are more automated.

■ All Edges – will desaturate colour along any edge where there's a sudden change of colour, but can produce some odd fringeing in itself

■ Highlight Edges – will only defringe edges where there's a significant change of contrast.

CAMERA CALIBRATION

Near the end of the tabs in the Camera RAW interface, you'll find Camera Calibration (Photoshop only). This is a rarely used part of the interface, and can look a bit daunting, but basically it just controls the way that colours are rendered in your pictures.

It's of most use if you've already colour-corrected your image using the Temperature and Tint sliders under the Basic tab, but are still not getting the results you're after.

One reason for this may be a difference between your camera's colour profile and the profile in Adobe Camera RAW for that model, but shooting under non-standard lighting conditions can also fox the Color Temperature settings, requiring further adjustment.

Within the tab you can use the Hue and Saturation controls to adjust the settings for the profile built into Camera RAW, and also specify whether to use the profiles built into Camera RAW or a profile built into the file itself. Unless you have serious colour casts in your pics though, the Calibration tab isn't one you'll need to bother with too often.

SAVE YOUR SETTINGS

To save the adjustments you've made and set them as the default image profile for your camera, click on the fly-out menu at the top-right of the palette and choose Save New Camera RAW Defaults. The other Profiles won't be deleted, so you can reset them at any time.

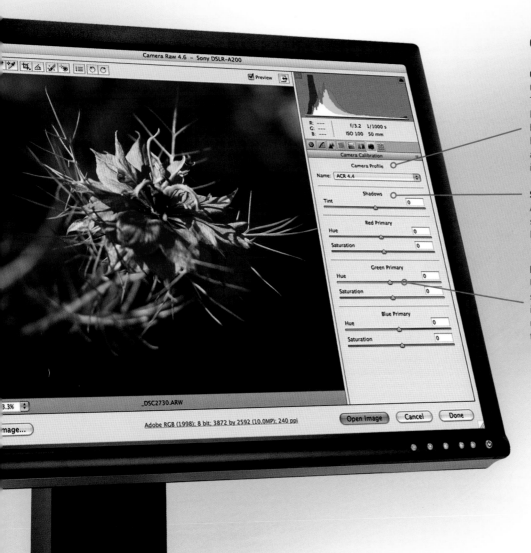

GET TO KNOW THE CALIBRATION TAB

CAMERA PROFILE
Click on the list and choose a profile from the menu. The options here will vary depending on whether your RAW file has an embedded profile and whether it has been processed with an older version of Camera RAW. Generally, pick the highest ACR version available (ACR 4.4 for instance) as this will represent improved camera profiles for some cameras.

SHADOWS
Adjust the Tint slider to remove any colour cast in the shadows of your image. Like the Tint slider in the Basic tab, the scale runs from Green to Magenta.

RED, GREEN AND BLUE PRIMARY
Under these headings, the Hue and Saturation sliders can be used to adjust the respective colours in the image. The preview image will react as you make adjustments but generally you should adjust the Hue first, then the Saturation.

The RAW workflow

Get your image-editing organised by setting up a "workflow"

SO FAR WE'VE SHOWN YOU the benefits of shooting in a file format that affords you much more control over fine-tuning exposures, making creative conversions, or fixing inherent optical faults. Hopefully, you've caught the RAW bug and will have adjusted your camera's Image Quality setting, downloaded the relevant Adobe plug-in software to process RAW files from your camera and are shooting the file format of choice for top photographers.

However, one of the less glamorous tasks in RAW is making sure all your images are saved and stored in such a way that you can easily find and work with them in the future. When you return from a shoot, spending time editing and categorizing images may sound like a real turn-off (many photographers leave it until the winter months when there's less opportunity to shoot), but establishing a good workflow can save not only vital disk space on your computer, but also your sanity when you've got hundreds of gigabytes of data to ort through.

Of course not all photographers' workflows are the same – we all like to work in different ways – but a good RAW workflow needs to take you from the starting point of having your images on a memory card to a finishing point of having saved, edited, categorized, and adjusted shots backed up in a time-efficient, productive way.

KEEP IT LOGICAL

In this final part of our Understanding RAW chapter we're going to share with you our top tips for a good RAW workflow. We'll start with the basics and show you the best ways to download your files from the memory card and look at a logical file structure system for saving images onto an external hard drive.

Excellent picture editing (or sorting the wheat from the chaff) is one of photography's most overlooked skills and it couldn't be more important when working with large RAW files. Deleting the rubbish and retaining only the best is necessary to ensure your hard drive doesn't get clogged up. Software packages Elements, Adobe Bridge or Lightroom 2 offer a failsafe star-rating system that makes the whole process so much easier.

Our "best practice" advice for converting RAW files in a time-efficient manner, using things like synchronization settings, means you'll not only get the most from RAW but you'll also have time to go out and shoot more images, without spending all day sitting in front of your computer.

Finally we look at batch processing your RAW files to JPEG and backing the whole lot up in case of disaster.

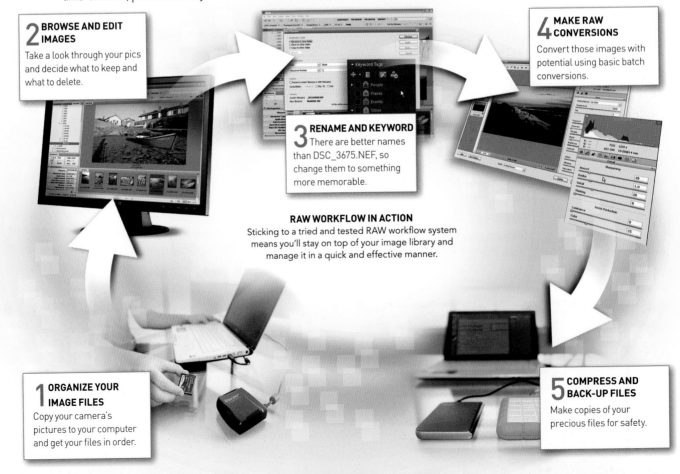

2 BROWSE AND EDIT IMAGES
Take a look through your pics and decide what to keep and what to delete.

3 RENAME AND KEYWORD
There are better names than DSC_3675.NEF, so change them to something more memorable.

4 MAKE RAW CONVERSIONS
Convert those images with potential using basic batch conversions.

RAW WORKFLOW IN ACTION
Sticking to a tried and tested RAW workflow system means you'll stay on top of your image library and manage it in a quick and effective manner.

1 ORGANIZE YOUR IMAGE FILES
Copy your camera's pictures to your computer and get your files in order.

5 COMPRESS AND BACK-UP FILES
Make copies of your precious files for safety.

1 ORGANIZE YOUR RAW FILES

So, you're back from a good day's shooting, and you're bursting to check how many great images you've captured. There's the temptation to hook up your camera and PC, dump everything on the desktop and start having a good root through your pictures. Although this is understandable, it's a mistake, because if you don't organize your images into a proper file structure now, it's unlikely you'll get round to doing it later. In no time at all your shots will be muddled together making it more difficult to find an image in a few months' time.

FILE STRUCTURE

The best file structures store images by year, month, and event, so when you want to locate an image you'll know exactly where to find it within an organized filing system. Creating a file structure is easy – we recommend saving your image libraries to an external hard drive so, with one connected to your PC, double-click the My Computer icon from the desktop. Now double-click the hard drive icon and go File>New>Folder and call the new folder "Image Library". Next, double-click the Image Library folder and create another new folder, this time naming it by the year, and then within that folder create 12 sub-folders, one for each month of the year. Then, when you're back from a shoot, you can download your RAW files into an event folder in the relevant place in your image library file structure.

Sound complicated? Not really – just follow our "Downloading Made Easy" step-by-step and in no time you'll have a well-oiled system for saving and storing RAW files.

Card readers are the fastest way to transfer images from your memory card to your computer.

EXPERT ADVICE

DOWNLOADING MADE EASY

1 COPY THE RAWS Use a card reader to download images as it's quicker than doing it from the camera. Connect the card reader, insert your memory card and then locate the RAWs from your shoot. Hit Ctrl+A to select all and then Ctrl+C to copy them to the computer's memory.

2 CREATE AN EVENT FOLDER Double-click on the My Computer icon on the desktop and then on the icon for your hard drive. Navigate to the relevant month folder in your image library and create a sub-folder with a relevant name for the event, for example: 2009>July>Bude.

3 PASTE THE RAWS Now double-click on the new Bude folder and hit Ctrl+V to paste in the RAW files from your shoot. That's it! Now all your images are saved in a logical place, you can get on with the fun stuff of browsing, editing and converting all your RAW images.

2 BROWSE AND EDIT

Once your files are downloaded and properly organized, you need a system to quickly and easily identify the shots you want to keep or delete. This can be time-consuming but it's worth doing because, when you're shooting RAW files even high capacity hard drives can start to fill up, so sorting the winners from the losers now will free up some valuable storage space.

To be as efficient as possible, use an image-editing program that allows you to browse RAW files, without having to open each shot individually, so you can quickly flag up the good and the not-so-good.

If you're running Elements on a PC, then use the built-in Organizer; for those with the full version of Photoshop (and those running Elements on an Apple Mac), you'll have access to a more powerful tool called Adobe Bridge.

Another option that works really well is Adobe's Lightroom software. This is an affordable add-on package that's excellent for cataloguing and editing RAW images.

Regardless of which package you choose, they all feature a system for rating images between 1 and 5 stars. Don't worry about using all the stars – all you need to do is rate any shots you want to delete with 1 star (duplicates, howlers, out of focus shots, and those where the exposure is so bad it can't be rescued), and rate the best images with 5 stars.

Once you're done you can select all the 1-star images easily using the star rating filters, and then hit Delete to remove them from your disk.

BROWSING USING BRIDGE
You don't need to import images into Bridge to browse, just navigate to your image library using the Folders panel. Thumbnails will then be displayed in the Content panel; hit Ctrl+1 to rate images 1 star, or Ctrl+5 for your 5-star best shots.

BROWSING USING ORGANIZER
The Organizer is a streamlined version of Bridge that comes bundled with Elements. You need to import images first (File→Get Photos) to make them visible and to star rate them simply select an image thumbnail and press either the 1 or 5 key to rate accordingly.

BROWSING USING LIGHTROOM 2
Lightroom 2 works differently and needs images to be imported. Hit Import in the Library Module, navigate to the folder you want to import, and click Choose. Now use the filmstrip to browse and hit the 1 key to rate images 1 star or 5 to flag up the best shots.

EXPERT TIP

USE THE LOUPE TO CHECK DETAIL

Named after the dinky little magnifying glass used by picture editors assessing transparencies in the olden days, the digital "loupe" feature is for checking image detail at 100%, so you can be confident the shots you keep are sharp in all the right places. It's a great editing tool, because if you've got lots of similar images you'll want to keep the one that's the sharpest.

When using Adobe Bridge, simply hover your mouse over the image preview panel and when the Zoom tool pops up click your mouse button to see the Loupe view. In Lightroom 2, make sure you're in the Library Module

displaying the Loupe view (shortcut E) and then press Z on the keyboard to zoom into 100%. It's not quite as easy in the Elements Organizer, but it is possible; hit F11 to view photos in full screen mode and then use the slider in the toolbar at the top to zoom in to 100%. When done, hit the Esc key to return to the image browser.

3 RENAME AND KEYWORD YOUR SHOTS

If you need to search your hard drive and locate RAW files from a particular day's shooting, the cryptic names your camera assigns – like DSC8671.NEF – will make shots impossible to find.

Many DSLRs offer you the option to change the file naming settings, so you could name files more appropriately for each shoot, but it's a bit fiddly and, realistically, are you going to remember to do it every time?

A much smarter way is to batch rename all your RAW files when you get back from a shoot. This is extremely easy to do in Organizer, Bridge or Lightroom 2. It only adds a few minutes to your RAW workflow and could really save your sanity further down the line when you need to find a particular shot or two!

Follow the batch renaming instructions in the panel below and, in no time at all, your vast quantity of RAW image files will be much easier to find.

KEYWORD FOR INTUITIVE BROWSING

Keywording RAW files is a smart way of grouping images from across different folders in your image library. Assigning keywords makes it possible to search for images by relevant words, for more intuitive browsing. You can add keywords in any format that works for you, but a common method is to group images by subject (using keywords such as "landscape", "portrait", etc). This means when you want to browse all the portrait shots in your library, all you need do is filter by that keyword.

EXPERT ADVICE

RENAMING YOUR RAWS

ELEMENTS ORGANIZER Navigate to the folder of pics you want to rename, select one thumbnail and then press Ctrl+A to select all. Now go to File>Rename, specify a common base name like "Bude Day Trip" and hit OK. All the images will be renamed Bude Day Trip followed by a consecutive number.

ADOBE BRIDGE Select the images you want to rename and go to Tools>Batch Rename. Leave destination folder to "Rename in same folder" and under the New Filenames menu type a generic file name in the text box, leave in Sequence Number, but hit minus to remove the other options and click Rename.

ADOBE LIGHTROOM 2 Select all the images you want to rename and go to Library>Rename Photos and under the File Naming box select Custom Name> Sequence. Now type a generic file name such as "Bude Day Trip" in the Custom Text box and enter a sequence number in the box provided, then click OK.

4 QUICK BATCH CONVERSIONS

If you had to painstakingly convert every RAW file you shot individually, it'd be a very time-consuming process. Thankfully you don't have to. Instead, a good approach to basic RAW conversion in your imaging workflow involves making some quick global adjustments to all the RAW files you've decided to keep.

The main post-processing enhancements include sharpening, increasing saturation or boosting contrast. There's really no need to apply such adjustments individually – all you need to do is make the relevant adjustments to one RAW image and then synchronize the settings across as many files as you like with a simple click of a button.

■ In Elements: from the Organizer, select any RAWs which all need the same adjustments. Hit Ctrl+I to enter Full Edit mode. In the film strip, Select All so any adjustments will be made to all the images selected. When you're done, hit Done

■ In Bridge/Photoshop CS4: highlight your RAW files to adjust as a batch, and hit the Open in Camera Raw icon. Make your adjustments then hit Select All, followed by Synchronise. Tick the settings to synchronize and hit OK, then Done

■ In Lightroom 2: in the filmstrip at the bottom of the Develop module, highlight all the RAWs you want to convert in the same way. Adjust one image then hit the Sync button. In the Synchronize settings box, tick those setting to apply across all the RAW image files. Hit Synchronize to apply.

All these RAW images from a recent coastal shoot require the same basic RAW adjustments applying in Camera RAW.

Use the Select All function within the Camera RAW Filmstrip or the Sync button in Lightroom 2 to apply the same adjustments.

5 ADVANCED RAW CONVERSIONS

When time is precious, concentrate your efforts converting only the best RAW files from your shoot. Unless you've got hours to spend fiddling about in Camera RAW it's only your very best images that deserve the full RAW conversion treatment, so don't waste your time. You've already flagged up your 5-star images during your workflow, so concentrate on those ones when making advanced RAW conversions.

As with any digital imaging workflow, it makes sense to do things in a specific order, then you don't end up repeating tasks later on down the line, or start making any adjustments that don't really matter.

If you're not sure what's the best order to do things in, follow our Advanced RAW Conversion step-by-step below to see which tasks should come high up on your Advanced RAW conversion checklist, and what tasks are best left to the end.

In Photoshop, fixing lens defects, such as vignetting or fringeing in the Lens Correction tab, should be done once you've adjusted the exposure and colour in your RAW image.

1 CROP AND WHITE BALANCE If necessary, recompose with the Crop tool then accept the new crop and the histogram will change – only displaying pixels within your crop, so you can be more accurate with other adjustments. Again, only if necessary, adjust White Balance using the eyedropper tool or Temperature slider.

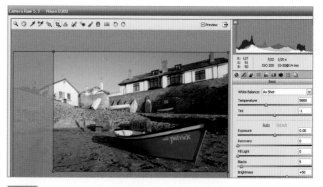

2 EXPOSURE If your shot is too dark (pixels bunched on the left of the histogram) move the Exposure slider right. If the shot's too light, move the slider left until the pixels are more evenly spread. For a more contrasty look, increase the Blacks and Contrast values too, but watch you don't lose detail in the shadows and highlights.

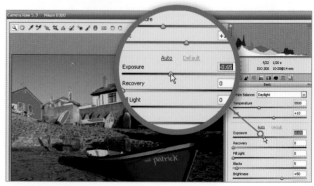

6 COMPRESS AND BACK UP YOUR FILES
Compress your RAW files to JPEG and share them much more easily. RAW is great for quality and control, but it's also a pain when you want to show off your work. Download a bunch of RAWs on a pen drive to take to a friend's, or try to upload them to the internet and you'll soon run into problems. This is when the universal JPEG picture format, recognized by every image viewer available, comes into its own. When you're done organizing, editing, renaming and converting your RAW files, compressing them to create a JPEG format copy will come in handy later. You don't need to save each shot individually – it's easy to batch process them in Elements, Photoshop or Lightroom 2.

The final step is to back everything up to a second hard drive – only when you've done this is it truly safe to delete RAWs from your memory card.

ELEMENTS Open the main image-editing area. Now go to File>Process Multiple Files and under Process File From ensure Folder is selected. Next under Source click Browse and then navigate to the folder of images containing the RAW files to be converted, click Choose and then select the same folder under Destination. Next, tick the box under File Type then select JPEG High Quality and click OK.

3 ADJUST COLOUR For a more vibrant finish it pays to boost any flat-looking colours, such as the blues, using the Vibrance slider. Next pep up the saturated Reds and Yellows with the Saturation slider. To adjust individual colours (in the full version of Photoshop) use the sliders under the HSL tab instead.

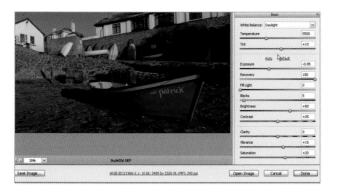

BRIDGE/PHOTOSHOP You'll need both Bridge and Photoshop open for this compression solution. In Bridge navigate to the folder of RAW images to convert. Then go to Tools>Photoshop>Image Processor and in the dialogue box under Section 2 make sure Save in Same Location is ticked. Now under Section 3 tick the Save as JPEG box and input 12 in the Quality box for the highest quality and click Run.

4 SHARPENING AND NOISE Once the basic adjustments have been made, click on the Detail tab. For most images the default sharpening values will be fine, but others may need a little more, so use the Masking slider to restrict where sharpening is applied. For high ISO images increase the Luminance and Colour sliders for less noise.

Glossary

Understand these photo terms and phrases

AF Servo
Focusing method used by cameras to lock onto a subject and retain the focus, even if the subject moves to a different plane.

Aspect ratio
The ratio between the height and width of an image. For example, a ratio of 1:1 will make a square picture.

Auto exposure (AE)
An in-camera system for setting the shutter speed and aperture automatically. There are several different types of auto exposure system: Program exposure is where the camera sets both the shutter speed and the aperture automatically.

Autofocus (AF)
This is the system by which the lens automatically focuses on the desired area or subject in the image.

Barrel distortion
This refers to image distortion created by a lens, making the subject look stretched at the edges, or "inflated". This is normally created by wide angle lenses when used at their widest setting.

Burst mode
A motordrive option on DSLRs allowing you to take a sequence of images in rapid-fire succession for a short period of time, measured in frames per second (FPS).

Clipping
This occurs when very dark and very light tones in an image are recorded as pure white or black in an exposure, removing detail in highlight and shadow areas. It is more of a problem when digital images are transferred to devices such as inkjet printers. If the range of tones offered by the printer is fewer than those in the original image, highlight or shadow detail will be lost, or clipped, when the image is printed.

Colour cast
Usually an unwanted overall colour tint that appears when the colour temperature of the light doesn't match the white balance set on the camera.

CPU (Central Processing Unit)
A solid-state electronic chip inside a DSLR that processes exposure and focusing data sent to it from other electrical components. The CPU can also be referred to as the central processor, processing chip or processor.

Digital zoom
An electronic process that will crop in on a subject to make it look larger in frame, without any physical or mechanical movement on the part of the camera lens. In the process of cropping in, image size and quality are reduced. See also Optical zoom.

DPI
A measure of printing resolution; in particular it refers to the number of individual dots of ink a printer can lay down on the print media within a linear one-inch (2.54cm) space.

EPS files (Encapsulated postscript)
A file format recognized by most page design and layout applications. EPS files are based on PostScript language and because of this they contain Vector and Bitmap graphics.

Exposure compensation
The act of adding or subtracting light to/from the camera's own automatic metered exposure. Expressed in EV (exposure value) + or - units, exposure compensation is a way of avoiding errors in the camera's automatic meter reading. One EV is also often called a "stop".

Extension tubes
Hollow tubes that fit between camera body and lens, increasing the distance between them and so decreasing the focusing distance of the lens. They are used for macro photography, giving

the photographer the opportunity to focus much closer to objects.

Field of view
The field of view (also field of vision or angle of view) is the extent of the world that can be seen at any given time. Humans have an almost 180° forward-facing field of view. In photography, fisheye lenses typically cover up to 180°, wide angle lenses between 84° to 64°; standard lenses 62° to 40°; telephoto lenses 30° to 10°.

Fill-in flash
Flash technique to help fill shaded areas of an image, especially when the background is lighter than the subject or when the subject is backlit.

Filter thread
The threaded section inside the front of a lens that filters and lens hoods can be screwed into.

Flash diffuser
A piece of opaque plastic or other fabric that is placed over a flash head to diffuse and spread the light, rather than focusing it at one specific point. Diffusers can be used to generate a more naturalistic lighting effect.

Flash drive (jump drive, pen drive)
A pocketsize digital storage device that plugs into any USB socket to transfer data (such as image files) onto the computer's hard drive, using either drag and drop or copy and paste commands.

Focus assist
Quick burst of visible or infrared light that helps a camera focus in dim conditions. The light can be emitted by the flash unit or from a separate lamp on the camera body.

Focus modes
Most autofocus cameras offer two main autofocus modes, single shot and servo (or continuous) focusing for shooting in

different situations and subjects.

• Single shot. In this mode the camera focuses when the shutter release is pressed halfway down.

• Servo (continuous focusing). Here the camera will adjust the focus all the time the shutter release is pressed. It adjusts the focus to take account of any delay when the shutter is fired. This mode is the default on the sport mode of many cameras.

Focus stacking
A digital process where multiple images, each with a different focus point, are combined into one. The final image has a greater depth of field than any of the individual images it comprises. This technique is mostly used in macro photography to show more detail in the finished image.

F-stop
You'll often see and hear exposure expressed in "stops", especially when using the exposure compensation function on your digital camera. As you move your aperture or shutter speed dial in increments, each stop either halves the amount of exposure given (-1 stop) or doubles it (+1 stop). See aperture.

Full frame sensor
Term used to describe DSLR sensors based on the nominal (24 x 36mm) dimensions of the traditional 35mm film frame.

Grey card
A neutral-coloured card that reflects 18% of the light falling on it. It is used for accurate exposure metering, or for taking a reading to set the white balance. To use it for accurate exposure metering, place the grey card so it lies in exactly the same light as the subject and take your meter reading direct from the card. For setting white balance, use the custom white balance option to achieve neutral colours.

Healing Brush tool
Allows you to clean up areas of imperfection, such as scratches or blemishes which occur on digital files as a result of dust on a camera's sensor. Works in the same way as the Clone Stamp tool, by sampling a clean area of the image then using it to paint over the area of imperfection.

Hotshoe
A connection on the top of most cameras to allow for mounting a flashgun. The hotshoe

provides a direct electronic connection to trigger the flash as the camera's shutter is released.

ISO (International Standards Organization)
Term referring to the camera sensor's sensitivity setting, equating to film speed in traditional film photography. Common settings are ISO 100, 200, 400, 800 and 1600. The higher the number the more sensitive the sensor is to light, allowing you to shoot in darker conditions.

Mirror lock-up
Camera function used to help reduce vibrations when taking a picture. Mirror lock-up facility often requires the shutter release to be pressed twice to take a picture. The first press will flip the mirror up, and the second will open the shutter to take the picture. Best used in conjunction with a cable or remote release to avoid jogging the camera.

Neutral density filters (ND) and grads
Filters that modify an image at point of picture taking. Designed to reduce light entering the lens, thus allowing you to make longer exposures for creative slow shutter speed effects or, when using ND grads, balance exposure in high contrast scenes. They have a slight grey/opaque tint to them, but because they're neutral, they only change exposure, not colour.

Optical zoom
A mechanical process where the elements in a lens are moved to allow a camera to zoom in on a scene. Unlike digital zooms, optical zooms don't reduce image quality because the image being recorded on the sensor isn't being cropped, interpolated or enlarged. See Digital zoom.

PNG (Portable Network Graphics)
An alternative image file format to GIF or JPEG that is a lossless compression format, with greater colour bit depth. Supports Indexed Colour, Grayscale, Bitmap mode images without alpha channels and preserves transparency in greyscale.

Program mode
Automatically takes the camera's meter reading and sets both your aperture and shutter speed in relation to the ISO, but still allows you to override many of the settings and use the exposure compensation function.

Reversing ring
Attachment that fits between the camera and lens and enables the reverse-mounting of lenses for macro photography. Focus is achieved by gently moving your camera backwards and forwards. Using a reversing ring gives a 1:1 life-size image ratio at a fraction of the cost of a macro lens. However, you'll lose automatic exposure functions such as aperture-priority mode.

SD (Secure Digital)
Memory card format developed by Matsushita, SanDisk and Toshiba for use in digital cameras. SDHC cards have now been released which offer a larger capacity than the traditional SD card. SDHC cards can only be used in SDHC compatible devices so always check your handbook to ensure your camera is compatible before purchasing one.

Slow sync flash (flash and time, flash and blur)
Creative exposure technique that generates images where the subject is part-frozen and part-blurred. Involves using flash with a slow shutter speed; as the exposure begins, the burst of flash freezes the subject.

Vignetting
The reduction of saturation or brightness at the corners of an image, leading to a darkening effect. Can be used as a creative technique to draw more attention to the centre of the frame. There are several causes of vignetting: mechanical, optical, natural and post-processing.

White balance
System of regulating the effect of varying colour temperatures from different light sources. The automatic white balance setting tries to interpret colours in a scene to give a neutral-looking result, avoiding colour casts. Most DSLRs offer a wide selection of manual settings (eg Shady, Tungsten) that give pre-set values to the colours so that you can generate a more predictable result.

Zoom burst
A technique that creates blurred streaks emanating from the centre of an image. At point of picture taking, the effect is created with zoom lenses that have a manual zoom ring. By using a slow shutter speed, generally under 1/60sec, and zooming into your subject while the shutter is open creates the zoom burst effect. The effect can also be replicated artificially in Photoshop.

Useful contacts

Add these organizations to your address book

UK

Alba Photographic Society
Netherton Community Centre,
Old Manse Road, Netherton, Wishaw, ML2 0EW
Tel: 01698 372983
Web: http://www.albaps.co.uk/index.html

The Association of Photographers
81 Leonard Street, London, EC2A 4QS
Telephone: +44 (0) 20 7739 6669
Web: www.the-aop.org

Belfast Photo Society
Sandy Row Community Centre, Sandy Row,
Belfast, BT12 5ER
Tel: 028 9022 0673
Web: http://www.belfastphotosociety.co.uk/
index.htm

British Association of Picture Libraries and Agencies
BAPLA, 59 Tranquil Vale, Blackheath,
London, SE3 0BS
Telephone: 020 7713 1780
Web: www.bapla.org.uk

British Institute of Professional Photographers
1 Prebendal Court, Oxford Road, Aylesbury,
Bucks, HP19 8EY
Tel: 01296 718530
Web: www.bipp.com

Disabled Photographers Society
PO Box 85, Longfield, Kent, DR3 9BA
enquiries@disabledphotographers.co.uk
Web: www.disabledphotographers.co.uk

Guild of Photographers
30 St Edmunds Ave, Newcastle-Under-Lyme,
Staffordshire, ST5 0AB
Tel: +44 (0) 1782 740526
Web: www.photoguild.co.uk

Master Photographers Association
Jubilee House, 1 Chancery Lane, Darlington,
County Durham, DL1 5QP
Tel: +44 (0) 1325 356555
Web: www.thempa.com

Redeye Photographic Network
Redeye, c/o Chinese Arts Centre, Market
Buildings, Thomas St, Manchester M4 1EU, UK
Web: http://www.redeye.org.uk/redeye/
default.asp

Royal Photographic Society
Fenton House,122 Wells Road, Bath, BA2 3AH
Tel: +44 (0)1225 325733
Web: www.rps.org

The Society of Wedding and Portrait Photographers
6 Bath Street, Rhyl, LL18 3EB
Tel: +44 (0) 1745 356935
Web: www.swpp.co.uk

North America

International Freelance Photographers Organization
P.O. Box 42, Hamptonville, NC 27020-0042
Tel: 336-468-1138
Web: www.aipress.com

The North American Nature Photography Association
10200 West 44th Avenue, Suite 304, Wheat
Ridge, CO 80033-2840
Web: www.nanpa.org
Phone: 303-422-8527

National Press Photographers Association
3200 Croasdaile Dr Ste 306, Durham, NC 27705
Tel: +919-383-7246
Web: www.nppa.org

Baltimore Camera Club
Mount Washington United Methodist
Church 5800, Cottonworth Ave Baltimore, MD
21209
Tel: 410-337-2939
Web: www.baltimorecameraclub.org

Photographic Society of America
3000 United Founders Blvd, #103, Oklahoma
City, OK 73112
Tel: 405 843-1437
Web: www.psa-photo.org

Australia

Australian Photographic Society
Suite 4, 8 Melville Street,
Parramatta, NSW 2150
Tel: +61 2 9890 6933
Web: www.a-p-s.org.au/index.php

Australian Photography Association
Web: www.australianphotographyassociation.
com

Manufacturers and distributors

Get to know who's who in the photo industry

UK

Adobe Systems Europe Ltd (imaging software)
3 Roundwood Avenue,
Stockley Park, Uxbridge, UB11 1AY
Tel: +44 (0) 208 606 1100
Web: www.adobe.com/uk

Bowens (studio lighting)
CT Distribution, PO Box 3128, Tilbrook, Milton
Keynes, MK7 8JB
Tel: 0870 458 5258
Web: www.bowens.co.uk

Calumet UK (major retailer)
Promandis House,Bradbourne Drive, Tilbrook,
Milton Keynes, MK7 8AJ
Tel: +44 (0) 1908 366 344
Web: www.calumetphoto.co.uk

Canon (UK) Ltd (cameras, lenses, system accessories)
Woodhatch, Reigate, Surrey
RH2 8BF
Tel: +44 (0)1737 220000
Web: www.canon.co.uk

Casio Electronics Co Ltd (compact cameras)
Unit 6, 1000 North Circular Road, London,
NW2 7JD
Tel: +44 (0) 20 8450 9131
Web: www.casio.co.uk

Color Confidence/TypeMaker Ltd (colour calibration devices)
Spectrum Point, 164 Clapgate Lane, Birmingham
B32 3DE
Tel: +44 (0) 121 684 1234
Web: www.colourconfidence.com

Daymen International (Lowepro bags, Giottos tripods, B+W filters)
Merryhills Enterprise Park, Park Lane,
Wolverhampton, WV10 9TJ
Tel. 0845 2500790
www.daymen.co.uk

Elinchrom (studio lighting)
Unit 7 Scala Court,Leathley Road, Leeds, LS10
1JD
Phone: +44 (0) 113 247 09 37
Web: www.elinchrom.com

Epson (UK) Ltd (printers, inks, papers and peripherals)
Westside, London Road, Hemel Hempstead,
Herts, HP3 9TD
Tel: 0871 4237766
Web: www.epson.co.uk

The Flash Centre (major retailer specialising in flash)
Unit 7 Scala Court, Leathley Road, Leeds, LS10 1JD
Tel: +44 (0) 113 247 09 37
Website: www.theflashcentre.com

Flight Logistics (sun position compass)
The Cabair Building, Elstree Aerodrome, Borehamwood, Herts, WD6 3AW
Tel: +44 (0)20 3210 1040
www.flight-logistics.com

Fotospeed Distribution (wet darkroom chemistry and digital papers)
Unit 6B, Park Lane Industrial Estate, Corsham, SN13 9LG
Tel: +44 (0) 1249 714 555
Web: www.fotospeed.com

Gary Fong products (flash diffusers)
BBJ Imports, 31 Monkswood, Welwyn Garden City, Hertfordshire AL8 7EF
Tel: +44 (0) 1707 694 320
Web: www.garyfongestore.com

Hahnemühle UK (art printing papers)
Suite 6, St Mary's Court, Carleton Forehoe, Norwich, NR9 4AL
Tel: +44 (0) 845 3300129
Web: www.hahnemuehle.com

Hewlett Packard (printers, inks, papers and peripherals)
Amen Corner, Cain Road, Bracknell, Berkshire, RG12 1HN
Tel: 0870 013 0790
Web: www8.hp.com/uk

Hama (UK) Ltd (bags, memory cards, lenses and filters)
Unit 4 Cherrywood, Chineham Business Park, Basingstoke, Hampshire, RG24 8WF
Tel: (0845) 230 4262
Web: www.hama.co.uk

Ilford Photo (wet darkroom, digital papers)
Ilford Way, Mobberley, Knutsford, Cheshire, WA16 7JL
Tel: +44 (0) 1565 684000
Web: www.ilfordphoto.com

Interfit Photographic (studio lighting, flashgun accessories)
Unit 4 Cleton Business Park, Cleton Street, Tipton, West Midlands, DY4 7TR
Tel: +44 (0) 121 522 48001
Web: www.interfitphotographic.com

Intro2020 (Joby Gorillapod, Seculine, Crumpler bags, Hoya filters, Sunpak flashguns, Tamrc bags, Tamron lenses, Velbon and Slik tripods)
Intro 2020, Unit 1, Priors Way, Maidenhead, Berks SL6 2HP
Tel: +44 (0) 1628 674411
Web: www.intro2020.com

Jacobs Digital Photo and Video (major retailer)
Jacobs House, Meridian East, Meridian Business Park, Leicester, LE19 1WZ
Tel: 0845 600 60 55
Web: www.jacobsdigital.co.uk

Jessops (major retailer)
Jessop House, 98 Scudamore Road, Leicester, LE3 1TZ
Tel: 0800 083 3113
Web: www.Jessops.com

Just Ltd (sensor-cleaning)
The Old Shop,Hook, Swindon, Wiltshire, SN4 8EA
Tel: +44 (0) 1793 855663
Web: www.cameraclean.co.uk

Kenro Ltd (Tokina lenses, Nissin flash, Marumi filters, Kenro studio lighting)
Greenbridge Road, Swindon, SN3 3LH
Tel: +44 (0) 1793 615836
Web: www.kenro.co.uk

Kodak Ltd (cameras, printers and accessories)
Hemel One, Boundary Way, Hemel Hempstead, Herts, HP2 7YU
Tel: +44 (0) 1442-261122
Web: www.kodak.co.uk

Lastolite (studio accessories, reflectors, backdrops)
18 Atlas Road, Hermitage Industrial Estate, Coalville, Leicestershire, LE67 3FQ
Tel: +44 (0) 1530 813381
Web: www.lastolite.com

Lee filters (filters)
Central Way, Walworth Industrial Estate, Andover, Hampshire, SP10 5AN
Tel: +44 (0) 1264 366245
Web: www.leefilters.com

Leica (cameras)
Davy Avenue, Knowlhill, Milton Keynes, Buckinghamshire, MK5 8LB
Tel: +44 (0) 1908 256400
Web: www.leica.com

Lensbaby LLC (lensbaby)
Intro 2020, Unit 1, Priors Way, Maidenhead, Berks , SL6 2HP
Tel: 01628 674411
Web: www.lensbaby.com

Lexar (memory cards)
Intro 2020, Unit 1, Priors Way, Maidenhead, Berks, SL6 2HP.UK
Tel: +44 (0) 1628 674411
Web: www.lexarmedia.com

Lumiquest (flash diffusers)
Newpro UK Ltd, Old Sawmills Road, Faringdon, Oxon, SN7 7DS
Tel: +44 (0) 1367 242411
Web: www.lumiquest.com

Manfrotto Distribution (Manfrotto tripods, Gitzo tripods, Kata bags, National Geographic bags, Lite panels)
Unit 4 The Enterprise Centre, Kelvin Lane, Crawley, West Sussex, RH10 9PE
Tel: +44 (0) 1293 583300
www.manfrottodistribution.co.uk

Newpro UK (Lumiquest and Stofen flash diffusers, Op/Tech pouches, Cullmann tripods, lens cleaning accessories)
Old Sawmills Road, Faringdon, Oxon, SN7 7DS
Tel: +44 (0) 1367 242411
Web: www.newprouk.co.uk

Nikon UK Ltd (cameras, lenses, system accessories)
380 Richmond Road, Kingston upon Thames, Surrey, KT2 5PR
Tel: 0330 123 0932
Web: www.nikon.co.uk

Olympus UK (cameras, lenses, system accessories)
KeyMed House, Stock Road, Southend-on-Sea, Essex, SS2 5QH
Tel: 0800 111 4777
Web: www.olympus.co.uk

Panasonic (cameras, system accessories)
Panasonic House, Willoughby Road, Bracknell, Berkshire, RG12 8FP
Tel: 0844 844 3852
Web: www.panasonic.co.uk

Paterson Photographic (wet darkroom, lighting, Benbo tripods)
2 Malthouse Road, Tipton, West Midlands, DY4 9AE
Tel: +44 (0) 121 520 4830
Web: www.patersonphotographic.com

Sony UK Limited (cameras, lenses, system accessories)
Jays Close, Viables, Basingstoke, RG22 4SB
Tel: 0844 8466 555
Web: www.sony.co.uk

Sigma Imaging (cameras, lenses, system accessories)
13 Little Mundells, Welwyn Garden City, Hertfordshire, AL7 1EW
Tel: +44 (0) 1707 329999
Web: www.sigma-imaging-uk.com

Samsung (cameras, lenses, system accessories)
Samsung House, 1000 Hillswood Drive, Chertsey, Surrey, KT16 0PS
Tel: +44 (0) 1932 455000
Web: www.samsung.com

Tenba (bags)
Profoto Ltd, 385 Centennial Avenue, Centennial Park, Elstree, Herts, WD6 3TJ
Tel: +44 (0) 20 8905 1507
Web: www.tenba.com

Vanguard (bags, cases, tripods)
ODS Optics, Units 9/10 Brickfield Trading Estate, Brickfield Lane, Chandlers Ford, Eastleigh, SO53 4DP
Tel: +44 (0) 2380 266300
Web: www.vanguardgb.com

Warehouse Express (major retailer)
The Showroom, Unit B Frenbury Estate, Drayton High Road, Norwich, NR6 5DP
Tel: +44 (0) 1603 486413
Web: www.warehouseexpress.com

North America

Adobe Systems Incorporated
345 Park Avenue, San Jose, CA , 95110-2704, USA
Tel: 408-536-6000
Web: www.adobe.com

Adobe Systems Canada
343 Preston Street Ottawa, Ontario, K1S 1N4, Canada
Tel: 613-940-3676
Web: www.adobe.com/ca/

Canon U.S.A., Inc.,
One Canon Plaza
Lake Success, NY 11042, USA
Tel: 516-328-5000
Web: www.canon.com

Canon
6390 Dixie Road, Mississauga, Ontario, L5T1P7,
Canada
Tel: (905) 795-1111
Web: www.canon.ca

Epson America, Inc.,
3840 Kilroy Airport Way, Long Beach, CA 90806-
2469, USA
Web: www.epson.com

Epson Canada Ltd.
3771 Victoria Park Avenue Toronto,
Ontario M1W 3Z5
Web: www.epson.ca

Hewlett-Packard Company
3000 Hanover Street, Palo Alto, CA 94304-1185,
USA
Tel: (650) 857-1501
Web: www.hp.com

Hewlett-Packard (Canada)
Co. 5150 Spectrum Way Mississauga,
Ontario L4W 5G1
Web: www8.hp.com/ca/en/home.html

ILFORD PHOTO
18766 John J Williams Hwy, Suite 4 – 327,
Rehoboth Beach, DE 19971
Web: www.ilfordphoto.com

Leica Camera Inc.
1 Pearl Ct, Unit A, Allendale, New Jersey
07401, USA
Web: us.leica-camera.com/home/

Lensbaby LLC
824 SE 16 Ave, Portland, OR, 97214-2676, USA
Web: www.lensbaby.com/

Lexar Media, Inc.
47300 Bayside Parkway Fremont, CA 94538,
USA
Tel: 510-413-1200
Web: www.lexar.com

Nikon Inc.
1300 Walt Whitman Road Melville, NY,
11747-3064, U.S.A.
Web: www.nikonusa.com

Nikon Canada
1366 Aerowood Drive, Mississauga, Ontario,
L4W 1C1, Canada
Tel: (905) 625-9910
Web: www.nikon.ca

Olympus
3500 Corporate Pkwy, Center Valley
PA 18034, USA
Web: www.olympusamerica.com/

Olympus Canada Inc.
151 Telson Road, Markham, Ontario,
L3R 1E7, Canada
Web: www.olympuscanada.com/index.asp

Panasonic Corporation of North America
One Panasonic Way, Secaucus, NJ 07094, USA
Web: www.panasonic.com

Panasonic
5770 Ambler Drive, Mississauga, Ontario,
Canada, L4W 2T3
Tel: 905-624-5010
Web: panasonic.ca/english/homepage.asp

Sony Electronics Inc.
1 Sony Drive, MD 1E4
Park Ridge, New Jersey 07656, USA
Web: www.sony.com

Sony of Canada Ltd.
115 Gordon Baker Road Toronto, Ontario, M2H
3R6, Canada
Tel: (416) 499-1414
Web: www.sony.ca/view/homepage.htm

Sigma Corporation of America
15 Fleetwood Court, Ronkonkoma
NY 11779, USA
Web: www.sigmaphoto.com

Samsung
105 Challenger Road Ridgefield Park,
NJ 07660, USA
Tel: 1800-SAMSUNG
Web: www.samsung.com

Australia

Adobe Systems Pty Ltd
Tower B, Level 13,
821 Pacific Highway,
Chatswood, NSW 2067
Tel: +61 2 9778 4100
Web: www.adobe.com/Australia

Epson
3 Talavera Road, North Ryde NSW 2113
Locked Bag 2238, North Ryde, BC1670
Tel: +61 2 8899 3666
Web: www.epson.com.au/

**Hewlett-Packard Australia Pty Ltd
(Melbourne)**
PO Box 221, Blackburn Vic 3130
or
353 Burwood Highway, Forest Hill Vic 3131
Tel: 13 13 47
Web: www8.hp.com/au/en/home.html

Lexar Australia Office
Lexar Media Pty Ltd, PO Box 658,
North Sydney, NSW 2060
Tel: +61 2 8923 4500
Web: au.lexar.com/

Nikon
Unit F1, Lidcombe Business Park
3-29 Birnie Avenue,
Lidcombe, NSW 2141
Web: www.nikon.com.au

Olympus Imaging Australia Pty Ltd
Ground Floor, 82 Waterloo Road,
Macquarie Park, NSW 2113
Tel: 1300 659 678
Web: www.olympus.com.au/

Panasonic Australia
1 Innovation Road,
Macquarie Park, NSW 2113
Web: www.panasonic.com.au

Picture Credits for pp.48–49

Many thanks to the following who kindly provided images for the accessories
section of the book:

Sigma Imaging, Nikon UK, Flight Logistics, Colour Confidence, Visible Dust,
Johnsons Photopia Limited, DayMen International, Intro 2020, Interfit
Photographic and Newpro UK.

For further product information please find website details below.

www.sigma-imaging-uk.com
www.nikon.co.uk
www.flight-logistics
www.colourconfidence.com
www.manfrottodistribution.co.uk
www.johnsons-photopia.co.uk
www.daymen.co.uk
www.intro2020.co.uk
www.interfitphotographic.com
www.newprouk.co.uk

Index

Accessories 30–49
 bags 38–39
 cases 38–39
 filters 34–36, 172
 flash kit, studio 178–181
 flashguns 40–41, 80, 176–177
 hard drives (for storage) 42
 monitors 43
 polarizers 36
 printing 44–47
 storage of images 42
 tripods 32–33, 53
Adobe Camera RAW 226–227
aperture 56, 58

backing-up files 249
backlighting 208–209
bags 38–39
black and white photographs 184–191
 convert from colour 126 129, 182, 183, 230–231
 convert to colour 130–131
 diffusion effects 196–197
 infrared in black and white 194
 splitting RAW conversions 236–237
blurring 70–71, 138–139, 154–155,172–173, 214–215
borders, adding 140, 192–193
Brush tools 96–99
budget DSLR 15–16
buying lenses 26–29

camera calibration 243
camera problems, fix 240–243
camera shake 66–67
Camera Skills 50–81
camera types 8–17

budget DSLR 15–16
enthusiast DSLR 16
full–frame DSLR 17
digital compacts 10–11
DSLR cameras 12–17
cases 38–39
changing colours 132–133
channels 124–125
choosing lenses 24
chromatic aberration 242
Clone Stamp 96
close–up shots 204–205
colour:
 balance 74–75, 88, 238–239
 changing colours 132–133
 channels 125–125
 colour cast 47
 colour control with RAW 238–239
 colour temperature 74
 hand-colouring 134–135
 HSL 239
 saturation 238
 settings 46
 space 46
compacts 10–11
 extreme compacts 10
 prestige compacts 10
 superzoom compacts 11
composition 76–77
compressing files 249
computer, transferring images onto 86–87
contrast, controlling 88, 92, 184–185
convert to black and white 126–129, 182–183, 230–231
convert to colour 130–131
cropping 90–91
Curves 88, 93, 185

depth of field 58, 64–65, 138–139
differential focus 65
diffusion effects in black and white 196–197
digital compacts 10–11
digital noise 240
Distributors 253
dodge and burn 184, 186–187
downloading images 245
DSLR cameras 12–17

Elements overview 84–85
enthusiast DSLR 16
exposure, long 172–173
extreme compacts 10

fast lenses 21
file formats 86–87
filters 34–36, 172
fireworks 200–201
flashes 78–81, 174–181
 flash kit, studio 178–181
 flashguns 40–41, 80, 176–177
 paint with flash 176–177
 pop–up flash 174–175
 studio flash 178–181
flower portraits 210–211
focal length 20–21
focal points 77
focusing 67
 differential focus 65
 soft focus effects 196–197
framing shots 76
fringeing 242
F–stops 58–59
full–frame DSLR 17

Glossary 250–251

hand-colouring 134–135

hard drives (for storage) 42
histograms 62, 88
HSL 239
hue 94–95, 239

infrared effects 194–195
Inspirational Photography 142–221
Introduction 6
ISO 56, 58–59

joiner pictures 216–219

landscapes 162–173, 182–183
Lasso tool 102, 103
Layers 114–123, 186–187
 blending 122–123
 masks 120–121
 RAW images 234–235
lenses 18–29
 buying 26–29
 choosing 24
 fast lenses 21
 fix lens problems in RAW 240–241
 lenses explained 20, 23
 macro lenses 29
 portrait lenses 29
 prime lenses 20, 29
 slow lenses 21
 telephoto zooms 28
 using 24
 wide angle zooms 27
 zoom lenses 20, 25–28,
Levels 88, 92, 162
lighting
 backlighting 208–209
 paint with light 202–203
 torchlight 206–207
lith effects 188–189

macro lenses 29
macro photography 205
Manufacturers 253

Marquee tool 102, 103
metering 60–63, 166
mode dial, using 54–55
monitors 43
monochrome see black and white photographs
movement 67, 72–73
 freezing 68
 static shots 214–215
 see also blurring

organization/workflow 244–249

paint with flash 176–177
paint with light 202–203
panning 72–73
panoramas 146–149
Pen tool 108–109
perspective 24–25
Photoshop and Elements Tutorials 82–141
Photoshop tools 85, 96–99, 102, 103, 108
polarizers 36
pop–up flash 174–175
portrait lenses 29
portraits 150–153, 156–159, 178–181
prestige compacts 10
prime lenses 20, 29
printing 44–47

RAW conversion 228–237, 248
RAW Imaging Advice 222–249
RAW, advantages 224–225
renaming images 247
resizing for print 47
re-touching tools 96–99
rule of thirds 77

saturation 88, 94–95, 238–239
selection 102–113, 162, 185
self–portraits 152–153
setting up the camera 52

settings in Photoshop 46
sharpening images 66, 100 101, 241
shortcuts, Photoshop toolbox 87
shutter speed 56, 57
silhouettes 144–145
slow lenses 21
smoke patterns 212–213
soft–focus effects 196–197
solarization effects 190–191
splitting RAW conversions (black and white) 236–237
static shots 214–215
still lifes 206–211
storage of images 42
studio flash 178–181
superzoom compacts 11

telephoto zooms 28
text, adding 141
texture effects 160–161
tone 92–93, 136–137
tools, Photoshop 85
 Brush tools 96–99
 Lasso tool 102, 103
 Marquee tool 102, 103
 Pen tool 108–109
 re-touching tools 96–99
torchlight 206–207
traffic trails 198–199
tripods 32–33, 53
triptych, make a 220–221

Useful Contacts 252

vignetting 242

white balance 74–75, 238
wide angle zooms 27
workflow (getting organized) 244–249

zoom lenses 20, 25–28,